The Great Central Valley
California's Heartland

Here's to another year of fun
& friendship Love, Susan
December 2003

Modesto Sign, 1986. Robert Dawson.

The Great Central Valley
California's Heartland

A Photographic Project by Stephen Johnson and Robert Dawson

Text by Gerald Haslam

Edited and Designed by Stephen Johnson

Published by the University of California Press in Association with the California Academy of Sciences

From an Exhibition Co-sponsored by the California Academy of Sciences and the Fresno Metropolitan Museum

Dedications

Stephen Johnson
For Mary, Sara Ann, and Matthew

Gerald Haslam
For Frederick, Alexandra, Garth, Simone, Carlos, and Jan

Robert Dawson
For my wife, Ellen, and our son, Walker

This book was made possible by a grant from
McClatchy Newspapers

Additional support was provided by
Apple Computer
Color Tech
Fleishhacker Foundation

The Great Central Valley Project exhibit was made possible by grants from
Agfa-Gavaert
California Arts Council
California Council for the Humanities
Eastman Kodak Company
Elyse Axell
Fleishhacker Foundation
Ilford Photographic
Mervyn's
Wilson & Geo. Meyer & Company
Professional Color Lab, San Francisco
L. J. and Mary Skaggs Foundation
van Löben Sels Foundation
Wells Fargo Bank

The publisher gratefully acknowledges the contribution provided by the General Endowment Fund of the Associates of the University of California Press.

Cover: Cattle, Merced County, 1988. Stephen Johnson.
Back Cover: Rice Mill, Woodland, 1985. Robert Dawson.

Photographs from this book have previously appeared in *American Photographer, Camerawork Quarterly, Golden State, California, Pacific Discovery, Aqueduct, This World,* and *Sierra.*

Excerpts from this text have previously appeared in *This World, California, Tularg Reports, The Monthly, Aqueduct, Pacific Discovery, Bay on Trial, The Californians,* and *Sierra.*

University of California Press
Berkeley and Los Angeles, California

University of California Press, Ltd.
London, England

© 1993 by
The Regents of the University of California

Text by Gerald W. Haslam © 1992
Photographs by Stephen Johnson © 1992
Photographs by Robert Dawson © 1992

Library of Congress Cataloging-in-Publicaton Data

Johnson, Stephen.
The great central valley: California's heartland/Stephen Johnson,
Gerald Haslam, Robert Dawson.
 p. cm.
Includes bibliographical references and index.
 ISBN 0-520-06411-9 (alk. paper). — ISBN 0-520-07777-6 (pbk. : alk.
paper)
 1. Central Valley (Calif. : Valley)—History. 2. Central Valley
(Calif. : Valley) —Description and travel—Views. I. Haslam, Gerald
W.
II. Dawson, Robert. III. Title.
F868.C45J65 1992
979.4'5 — dc20
91-20708
 CIP

Printed in Singapore

9 8 7 6 5 4 3 2

The Great Central Valley Project: Acknowledgments

The photographic project, and consequently this book, would not have been possible without the help of many people and organizations. Gene Behlen and Jeffery Meyer at the California Academy of Sciences in San Francisco were first among many who had confidence in our vision of what this exhibit could be. The Academy sponsored the entire project and went on to design, produce, and sponsor the exhibition. Madeleine Graham of the Academy's Exhibits Department designed a great installation for the exhibit's premiere at the Academy, much of which went on tour with the show.

A special thanks to Ansel Adams for his early support and encouragement. Our friend and part-time pilot Bill Johnston made many things possible, particularly our aerial photographs. Susan Jacobson spent many hours helping us fine-tune grant proposals.

James McClatchy, chairman of McClatchy Newspapers, provided encouragement and the critical funding to publish this work.

Dan Warrick at the Academy and Jim Clark at U.C. Press deserve much credit for making this book possible. Tony Crouch, Steve Renick, and Chet Grycz of U.C. Press all worked very hard to turn this book from idea to reality. Jim Quay and Cait Crogan at the Humanities Council were understanding and encouraging as they helped to broaden the project. Don Villarejo and Trudy Wischemann at the California Institute for Rural Studies helped with our facts, details, and perspective. Bill Preston and Stan Dundon gave us much encouragement and needed confirmation of the directions in which we were heading.

Barbara Redmond and Kingston Ku at Color Tech brought a unique dedication to the project. The book we all dreamed of was made possible by their persistence and skill in color separating most of the photographs and providing the final film for reproduction. Sanjay Sukhuja at Digital Pre-Press International provided critical film output to complete the project.

Thanks to James Docherty who trusted us with the glass-plate negatives by Frank Day Robinson that he helped to rescue and preserve. Thanks to John Csongradi for help with prints and care of the Robinson negatives. Dave Woods at the Maricopa Market allowed his collection of historical photographs to be copied and used in the exhibit. Wanda Belland and Ken Stevens helped with proofing Steve Johnson's work. Susan Thomas and Pamela Cobb provided much needed help as editorial assistants. Darin Steinberg spent many hours copying historical works for reproduction.

Our compatriots Gerry Haslam and Michael Black stayed with us through the long haul. Our wives, Mary Ford and Ellen Manchester, were helpful, tolerant, and critical in countless important ways.

The following organizations have our thanks for their contributions to the project.

California Academy of Sciences
California Historical Society
California Institute for Rural Studies
California State Library
Delano Historical Society
Fresno Metropolitan Museum
Great Valley Museum, Modesto
Kern County Library
Library of Congress
Merced County Courthouse Museum
National Aeronautics and Space Administration
Redding Museum
United States Geological Survey

Gerald Haslam: Acknowledgments

A number of individuals aided me in various ways with the preparation of this manuscript: Claude Minard, Don Isaac, Dan Markwyn, Bill Preston, Robert Speer, Jim Rawls, George Zaninovich, Richard Rodriguez, W. Harland Boyd, Trudy Wischemann, Isao Fujimoto, Jim Houston, Don Villarejo, Stan Dundon, Jack Zaninovich, Harold Gilliam, Richard Smoley, and Leo Lee, along with my colleagues Michael Black, Sheridan Warrick, Bob Dawson, and Steve Johnson. Special help came from the editors of *The Plow* and *Golden Notes*. My wife Jan and my daughter Alexandra, and my pal and mentor, the late W. H. Hutchinson, who proofread and offered valuable suggestions, were most important of all; to them and for them I am especially grateful.

I also wish to thank the following organizations and agencies for their cooperation during research for this project:

Bancroft Library
Bidwell Mansion State Historic Park
California Academy of Sciences
California State Archives
Chinese Historical Society of America
Colusa County Historical Society
Delano Historical Society
Holt-Atherton Center for Western Studies
Huntington Library
Japanese-American National Museum
Jedediah Smith Society
Kern County Historical Society
Kern County Museum
Madera County Historical Society
Paradise Fact and Folklore, Inc.
Roy J. Woodward Memorial Library of California
Sacramento County Historical Society
Stockton Corral of Westerners
Tehama County Genealogical and Historical Society
Yolo County Historical Society

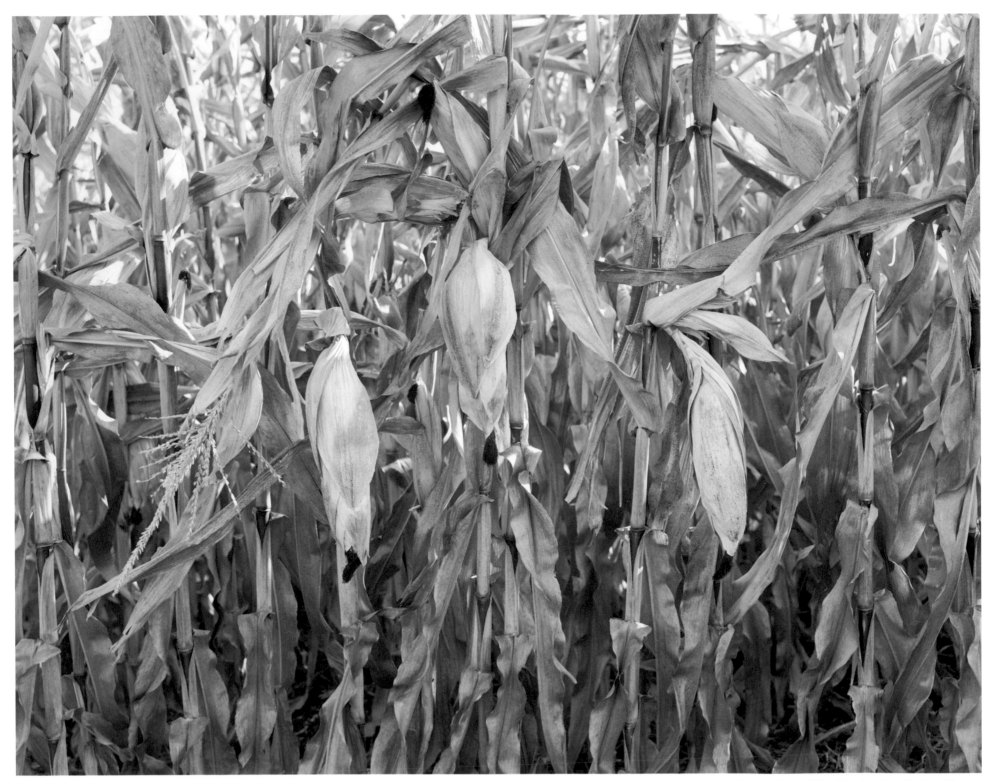

Summer Corn, Tyler Island, 1984. Stephen Johnson.

Introduction: Stephen Johnson

I grew up in the San Joaquin. I never dreamed I would be involved in the arts. An architect maybe; more likely a lawyer. I remember the fields all around me, and the farmers and farm workers in those fields. I can't recall thinking much about them at the time, their link to the land seemed natural, expected.

It was years later before I realized the influence some of those memories had on me. Those wide open spaces with their geometric rows and patterns had set something in motion in my mind. Although the workers in those fields seemed ordinary and natural, there was nonetheless something strange about the scene, something uncomfortable about dragging men and machines across the earth to cut, tame, and harvest. Even in the Great Central Valley, the process seemed disconnected from the food in the grocery store.

But I was drawn to those fields; in fact, I still am. Walking, riding my bike, and eventually on long drives, those endless, decaying two-lane country roads became a passion. My partner in this project, Bob Dawson, was riding those winding levee roads outside of Sacramento on the big river up north. A few years earlier, our good friend Gerry Haslam was exploring the secrets of ripairian woods along the Kern River and learning the real meaning of hard work in the oil fields of Kern County.

I gradually dared farther out of Merced's suburbs, edging ever closer to the foothills. Sometimes in wet, white fog, but most often with heat radiating on the horizon and blurring the road into mirage—those roads became visually and emotionally important. Strangely, for me they were similar experiences to hiking in the backcountry of Yosemite. There was a similar space and solitude.

I didn't give much thought to productivity, pesticides, chemical fertilizers, or irrigation. Irrigation was what some of my high school friends had to get up at 2 or 3 A.M. to do, so they could go back to bed and get up again at 4:30 A.M. to milk the cows before school. On graduating from high school, one good friend who grew up on a dairy said he was leaving the Valley and would never come back.

I did eventually settle on photography as my work, seduced by the beauty of a photographic image, by the wild country it took me to, and, I think, by my childhood memories of Valley fields. I know that when I think of how we have altered this world, I think of the Valley first.

The Valley is too vast to understand easily. And too complex. On a purely visual level, it is a very difficult place to photograph. It is hard to find a vantage point to see very far, and yet everywhere there are wide vistas. It is certainly not about old men with scruffy beards or decaying

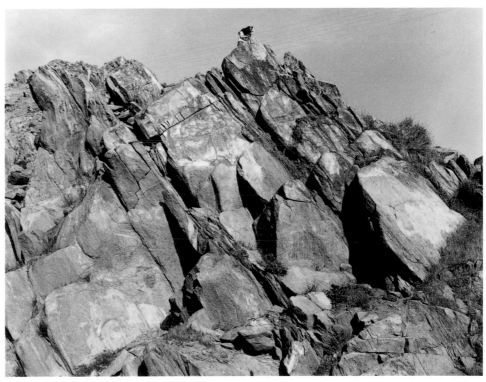

Rocks and Steve, Kern River Canyon, 1983. Robert Dawson.

barns and quaint wooden fences. It is so much more than that. It is tempting to look for quirky sides to the Valley, and some have proven irresistible, but they are not telling. The Valley is much more than its rural oddities.

It is heat, oppressive and reassuring, and land, vast, but fading into a growing haze that makes the horizon disappear. It is a valley so big that it doesn't seem like a valley. It is stacks of statistics so impressive and large that they quickly lose meaning. It is also a land whose anonymity is cause for concern, because what goes on here is not usually made of high drama, but of long-term change and consequences that are easy to miss, and possibly devastating. It was a challenge to go home and try to see this place clearly.

When Bob Dawson and I decided to return home to the Valley to photograph, I did so with mixed emotions. In some ways I don't think I was quite ready to go home: my love for home was still there, but there were many other emotions as well. It wasn't long before we realized that what we were doing could be important. We were creating an opportunity to go home, to try to understand where we came from, in a way that might never have been possible had we stayed. It also became clear that there were compelling reasons to embark on *The Great Central Valley Project,* outside of any personal motivations.

The Great Central Valley Project began in the summer of 1982 with initial sketches for the project, long discussions, and our first photographic fieldwork. We began background research and continued photographing during 1982 and through 1983. In 1984 we began to seek funding for the project. The entire photographic project was sponsored by the California Academy of Sciences in Golden Gate Park, San Francisco. Eugene F. Behlen, then public programs director at the Academy, provided help, guidance, and enthusiasm for the project.

Our fieldwork, fund-raising, and basic research continued through 1984 and 1985, resulting in the premiere of the exhibit at the California Academy of Sciences on July 2, 1986. The exhibit closed on October 16, 1986. During this period 433,000 people visited the museum. Our good friend and fellow son of the valley Dr. Michael Black organized the symposium *The Great Central Valley: Heartland in Transition* which was conducted at the Academy on October 11, 1986, with 150 people in attendance and 24 speakers.

Gerry Haslam, Cottonfield, Bakersfield, 1949.

Bob Dawson at Yankee Slough, 1984. Stephen Johnson.

It was back in 1984 that Bob and I became acquainted with Gerald Haslam, who we found shared our interests in the Valley. We were immediately fond of Gerry; he knew plenty of stories about a dingy bar called Trouts that Bob and I stumbled onto in Oildale. Gerry agreed to write the text for the book at a planning meeting in 1985. We were excited at the prospect of pulling together the diverse and complex history of the Valley into one volume.

The exhibit began its tour through the Valley at our co-sponsoring museum, the Fresno Metropolitan Museum. The tour continued through mid 1988, with an itinerary that included Chico, Redding, Stockton, Merced, Bakersfield, Modesto, Visalia, and Tulare. A national tour is planned for the 1990s, during which we hope to reach a few million people with the exhibit.

Ten years ago, when I organized the exhibit *At Mono Lake,* I realized that as an artist I had an obligation and an opportunity to have an impact on things I cared about. As a landscape photographer, I feel an attachment to the land similar to those who work it, and care for it. Such obligations are strongly felt. I spend time moving around the American West because I identify with the landscape, and I care about its future. This may be most true in the Valley. Because it is my homeland, the concern is personal as well as social.

This is no longer the wild Valley Native Americans enjoyed, and it never can be again. The native Valley was long ago sacrificed to agricul-

ture and settlement. But we have built something valuable here, we have carved a land able to produce food like no other. Having grown up in one of those Valley towns, and cherishing many of my childhood memories, I can partially understand that sacrifice. But I can't understand some of the directions we are currently going, damaging the land the Valley's wealth rests on, or paving it over to make room for more suburbs.

Looking back over time, the fate of irrigated societies is not promising. Most have destroyed the land that sustained them. All have used the best technology available to them, but they have rarely seen the warning signs of trouble ahead soon enough. Fertile valleys and plains have been turned to deserts. The poisoning of birds at Kesterson's agricultural wastewater ponds may be such a warning. And although we are proud of how far technology has brought this valley, we don't seem to be getting much better at looking ahead. Our predictions are more long-term, and based on something somewhat more reliable than fortune-tellers, but are often not taken any more seriously.

There is a growing tendency to set aside what we hear about the latest danger to our health or the land. And it's no wonder. There constantly seems to be something new we are told to fear. Something new in our food or our air that has been found to be dangerous. And we begin to shut down. We feel powerless to really affect these dangers. It may be ironic, but the long-term health of the Valley may be tied to the same decisions we probably ought to be making about our own long-term health. We need to find new ways to control pests, new ways to keep the land fertile and use only as much water as is absolutely necessary to grow our crops. And we need to look carefully at those crops. Just because we can grow something in a particular place doesn't mean we should. It may ultimately take more from our valley than the money it brings.

We are caught in the same web of surviving day to day, paying the bills, and getting by, much like any other culture in history. Farmers can't simply decide they don't like pesticides or chemical fertilizers and stop using them tomorrow. Bank loan officers would soon be at the door foreclosing on their land, and it would be sold to someone willing to use whatever it takes to pay the loans. It takes involvement by many different people to change how we treat our land. Perhaps we have to accept less-than-perfect produce. Maybe that produce needs to cost more. And as more and more countries around the world export food, maybe our goals should turn toward a different definition of productivity: where quality is as important as quantity, and where quality means free of chemicals and good-tasting rather than perfect in appearance or easy to pick, pack, and ship.

There are some major challenges facing the Valley. We want to help solve them. We are not agricultural economists, scientists, or

Steve Johnson, Porterville, 1984. Robert Dawson.

farmers—not even politicians or bankers. The best thing we can imagine doing is to explore the Valley, work in it, react to it, and make our art. We want to draw attention to this place, and construct ways for people to become more involved and more appreciative of what is at stake in the Valley.

The Great Central Valley Project exhibit, and now this book, came to exist because we were interested in our own artistic response to the landscape of our homeland—and we wanted to stimulate greater discussion and participation in the ongoing evolution of this valley. We don't have the answers, but we have learned a few important questions. Change is often slow, but if we can help shape tomorrow, rather than letting it shape us, we believe the Valley can survive as a healthy home, and as the productive heartland of California agriculture. The photographer W. Eugene Smith said in his book *Minamata* (which portrays a Japanese fishing village suffering from mercury poisoning) that, as artists, "to cause awareness is our only strength." As artists we can only hope to rise to that challenge.

Stephen Johnson
Pacifica, California
June 1990

Valley Fruit Box Labels. California State Library.

Contents

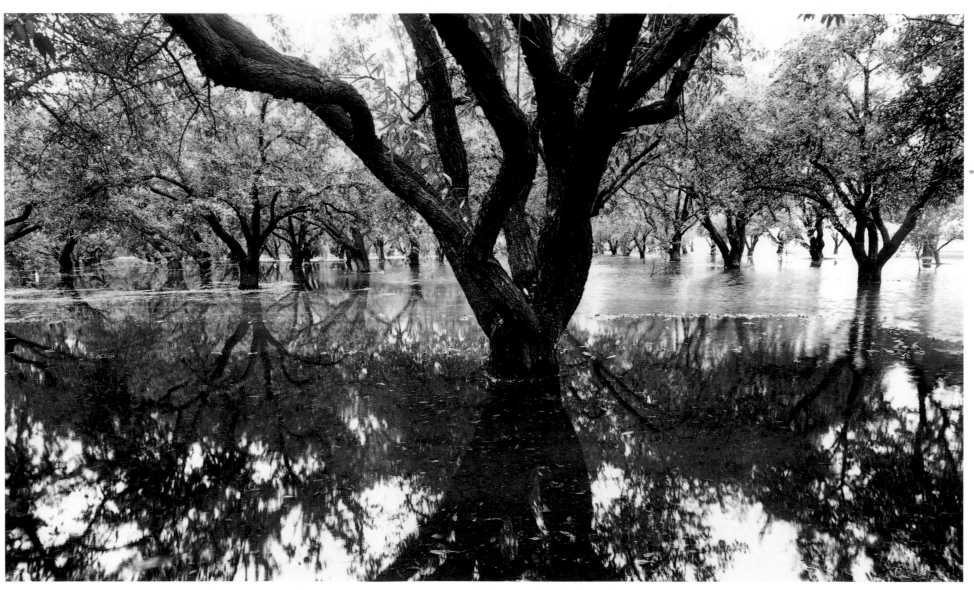

Flooded Orchard near Manteca, 1982. Robert Dawson.

Winter 1986: A Journey

This Valley has rarely been more beautiful. We drive down Interstate 5 toward Oildale in crystal air, past patches of vegetation mirrored by standing water, a brisk crosswind tugging at our car. Far to the east loom muscular mountains dusted with snow, while closer two rows of aging palms stand as sentries along a farm road. To the west, treeless hills are emerald now and dotted with muddy cattle.

As we speed south, the familiar aroma of wet soil invades and softens, while scythes of sound lift from crow clusters celebrating in nearby drenched fields. Farther down the freeway, we pass mallards dipping and chuckling in roadside ditches, coots assembling in flooded fields that were once the bed of Tulare Lake. Finally, an irrigator, his legs encased in rubber boots that sag like elephants' feet, waves as we pass, and I give him thumbs up; then turn and smile at my wife—two Valley kids growing gray, happy and a little startled to be home.

This intimate region may hide its beauties and its blemishes from strangers, but not from us. We turn east on Lerdo Road and ahead an isolated storm cloud trails tendrils of rain—a dark jellyfish in the sky. On both sides of the route, premature wildflowers dot uncultivated fields and hay is volunteering. Visible, too, are tracts of stucco houses, now covering what only last year were productive fields, the buildings seeming to crawl toward us as we approach.

Beyond them, in open country again, we still smell the living earth, but its musk is darkened here by the faint breath of petroleum; oil pumps salaam in the middle of cotton fields on both sides of us. Where the road swerves, a tractor is bogged down in a half-furrowed tract. Well ahead—our perspectives distorted by angle and distance and crispness—we glimpse Oildale's roofs and clusters of dark trees, with steam plumes rising from creased hills beyond, and we see Bakersfield sloping on river bluffs to the south. From our radio, we hear a tug from home, country music drawing us closer, ever closer, our long journey nearly over.

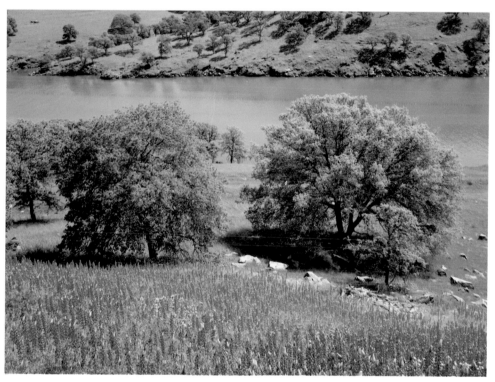

Oaks and Lupines, Merced River, 1985. Stephen Johnson.

A few minutes later, we swing into the driveway, as usual disturbing doves drinking from water puddled in the gutter. As we climb from our car, a neighbor who fifty years ago struggled into this valley from Oklahoma grins, extends a leathery hand, and welcomes us.

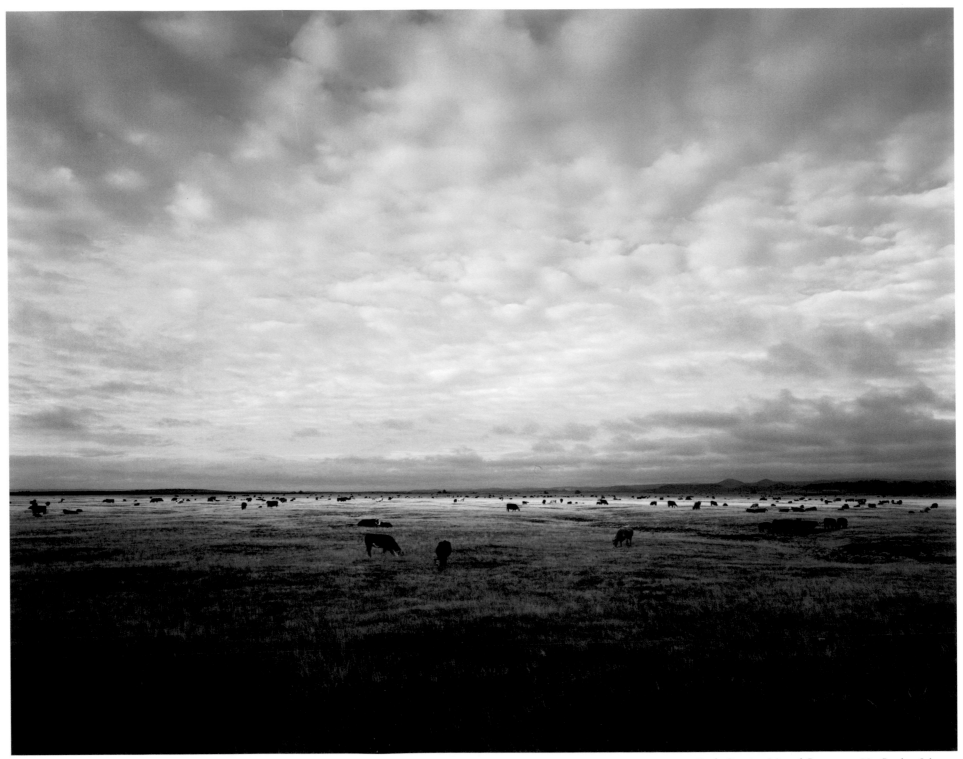

Cattle Grazing, Merced County, 1988. Stephen Johnson.

Chapter I: An Overview

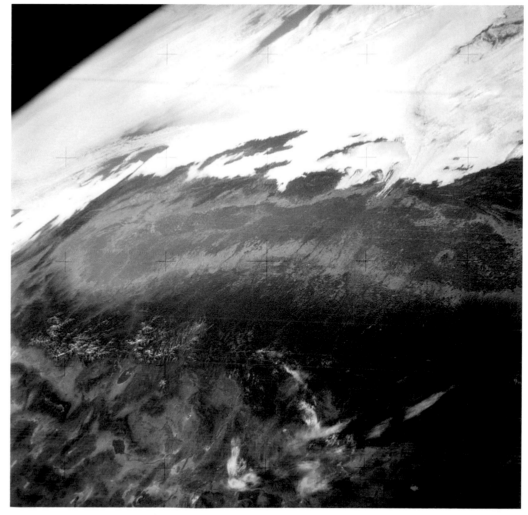

A satellite soaring nearly six hundred miles above earth reveals California's most arresting landmark, a vast tan-and-green trough crowded with geometric patches. Dark ganglia of rivers, their forms sensuous, perhaps deranged, plunge into it from the east, contrasting dramatically with the precise angles of an engineered aqueduct that stretches along much of its west side. Illusions of disorder and order, of nature and human aspiration, seem poised in that distant earthly realm, the Great Central Valley.

Over 430 miles long and an average of 50 miles wide—about the size of England, some fifteen million acres—this vast trench is one of the world's largest valleys. It is California's core, and it drains two major river systems, the Sacramento flowing from the north and the San Joaquin from the south, both of which eventually pour into San Francisco Bay.

The Great Central Valley is composed of far more than its physical features: it has a human landscape too. A middle-aged black man chopping cotton near Buttonwillow can see not only inexorable rows ahead of him, but also varied people around him. He can hear a cacophony of languages—Tagalog, Hmong, Spanish, and Italian—while he covets a hint of wind that might cool him. He can also think of his children, attending school so that they will never have to trudge these same fields. That thought comforts him far more than a breeze.

Three hundred miles north near Colusa, a fair girl bounces a pickup along a dirt track next to a rice field searching for weak spots in an irrigation ditch; behind her, close to a large, metallic barn, dark smoke rises from stubble being cleared by fire. She will return to college soon and, after her graduation, perhaps operate this farm, as have three previous generations of her family. When she emerges from the truck, her blonde hair glows like flax in late summer sun, and a black dog leaps from the pickup's bed to splash in the water while the girl examines a softened embankment.

Approximately midway between Buttonwillow and Colusa, an aging man sits on a bench in front of a weathered building in Locke.

California and the Great Central Valley from the Northeast, 1975. Skylab, NASA.

His hands are spotted, and his creased face shines like waxed leather. He was born in China but has spent six decades in California and is no longer certain which is home. From his vantage, he can view the mighty Sacramento River sliding by, smell the layers of life in freshly turned earth, and he can speak in Cantonese to other aging men about an old country they will never again see.

This is a region demanding in work and rich in people; it gives little away, but it can be forced to yield opportunity, even prosperity, although the odds are by no means equal for everyone. The price of both survival and success here is frequently sweat, whether in the domain of the Sacramento River to the north or the realm of the San Joaquin River to the south—each forming a unique vale within the Valley. They are separated by a low alluvial divide, which disjoins drainages and leads to a complicated delta, formed by the meandering channels of the two major streams, some minor ones, plus resulting marshes, swamps, and islands. These three connected areas—the Sacramento Valley, the Delta, the San Joaquin Valley—are said to constitute this realm's major subregions.

But there is delusion in the latter component—the San Joaquin Valley—that reveals the degree to which humans have altered this ap-

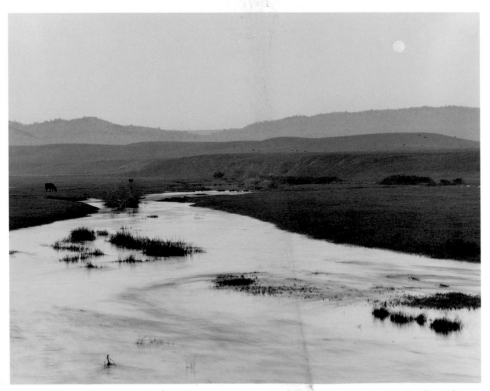

Creek and Moon, San Joaquin County, 1986. Stephen Johnson.

parently open and natural landscape: historically, there existed a geomorphic and ecological distinction between the San Joaquin Plain and the now-forgotten Tulare Basin, because the Valley's southernmost rivers did not flow into the San Joaquin's drainage. Today, most of those rivers don't drain at all, not in the old sense at least, because their flows have been put to work. The basin's erstwhile wetlands are now indistinguishable from the agricultural geometry of the plain that fronts it, and its residents say they live in the San Joaquin Valley. Conceptually, the Tulare Basin has ceased to exist.

Two hundred years ago, the narrower valley of the Sacramento to the far north was characterized by vast riparian forests and large marshes, both products of the seasonal surgings of the mighty stream and its tributaries. Since Shasta Dam has reduced and tamed the Sacramento River's volume, and most of its tributaries have also been dammed, those overflows have been mitigated, but its channel still bisects the verdant prairie, following a course near its center.

Below, in the San Joaquin section, which widens to seventy-five miles at one point, the land slopes distinctly from the east, and the river cuts across its dry surface, then wends along the once-barren western side; here, in the old days, parched prairie dominated, and William Henry Brewer described it in 1863 as "a plain of absolute desolation." Dams and irrigation projects have considerably enriched the land through which the San Joaquin River travels, just as they have altered and diminished the stream itself and its attendant wetland.

The drainages of the Sacramento and San Joaquin converge in the Delta, which before development channeled an average of 8.8 trillion gallons of water annually and was filled with riverine forests along the many curling channels of streams born in high mountains. Marshes and swamps and sloughs also characterized the region. It has now been thoroughly diked, somewhat drained, and rigorously cultivated, although never completely controlled.

South of the San Joaquin, where any drainage north was blocked by the Kings River's alluvial fan, lay the wetlands of Tulare Basin; here vast tracts of rushes led the Spaniards to name it *el valle de los tulares*, the valley of the tules, and wetlands there were bordered, paradoxically, by arid-to-semi-arid tracts, even alkali desert in places: it was a strange region of contrasts, broad, shallow lakes shimmering on a desert. With rivers dammed, marshes and lakes drained, it now boasts miles of orchards and cultivated fields; oil pumps dot the desiccated hills on its southeastern and southwestern edges.

These were and are, in any case, all parts of a single remarkably productive valley—"the richest agricultural region in the history of the world," according to environmental scientist Garrison Sposito. Statistics certainly back that assertion: according to county agricultural commissioners' reports, Fresno County in 1985 yielded $310,600,000, Kern

THE GREAT CENTRAL VALLEY

The Native Landscape

1. Sacramento River
2. Feather River
3. Yuba River
4. Bear River
5. American River
6. Cosumnes River
7. Mokelumne River
8. Calaveras River
9. Stanislaus River
10. Tuolumne River
11. Merced River
12. San Joaquin River
13. Kings River
14. Kaweah River
15. Tule River
16. Kern River

Central Valley

Rivers

Lakes (now dry)

Riparian Woodland

Marsh

Saline Lands

The Emerging Valley (5 million years ago)

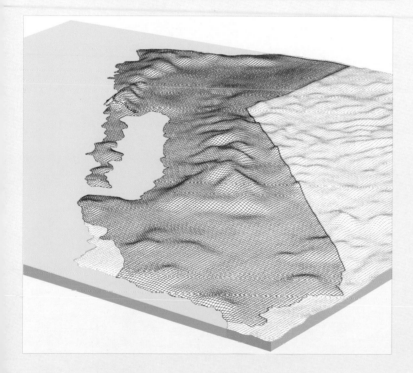

Valley Cross-Section

(alluvial fill)

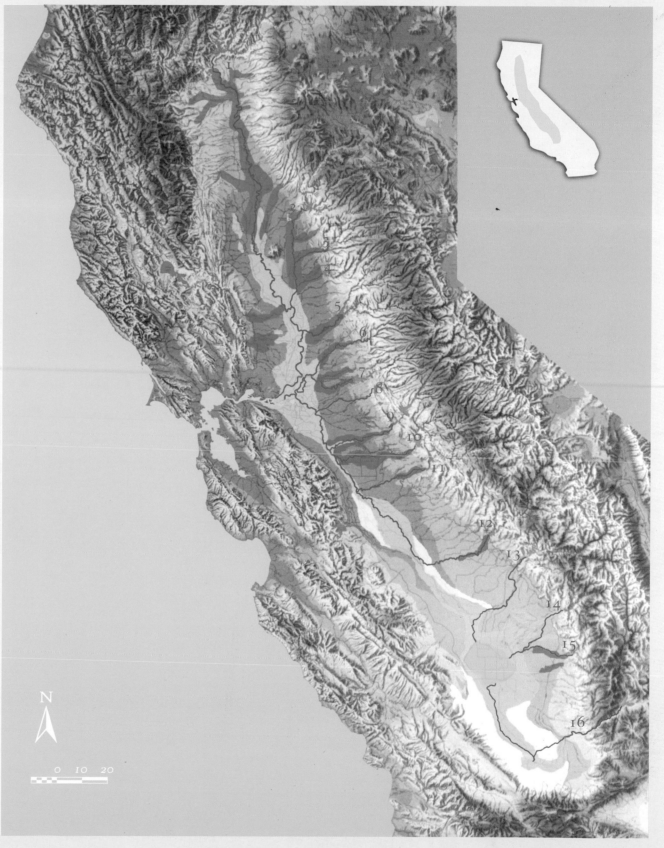

N

0 10 20

Graphic by Stephen Johnson.
Base map Copyright 1987 by Raven Maps and Images.

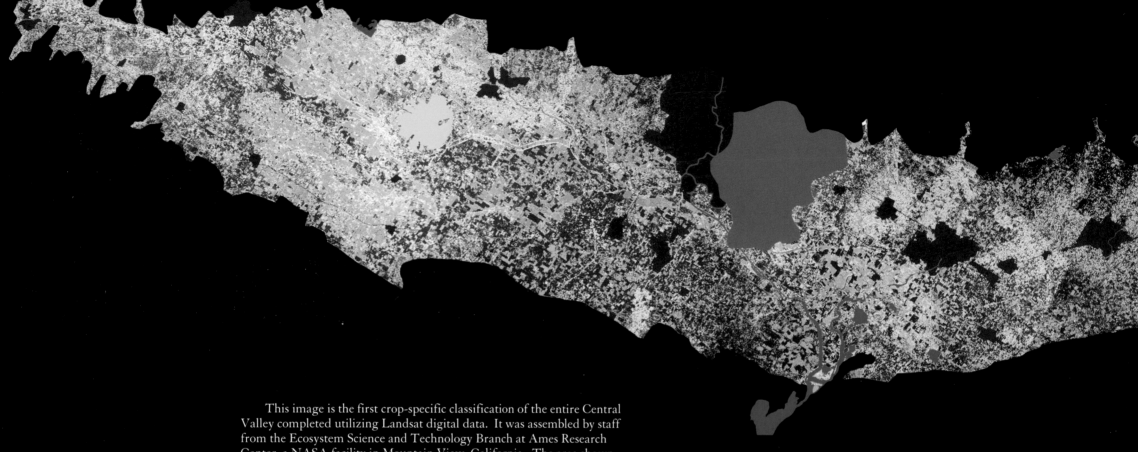

This image is the first crop-specific classification of the entire Central Valley completed utilizing Landsat digital data. It was assembled by staff from the Ecosystem Science and Technology Branch at Ames Research Center, a NASA facility in Mountain View, California. The area shown extends from south of Bakersfield to Red Bluff and includes approximately 95% of the Central Valley physiographic province.

Crop types were identified using digital data from the Multispectral Scanner (MSS) on Landsat 4 and Landsat 5. Seven Landsat frames from three orbital paths were required to obtain complete coverage of the Central Valley. A spring scene, a mid-summer scene and a fall scene were acquired for each frame. Data values in MSS band 7 (0.8–1.1 microns) and MSS band 5 (0.6–0.7 microns) from fields of known crops and other land cover types were used to develop a classifier, or statistical model. The model was applied to the MSS bands 5 and 7 values of all picture elements (pixels) in the area of interest, and each pixel was assigned to the land cover type it most closely resembled.

The images were created by generalizing the classification and rendering it in photographic prints. Twenty-eight cover types were reduced to fifteen to enhance the interpretability of the image. The reduction was made by combining minor crops in an "other crops" category and combining all orchards into two categories. To make a product of reasonable scale and resolution, the classification was divided into thirty-six sections. Each section contained a maximum of 1,024 columns and 1,024 rows of pixels. The sections were sampled every other pixel, enlarged by a factor of two and reproduced on color negatives.

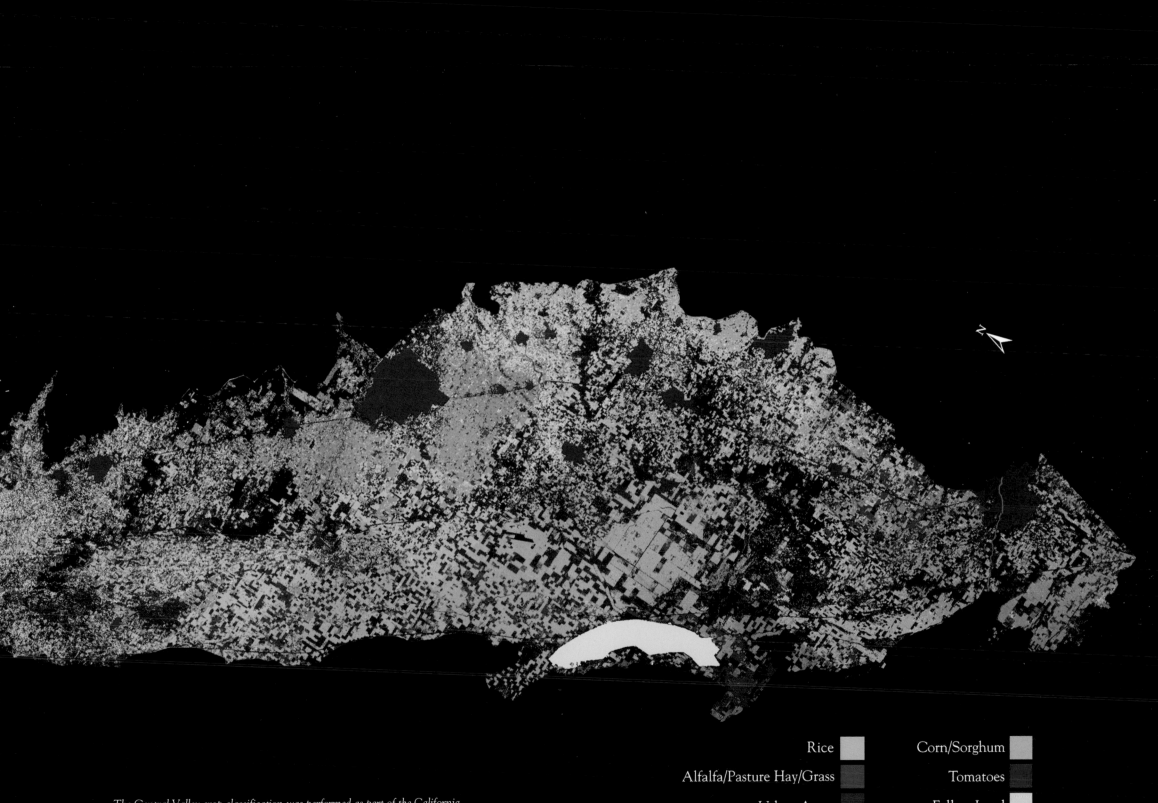

The Central Valley crop classification was performed as part of the California
Cooperative Remote Sensing Project. Participants were:

National Agricultural Statistics Service, U.S. Department of Agriculture
California Department of Water Resources
California Crop and Livestock Reporting Service
Remote Sensing Research Project, University of California, Berkeley
Ecosystem Science and Technology Branch, NASA Ames Research Center

Principal investigators at NASA/Ames in Mountain View, California:

C. A. Hlavka, NASA, and E. J. Sheffner, TGS Technology Inc.

Rice

Alfalfa/Pasture Hay/Grass

Urban Areas

Other Orchard

Water

Safflower/Sugar Beet/Sunflower

Almonds/Walnuts/Pistachios

Corn/Sorghum

Tomatoes

Fallow Land

Grapes

Obscured by Clouds

Cotton

Wheat/Barley/Oats

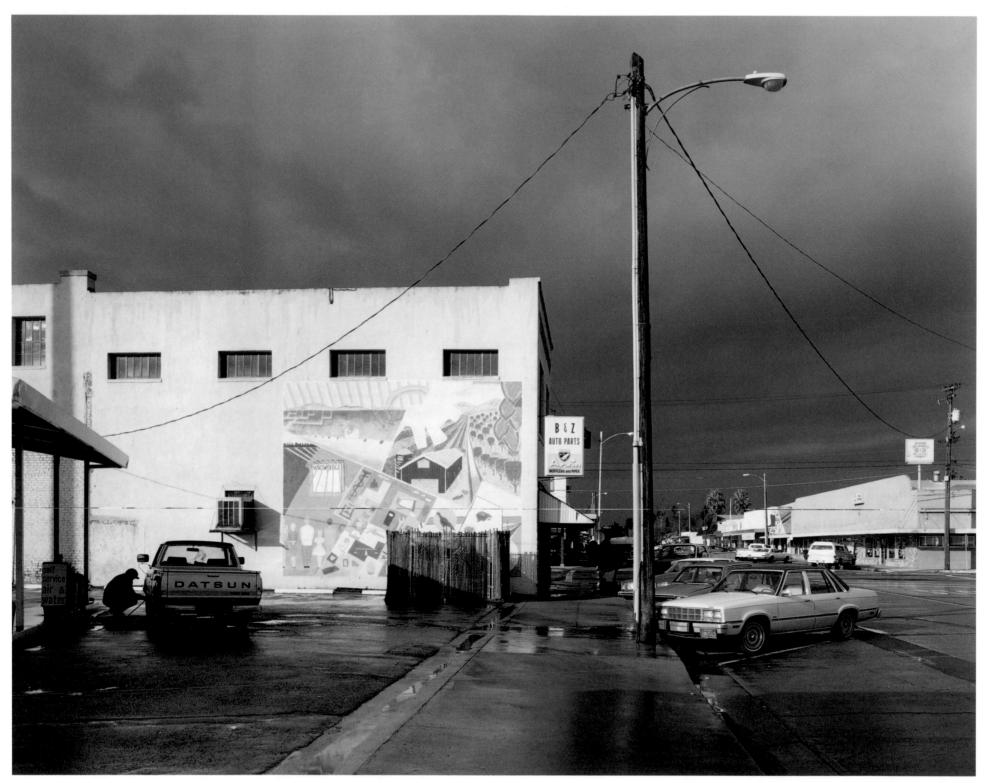

Main Street, Ceres, 1986. Stephen Johnson.

produced $231,200,000, while Kings contributed $187,600,000 *for cotton alone*. Grapes contributed $292,100,000 in Fresno, $194,800,000 in Tulare, and $152,700,000 in Kern. Tomatoes added $107,100,000 to Fresno County's economy; $68,600,000 to Yolo County's, and $36,200,000 to San Joaquin County's. The roll could be much, much longer, its line of zeros ever less comprehensible, since nearly three hundred commercial crops are grown here, but the point is that agriculture is big business indeed in this domain—$14 billion in 1986—and it is a vital link in America's food chain. As historian W. H. Hutchinson points out, the annual value of agricultural production exceeds the total value of all the gold mined in the Golden State since 1848.

The Great Central Valley is geologically a trough between mountains: the Coast Ranges and the Sierra Nevada wall it to the west and east, the Cascades border it above, and the Tehachapis mark it below. It is covered by marine and river deposits. "For all practical purposes . . . the Great Central Valley is one vast alluvial plain," geographer David Hartman observes. The most significant break in its apparently level, actually west-slanting, topography is a large extrusion of Plio-Pleistocene volcanic rock, the Sutter Buttes, in its upper reaches. But flatland dominates. "This is what California is: a long central valley encircled by mountains . . . It is a single, mountain-walled prairie," another geographer, John A. Crow, asserts.

To inhabitants, it is simply "the Valley," home, the unique arena that is theirs. Ann Williams, a native daughter, reveals her deep and enduring sense of the region where she still dwells:

> *During the last three months of my eighth-grade year, my mother and I commuted from Chico every weekend by Greyhound. Unthinkable as that marathon would seem today, I remember it with appreciation. It was a schooling in American life, and was partly responsible for my present sense of place.*
>
> *Names of towns were sung out by good-natured drivers: Stockton, Modesto, Turlock, Merced, Chowchilla, Fresno, Tulare (they said* too-lar*), Pixley, Delano and, finally, Bakersfield, by the sea. The last was good for laughter and applause, especially in late May when the heat had set in.*

Although it is most noted for stretches of green, furrowed fields—flipping by mesmerically when viewed from a moving bus—the majority of the Valley's inhabitants have long lived in towns, which themselves have tended to grow as agricultural adjuncts, primarily centers for packing and shipping. In the morning, pickups may be seen bouncing out on county roads toward farm jobs, and company cars filled with fertilizer sales reps or sellers of irrigation systems soon follow. Near midday, it is not unusual to see vehicles heading back toward town—more this time, since farmers, too, are driving toward favorite coffee shops, where the day's affairs will be discussed with friends; it is a ritual dating back to the sweat house and every bit as important.

These rural towns quickly became centers for culture, too, where folks could gather and chat, worship and educate their children. It is also true that in many communities there have traditionally been distinct and literal right and wrong sides of the tracks: to the west resided laborers, frequently nonwhite; to the east lived growers, merchants, and professionals, usually white. The boundary was often a railroad track lined with packing sheds. While this division is slowly breaking down, it nonetheless continues to influence Valley life.

What *is* life like in the Valley? During the long, dominant hot season, there is a deliberateness of movement—heat precluding speed, especially in those great ovens called packing sheds. Kids of all colors plunge into forbidden-but-cooling irrigation canals or hop from vacant lots, feet wounded by puncture vines. Except for those able to afford air-conditioners, folks sleep sweaty on screened porches, hoping for a breeze, even a puff. Rising at dawn into day's coolest grasp, menfolk assemble at a diner for coffee and a short stack, for groggy greetings and laughter, then fill the thermos and once again head for the shed or the field or the office.

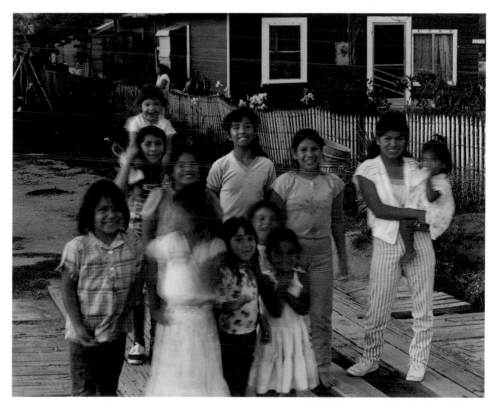

Kids, Yettem, 1984. Stephen Johnson.

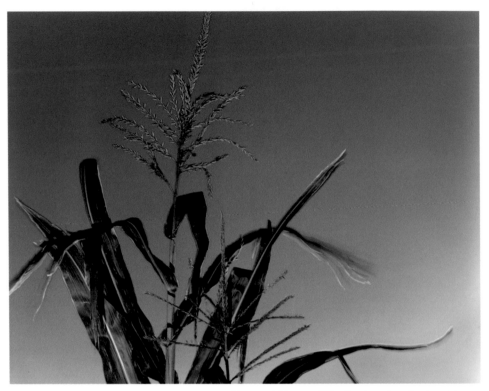

Corn and Sky near Woodland, 1985. Stephen Johnson.

Agriculture here has been creative, developing unique equipment and techniques, experimenting with unusual crops. And it has been big business indeed. Despite domination by the boardrooms of conglomerates—Robert de Roos refers to them as "agricultural baronies"—there are still many small spreads, and their owners are among the hardest-working people in the state. The Almond Exchange, for example, has 5,800 members, many of them with holdings of less than 50 acres.

Family farmers, those who live on the same soil they work, can say one thing that few corporate growers can: they have formed what George Zaninovich from Delano calls an "identific" relationship with their land—they identify with it and love it as the living thing it is. "I look out my door…I know every inch of this dirt," Aldo Sansoni, who grows crops on nearly ten square miles of Valley soil near Los Banos, observes. "I don't farm through the windshield of a pickup. I've gotten out there and worked that land for many years, for hours on end. I've done the hay. I've picked my share of tomatoes and cantaloupes. And I'd like to be able to hold on to what I've got." And Francis DuBois, a Davis rice farmer, says, "I know what that mud feels like between my toes, and I like it."

But large corporations, whose officers are more adept at picking stock options than tomatoes or cantaloupes, control far more acreage. In Tulare, Kings, and Kern counties in 1982, for instance, Don Villarejo, executive director of the California Institute for Rural Studies, found 5,766 farms of 80 acres or less, totaling 234,622 acres; but he also found 26 spreads of 5,121 acres or more, a total of 646,735 acres.

Big spreads are an old tradition hereabouts, where the Spanish once bestowed gluttonous grants. James B. Kendrick, Jr., who recently retired as vice president of Agriculture and Natural Resources at the University of California, points out that in 1982 there were 2.2 million farms in the nation, 87% of which were classified as small or part-time. By the year 2000, it is predicted, there will be about 700,000 fewer in this category. That same year, moreover, large farms are expected to capture 85% of total agricultural income. "There seems little doubt that small and medium-size farms, constituting 80% of the total…will require off-farm income and assistance in adopting new agricultural technologies if they are to survive," Kendrick adds. His observations apply with special poignancy to the Central Valley.

Not even hard work and ingenuity necessarily allow owners of small operations to compete effectively with powerful agribusinesses, and in many ways they have little in common with them. It is one consistent Valley irony that the operators of huge spreads often publicly equate themselves with owners of diminutive family farms when it suits their ends ("We're just struggling farmers.…"). Those with small holdings rarely have the luxury of doing the opposite.

Fair is fair, and it must be conceded that corporate agriculture in the Valley has produced abundantly. "Each…farmer feeds 82 people. Americans eat better than citizens of any other nation and pay less," points out Richard Smoley, managing editor of *California Farmer.* Who are those agriculturalists? Some here are called Sandrini and Mettler and Masumoto, successful family farmers from immigrant backgrounds; others are household names: Prudential and Equitable and Travelers, for instance. In 1984, nearly $2 billion of the $9.1 billion in California's farm real estate loans were held by insurance companies, to mention just one kind of national and multinational corporation that is deeply involved in the business of agriculture. Such giant corporations (often employing local farm managers) control capital that allows them to take advantage of the newest technological advances—and to lobby effectively for what they want from government.

The use of local managers sometimes links traditional family farming with contemporary corporate farming. Met West Agribusiness in Fresno, whose parent corporation is Metropolitan Life, seeks the best of both worlds. "The majority of our farmers are from family-farm backgrounds. The family-farm model is something that works and we believe in it," explains its president, Steven Wilmeth.

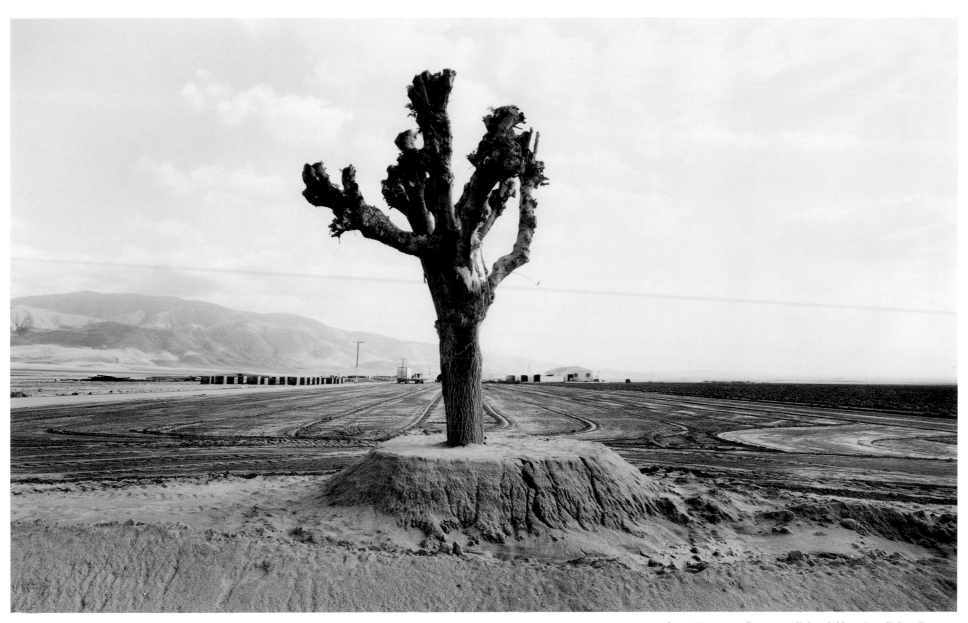

Large Corporate Farm near Bakersfield, 1984. Robert Dawson.

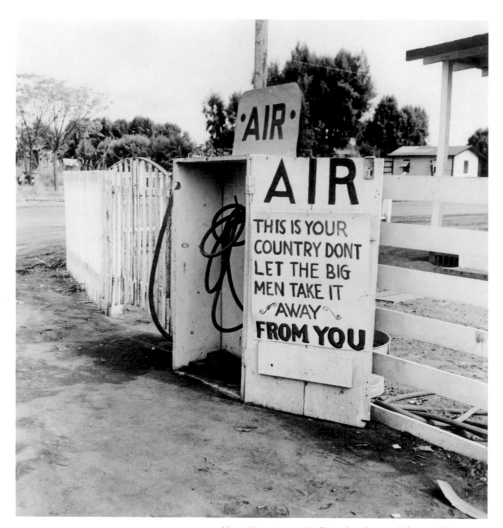

Kern County, 1938. Dorothea Lange. Library of Congress.

The ownership pattern and the need for seasonal labor have social effects that are not abstract. Class distinctions are evident in Valley towns. There are the nonresident rich, mostly corporate owners, some of whom control great spreads of land but develop no relationship with the community; the resident rich, who also control large tracts (this group includes a few family farmers, as well as corporate managers, and some elite professionals, along with the owners of firms servicing agri-business); a complicated and growing middle class, encompassing many owners of small farms, professionals, and both blue- and white-collar service workers; the upwardly mobile poor, some of them small farmers too, but including workers in the process of escaping the cycle of mi-grant labor; finally, a large underclass—many of them migrant labor-ers—composed of recent arrivals and of those established here who have never been able to escape poverty's grip.

Each of those classes has traditionally been smaller, and whiter, than the one below it. The great and enduring political game in this valley is to convince members of the large middle and lower classes that their interests coincide with those of the rich. The stake is power.

There remains a tragic gap between haves and have-nots here; in 1980 the *New York Times* announced that six of the ten metropolitan re-gions in the nation with the highest percentage of population on public assistance were located in this valley: the greater Visalia, Stockton, Yuba City–Marysville, Fresno, Modesto, and Redding areas. Part of the prob-lem is, of course, that many poor people swell the rolls when they come here seeking work, but it is also true that the established economic struc-ture of the region has demanded a malleable and eternal lower class that can be utilized for seasonal labor. There has always been great wealth in the Valley, but it has not been equitably distributed.

What has resulted is communities that are frequently convivial, sometimes rough, usually conservative, and in general not interested in advice from outsiders. A few have been, in effect, company towns, dominated by big growers, packers, or oil interests, while others have been richly diverse, though usually tied to agriculture. Many are grow-ing rapidly, developing urban patterns, urban problems, and urban re-wards. This is no longer strictly a rural region, although open land still dominates; today Sacramento, Stockton, Fresno, and Bakersfield can fairly be called cities, and housing tracts are covering the farm fields that once surrounded those communities. As population concentrates, other settlements have died, their streets veined by weeds, their buildings blank as skulls. Around nearly all of them, the living and the dead, are crops, reminders of why the communities ever existed.

Inhabitants of Valley towns are linked by an often-unacknowledged tension: everyone is dependent on everyone else for economic survival. They often appear unaware of the parochialism and self- serving nature of some local values. Opinions on economic opportunity, welfare, taxes, farm labor, race relations, and even the agricultural use of chemicals, may be expressed in what hereabouts passes as practical, perhaps patriotic terms: free enterprise and jobs, jobs and free enterprise—the business of the Valley is business. A Kern County oil executive, for instance, told a service club that air-quality controls would "have a devastating effect" on the local economy; he did not mention the potential health hazard posed by pollution. In 1986, when California voters approved a proposition re-stricting the use of toxic chemicals, Ed Giermann, corporate counsel for the J. G. Boswell Company, which farms 50,000 acres in the Tulare Basin, complained, "What they're trying to do is generate a new fear of the word 'carcinogen.' Chemicals are absolutely necessary for everyday life."

Speck Haslam, a retired oil worker and long-time Valley resident, pointed out an incongruity when he observed, "The big shot who moans and groans when some poor people around here collect welfare—because it means he can't hire them for next to nothing—will howl bloody murder if the government doesn't subsidize *his* crops, *his* welfare, and he won't see a damn thing inconsistent about it."

As a farmer, Sansoni offers a different perspective when he scores "payoffs for setting aside certain crops." He adds, "If you talked to the average farmer here, he'd tell you, 'Let us produce. We've got the land, we've got the resources, the ability, the climate, we've got everything. We can feed the nation in California.'"

North of Sansoni's large Los Banos holding, an anonymous member of the Posse Comitatus explains, "I'm against illegal taxation and them giving all the money to a bunch a Mex'cans." He is sitting in the cab of a pickup next to a field near Stockton, where he and five others are protesting the presence of United Farm Workers' pickets, whom he calls "commies"—a word that is used freely and sometimes creatively hereabouts.

Paradoxically, this valley—which some outsiders choose to regard as the realm of rednecks and clodhoppers—has contributed in unexpected ways to California and the world. In the 1980s, it exported award-winning writers: Maxine Hong Kingston (Stockton), Richard Rodriguez (Sacramento), Frank Bidart (Bakersfield), Joan Didion (Sacramento), Larry Levis (Selma), David St. John (Fresno), Leonard Gardner (Stockton), Gary Soto (Fresno), Luis Valdez (Delano), and Sherley Anne Williams (Fresno), among others. Fresno, in particular, has produced poets to a degree that rivals its agricultural riches, and in a recent collection, entitled *Piecework,* the editors, Jon Veinberg and Ernest Trejo, venture this explanation of why: "Although we don't subscribe to the narrow theory of geographic determinism, we nevertheless feel that a confrontation with the stark, elemental beauty of the landscape, the unescapable awareness of its rigid social order, and the fact that ultimately very few care about anything other than survival or making and spending money somehow equips the true follower of the Muse for the long haul."

Thanks to the hard work of elders, this valley has become a place where for the first time in many families' histories, members of younger generations are free to ask how and why and at what cost, free to pursue those questions as well as the meanderings of their unique imaginations.

Contemporary Valley writers discuss new worlds and old ones, touch realities long mute and reveal a vital California frequently ignored by savants. Luis Valdez explains how he came to develop a new concept in American drama, El Teatro Campesino—The Farmworkers' Theater. Born in Delano of parents who worked the surrounding fields,

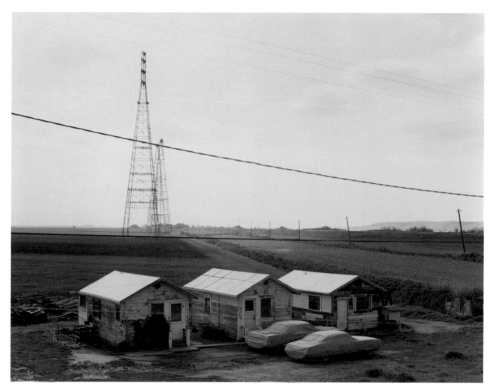

Shacks and Cars, Sherman Island, 1984. Stephen Johnson

he established the drama group in his hometown to aid the organizing efforts of the United Farm Workers union in 1965, understanding full well that

> theater, as we know it, had been pretty much something of the privileged classes or people in this country. And so, here we were combining this function, this community event, with another kind of function, [that] of the worker. And the juxtaposition of the two created a new something that was very weird. Farmworkers' theater, or teatro campesino.

El Teatro Campesino has now toured Europe six times, and received major critical awards in Los Angeles, New York, and San Francisco. It has produced great commercial successes—*Zoot Suit* and *Corridos*—to accompany its literary achievements. Yet its roots remain in those same fields where Valdez's parents once picked cotton and cherries and grapes in the hope that their children would not have to. And that hope is the intangible crop that has drawn so many people here.

How *do* the residents of this surprising place appear to an outsider? Stephen Birmingham in *California Rich* observes:

Raisin Vineyard, Selma, 1987. Stephen Johnson.

This valley after the storms can be beautiful beyond the telling,
Though our cityfolk scorn it, cursing heat in the summer and drabness
in winter,
And flee it—Yosemite and the sea.
They seek splendor; who would touch them must stun them;
The nerve that is dying needs thunder to rouse it.

I in the vineyard, in green-time and dead-time, come to it dearly,
And take nature neither freaked nor amazing,
But the secret shining, the soft indeterminate wonder.
I watch it morning and noon, the unutterable sundowns,
And love as the leaf does the bough.

Authors blooded in the domain seem incapable of *not* writing about it, no matter where they now live. Pro or con, they remain involved with the unique region that shaped them.

While the Valley's climate—too hot in one season, too cold in another—by no means seems perfect to all residents, it is certainly close to perfect for farmers: hot and dry in summer, cool and wet (and foggy) in winter. Those two seasons are separated by a brief, glorious spring and a desiccated, almost unnoticed fall.

The thermometer often climbs to over 100° Fahrenheit during the summer, and it does so as frequently in the north as in the south. There is abundant sunshine throughout most of the year, and the growing season is long, up to 300 days a year. Rainfall may reach thirty-five inches annually in the northern section of the Sacramento Valley, but seldom exceeds six inches at the southern end of the Tulare Basin, where pan-evaporation may reach twenty inches a month during summer. Moreover, rainfall tends to be concentrated in the winter. It is revealing that when California is divided into life zones by scientists, the south Valley is classified as Lower Sonoran—a designation it shares only with the Mojave and Colorado deserts. Explains geographer John Crow, "Fifty years ago, during the long dry season, the valley floor resembled a desert"; before water was pumped onto Valley soil, only its brief spring glory—Sierran rivers running high, wildflowers blooming—gave a hint of its potential richness.

Driving through this area during spring and summer can be an olfactory adventure, heated air carrying fragrances as dense as gravy, but marred here and there by the sharp nasal slice of imposed chemicals. At night especially, senses focused, traveling those titillating, those primordial scents can be a dream journey.

Despite the imposed chemicals, insects in fabled numbers—the basis of great and enduring commerce hereabouts in such devices as bug zappers, bug screens, and bug deflectors—still snap against the windshields and grills of moving vehicles, decorating them with their

There is something about Valley people that seems to set them apart from city folk—a certain manner and a certain cast of mind. Being farmers—or, in the current vernacular, being in the "agribusiness"—the Valley men are tough, pessimistic, politically conservative, fiercely independent, contentious, and hot-tempered. If there is one thing a Valley rancher resents it is "folks from the outside trying to tell us what to do."

For better or worse, farm economy and farm society certainly do shape this unique arena, but they do not limit its output or accomplishments.

Of the Valley, where scuffed boots remain more common than oxfords, pickups than limousines, and where Veterans' Day parades and Fourth of July picnics still remain major attractions, James D. Houston has aptly observed, "It is actually a subregion of the American West, in many ways a realm unto itself." David Spaur, of the Modesto Chamber of Commerce, revealed two California styles clashing when, discussing the emerging impact of Bay Area commuters moving into his area, he observed, "For the first time around here Japanese subcompacts are starting to outsell American pickup trucks."

Despite what some outsiders choose to think, Valley natives evince little desire to flee their untrendy heartland, whether in trucks or subcompacts. As William Everson of Selma, the first major poet produced here, writes in "San Joaquin":

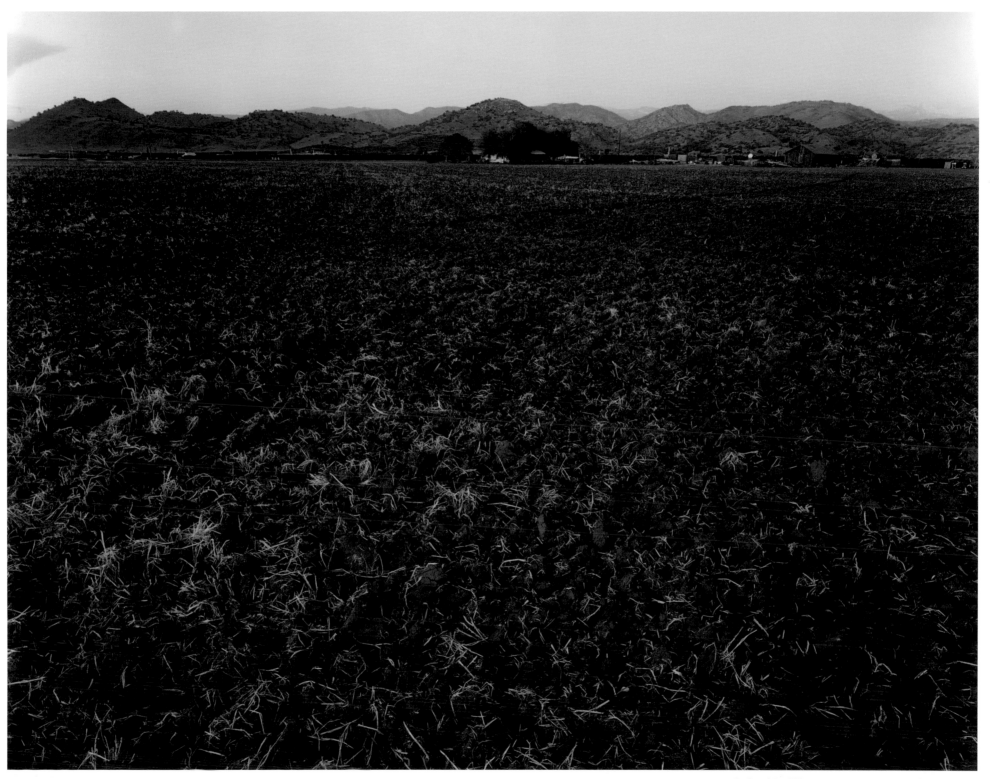

Soil and Stubble near Yettem, 1985. Robert Dawson.

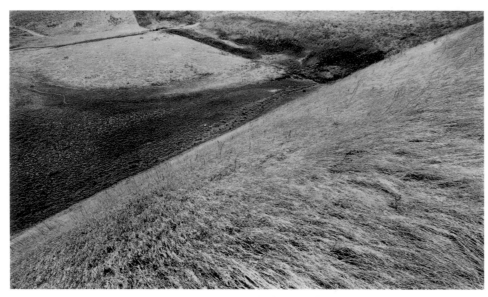

Embankment, Altamont Pass, 1982. Robert Dawson.

multi-hued carcasses. W. H. Hutchinson remembered returning from a trip in the Chico area and finding the windshield "plastered with juicy, yellow bugs that made driving 99E at night an encounter with space aliens."

During the winter, especially in the south, details of the Valley are often obscured when radiation fog—"tule fog" or "Valley fog" in local parlance—rises from this antique seabed; photographs from a weather satellite reveal a massive gray protozoan dominating the state's core. On the earth, in what Lynn Ludlow calls "one of the world's biggest ground clouds," thick fog hugs the soil, deadens the sun, and produces an eerie, chilled beauty, with scenes and subjects rendered in low-contrast black and white. "You can't see but a few feet sometimes," reports Earl Wood of Suisun City. "Fog is depressing. The light of day doesn't change from morning to evening. It's a persistent shade of gray. I can't take it for long," Kathleen Goldman of Stockton says.

Following the short, splendid spring, an extended summer develops: sun prevails and the horizon seems to expand; the earth itself appears to be sweating. Roads disappear into omnipresent heat waves and mirages, while dust devils gambol over unplanted tracts. The mirages, the whirlwinds, the barren tracts themselves are surrounded by squares and rectangles of various greens extending out of sight, cultivated fields folded into irrigation rows. Above, a faded sky presses the leaves, presses the soil, presses the breath: heat, heat…

During a broiling harvest season that extends well into what elsewhere would be autumn, heat waves continue to curve daylight, and the phantom figures of toiling farmworkers swerve across the horizon like sojourners on the floor of a molten sea. Remaining stretches of uncultivated earth are dry, almost charred, but they, too, are surrounded by the startling green agricultural patches created by imported water and introduced chemicals.

Those chemicals, which have been so central to Valley agriculture, are often derived from petroleum, and it, as social ecologist Michael Black points out, is a form of energy captured from the sun: "Fossil fuels essentially equal frozen sunlight, stored energy over the millennia, a finite resource which we're squandering."

The Valley's uncultivated prairie once waved and surged in spring gusts—Marc Reisner calls it "the Serengeti of North America"—and it endured storms of dust, summer grass fires, and winter floods. Today it is unrecognizable. "There is little doubt that more changes have occurred to the flora of the Great Valley than to the plants within any other botanical region of California," observes botanist Joseph Medeiros. And not merely to plants: as A. Starker Leopold points out, "Both the variety and abundance of wildlife in the Central Valley are declining and will continue to do so as agriculture becomes more mechanized." This area's remarkable productivity has involved loss as well as gain.

Now that great prairie has been tamed, many of its native plants are gone beyond memory, and most of its great animals survive here only as stuffed specimens in local museums. Massive earthmovers level the already flat surface where perennial bunchgrasses once thrived; trucks and tractors now cross where early travelers saw herds of pronghorns and elk; crops burgeon where desert plants shaded horned toads.

This is a man-made agricultural factory of extraordinary proportions. Absent "this modern-day Valley of the Nile," Irving Stone writes without hyperbole, "California would be a magnificent front, able to support less than half its population, hollow at its economic core." Fully 25% of *all* table food produced in the United States is grown in this single valley, a profusion that has, among other things, spawned its own vocabulary: farms are "ranches"; farmers are "growers"; farming is "agribusiness."

Where would the Great Central Valley rank nationally among states in agribusiness? Garrison Sposito answers: "There would be Iowa, Illinois, Texas, then the Valley—it would be the fourth most important *state*. Of the top ten agricultural counties in the United States, five are in the Valley." Fresno, Tulare, and Kern counties rank one, two, and three nationally as agricultural producers most years. Kern, the southernmost, also produces more oil than some OPEC nations, more than all but two states. This region is California's most vital organ, and, fittingly, the state's capital is Sacramento, located in the Great Valley's midsection.

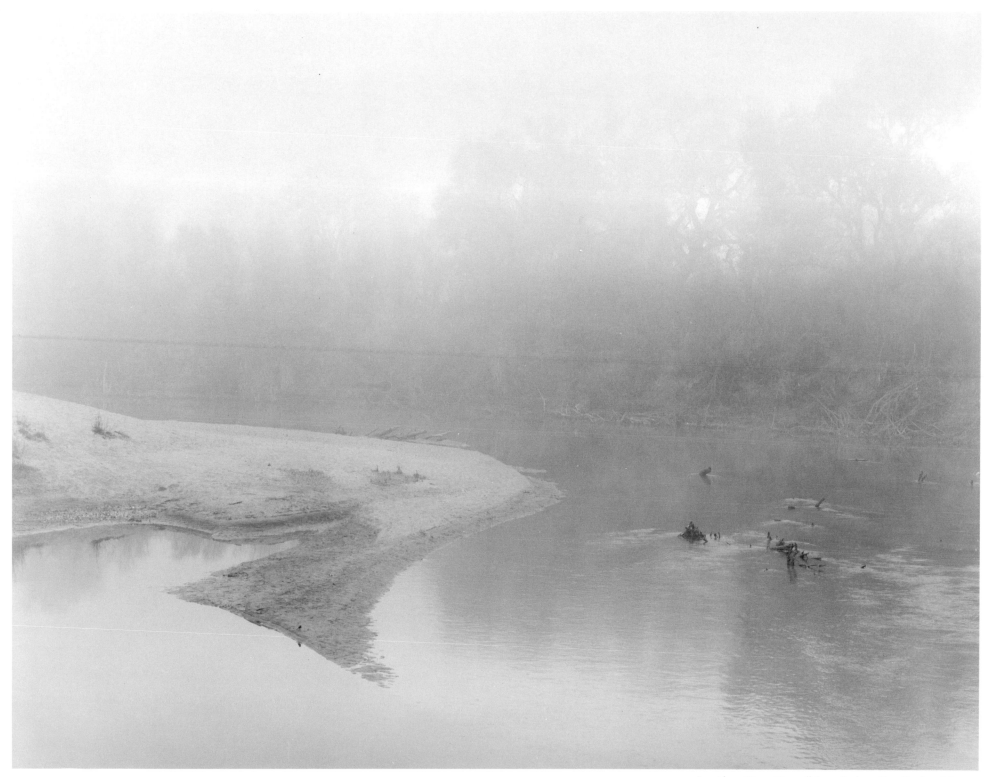

Stanislaus River, Caswell State Park, 1985. Stephen Johnson.

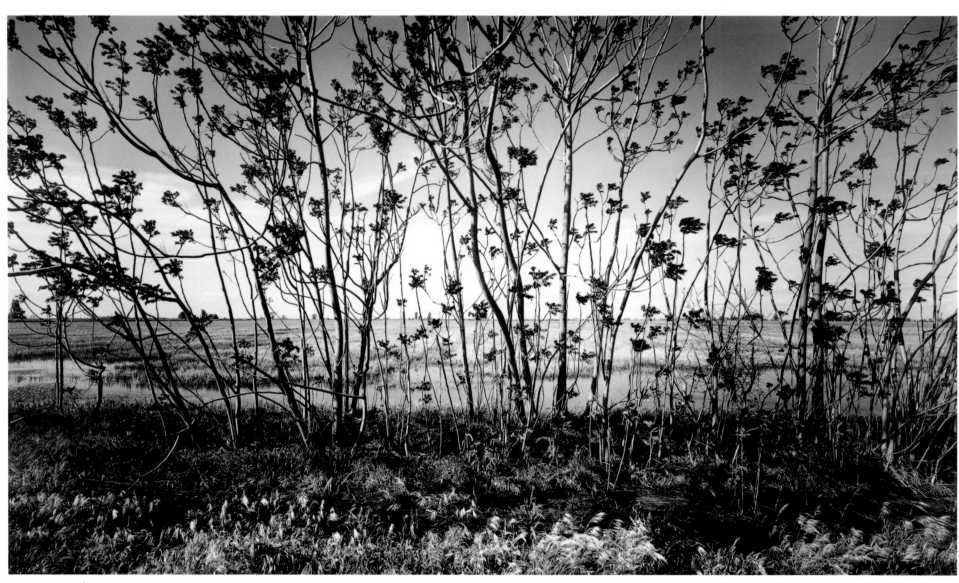

Trees as Windbreak, Merced County, 1983. Robert Dawson.

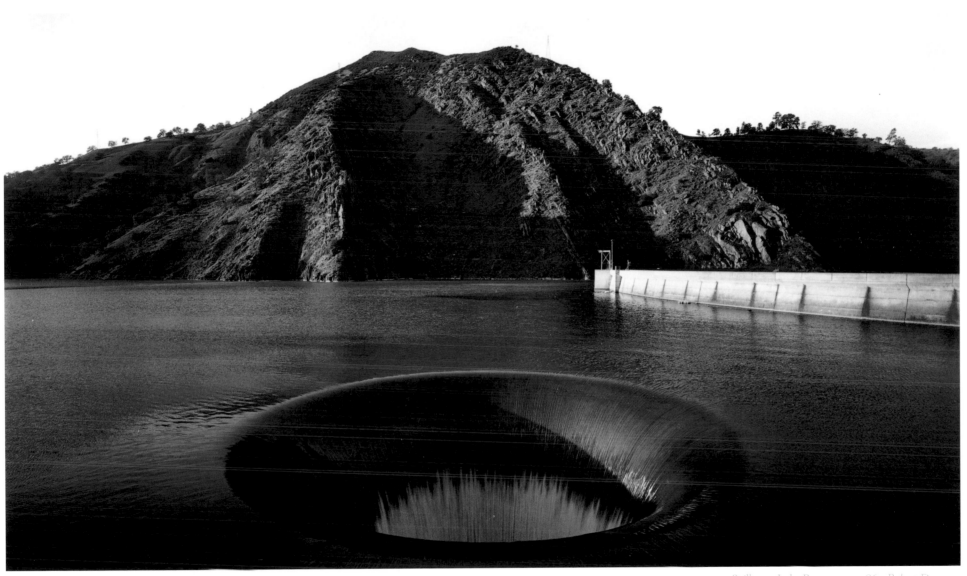

Spillway, Lake Berryessa, 1986. Robert Dawson.

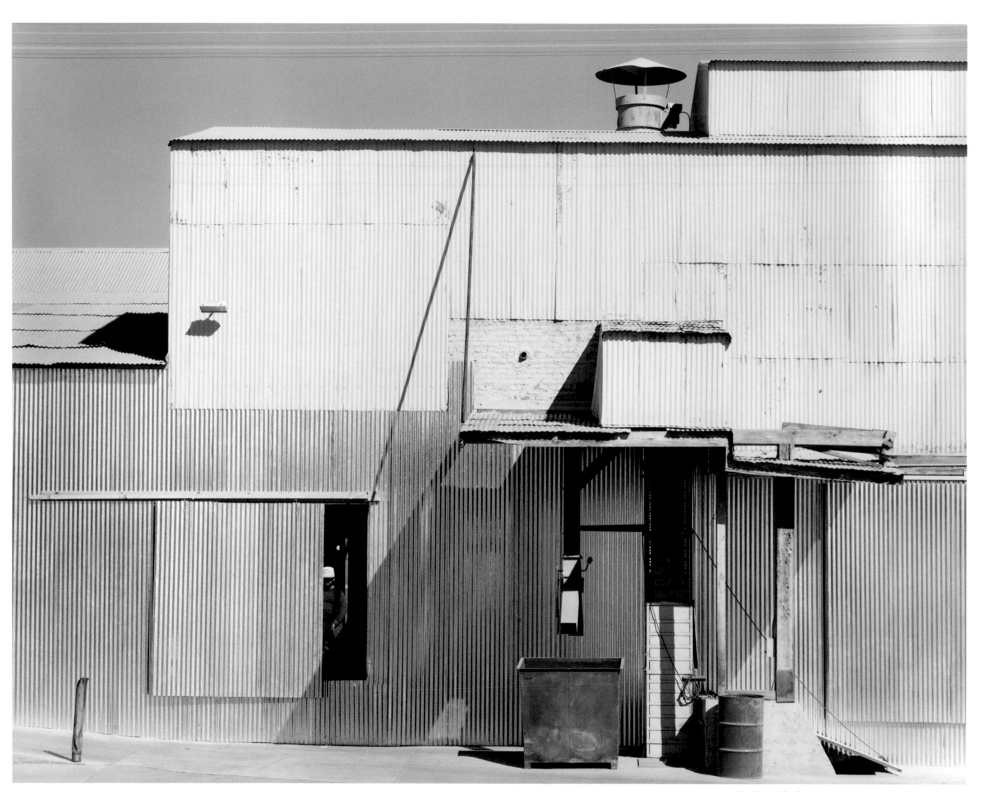

Packing Shed, Newman, 1984. Stephen Johnson.

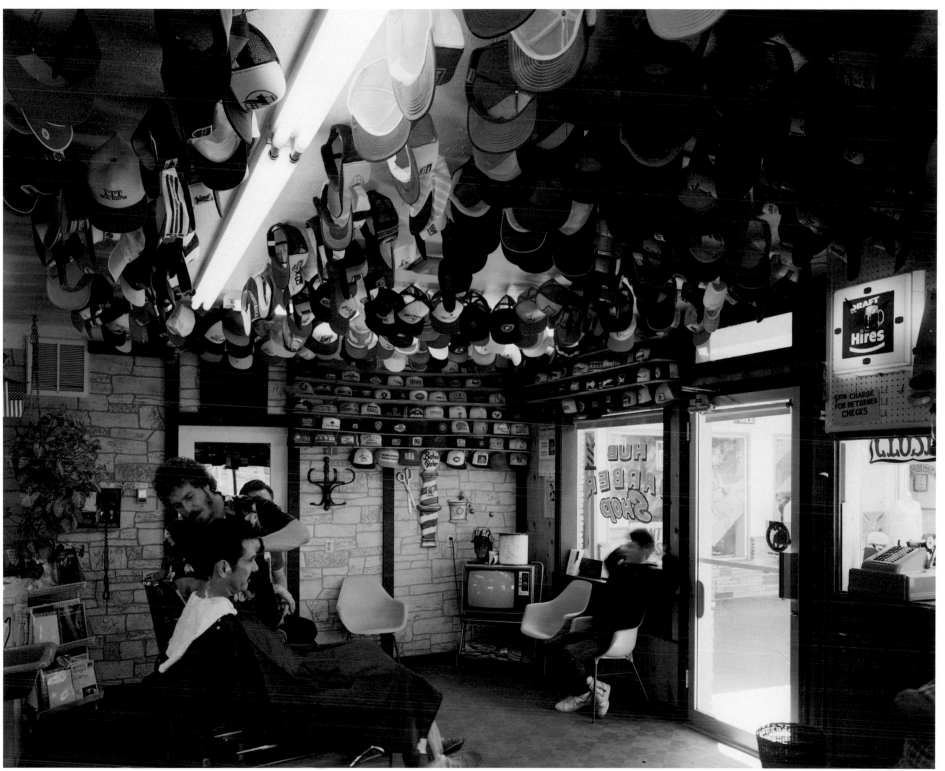

Hub Barber Shop, Vacaville, 1984. Robert Dawson.

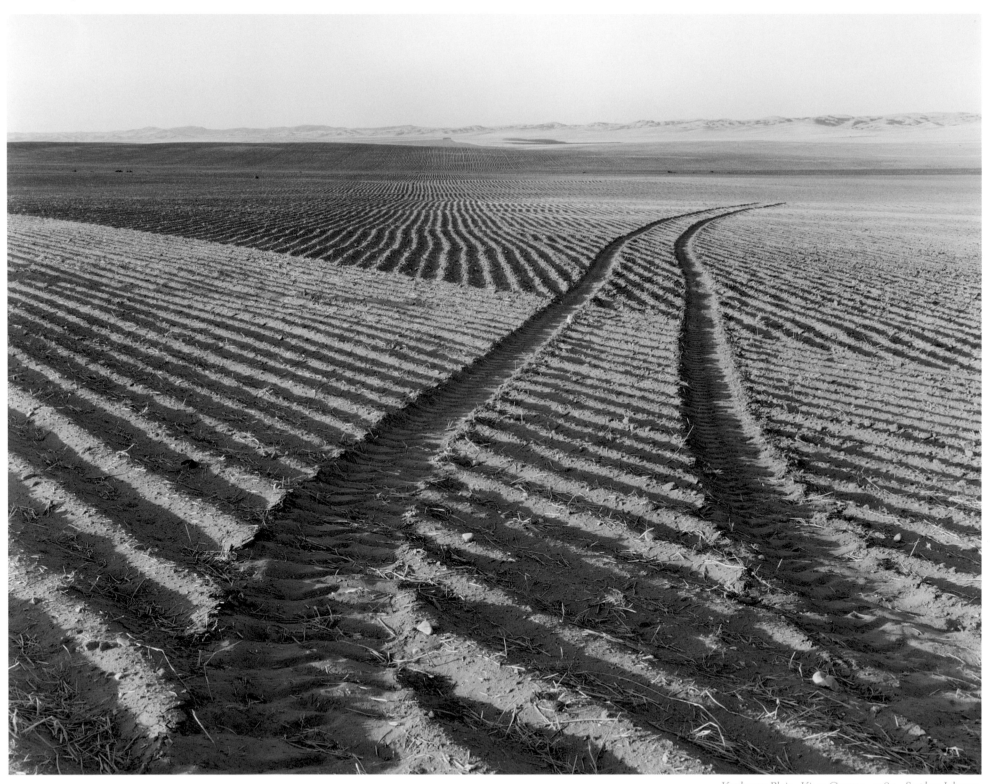

Kettleman Plain, Kings County, 1983. Stephen Johnson.

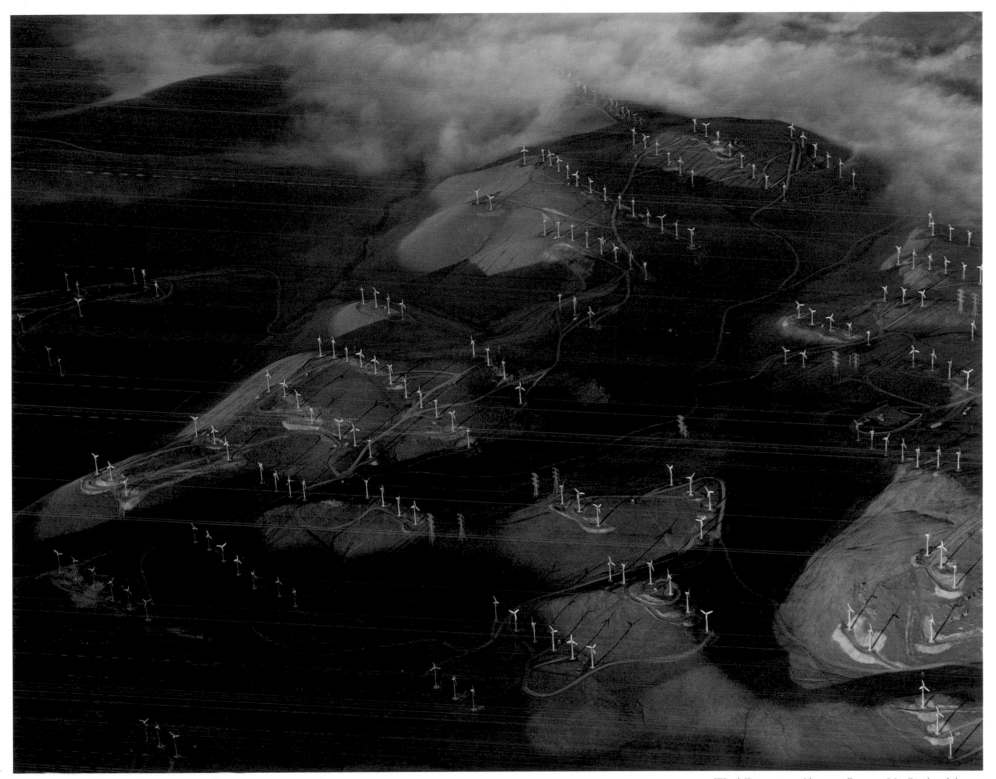

Wind Generators, Altamont Pass, 1986. Stephen Johnson.

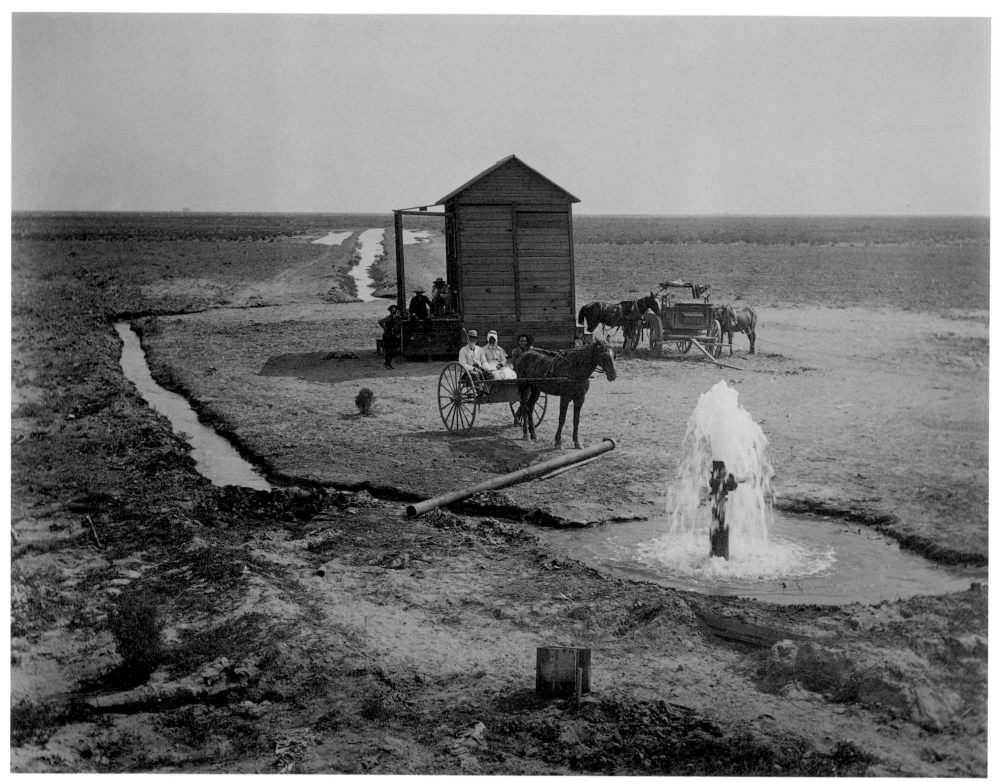

Artesian Well, Kern County, 1888. Carleton Watkins.

Chapter II: Historical Patterns

Long before Europeans saw this valley, its abundance was apparent and it hosted one of the richest concentrations of Native Americans on the continent. Who were those indigenous Valley dwellers? "Here were to be found most of her [California's] Indians, the predominant physical type, and carriers of the most idiosyncratic culture. Three hundred tribelets of California's five hundred or more belong to this area," observe anthropologists Theodora Kroeber and Robert Heizer. Four major tribes dominated the region: Maidu and Wintun lived in the north; Yokuts inhabited the south; Miwoks separated the others with a relatively small east-central enclave. Dwelling in an area that, according to their own oral histories, had never suffered a famine, Valley dwellers were considered peaceful as well as fortunate.

Since the region itself was rich in rivers, marshes, and swamps—all the results of drainage from the nation's deepest snowpack in the Sierra Nevada, which borders it to the east—even the south Valley's relatively low and distinctly seasonal rainfall was not a major hardship. On its vast plains grazed various ruminants, while its waterways and lakes provided not only native vegetation and animals but also trout and salmon, ducks and geese.

The tenure of the Valley's Indians was not, however, without its effects; they interacted with and became part of the ecological system in which they found themselves. Despite romantic notions to the contrary, Valley natives began the human alteration of the region long before Europeans arrived; whether merely digging for bulbs or grubs, directing the flow of water, or using fire to transform surroundings to their advantage, they employed as much technology as was necessary for survival. As it turned out, little was needed, but Indians were participating in an ancient and enduring pattern: as anthropologist William Cronon suggests, "Human beings reshape the earth as they live upon it, but as they reshape it, the new form of the earth has an influence on the way people can live. The two reshape each other."

For example, the Indians coexisted with valley oaks, whose acorns furnished the basis of their diets. But even that delicate relationship was not entirely benign: humans provided ashes when they burned grass to reveal fallen acorns, and ashes nourished the trees, but those same fires also destroyed oak seedlings, and in some years, hungry Indians overharvested the seed crop.

Nonetheless, their impact was a dimension less than that of the Europeans and Americans who displaced them; they differed especially in "their commitment to producing for *security* rather than for maximum yield," explains historian Richard White. Basically, the area's natural output was sufficient, and the relatively limited numbers of Native Americans did not greatly affect this huge valley. Today, however, with

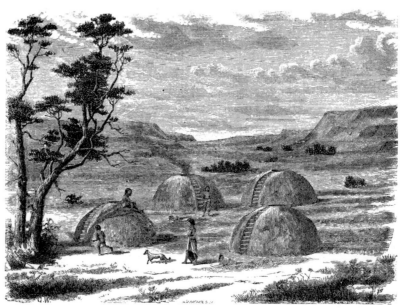

Sacramento Valley Indians, 1877. Artist Unknown.

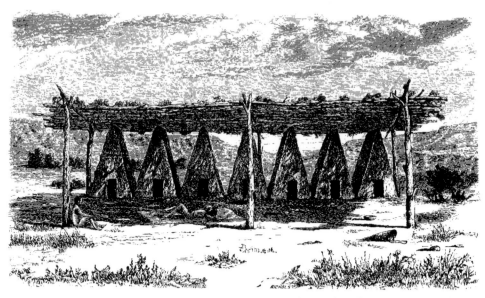

Yokuts Tule Lodge 1877. Artist Unknown.

the Valley's population growing toward six million and local agriculture feeding much of the United States, human influence has become pervasive, inexorable, and destructive.

Riding through in 1863, the valley's first surveyor William Henry Brewer and his party encountered an Indian settlement:

> **On Kings River we visited a camp of the Kings River tribe. They were hard looking customers. They lived in a long building, made of rushes carefully plaited together so as to shed the rain, making a long shed perhaps sixty or eighty feet long. The children were entirely naked; the adults all with more or less civilized clothing. All have very dark complexions, nearly as black as negroes.**

By then the tribe had good reason to be "hard looking," for the American incursion had begun in earnest and the Indians' population had begun its tragic decline, due mostly to introduced diseases.

A hundred years before Brewer visited, "the Great Central Valley sustained a population of more than 100,000 Indians speaking some thirty different languages, all of them of Penutian linguistic stock," according to archaeologist Michael Moratto. In the classic *Handbook of Indians of California*, Alfred Kroeber writes,

> *The Penutian family occupied nearly half of California. It also held the core of the state—not only in spatial sense but physiographically. This heart and kernel is what the geographer knows as the Great Central Valley...together*

with the flanking and enclosing mountains....There are few regions of the same size that nature has endowed with greater diversity of surface, altitude, humidity, soil, and vegetation than this one. But there are also few that have been so distinctly stamped by her as a compact and indissoluble unit. This unit was the Penutian empire.

The Yokuts constituted the largest single tribe in that empire, dominating the San Joaquin Plain and Tulare Basin. They were typical central California Indians in appearance: their skin was light copper brown, their hair black. Of medium height and weight, with smooth skin that appeared soft, they were, according to scientific tests, stronger than their white counterparts. Theodora Kroeber and Robert Heizer refer to them as "the ultimate realization of the heartland people in feature and form, in the extreme rounding of face and body and in a temperament that fitted the ample curves like a second skin."

They may have appeared placid, but the Yokuts were a tough and resourceful people. The Spaniards forced inland Indians to work in coastal missions—the entire west side of the San Joaquin Valley was effectively depopulated by Spanish raids—but found these generally peaceful people intransigent. Worse still from the Spanish perspective, Valley natives resisted conversion to Christianity. They were, nonetheless, a profoundly spiritual people. Living in a vitalistic cosmos, the Penutian speakers ritually sought to transcend their human limitations. The Great Valley was their home; they were part of it, products of the same life force that created and sustained even the trees and rocks. As a Yokuts shaman sang,

> *My words are tied in one*
> *With the great mountains,*
> *With the great rocks,*
> *With the great trees,*
> *In one with my body*
> *And my heart.*
> *You all help me*
> *With supernatural power*
> *And you, day,*
> *And you, night!*
> *All of you see me*
> *One with this world.*

William Brandon, an anthropologist, has noted that "the Indian world was, and is, a world immensely alien to European tradition, more alien...than we can quite realize," and tale-telling, also a sacred activity, illustrates just that. Stories were used to explain the phenomena of the world to establish sacred sources. If they seem incredible from a non-

Indian perspective, they are nonetheless vitally true, employing mythic power to capture a deep sense of life-in-the-living. For example, the Maidu, who lived far to the north of the Yokuts, explained the birth of the Sacramento River, the giver of life that dominated their culture, thus:

> *A whole lot of water came down here and the whole Sacramento Valley was turned into an ocean. Most of the people were drowned. Some tried to swim away but the frogs and salmon caught them and ate them. Only two people got away safe into the Sierras.*
>
> *Great Man blessed the Maidu with many children, and all the tribes arose. One wise old chief ruled all of them. This chief went to the Coast Range but was disconsolate because the Valley was still under water. He stayed there for nine days without any food, thinking about the water that covered the plains of the world.*
>
> *This thinking and fasting changed him. He was not like a man. No arrow could hurt him. He could never be killed after that. He called out to Great Man and told him to get rid of the flood waters. Great Man tore open the Coast Range and made the waters flow down to the ocean. This flow of water was how the Sacramento River began.*

Many such stories were said to have originated in dreams, and dreams, as Kroeber and Heizer comment, "were an intrinsic part of life.... And dreams led to the Great Ones—the earlier inhabiters and establishers of things-as-they-are. From dreaming came shamanistic power and other power and all knowledge." Today most of the Valley's Indians and their dreams are gone, assimilated into the dominant gene pool or simply dead: "the plains of the world" no longer echo with their laughter, no longer keen with their weeping. What was once California's densest Indian population is but a shadow, aside from a few scattered, poverty-stricken reservations or rancherias and a handful of mysterious place names—Chowchilla, Tuolumne, Cosumnes, Monache, Kaweah, Mokelumne, Cholame.

The Indians understood this place. Many of their creation tales began, "Once there was a time when there was nothing in the world but water,...." The Valley was their world, and it was indeed once covered by an ancient sea; their version differs from ours only in style. For example, geologist Gordon Oakeshott points out that marine sediments in the Valley today are as deep as *ten miles*. Those sediments have been covered by topsoil deposited by rivers and creeks, lakes and marshes during the past million years or so. Nonetheless, Valley residents know of nearby places where sharks' teeth can still be dug up, where marine fossils may still be uncovered. Early settlers were astonished when they made such discoveries.

The first party of Spaniards to view the Great Central Valley is thought to have been the expedition led by Captain Pedro Fages in 1772.

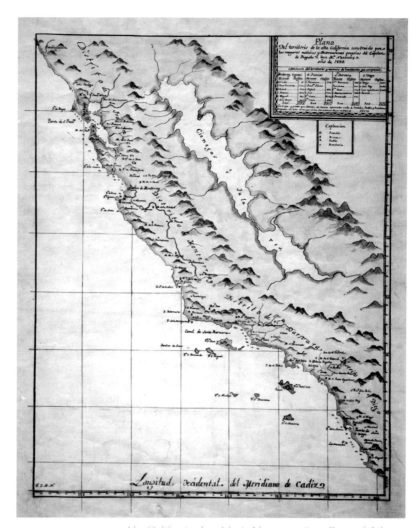

Alta California. Jose Maria Navarez, 1830. Bancroft Library.

Skirting the eastern shoreline of San Francisco Bay, it was forced inland by the Carquinez Strait. Eventually, the party climbed a spur of Mount Diablo and, to quote Fray Juan Crespi, an expedition member, "We ascended a pass to its highest point in order to make observations, and we saw that the land opened into a great plain as level as the palm of the hand, the valley opening about half the quadrant, sixteen quarters from northwest to southeast, all level land as far as the eye could see." They reached the San Joaquin River and also saw the great stream that would be named Sacramento.

Four years after Fages and Crespi first viewed the Valley, Padre Francisco Garces entered the region's southern reaches while seeking a

new route to Monterey from northwestern Mexico. Crossing the Te-hachapi Mountains, he came upon "a great river which made much noise and whose waters [were] crystalline, bountiful, and palatable." Unable to swim, he was carried across the Kern River's icy water by four Yokuts, whose village was near the present site of Bakersfield. Garces noted in his journal:

> The people of the rancheria had a great feast over my arrival, and having regaled me well I reciprocated to them all with tobacco and glass beads, congratulating myself on seeing the people so affable and affectionate. The young men are fine fellows, and the women very comely and clean....They take great care of the hair and do it up in a topknot; they wear petticoats of antelope skin and mantas of fur; though they are not very coy.

Certainly not coy by Spanish standards of that day, at any rate, and as it turned out, too trusting for their own good. Continuing north, Garces performed the first Christian baptism in the Valley a few days later at another Yokuts village, near present-day Delano.

Although Spanish penetration of the northern Valley dated to journeys led by Francisco Eliza (1793), Gabriel Moraga (1808), and José An-

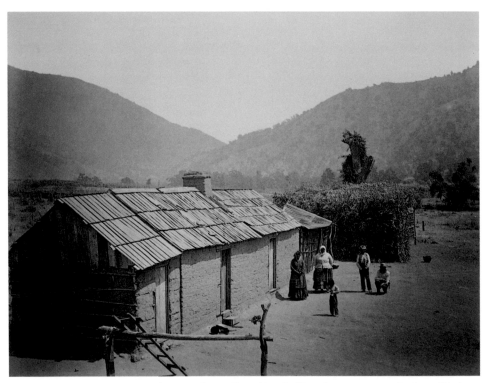

Indian Rancheria, Tejon Ranch, Kern County, 1888. Carleton Watkins.

tonio Sanchez (1811), and although Captain Luis Arguello guided parties into the northern Valley in 1817, 1820, and 1821 in search of possible mission sites, actually naming the Feather River (El Rio de las Plumas) in 1820, the region of the Sacramento nonetheless remained largely unexplored.

Despite their early penetration and nominal control of the area, Spaniards did not effectively settle or rule the Valley. It was considered a wild domain, a haven for fugitives, and, for a while, a great source of potential, if unwilling, neophytes (or slaves—the exact classification is a matter of perspective) for coastal missions, so raiding parties were common. That pressure had a profound effect: "As early as 1850," points out Frank F. Latta, "and probably long before that time, there were no living Indians occupying the entire west side plains, from Byron on the north to Paleta in Kern County."

An aging survivor of Spanish raids on the west side, a man named Sopahno, told a younger Yokuts, Pahmit, about the attack that had led to his own enslavement for twenty years at Mission San Juan Bautista. Pahmit, in turn, recounted the event to Latta this way: "One morning they all asleep when they hear big noise, lots shoot, lots yell. Lots Indian run way in tules. Spanish shoot, kill lots Indian men, women. They kill Sopahno's father. His mother run away in tules. Spanish take 'bout twenty-thirty Indian boys and girls."

For Father Felipe Arroyo de la Cuesta, the pastor of Mission San Juan Bautista in 1817, the Valley constituted a considerable problem: he had been losing neophytes, who fled across the hills into the Valley. There some of them had joined escapees—"fugitives" to the Spaniards—from other missions and had actually returned to de la Cuesta's domain, stealing horses, liberating neophytes, even killing defenders. The system seemed to be turning back on itself, the erstwhile raiders now being raided. Moreover, the Valley's interior, unlike its sparsely inhabited west side, was densely settled by Indians willing to defend themselves, so Spanish parties could not counterattack with impunity.

As a result, Hispanic settlement in Alta California did not effectively extend beyond a narrow coastal strip. Still, with all the advantages offered by existing mission sites, there seemed little reason to extend settlement inland, although the Franciscans dispatched several parties into the Valley seeking possible new locations. In fact, the community now known as Los Banos is said to have acquired its name from Fray de la Cuesta's habit of bathing himself there on his journeys from San Juan Bautista.

A few small Spanish settlements did develop in the interior: just east of Coalinga, for instance, on the site of an old Yokuts (Chana) village, was a largely Hispanic settlement named Poso Chana. A small Mexican settlement called Las Juntas—many of its inhabitants were mestizos, blends of local Indian and Spanish—developed where Fish Slough joins the San Joaquin River. Such communities were, however, exceptional.

Most Spanish penetration of the Central Valley was limited to those who got lost or who fled there—AWOL soldiers frequently escaped to the Valley, where they could hide among the sloughs and tules—and to sorties to kidnap neophytes or to pursue runaways. Expeditions were later mounted in search of livestock raiders. The major explorer of the region was Gabriel Moraga, who between 1805 and 1817 led a number of excursions here and bestowed such names as Sacramento (sacrament) and Merced (mercy) rivers, as well as Mariposa (butterfly), Calaveras (skull), and, of course, San Joaquin and Tulare.

In 1828, following independence, the newly established Mexican government, like its imperial predecessor, began sending military expeditions to control rebellious Valley Indians. Twelve years later, a Law of Colonization seeking to deflect American encroachment was imposed, and much of the Sacramento Valley was divided into great ranchos, but few land grants were claimed in the Tulare Basin. Southeast of present-

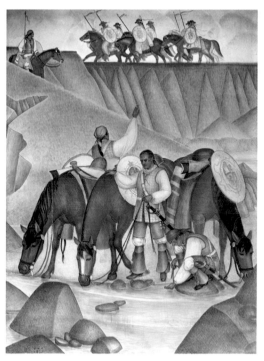

Moraga and Company at the Merced River.
Mural, Merced Post Office, 1937. Dorothy Puccinelli.

day Maricopa, however, the 17,709-acre San Emideo (1842) was settled; it would later become one of California's great cattle ranches. Other major southern grants were situated in surrounding mountains, although their holdings extended into the flatland: 22,178-acre Rancho Castaic (1843); 26,626-acre Alamos y Agua Caliente (1843); 48,799-acre Rancho La Liebre (1846).

These huge holdings set a pattern that would be followed during the American period, just as the grants themselves would become the basis for complicated legal machinations: for a time following the Mexican period, no one knew for certain who owned what. During the 1860s, General Edward Fitzgerald Beale consolidated the four vast southern grants into his Rancho Tejon, which today remains the largest tract of privately owned land in California. By 1870, virtually all Mexican land grants had been taken over by Americans.

William Preston, a geographer, well summarizes the nature of Hispanic influence throughout the Valley, although his remarks refer specifically to the Tulare Basin:

> *Despite the brevity of their tenure in the basin, the Hispanos had wrought great changes: Yokuts populations, subsistence, and settlement had been severely disrupted; new flora and fauna, especially European grasses and feral horses and cattle, had been introduced; new place names had been assigned to the features of the basin; and new kinds of boundaries had been delimited there.*

The replacement of native grasses most characterizes European influence. "Cereals and fruits were soon imported and grown around missions established around the coast," explains botanist Beecher Crampton. "Other plants were also introduced—some purposely, some accidentally." Imported batches of seeds often included those of weeds, as did the soil surrounding fruit cuttings transported by settlers. Straw, which was used as packing material by conquistadors and missionaries alike, contained pestiferous specimens, and so did the ballast carried in

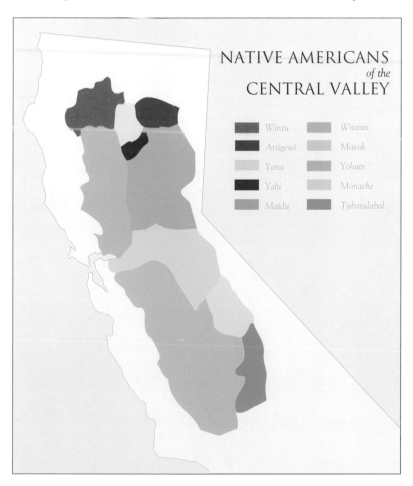

NATIVE AMERICANS
of the
CENTRAL VALLEY

Wintu	*Wintun*
Atsigewi	*Miwok*
Yana	*Yokuts*
Yahi	*Monache*
Maidu	*Tubatulabal*

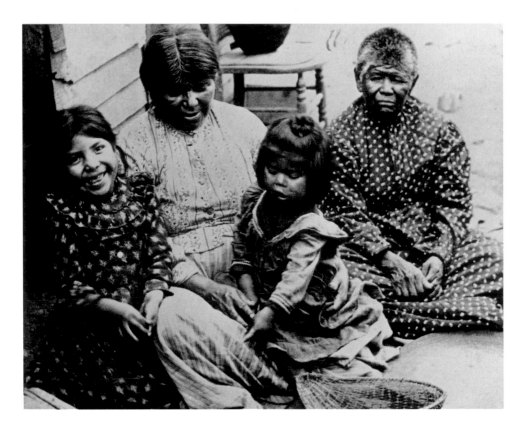

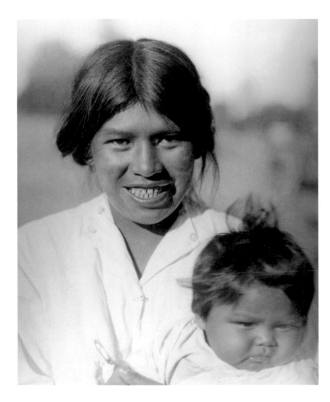
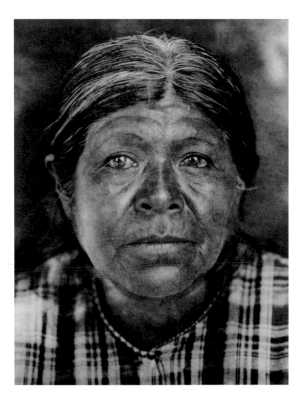
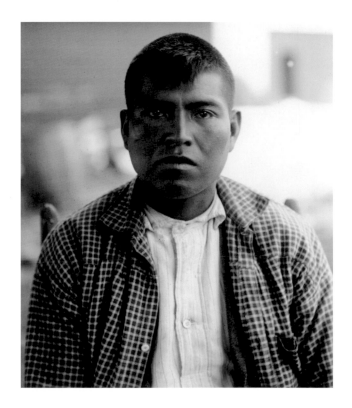

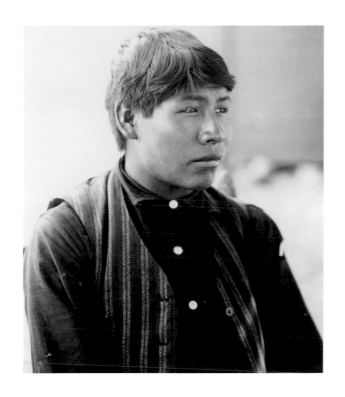

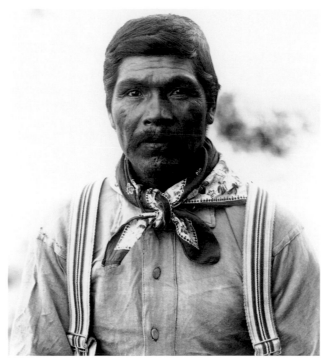

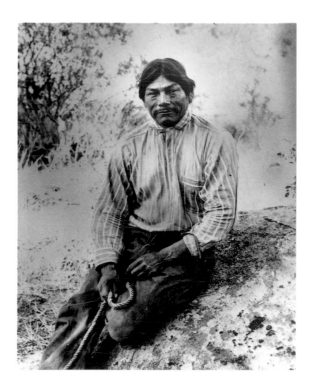

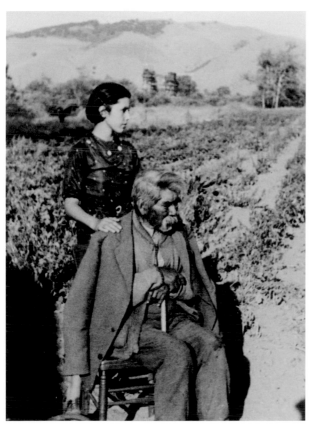

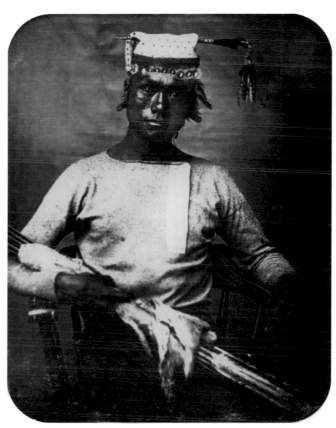

Grasses near the Sutter Buttes, 1984. Stephen Johnson.

ships from abroad. Imported livestock were walking dispensers of alien flora, their coats and their digestive tracts carrying hardy seeds from the old country. Bur clover, Johnson grass, wild oats, and various foxtails, among other now omnipresent weeds, were thus introduced. The change in flora began as soon as the first explorer entered the Valley.

The originally introduced European grasses were mostly of Mediterranean extraction, annuals that dried out each summer, then emerged again after winter rains vivified their seeds; they were not grazed year-round as were the native perennials and, moreover, many were only marginally palatable to ruminants. The result is explained by botanist Robert Ornduff:

> Originally, Valley Grassland was made up of various perennial bunch grasses such as needle grass (Stipa spp.), bunch or blue grass (Poa spp.), and three-awn (Aristida spp.). These grasses have completely disappeared in large areas of the Central Valley where the native grass cover has been removed and the land has been planted with cultivated crops, or where destructive sheep or cattle are pastured. Much of the Central Valley is still grassland, but even in grazed areas the cattle or sheep have exterminated the native perennial grasses, and these have been replaced by introduced annual grasses such as brome grass (Bromus spp.), wild oats (Avena spp.) and fescue (Festuca spp.).

Ornduff points out further that "about one-eighth of the present flora of the state consists of plant species that have been introduced into the state from elsewhere in the last 200 years. These are plants that mostly are classified as 'weeds.' " Because the Central Valley contains great stretches of open land, irrigated and "disturbed"—plowed, disked, or just plain dug—it has offered weeds ample opportunities to establish themselves, and they, in turn, have been fought of late with herbicides.

Grassland uncontaminated by imports can no longer be found in the Valley. In the 1980s, rancher Eben McMillan surveyed a southern range and observed, "Looking around here today you'd probably say 99% of the 'native' vegetation was wild oats and foxtail. But there's not a native plant in sight right now." Ornduff agrees, pointing out that the region's golden summer grasses are imports: "It is probable that when these areas were occupied by the native perennial grasses they were green or gray-green during most of the year."

If native rangeland is rare, so is clear cultural evidence of Spanish and Mexican rule. One obvious proof of their lack of power during the period of nominal domination is the relative freedom enjoyed by American trappers in the Valley. Lured by rumors of abundant game, Yankees began trickling in, not to settle but to reap. Best known was Jedediah Strong Smith. One of his 1828 journal entries reads,

> 29 the March N 6 Miles and encamp on river. i was obliged to cross many slous of the River that were verry miry and passed great numbers of indians who were engaged in digging Roots. I succeeded in giving to them some presents. they were small size and apparently verry poor and miserable. The most of them had little Rbit Skin Robes. 11 Beaver taken.

Smith and his party had astounded Mexican officials by appearing in San Bernardino in 1826, after trudging across the supposedly impenetrable desert from the east. When Governor José Maria Echeandia ordered them to leave California, the trappers simply headed north to the Valley, where, according to rumors, there were "plenty of beavers" and no authorities to harass them. The hearsay proved true, and by the time Smith reached the American River in 1827, his party was toting fifteen hundred pounds of beaver and otter pelts.

Other trappers who moved with impunity through the Valley included such redoubtable figures as Joseph Walker, John Work, Alexander McLeod, Peter Ogden, Ewing Young, and Kit Carson. In the early 1830s, the latter two were members of a 40-man party that was chased from the Valley by a military force under the command of Lt.

Francisco Jiminez from Mission San Jose. It was a futile gesture, since when the troops returned to their barracks in San Jose, the trappers returned to the Valley's streams and marshes.

John Work led a Hudson's Bay Company expedition into the Valley in 1832. They wintered near the Sutter Buttes, and Work's notes reveal the region's verdancy: "We have been a month here and we could not have fallen on a better place to pass a part of the dead winter season.... There was excellent feeding for the horses and abundance of animals to subsist on; 395 elk, 148 deer, 17 bears, and 8 antelopes have been killed in a month." Although Work's large party consisted of over a hundred people, that is still an enormous quantity of game—several thousand pounds—and illustrates what was called meat hunting, a practice that (especially during the Gold Rush) led to the extermination of large animals.

Only thirty years after Work's visit, Brewer reported: "Game was once very abundant....[A pioneer] said he had known a party of thirty or forty to lasso twenty-eight elk in one Sunday. All are now exterminated, but we find their horns by the hundreds." Once large land animals had been all but eliminated, commercial hunters turned to waterfowl and even shorebirds, putting a considerable dent in those populations too.

Ironically, as golden beavers and river otters became rare, and as changes in fashion lessened the demand for pelts, trappers themselves became an endangered species. In 1841, an event of singular symbolic significance occurred on the Green River in Wyoming: the first wagon train of immigrants that would reach California and enter the Valley met and camped with a band of mountain men, some of whom had trapped here. An old frontier was meeting a new one. The wagons that followed that initial group eventually swept the continent's distant coast and inland reaches into the thrall of America's Manifest Destiny, and the fur trappers, who had established the overland routes to that remote domain, would never again rendezvous. Happily, both otters and beavers would one day reestablish populations in the Central Valley.

A member of that beleaguered 1841 trans-Sierran party was a young schoolteacher named John Bidwell. He recalled years later that, disoriented and near despair, this wagon train had in fact abandoned all of its wagons, most of its gear, and had eaten nearly all of its animals by the time it reached the western slope of the Sierra Nevada. Although the emigrants stood near the edge of the Valley, "we did not even know we were in California," said Bidwell. They had barely survived the deserts and mountains, so party members were devastated when they saw to the west yet another range to be surmounted. Then, as Richard Batman describes it, everything changed: "They had been looking at the Coast Range from a perspective that blocked off a view of the San Joaquin Valley, and suddenly the canyon opened up and they saw the valley just

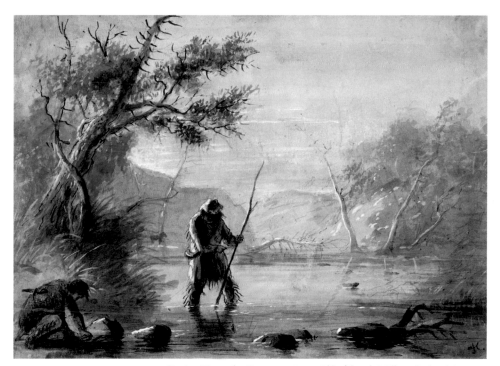

Setting Traps for Beaver, 1837. Alfred Jacob Miller. Joslyn Museum.

below them." Thus did the first wagon train—sans wagons by that time, of course—breach the mountain barrier.

By 1878, less than forty years after Bidwell had stumbled hungry and exhausted into the Central Valley, wheat from his 26,000-acre Rancho Del Arroyo Chico won a Gold Medal at the Paris International Exposition; it had been judged the finest grain in the world. If the ex-schoolmaster's success epitomized the California dream of unlimited opportunity come true, his rancho was itself a prototype of a California reality, as Kevin Starr points out: "Diversified in their industries, employing scores of men bound together into an economic and social hierarchy, the great ranches of California resembled feudal baronies, having as their underlife very ancient modes of loyalty, dependence, and service." Bidwell grew not only wheat, but an entire community, for he also owned vines, fruit, sheep, poultry, a cannery, an apiary, a nursery, and a flour mill. Generations of workers were employed by him, and, as was true of many great ranchos in the Valley, Bidwell's was a plantation; it fostered a feudal mentality, which still characterizes some local landholders.

Whatever else John Bidwell was, he was not sanguine; of interior California, he said, "People generally look on it as the garden of the world or the most desolate place of Creation." In fact, it was a little of

both, as an even earlier settler, Dr. John Marsh, had recognized. Historians have labeled Marsh the first important settler in the American overland migration. He had emigrated to Los Angeles in 1836, and in 1837 he bought a huge tract of land in the shadow of Mount Diablo, near the western border of the Sacramento–San Joaquin Delta. He developed his holdings into the first successful rancho in the Great Central Valley.

In 1839 a Swiss entrepreneur named John Sutter, skillfully playing on the rivalry between the Mexican governor, Juan Bautista Alvarado, and Comandante Mariano Vallejo, settled a tract at the junction of the American and Sacramento rivers—site of the present-day capital city. Because his presence suited the purposes of Alvarado, the ambitious newcomer received Mexican citizenship as well as a grant of eleven square leagues after only a year's residence. Soon Sutter's Fort would become a major destination of America's overland migration.

It was a central locale during the Gold Rush, and that singular time did much to change the Central Valley. The few farms that were already present in the late 1840s suddenly had more consumers than they could satisfy. Cattle ranches, which were far more common, also took full advantage of the sudden seller's market; so did hunters for the market, who put a considerable dent in the area's population of waterfowl and ruminants.

There were other effects in and on this arena, both positive and negative. For example, the ability to create sluices and channels for mining was a skill that would later be profitably transferred by some to the building of irrigation systems. A related, negative outcome of mining hydrology that would continue for years was the silting of Valley rivers, which led to both habitat destruction and increased flooding.

Most people had to travel across the Valley to reach the diggings in the Sierra foothills. In the grip of gold fever, they were not initially im-

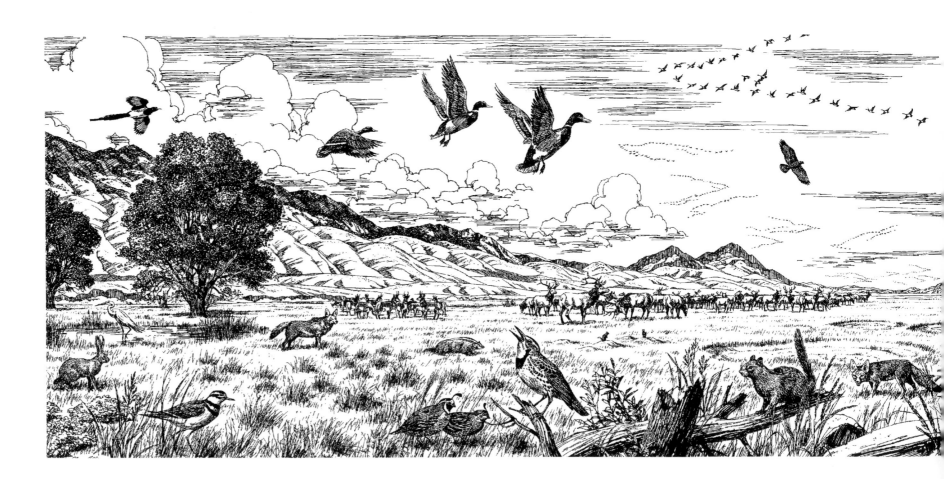

pressed with the largely unsettled region. As J. S. Holiday observes, "Farming seemed too slow a route to wealth in 1850 and for several years thereafter"; but, if it did not at first attract many, some nevertheless did return to farm. Others entrenched themselves and built lives in Valley towns such as Stockton or Sacramento, while still others remained stranded in the Valley because they had failed at the mines and could afford to travel no farther.

The latter may have been most important of all to the Valley's development, for they came to constitute a large, desperate—and thus malleable—work force. Not all of the region's initial migrant laborers were unsuccessful prospectors; the all-important Chinese, for example, were relatively successful but had been forced from their diggings by Americans fired with a combination of nativism and opportunism. In any case, the region's work force would in the next decade help develop large agricultural tracts and create, especially in the north Valley, a ma-

jor barley industry. It was soon overshadowed: by 1860 the three million bushels of barley produced equaled only half the amount of wheat harvested. The area's first truly major crop had arrived.

The Sacramento Valley, where most of the grain was raised, had actually functioned as something of a sanctuary for American settlers during the Spanish and Mexican periods. To the south, American settlers arrived later. The area that would become Bakersfield, for instance, was known as Kern Island—a complex of distributary channels, sloughs, and marshes produced by the Kern River, which emptied into two shallow lakes that were, in turn, surrounded by desert in the southern Tulare Basin. One of the West's first important humorists was a topographical engineer for the U.S. Army named George Horatio Derby (a.k.a. John Phoenix); in 1849–50, however, that noted wag was profoundly humorless when describing this barren section, calling it "the most miserable country I ever beheld."

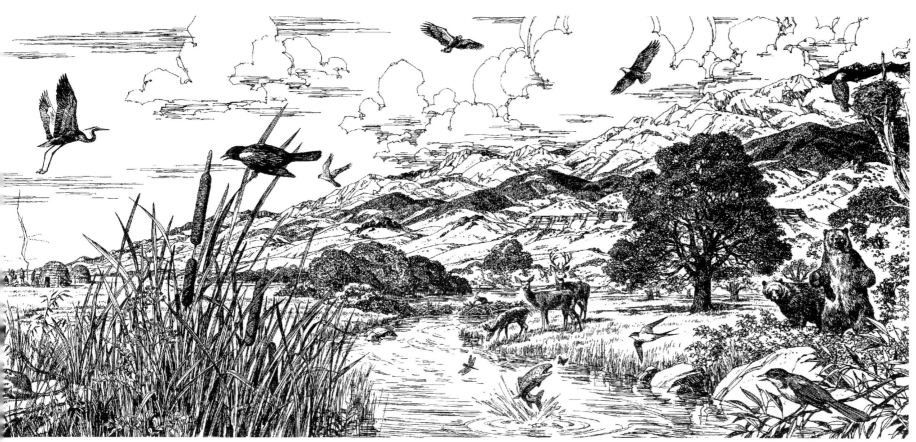

The Native Valley. The Great Valley Museum, Modesto.

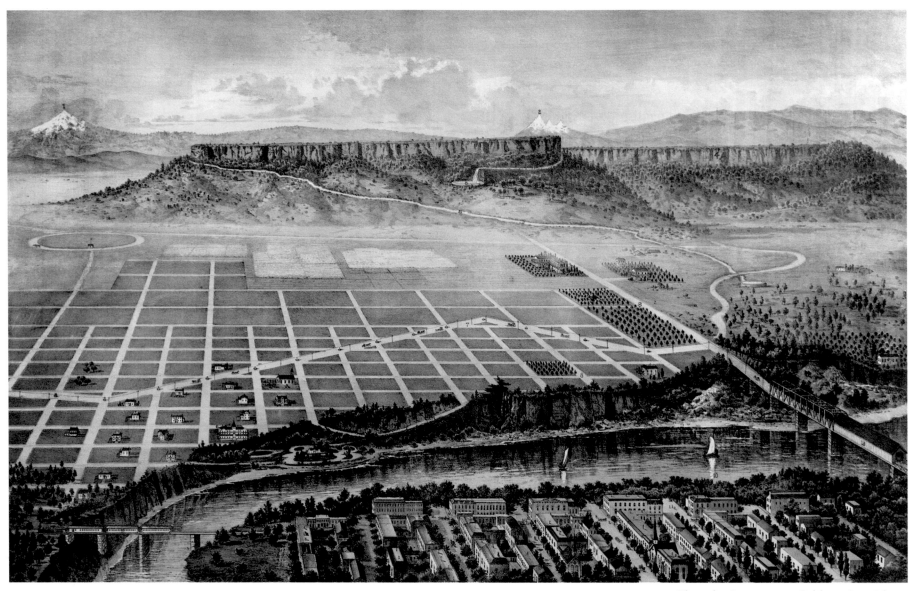

In the winter of 1862–63, a soaking season, floods washed out the German immigrant family that constituted the area's principal non-Indian population. Colonel Thomas Baker and Harvey Brown took advantage of the flooding and purchased a rain-enlarged swampy tract extending north from Kern Island all the way to Fresno, approximately 400,000 acres—much of which was dry except during spring floods, so that it "reclaimed" itself as soon as the normal rain pattern returned. In 1863 Baker bought out his partner, and three years later he began to survey a proposed city. He retained 80 acres for his family's homestead, and the area was known to travelers as "Baker's field."

The very year Baker actually began living at the site of the city that bears his name, a nearby community suffered a death blow. On the night of April 13, long after white farmers had without incident established themselves nearby, Captain Moses McLaughlin ordered his troops to surround a village of Tubatulabal, a notably peaceful Shoshone tribe of Kern River dwellers, and to attack it. The soldiers met little resistance. "Killed 35 of them," McLaughlin's official report boasted. "Not a soldier was injured." Survivors who couldn't hide were rounded up by troops and herded to a reservation at Fort Tejon, nearly seventy-five miles away in the Tehachapi Mountains.

Patti Wermuth, whose great-great-grandmother escaped, says her ancestors were "very timid people. They didn't have a word for 'war' or 'peace.'" The village was never again populated: one community destroyed, another born, in a sad dance of history. Today the Tubatulabal are gone as a culture.

The Gold Rush accelerated the decline of native populations in the Central Valley. "Never in the history of the country had so many Indians come in contact with so many white men so quickly," William Poole points out. Predictably, clashes were more or less chronic during the early years of American settlement. Brewer reports one example in November 1862:

> **A teamster, on a wood road near [Chico] had been shot in his wagon, and his horses killed. Two girls had gone up blackberrying, on horses, with a little brother; the girls were murdered, each one pierced by over thirty arrows; the boy was carried off, and his remains were found two weeks later, sixty miles distant, where they had tortured him.**

The aggressive newcomers began to cultivate or mine or graze stock on land previously used freely by natives. Their impact was felt nearly everywhere. Indians were seen as threats by some, nuisances by others.

A great number had already succumbed to introduced illnesses, of course, and still others were killed during the Gold Rush, but surviving Indians, especially in the north Valley, were determined in their resistance. As late as 1866 the *Chico Courant* claimed: "It is a mercy to the red devils to exterminate them, and a saving of many white lives. Treaties are played out. There is only one kind of treaty that is effective—cold lead."

One unusual event highlights early encounters between whites and Indians. Tulare County's first grand jury, which convened in a cabin in Woodsville in 1853, convicted a man named Samuel Logo of assault with intent to commit murder on two Indians. Observes Annie Mitchell, a local historian, "At the time, Indians had no legal rights whatsoever and it speaks well of our pioneers that a white man was found guilty of assault." Unfortunately, most such encounters were not settled so equitably.

An article in the *Sacramento Daily Transcript*, April 28, 1851, for instance, tells of an aggrieved stockman from the upper Valley who organized a raiding party to go after Indians who had stolen some of his cattle:

> *They traveled back about 35 miles from the river and entered the mountains. Here they found a very large ranchedero [sic], consisting of about 500 Indians. They attacked them, but the Indians were prepared and fought most desperately. The Indians used arrows only, and the whites had much the advantage with the rifle. Although 25 in number only, the whites killed 40 Indians, while none of their party were shot.*

Gilbert Ranch, Chico, circa 1900. George G. Collom. California State Library.

It was a common result of such encounters, Indian actions leading to immediate retaliation.

On August 9, 1862, another article, this one in the *Marysville Appeal*, was headlined "Fight with the Indians."

> *From private information, we learn that Capt. Good's company of volunteers overtook a party of Indians near the site of the last massacre in Butte County, near Chico, and gave them battle. Seventeen of the Indians were killed and scalped by the volunteers, who, being from the immediate vicinity of the former massacre, are highly exasperated at the redskins. None were killed on the side of the whites. They are determined to drive off or exterminate the Indians, it is said.*

Only a year later, California's version of the Trail of Tears occurred. On September 4 of 1863, 461 Maidus were herded on foot from Fort Bidwell, near present-day Chico, west across the scorching Valley, and then into the dry, precipitous mountains that surround various forks of the Eel River. Two weeks later they arrived at Round Valley, deep in the range, but over 30 had died and well over 100 were in a weakened condition. At the reservation, the Maidu joined other tribes—eight different languages were spoken there—and struggled to rebuild their lives, or at least those who didn't escape did that. However, given the attitudes of the time, those who remained were certainly safer because, as Poole explains, the army had acted in the first place "partly to protect white lives, but also to

The Bee Pastures by John Muir

The Great Central Plain of California, during the months of March, April, and May, was one smooth, continuous bed of honey-bloom, so marvelously rich that, in walking from one end of it to the other, a distance of more than 400 miles, your foot would press about a hundred flowers at every step. Mints, gilias, nemophilas, castilleias, and innumerable compositae were so crowded together that, had ninety-nine per cent of them been taken away, the plain would still have seemed to any but Californians extravagantly flowery. The radiant, honeyful corollas, touching and overlapping, and rising above one another, glowed in the living light like a sunset sky— one sheet of purple and gold, with the bright Sacramento pouring through the midst of it from the north, the San Joaquin from the south, and their many tributaries sweeping in at right angles from the mountains, dividing the plain into sections fringed with trees.

Along the rivers there is a strip of bottom-land, countersunk beneath the general level, and wider toward the foot-hills, where magnificent oaks, from three to eight feet in diameter, cast grateful masses of shade over the open, prairie-like levels. And close along the water's edge there was a fine jungle of tropical luxuriance, composed of wild-rose and bramble bushes and a great variety of climbing vines, wreathing and interlacing the branches and trunks of willows and alders, and swinging across from summit to summit in heavy festoons. Here the wild bees reveled in fresh bloom long after the flowers of the drier plain had withered and gone to seed. And in midsummer, when the "blackberries" were ripe, the Indians came from the mountains to feast— men, women, and babies in long, noisy trains, often joined by the farmers of the neighborhood, who gathered this wild fruit with commendable appreciation of its superior flavor, while their home orchards were full of ripe peaches, apricots, nectarines, and figs, and their vineyards were laden with grapes. But, though these luxuriant, shaggy riverbeds were thus distinct from the smooth, treeless plain, they made no heavy dividing lines in general views. The whole appeared as one continuous sheet of bloom bounded only by the mountains.

When I first saw this central garden, the most extensive and regular of all the bee-pastures of the State, it seemed all one sheet of plant gold, hazy and vanishing in the distance, distinct as a new map along the foot-hills at my feet.

Descending the eastern slopes of the Coast Range through beds of gilias and lupines, and around many a breezy hillock and bush-crowned headland, I at length waded out into the midst of it. All the ground was covered, not with grass and green leaves, but with radiant corollas, about ankle-deep next the foot-hills, knee-deep or more five or six miles out. Here were bahia, madia, madaria, burrielia, chrysopsis, corethrogyne, grindelia, etc., growing in close social congregations of various shades of yellow, blending finely with the purples of clarkia, orthocarpus, and oenothera, whose delicate petals were drinking the vital sunbeams without giving back any sparkling glow.

Because so long a period of extreme drought succeeds the rainy season, most of the vegetation is composed of annuals, which spring up simultaneously, and bloom together at about the same height above the ground, the general surface being but slightly ruffled by the taller phacelias, pentstemons, and groups of *Salvia carduacea*, the king of the mints.

Sauntering in any direction, hundreds of these happy sun-plants brushed against my feet at every step, and closed over them as if I were wading in liquid gold. The air was sweet with fragrance, the larks sang their blessed songs, rising on the wing as I advanced, then sinking out of sight in the polleny sod, while myriads of wild bees stirred the lower air with their monotonous hum—monotonous, yet forever fresh and sweet as everyday sunshine. Hares and spermophiles showed themselves in considerable numbers in shallow places, and small bands of antelopes were almost constantly in sight, gazing curiously from some slight elevation, and then bounding swiftly away with unrivaled grace of motion. Yet I could discover no crushed flowers to mark their track, nor, indeed, any destructive action of any wild foot or tooth whatever.

–John Muir,
The Mountains of California, 1894.

prevent the whites from butchering the Indians en masse." Ultimately, a combination of forces would decimate Valley Indians.

Near Oroville, not far from the original homeland of the Maidu, on August 9, 1911, one of the great symbolic events in American history occurred: "the last wild Indian in North America," a Yahi named Ishi, surrendered at the corral of a slaughterhouse. His story, recorded so well by Theodora Kroeber in *Ishi in Two Worlds,* remains one of the nation's most poignant, for, in a sense only now being understood, Ishi's fate may represent that of many people in this area.

Long before the last Yahi surrendered in Oroville, Henry George produced one of the most important books ever written about California, *Progress and Poverty* (1879). "The ownership of land is the great fundamental fact which ultimately determines the social, the political, and consequently the intellectual and moral conditions of a people," he asserted. Kevin Starr comments, "George realized with the clarity of a revelation that land monopoly was the cause of California's polarization into tight sectors of poverty and wealth." The Great Central Valley might serve as the prime example of that polarization.

Unsettled land titles in the Valley during the early period of American settlement certainly retarded the development of a small-farm economy and encouraged what Carey McWilliams labeled "factories in the fields." The legal tangles attendant on disposition of the approximately thirty land grants authorized by Spain and over eight hundred approved by Mexico remain rich fodder for historians but, in general, large holders not small, and Americans not Californios tended to be the winners in court. More than a few bogus grants and duplicate deeds found their ways into evidence, and the seeds of both the vast holdings and the continued speculation of today were sown.

At the time Brewer visited the Valley in the early 1860s, prospective farmers here found themselves surrounded, and frequently excluded, by agricultural duchies worthy of Europe. He understood the source of such inequity: "The story of...Spanish grants is a long one, and a black one. Our central government has much to answer for....*The* great drawback on the settlement of this state has been, is now, and will be for years to come the insecurity of land titles."

If the legal tangle of early Spanish and Mexican land titles set a pattern, the sale of more than eight million acres of state grants at absurdly low prices confirmed it: big was better in this state's ranching and farming, and centralized ownership tended to exclude the unwealthy. Other factors reinforcing that pattern included gigantic railroad grants, hustling land brokers, and governmental manipulation. By the 1870s, one five-hundredth of the state's population—only .2%—owned *half* of California. In 1871, for example, forty-eight Fresno County residents reportedly owned more than 79,000 acres each, accounting for virtually every available inch of land.

In the Valley, the results of such concentration were most visible in the pattern of settlement. Rather than featuring small tracts dotted by farmhouses, the area instead developed with vast stretches remaining apparently unsettled—no houses, no trees—though cultivated, while the population providing labor on that land concentrated in nearby communities, some of them (such as Corcoran or Arvin) virtually company towns.

It is a system that, like those common to many developing nations, has traditionally produced a small, wealthy elite and a large, manipulable underclass; the former has frequently been able to deploy the resident middle class as a buffer during troubled times by convincing it that the interests of the wealthy are also its own. Although education, growing affluence, and new population patterns are bringing changes, Starr nonetheless remains correct in characterizing settlement here as "a plantation-like pattern..., huge acreages worked by gangs of paid laborers."

During the last third of the nineteenth century, many farmers worried about an entity that not only controlled huge tracts of land but had the power to determine agricultural markets: the railroad monopoly, which became a dramatic—some say insidious—force in the Valley. California's first rail line was constructed from Sacramento to Folsom in 1855–56. Four years later, the "Big Four"—Collis P. Huntington, Leland Stanford, Charles Crocker, and Mark Hopkins—formed an association that would eventually accumulate unimagined riches and power via control of transportation.

Construction subsidies provided great potential wealth and, when the company decided to link northern and southern California, it chose a route through what is now called the San Joaquin Valley, where government land along the right-of-way would be part of its booty. "The Development of the Great Valley, the unlocking of its full agricultural potential," explains W. H. Hutchinson, "began in the decade of the 1870's with railroad construction along its entire length by subsidiaries of the Central Pacific."

In this region, far removed from competition—the Big Four bought control of the major steamboat firm, their only real rival, in 1869—the railroad prospered and power coalesced. Eventually, the monopoly, by then called the Southern Pacific (or simply the S.P. by Valley residents), controlled 11,588,000 acres in California. Historians have traditionally assigned a distinctly villainous visage to the S.P., as Walton Bean and James Rawls (in *California: An Interpretive History*) exemplify:

> The railroad's power to make or break almost anyone engaged in agriculture, mining, manufacturing, or commerce, through its discriminatory freight rates, was effectively used in interrelation with the development of its control over politics....The railroad...corrupted politics in a variety of ways and at all levels of government, federal, state, and local.

The Great Rabbit Drive
Fresno County–1892

The great rabbit drive, described as "one of the most successful and picturesque ever had in California," was the work of more than 5,000 people and resulted in the slaying of about 20,000 rabbits. This day's "grand sport" had such an impact on fledgling California writer Frank Norris that he later incorporated it into one of the most vivid chapters of his classic novel, The Octopus.

By noon the number of rabbits discernible by Annixter's field glasses on ahead was far into the thousands. What seemed to be ground resolved itself, when seen through the glasses, into a maze of small, moving bodies, leaping, ducking, doubling, running back and forth—a wilderness of agitated ears, white tails, and twinkling legs. The outside wings of the curved line of vehicles began to draw in a little....

Then the strange scene defined itself. It was no longer a herd covering the earth. It was a sea, whipped into confusion, tossing incessantly, leaping, falling, agitated by unseen forces. At times the unexpected tameness of the rabbits all at once vanished. Throughout certain portions of the herd eddies of terror abruptly burst forth. A panic spread; then there would ensue a blind, wild rushing together of thousands of crowded bodies, and a furious scrambling over backs, till the scuffing thud of innumerable feet over the earth rose to a reverberating murmur as of distant thunder, here and there pierced by the strange, wild cry of the rabbit in distress.

...Like an opened sluice gate, the extending flanks of the entrance of the corral slowly engulfed the herd. The mass, packed tight as ever, by degrees diminished, precisely like a pool of water when a dam is opened. The last stragglers went in with a rush, and the gate was dropped.

The corral, a really large enclosure, had proved all too small for the number of rabbits collected by the drive. Inside it was a living, moving, leaping, breathing, twisting mass. The rabbits were packed two, three, and four feet deep. They were in constant movement; those beneath struggling to the top, those on top sinking and disappearing below their fellows. All wildness, all fear of man, seemed to have entirely disappeared. Men and boys, reaching over the sides of the corral, picked up a jack in each hand, holding them by the ears, while two reporters from San Francisco papers took photographs of the scene. The noise made by the tens of thousands of moving bodies was as the noise of wind in a forest, while from the hot and sweating mass there rose a strange odor, penetrating, ammoniacal, savoring of wild life.

On signal, the killing began. Dogs that had been brought there for that purpose when let into the corral refused, as had been half expected, to do the work. They snuffed curiously at the pile, then backed off, disturbed, perplexed. But....the killing went forward. Armed with a club in each hand, the young fellows from Guadalajara and Bonneville, and the farm boys from the ranches, leaped over the rails of the corral. They walked unsteadily upon the myriad of crowding bodies underfoot, or, as space was cleared, sank almost waist-deep into the mass that leaped and squirmed about them. Blindly, furiously, they struck and struck.

—Frank Norris,
The Octopus: A Story of California (1901)
from *California History*, Summer 1992.

Rabbit drive, Caruthers Station, Fresno County, March 10, 1892. CHS Collection, San Francisco.

Railroad Tracks and Landcuts, Altamont Pass, 1982. Robert Dawson.

Of late, however, a less polarized view has emerged. "The Espee was politically undemocratic and economically oppressive whenever it thought its interests, as it saw them, were threatened. Of this there can be no question," writes Hutchinson. "On the other hand," he continues, "the railroad built far more in California than it ever stifled or destroyed, but this was over the long haul of time, and human nature is hard pressed to see the long-range benefits from something that at the moment seems oppressive."

Another historian, Richard Orsi, agrees with Hutchinson, pointing out, among other things, that the Southern Pacific's self-interest frequently coincided with that of other Valley groups, including farmers. The company sought to promote population growth and property in the region, and its land policies were pro-settler, working to encourage small-scale farming, he suggests. Moreover, Orsi has found that the S.P.'s land prices were generally low and its freight rates not excessive. Finally, he stresses that its political power has been exaggerated.

In any case, late in the century, the Southern Pacific finally found itself confronted by an adversary. The Atchison, Topeka & Santa Fe extended its line through San Bernardino to Los Angeles in 1887, then eventually annexed "The People's Road" that had been built to compete with the S.P. along the line from Bakersfield to Stockton. The Santa Fe added tracks to Richmond in the Bay Area, and the Big Four finally had a rival worth worrying about. Circumstances worked against the Santa Fe, however, and onerous construction costs, combined with the depression of 1893 and, of course, the Southern Pacific's continued and vigorous opposition, led to the interloper's bankruptcy and eventually it would align itself with the S.P. on projects such as laying track across the Tehachapi Mountains.

Many a Valley town exists today because the Southern Pacific decided to ship from that point. The railroad also terminated the region's traditional isolation, altered the nature of its economy and settlement pattern, and opened national—even international—markets. More intense agriculture followed. Trains remain vital links for Valley farmers, and today Roseville, near Sacramento, contains the largest railroad assembly yard west of the Mississippi. But two more things were needed in abundance if the Central Valley was to take advantage of its improved transportation facilities: a reliable water supply during the growing season and, especially during harvest season, a mobile labor force.

Above all else, the transformation of the Valley has required a consistent supply of water. Its distinct seasonal weather pattern—rainfall concentrated in the winter and principally to the north—mandates irrigation during the extended growing season, whether water be provided by pumps sucking from aquifers, by nearby weirs diverting river water, or by dams on distant rivers. Versions of those things began appearing here shortly after the Gold Rush. Irrigation districts or associations followed soon, because farmers found that by combining effort and money they could better afford to take advantage of what was locally possible—and more effectively compete with land barons. Water soon became power.

"The technological control of water was the basis of a new West," asserts historian Donald Worster, who argues persuasively that the Great Central Valley is a prime example of a pattern common to the American West: a highly centralized technological empire based on vast water projects and complex irrigation systems, controlled by a tiny business elite, which developed "a sharply alienating, intensely managerial relationship with nature."

The relationship of land and water and power is illustrated by a tale that merges Central Valley history and folklore. First the history: in 1850, Congress passed the Swamp and Overflow Act, which granted

Appropriative vs. Riparian Water Rights
The Californian Doctrine

The state adopted the riparian principle but accepted appropriation rights derived from the federal government, which in its **Mining Act of 1866** had conceded such rights on the public domain. Where an individual had bought state land or a Mexican grant, the water rights were declared to be riparian; where he had claimed water from the public domain before 1866, he had a right of prior appropriation that could be exercised or sold as personal property. All grants after 1866, state or federal, came under the riparian rule, which in California meant that the appropriator could divert only as much water as riparian [streamside] owners allowed. Whenever they decided to use the river, the appropriator had to relinquish, no matter how long he had irrigated, no matter how established his orchards and gardens, no matter whether his farm died. . . .in California, until 1928, the riparian owner was restricted only in relation to other riparian owners. . . .

Although it was a messy fusion of riparian and appropriationist thinking, the California doctrine was emphatically clear in one particular: it put the irrigator without stream frontage at a disadvantage—potentially a fatal disadvantage for his fortunes. . . .

–Donald Worster, *Rivers of Empire*, 1985.

various states title to what was deemed valueless, waterlogged land. Such parcels became unavailable to homesteaders, an important point in terms of future patterns of settlement. In California, however, many tracts turned over to the state were boggy only during the rainy season—those claimed by Thomas Baker near Tulare, Kern, and Buena Vista lakes, for example—so they could be cultivated during nine months of most years. The state sold such property for $1.15 to $1.25 an acre and established landholders tended to benefit.

Now the folklore: one of the genuine land moguls of that period, a resourceful German immigrant, Henry Miller (of Miller & Lux fame), is reported to have hitched teams of horses to a boat and had himself pulled about over a vast, dry tract so that he could swear when applying for it that he had navigated a boat over the property.

Hutchinson winks at that story, but he confirms that the region's agricultural diversity "stems from the variety of favorable soils and climates—plus always *irrigation*." Wallace Stegner extrapolates: "If you want to make a study of western history, western culture, western society, western economics, politics, everything else these days, I think you start with water. And you might end with water."

Owing to the unique precipitation pattern, commercial agriculture in the Valley was at first limited to dry-farmed crops, principally grains, and they soon confirmed the region's enormous agricultural potential—in the 1870s, for instance, Hugh Glenn of Colusa County produced a million bushels of wheat in one year from his own "bonanza grain farm," and by 1873 California was the nation's leader in wheat production. If a variety of crops were to be grown here, however, a consistent supply of irrigation during summer was necessary.

In 1881, Henry Miller also figured in a major historical event involving irrigation rights, the case of *Lux v. Haggin*, a battle of corporate goliaths that pitted the company of Miller and his partner Charles Lux against one controlled by James Ben Ali Haggin and Lloyd Tevis (incorporated in 1890 as the Kern County Land Company). The result of the suit decided water rights in California for decades to come.

Miller & Lux owned fifty miles along both sides of the Kern River and had built a 100-foot-wide canal to carry water to other holdings. Trouble arose when Haggin and Tevis bought land upstream and filed claims for use of river water. The battle pitted riparian landowners—ranchers who owned river frontage and wanted water restricted to streamside landholders, represented in the case by Lux—against Haggin's "doctrine of appropriation," which asserted the right to divert water for use on distant farms.

Five years later, after Haggin and Tevis had won in a lower court, a Supreme Court justice performed what Carey McWilliams describes as "a curious flip-flop," and a split decision upheld Miller & Lux's riparian right—or privilege—establishing the "California Doctrine." Ultimately

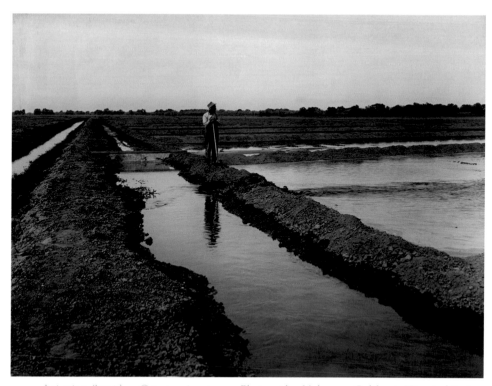

Irrigating, Stanislaus County, circa 1920. Photographer Unknown. California Historical Society.

Miller and Haggin compromised, but the doctrine endured until 1928. A lawyer's dream or nightmare, it nonetheless made one thing clear: farmers who did not own river frontage might go without water. That, in turn, led to both greater reliance on pumps for underground supplies and one of the nineteenth century's most important pieces of agricultural legislation, the Irrigation District Act of 1887, which allowed farmers to cooperatively build and operate watering systems in the thirsty Valley. This, in turn, gave less wealthy landholders a means to compete against the Henry Millers and James Ben Ali Haggins.

Valley farmers for a long while made do with what today seem primitive pumps, until, near the end of World War I, a new, powerful centrifugal unit finally allowed them to tap their zone's vast aquifer effectively. The increase of production was explosive: there had, for example, been only 739 pumps in Tulare county in 1910; by 1919, the region had 3,758 and had become the fourth most productive agricultural county in the nation.

The development of the Valley's other great product—petroleum—was indirectly linked to both the Gold Rush and agriculture, since many pioneer petroleum seekers were erstwhile diggers of gold mines or drillers of water wells. Oil seeps had long been observed in the desert hills

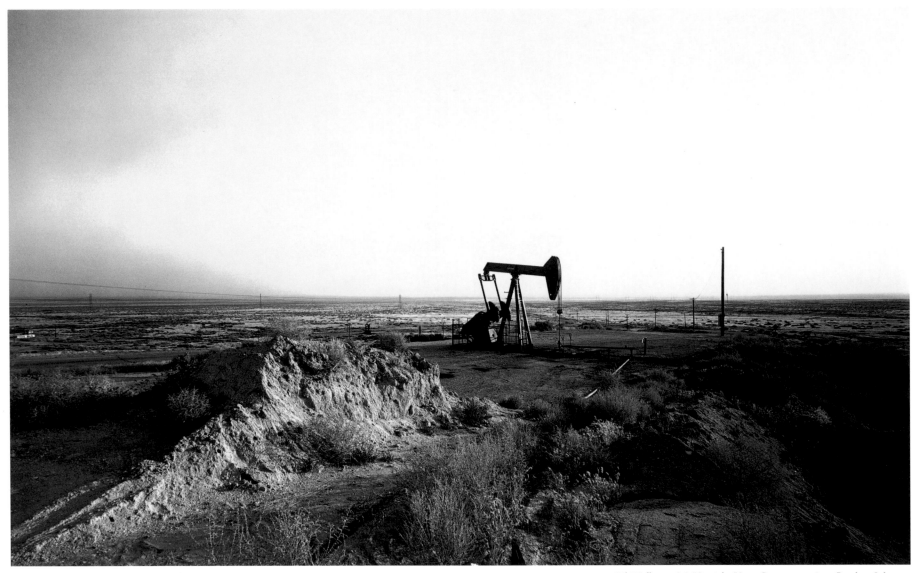

Oil Well near McKittrick, Kern County, 1983. Stephen Johnson.

that ring the Tulare Basin's southern edges, and that region soon yielded petroleum. After years of commercially marginal production, local fields moved toward profitability in the final decade of the last century when the Midway-Sunset, Kern River, and McKittrick fields became the state's leaders. The great demand for so-called black gold created by World War I, aided by new technology, stimulated impressive production.

"Between 1911 and 1918," as writer David Holmstrom points out, "California's annual production ranged between 81 million and 97 million barrels, ranking it either first or second place in the nation for that period," but one Valley well, the fabled "Lakeview Gusher," produced 90,000 barrels *in a single day* after exploding from the earth in 1910. By that time, Taft had become the principal oil town in the Valley, although in 1899 Bakersfield had experienced its own boom when, as author William Rintoul explains, "for the first time on the West Coast a vast supply of petroleum light enough to be used as fuel had been discovered close to a railroad leading to the great harbor at San Francisco." Kern County has remained a major source of petroleum ever since. Nevertheless, agriculture—which ironically uses many petrochemicals—dominates the Central Valley's image and economy. This is a cornucopia, but one with its own oil supply.

In the mid-1920s, innovative farming and intensive irrigation had allowed California to pass Iowa and become the nation's leading agricultural state, and not only wells were involved: streams were increasingly diverted. By 1930, the Kings River provided water to one million acres, more than any in the world except the Nile and the Indus rivers. By then, also, the Central Valley Project and the California State Water Project, two of the most ambitious and expensive irrigation complexes in human history, had been conceived, although it would be many years before they began to provide the water that allowed even marginal Valley tracts to become productive.

Agriculture, however, also required laborers, and as an editorial appearing in the *San Francisco Morning Chronicle*, on September 5, 1875, noted, "The farm labor problem of California is undoubtedly the worst in the United States. It is bad for the farmers themselves, and worse, if possible, for those whom they employ. In many respects, it is even worse than old-time slavery."

Walter Stein lists the general ethnic pattern of migrant laborers this way: Chinese in the 1870s; Japanese in the 1890s; East Indians after the turn of the century; Mexicans and Filipinos during and after World War I; Okies during the 1930s; southern blacks along with Filipinos and Mexicans again during the 1940s. Add to that generalized list a continual supply in the early years of white "bindle stiffs," these and many, many others. As McWilliams observed, "the diversity of rural population [in the Valley] matches or parallels the diversity in production."

"Foreigners"—so called by those who earlier were foreigners themselves—have certainly been vital here. For instance, an immigrant from China shipped the first load of potatoes from this region, and Sucheng Chan has built a strong argument that Chinese ingenuity as well as labor was central to the Valley's emergence as an agricultural empire. But the Chinese were not alone in making significant contributions: migrants brought crops such as dwarf milo maize from Japan, alfalfa from Chile, and flax from India, and at least twenty different nationalities have contributed to the wine industry. Few groups have had a greater impact on Valley farming than those known as *los braceros*, "the strong-armed"; between 1942 and 1963, an average of one hundred thousand of these Mexican residents each year provided indispensable seasonal labor. Their employers were themselves often the progeny of immigrants: Italians, Japanese, Portuguese, Yugoslavs, Irish, and, yes, Mexicans, among many others. The Valley became what Anne Loftis calls "a laboratory of races," to which groups often brought agricultural skills honed in their native lands.

It remains today a refuge for the determined and the desperate, a place where poor people of any background can come and at least hope to struggle out of the cycle of poverty—one generation toiling so that

another might take advantage of the region's promise. But desperation leaves people vulnerable and many have been exploited over the years, an impropriety unrecognized and denied by many locals: "Hey, we give 'em jobs, don't we?"

It isn't widely recognized that among the first to provide labor on Valley farms were indigenous Indians, members of the ethnic group that suffered the most overt and violent fate of all as cultures clashed. William Henry Brewer did not accept the popular rationalizations of the time. "There are now 'Indian troubles' at various places in the upper part of the state…," he noted in 1862, "and as yet I have not heard a single intelligent white man express any opinion but that the whites were vastly more to blame than the Indians."

From 1860 to 1864, Brewer was a leader of the first California Geological Survey. His work took him all over the state and his later book, *Up and Down California in 1860–1864*—which was edited by Francis Farquhar before its publication in 1930, twenty years after Brewer's death—remains a classic account of the period. Observes Lawrence Clark Powell, "His description of California in the early 1860s is unmatched by any other in its variety, fidelity and human interest." More-

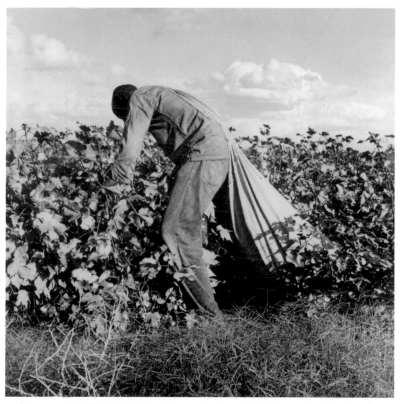

Migratory Field Worker Picking Cotton, San Joaquin Valley, 1938. Dorothea Lange. Library of Congress.

Brewer & Co. (Gardiner, Cotter, Brewer, King), 1864. Bancroft Library.

over, Brewer's descriptions of the Valley early in its American period remain unrivaled.

Brewer was the first man selected by the state geologist, Josiah Whitney, in 1860 when it was decided to survey California. He proved a wise choice—bright, energetic, and, at thirty-two, in his prime. As Farquhar observes,

> *The next four years were to show how extremely fortunate Whitney was in this selection. It was of vast importance that his right-hand man should be of the strongest fiber, of unflagging energy, the soundest judgment, the utmost tact, and of unequivocal honesty and loyalty. Happily, these were the very qualifications that distinguished the character of Brewer.*

Brewer and his youthful associates, including another who would become an important writer, Clarence King, trooped all over the state— on foot, on muleback, by riverboat, by stagecoach—climbing mountains and fording streams, narrowly avoiding mayhem and embarrassment. These adventurers experienced many of the extremes that the Great Central Valley and its environs had to offer, for the winter of 1861–62 was among the wettest on record, and it was followed by devastating droughts in 1863 and 1864. Through it all, Brewer kept a daily journal

and sent frequent letters to his brother in New York; his observations were both sensitive and candid: "I would rather see the nation reduced to poverty and a million men perish than see the Union broken," he admitted in an 1861 note. The Civil War that raged during his stay in California nearly rendered that remark prophetic.

The young scientist was the first American to really apprehend the Great Central Valley—its enormous size, its various settings, its layers of life—and to write about it with what Powell calls "clear and sensuous vision." Even in his day, however, sensitive people were aware of how and how much the region was being altered. "Here we are in the Sacramento Valley again, a plain with majestic oaks and fertile land," he noted in his journal on October 26, 1862. "We camped at Mr. Dye's ranch, an old pioneer. He was a fine old man—had come into the state in 1832 and had settled on that ranch in 1842. What changes he has seen on this coast!"

The Whitney party was indirectly involved in a momentous conceptual change regarding this fertile land. Their maps would be employed, as Alvin Urquhart phrases it, "to impose geometry on geography," to begin the American process of "manhandling the land into a shape in accordance with perceived needs, building a physical reality to fit an abstract model." That model was the gridwork of land parcels, of roads and rails, the gridwork of perception itself, that would ultimately be sold and developed. But those things were not on Brewer's mind as he explored the region.

Although he was by no means immune to the prejudices of his time—his disparaging references to "Seceshes," for instance, humorous to present-day readers, reflect his genuine and deep antipathy for the Confederate sympathizers he found in the Valley during those Civil War years—the young scientist nonetheless achieved a balance surprising in one so inexperienced in the Wild West. Occasionally, though, he and his crew looked like greenhorns: "We all continually wear arms— each wears both Bowie knife and pistol (navy revolver), while we have always for game or otherwise a Sharp's rifle, Sharp's carbine, and two double-barreled shotguns."

It is appropriate that Brewer, who went on to enjoy a distinguished career as a professor at Yale's Sheffield Scientific School after his stint in the Golden State, should have been the first major chronicler of the Valley, now the world's agricultural center. As Farquhar has written, "Notwithstanding the high rank to which he rose in the academic world, Brewer was first and last a farmer, and his life story constantly reflects his closeness to the soil."

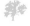

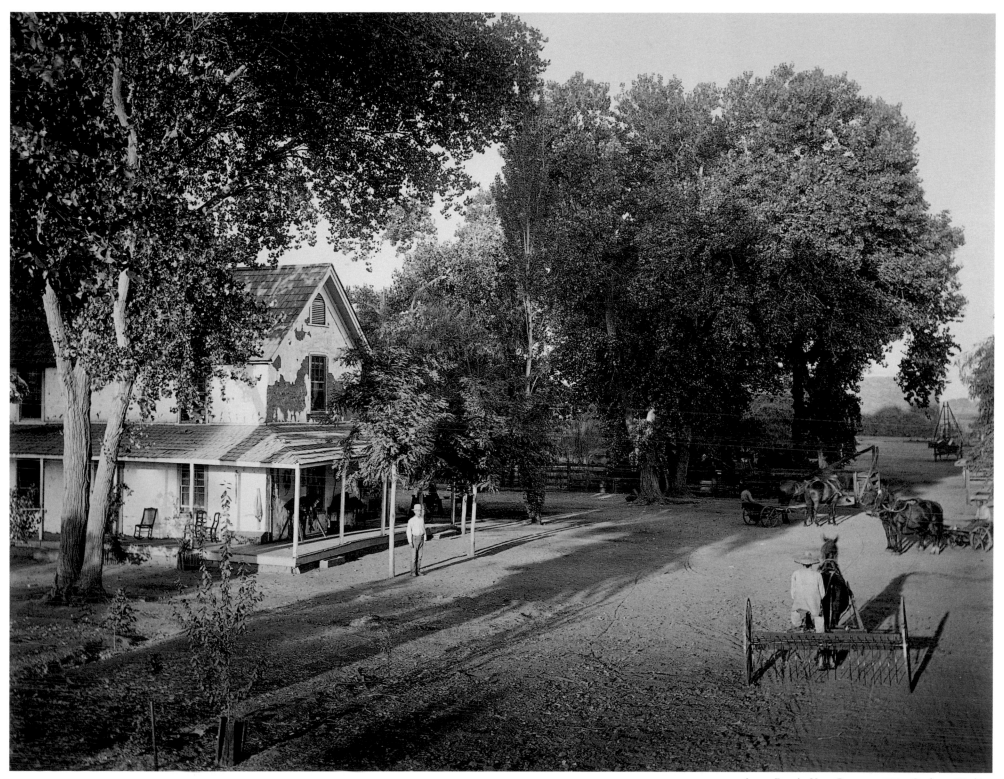

James Ranch, Kern County, 1888. Carleton Watkins.

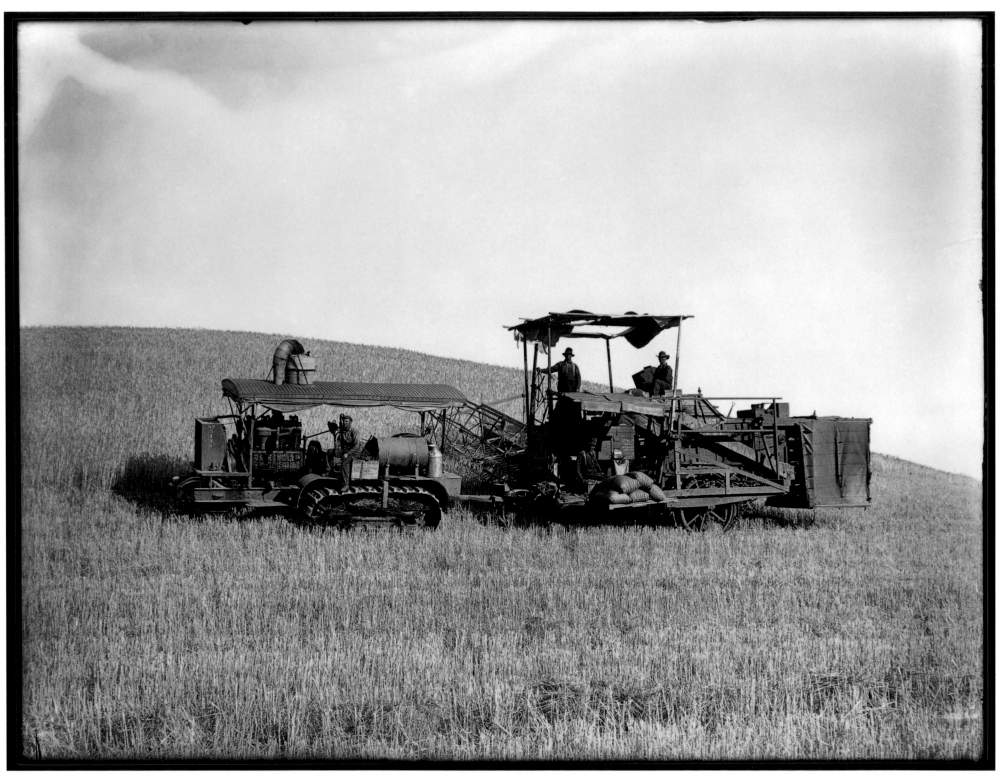

Holt Harvester, Merced County, circa 1925. Frank Day Robinson.

Man in Field, Merced County, circa 1925. Frank Day Robinson.

Canal and Workers, Eastern Merced County, circa 1925. Frank Day Robinson.

Planting, Merced County, circa 1925. Frank Day Robinson.

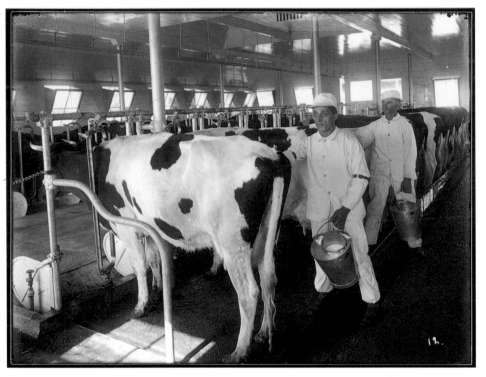
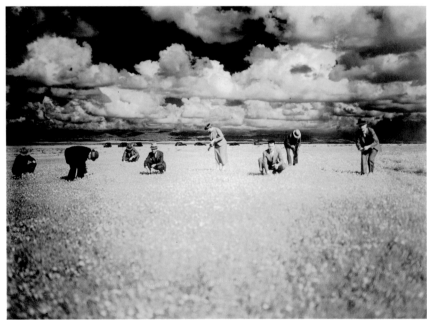
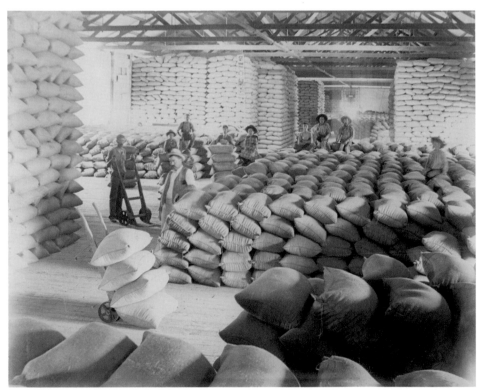

Clockwise from upper left:
Acres of Barrels of Green Olives. Lindsay, Tulare County, circa 1930. Ewing Galloway.
Merced County Dairy, circa 1925. Frank Day Robinson.
Warehouse, Fresno, circa 1917. Photographer Unknown.
Picking Wildflowers, Kern County, 1937. Photographer Unknown.

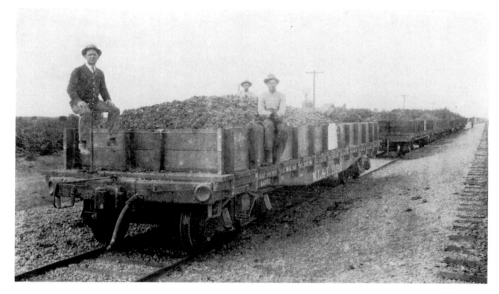

Clockwise from upper left: *Fair Display, circa 1925. Frank Day Robinson.*
Loading Grapes, Ripon, circa 1915. Photographer Unknown.
Man and Citrus, circa 1925. Frank Day Robinson.
Cannery Workers, Merced County, circa 1925. Frank Day Robinson.

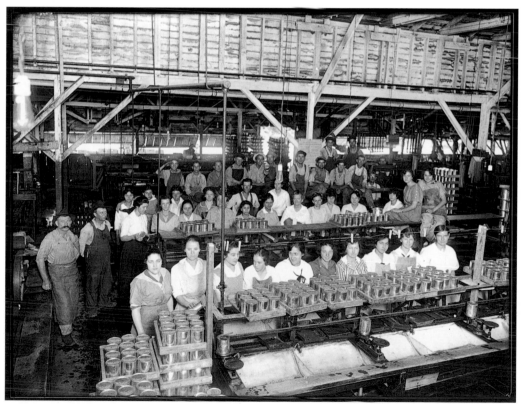

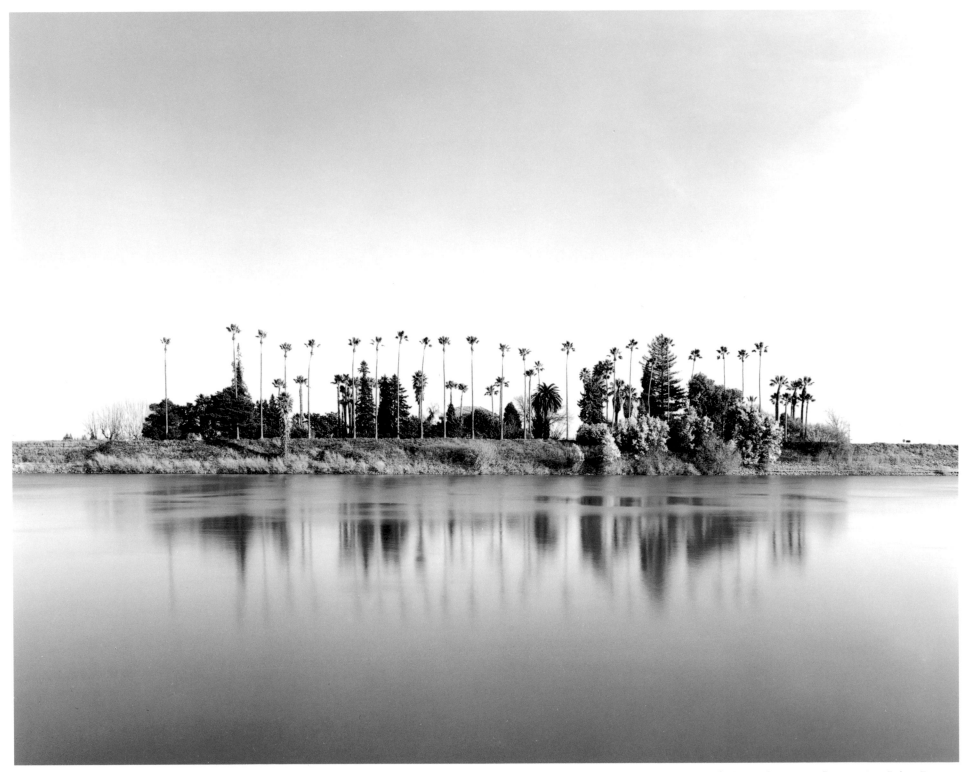

Delta Farm, Sacramento River, 1984. Robert Dawson.

Chapter III: The Delta

Mount Diablo stood up, a most majestic object, until shut out by the shades of evening. We were in the "sloughs," as the many mouths of the Sacramento and San Joaquin rivers are called, when the moon rose from the plain as from the sea.

William H. Brewer, August 17, 1862

Brewer's "sloughs" characterized a singular locale that is among the Valley's most controversial. Today the Sacramento–San Joaquin Delta dramatically illustrates human manipulation of a region's landscape and the sort of unforeseen problems that can follow such alteration. Composed of a thousand miles of marshes, swamps, reclaimed "islands," and braided river channels, along with the secondary cuts called sloughs, this watery domain is among the world's most unusual deltas, for it empties into an elaborate system of bays before reaching the Pacific Ocean. The Delta itself is located far inland. It is shaped like a ragged triangle, draining from its narrowest point—an inversion of the wide-mouthed form most other deltas assume. This single region provides 40% of the state's drinking water, 45% of its irrigation flow.

One thing Brewer did not sense—and, indeed, few contemporary commentators have noted either— is that the Valley actually reaches the Pacific Ocean. The trough that channels river water from inland rivers via the Delta and slices through coastal mountains at Carquinez Strait, stretches into San Pablo Bay, into San Francisco Bay, and finally into the sea through the Golden Gate— an extension of the landlocked valley. The bays constitute a generative cusp where inland water, inland soils, and inland nutrients sustain estuarine wetlands, among the most biologically productive of all earthly environments.

Most of the water from the Southern Cascades and the Sierra Nevada drain from the Valley to the Bay, or used to; less than half of it is believed to have survived dams and diversions now —13 million acre-feet annually where once 28.3 million are estimated to have passed. Nonetheless, the interrelationship of mountain and valley and bay is intimate and vital. "That drastic reduction in the water flowing into San Francisco Bay," suggests K. Patrick Conner, "has clearly limited the estuary's ability to dilute or cleanse the agricultural chemicals and the industrial and municipal wastes flowing into it."

During flood seasons, fresh water from the Delta may extend as far into the ocean as the Farallon Islands and tides each day send more from the Delta through the Golden Gate than flows out the mouth of the Mississippi River. "Fresh nutrients and water must continually replenish the Bay or it will be starved and poisoned," explains David Rains Wallace, "and the storms that increase winter and spring river flows sixfold are the source of the Bay's lifeblood in a more than figurative sense."

In the face of studies that suggest Delta outflow may have been reduced by as much as 60% owing to various diversions, Phyllis Fox of the University of California has asserted that estimates of "unimpaired" historic flows are wrong because they don't take into account the Valley's original ecosystem, which included over a million acres of tules, 1.4 million acres of riparian forests, plus 5.3 million acres of grassy prairie— each of which soaked up water. Tules, for example, drank 9.63 acre-feet

The San Joaquin River with Mount Diablo, circa 1873. Thomas Moran.

per year (contrast this with potatoes, which require 2.09 acre-feet, or asparagus, which consumes 2.69). So, argues Fox, the unimpeded flow from the Delta was not that theoretical 28.3 million acre-feet (an acre-foot is 325,900 gallons) that has been estimated, but something much closer to today's figures.

Unfortunately—at least for those who want Fox to be correct—hydrologist David Dawdy has pointed out significant errors in her calculations, and biologist Joel Hedgepeth suggests that much of her evidence is anecdotal, not empirical, and that she overlooks facts such as the annual summer burn-off of tules. Fox herself acknowledges a 50% margin of error.

Nothing is simple. "The fate of San Francisco Bay is married for better or worse to the high-powered politics of water in California," Umberto Tosi points out, and with six thousand separate legal rights claimed for Delta water, Fox's theory—like opposing hypotheses—has quickly been employed as political propaganda.

Propaganda and theories aside, no one denies that fresh Delta water is vital to the Bay's health. It is necessary to flush the entire estuary—that is, San Pablo and San Francisco bays combined, which cover some 435 square miles. Far from the Carquinez Strait and the Golden Gate, the continued diversion of Delta river flows has contributed to a dismal ecological picture made worse by rampant, sometimes thoughtless local development in the South Bay area that runs roughly from Fremont to San Jose. "The freshwater input from the Delta is really critical, particularly down here where the pollution concentrates.... There just isn't enough water coming in to flush out the increasing contaminant levels

from all the new development," explains South Bay wildlife biologist Tom Harvey.

Only in the Delta is the Valley's intimate relationship with San Francisco obvious. Cattle ranchers in the San Joaquin foothills or rice farmers on the curving edge of a Sacramento Valley dike have little sense of how their activities affect that distant body of water, those distant organisms. In the Delta, however, where tides rise and fall like the breath of the sea, where fresh and salt water mingle, the sense that the great dry trough of the Valley and the great watery trough of the Bay may be extensions of one reality is more easily grasped.

John C. Frémont, "The Pathfinder," passed through the Delta in 1845. His journal records the following:

> *March 25. —We traveled for 28 miles over the same delightful country as yesterday, and halted in a beautiful bottom at the ford of the Rio de los Mokelemnes, receiving its name from another Indian tribe living on the river. The bottoms on the stream are broad, rich, and extremely fertile; and the uplands are shaded with oak groves. A showy lupinus of extraordinary beauty, growing four to five feet in height, and covered with spikes in bloom, adorned the banks of the river, and filled the air with a light and grateful perfume.*

Frustrated forty-niners seeking better opportunities would also recognize its richness, settling and cultivating parts of it in the early 1850s, chiefly growing wheat during that decade. Still, the Delta had yet to become a major agricultural entity in the 1860s when Brewer traveled through it.

Because of its intense, highly specialized development since Brewer's day, however, the contemporary Delta also shows clearly the mixed blessing such change has wrought, for development always involves compromises with nature. This deceptively tranquil area has in many ways been as profoundly reshaped as any other comparably sized landscape in the state. Pleasure boats ply its channels, tractors chug its fields, cattle graze its margins, chemicals foul its water. With the introduction of intensive agriculture here, some of the necessary compromises may return to haunt residents, for this area, which deposits so many asparagus spears and potatoes on plates, also contributes problems unexpected and virtually unnoticed by outsiders. Harold Gilliam reveals one such dilemma, wind erosion:

> *The light peat soil readily oxidizes. It is picked up by spring winds and carried for miles, at times darkening the skies over Stockton. The soil in the Delta's islands has been disappearing at the rate of one to three inches a year. As a result much of the ground surface behind the levees now lies 10 to 20 feet below water level, putting more pressure on the levees, resulting in flood-season breaks that in some cases have caused whole islands to be abandoned.*

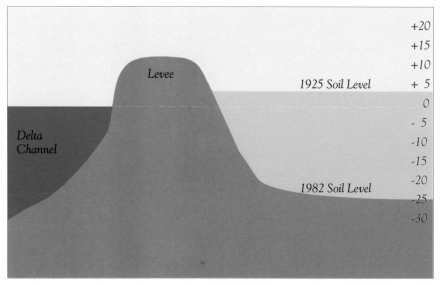

Soil Oxidation in the Delta.

Wildflowers and Orchard, Brentwood, 1985. Stephen Johnson.

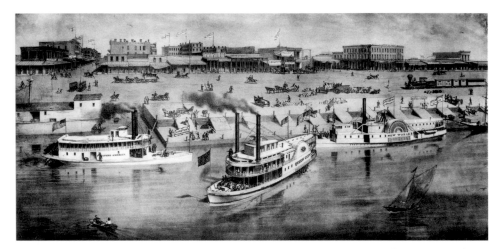

Sacramento City Waterfront, 1855–56. California State Library.

"Peat storms" are both memorable and common in the area. "When those clouds appear on the horizon, Delta residents know to rush out and pull their fresh laundry from the line," observes Michael Black, a local boy.

Originally, eight rivers drained Sierra and Cascade runoff into the San Joaquin and Sacramento rivers' delta tangle; most early settlers remembered miles upon labyrinthine miles of tule-lined sloughs, channels and secondary channels that seemed eternally tempting to boat captains. William Swain, after traveling from Sacramento to San Francisco in 1850 on a commercial vessel, noted one slough that had been taken as a shortcut "was but a few feet wider than the steamer and many of the bends occasioned her considerable trouble. Her bow sometimes ran in among the boughs of the trees, where she cannot well be backed without her stern going into the opposite bank." Later, he wrote with relief, "our steamboat kept to the main channel, it being better."

Main channels and sloughs alike were surrounded by tule-choked marshes, by boggy islands, by swamps and riparian forests—jungles of huge sycamores, cottonwoods, walnuts, ashes, and oaks, tangled with wild grapevines and cushioned by dense grasses, herbs, and bushes—with brackish water penetrating its lower reaches: a varied and rich ecosystem. "Vast garden. Orchard. Tules, the interminable sea of tules —water, wind, rain, tides. The seasonal inundations far to the backswamp," writes Dave Bohn. And Charles Bohakel adds: "Life along the Delta has always been associated with water. Residents often had to build their homes on stilts and sent their agricultural products to market on scows and steamboats."

A great variety of animals roamed the Delta's islands and waded its bogs: waterfowl pranced in its shallows and nested in its rushes; tule elk snorted at the scent of roaming grizzly bears; voles darted from the

shadows of red-tailed hawks. And always, it seemed, the air was rich with insects, the earth was rich with insects, the water was rich with insects. The soil itself was alive, composed of deep layers of peat, decomposing vegetation of remarkable richness that has mixed with river silt. The area evolved over millennia as the two major river systems merged and flowed toward the Strait and the Bay. Geographers Paul Griffin and Robert Young describe the process this way:

> The development of the Delta was as slow as geologic time itself. The waters of the Sacramento coursed down from the mountains to spread their burden of gravel and silt as they reached the valley floor. The river frequently changed course as winter flood followed winter flood, and finally split into a multitude of channels at that point where it met the San Joaquin, the channels in their turn forming a complex of low-lying islands. As the San Joaquin flowed north through the Central Valley, it deposited sediments in its lower reaches so thick that they blocked the course of the river and so caused it to overflow and branch out into several channels. These channels webbed out across the lowlands to form a complex braided pattern of waterways between the river and its junction with the Sacramento and the Bay.

Flying west from Stockton today, a shimmering mosaic of tracts and channels appears below, reclaimed land banked by eleven hundred miles of levees. One-third of California drains into this vital district, which constitutes only 1% of the state's total area. Richard Dillon aptly calls it "the keystone of California's water supply," and its water is much coveted. Already the Delta-Mendota and the Delta Cross Channel funnel a portion of it elsewhere. The diversion of considerable Central Valley drainage even before it reaches this region has weakened the Sacramento River's usual strong surge and its vital barrier to saltwater penetration. According to William Davoren of the Bay Institute of San Francisco, 50% of the fresh water that should enter the Bay during an average runoff year is now diverted elsewhere; during drought years, the proportion of water diversion climbs toward 75% and salt water penetrates farther and farther inland, into the Delta's traditional freshwater domain, upsetting its ecosystem. As Sacramento poet Dennis Schmitz captures it:

> Late November: a sixty-knot
> squall through Carquinez
> Strait breaks
> levees, backs salt water miles
> to preserve
>
> what it kills…
> —from *Delta Farm*

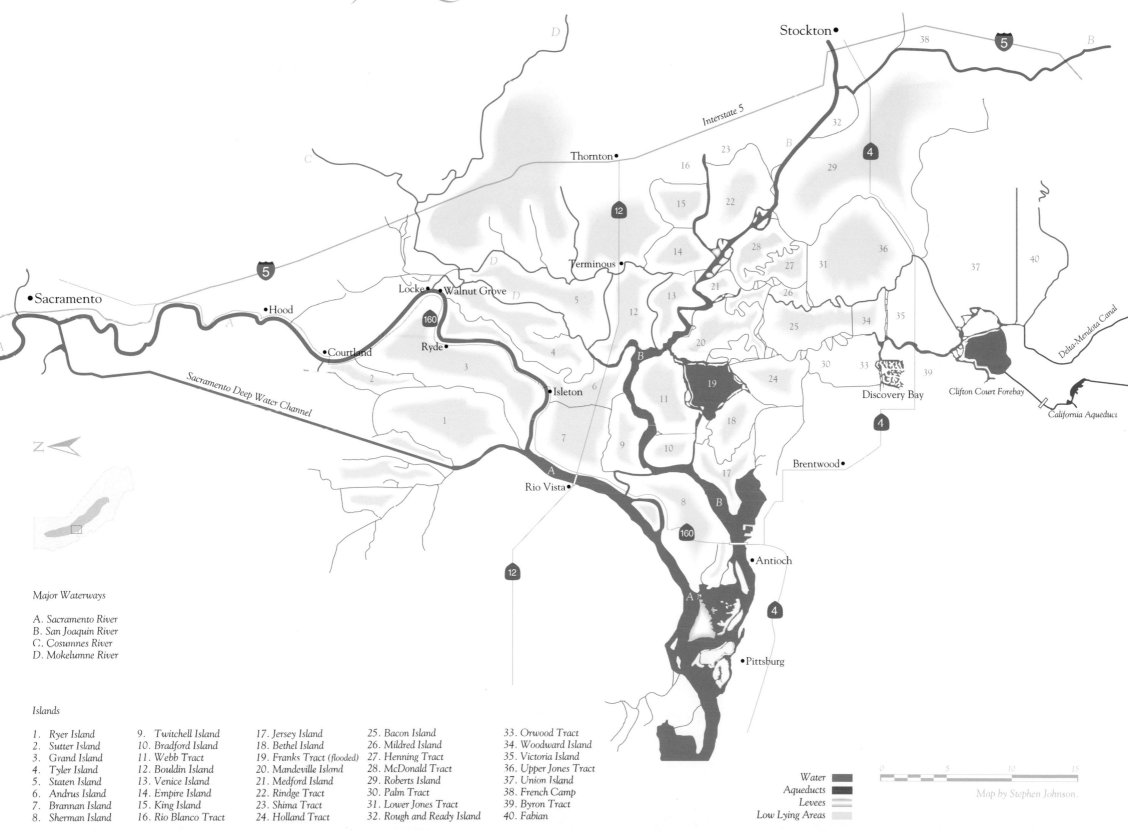

SACRAMENTO-SAN JOAQUIN DELTA

Stockton

Interstate 5

Thornton

Terminous

Sacramento

Locke
Walnut Grove

Hood

Courtland

Ryde

Isleton

Sacramento Deep Water Channel

Rio Vista

Discovery Bay

Clifton Court Forebay

Delta-Mendota Canal

California Aqueduct

Brentwood

Antioch

Pittsburg

French Camp

Major Waterways

A. *Sacramento River*
B. *San Joaquin River*
C. *Cosumnes River*
D. *Mokelumne River*

Islands

1. *Ryer Island*
2. *Sutter Island*
3. *Grand Island*
4. *Tyler Island*
5. *Staten Island*
6. *Andrus Island*
7. *Brannan Island*
8. *Sherman Island*

9. *Twitchell Island*
10. *Bradford Island*
11. *Webb Tract*
12. *Bouldin Island*
13. *Venice Island*
14. *Empire Island*
15. *King Island*
16. *Rio Blanco Tract*

17. *Jersey Island*
18. *Bethel Island*
19. *Franks Tract (flooded)*
20. *Mandeville Island*
21. *Medford Island*
22. *Rindge Tract*
23. *Shima Tract*
24. *Holland Tract*

25. *Bacon Island*
26. *Mildred Island*
27. *Henning Tract*
28. *McDonald Tract*
29. *Roberts Island*
30. *Palm Tract*
31. *Lower Jones Tract*
32. *Rough and Ready Island*

33. *Orwood Tract*
34. *Woodward Island*
35. *Victoria Island*
36. *Upper Jones Tract*
37. *Union Island*
38. *French Camp*
39. *Byron Tract*
40. *Fabian*

Water
Aqueducts
Levees
Low Lying Areas

Map by Stephen Johnson

The Caterpillar Track

*The development of specialized machines and techniques for agriculture in
the Central Valley has had a profound influence worldwide. Irrigation systems
and high-technology agriculture are among the products of Valley ingenuity.
The caterpillar track, developed to work soft Delta soil, went on to revolutionize
earthmoving machinery, and made the tanks of World War I possible.*

Benjamin Holt and the Caterpillar Tractor

Holt's first attempt to build machines capable of working the
delta was only a partial success. One Holt machine built around 1900
had two additional wheels extended from each drive wheel. Each
wheel was seven and a half feet in diameter and six feet wide, resulting
in a colossal traction engine forty-six feet wide. After some [additional]
experimentation in the company shops Holt successfully tested his first
track-type tractor—on Holt property in the Delta close to the Stockton
city limits—on Thanksgiving Day, November 24, 1904.

The first Holt crawler was a refitted steam traction engine. The
wheels were removed and replaced with two track frames 30 inches
high, 42 inches wide and nine feet long. The tracks fitted to each frame
were constructed of 3 x 4 wooden slats. This first crawler was able to
operate on ground where men and horses had quickly sunk into the
soft earth. The success of the crawler was due to its greater area of sur-
face bearing on the ground, estimated by Holt to be equivalent to
wheels 75 feet in diameter. After further experiments, regular produc-
tion models of the Holt track layer were introduced in 1906.

—Walter Payne, *Benjamin Holt: The Story of the Caterpillar Tractor,* 1982.

The Sacramento River flows for 382 miles from the north, while the
San Joaquin covers 317 from the south; together they drain all but the
extreme southern end of the Great Valley. The former stream is domi-
nant, contributing nearly three-quarters of the Delta's freshwater vol-
ume. Its main channel gathers water from the San Joaquin just before it
rolls into Suisun Bay on its way to the narrow channel between the
Montezuma Hills and the Diablo Range, the channel called Carquinez
Strait. The current grows stronger as it passes through that constricted
outlet, little over a mile wide, fresh water gushing into San Pablo Bay,
the northern extension of the great estuary, which itself finally empties
from the Golden Gate into the Pacific.

This is backroads country, with no major highway penetrating it.
"On the freeway between San Francisco Bay and Sacramento one forgets
that this [Delta] was once wild land with golden beaver going about their
industrious ways and great blue herons on guard," ecologist Elna Bakker
observes. The freeway skirts this rich region, only touching its edge.
Within is a land of margins: Valley meets Bay, fresh water mingles with
salt, levees abut uncontrollable channels, and humans confront nature.

The Delta encompasses 565,000 acres of silt and peat, over 50% of
which—those reclaimed islands, for example—is below sea level. About
350,000 of its acres are irrigated and farmed. The fecund peat soil is so
soft and so deep—up to fifty feet—that special equipment is necessary.
In the old days, as historian Erling Erickson explains, "Wagons with
rims ten inches wide sank into the soil, as did horses equipped with spe-
cial shoes one foot in diameter." To move across this soft loam, Benjamin
Holt in 1904 developed the Caterpillar tractor, which spread its weight
over a wide area. One of the inventor's prototypes was a colossal machine
forty-six feet across, but his first successful "Cat" employed tracks only
forty-two inches wide. It went into production in 1906, and a decade later
75% of all tractors being used in the state were Caterpillars.

Holt was not alone in developing unique equipment in the Delta.
Peter Le Tourneau devised his mammoth earthmovers here, and yet
another local invention that has proven generally useful is the modified
clamshell dredge. Huge pumps have also been developed in this area to
drain islands inundated when levees are breached. More recently, those
same pumps have been used to ship the region's water south. As seems to
be the rule throughout the Valley, considerable capital and creativity are
required to farm effectively, so large corporations, which possess plenty
of both, control much local farmland.

The Delta's peat soil is unusual in another way: it is combustible.
Composed of decomposing vegetation—principally the region's charac-
teristic tules—it is an organic humus. When dry and ignited, peat burns
for long periods, like matter on the way to becoming coal, which is ex-
actly what it is. The Delta contains over 300,000 acres of peat land. The
remainder is mineral soil, actually richer than the decaying plant matter.

To enter the Delta, William Henry Brewer embarked on a steamer in San Francisco that traveled north into San Pablo Bay, then east up the combined channels of the San Joaquin and Sacramento rivers through the Carquinez Strait and past Suisun Bay into the Great Central Valley. Penetrating the narrow sluice at Carquinez, Brewer and his party passed the old state capital at Benicia on the north and, to the south, Martinez, where John Muir would die and be buried in 1914. It is a major site of oil refineries today, and they are suspected of contributing pollution to the Delta via tidal waters that flow upstream against the diminished freshwater barrier.

Farther inland, on the Valley's outer boundary, Brewer's steamer skimmed Pittsburg, a township laid out in 1849 by William Tecumseh Sherman, a famous Civil War general by the time Brewer passed it thirteen years later. Just north was Suisun Bay's estuarine marsh, along which boats had traveled since Gold Rush days. This is the largest marsh in the United States, a wonderland of tules and cattails and grasses, with patches of wildflowers and abundant animal life.

A little way upstream, Brewer's steamer veered into the main channel because, just beyond, lay Sherman Island and a maze of passages, sloughs, and islands created where the Sacramento and San Joaquin rivers meet. Antioch, near the Delta's western boundary at Sherman Island, was founded by the twin brothers Joseph H. and W. W. Smith, Boston natives who arrived in 1849. Joseph Smith soon died, but the following year his brother lured a shipload of New Englanders to join his family, and the settlement was established.

The Smiths of Antioch were rank latecomers relative to their neighbor, "Dr." John Marsh, who lived inland south of Pittsburg. The first important American settler hereabouts, Marsh was reputed to be an irascible, greedy man. Nevertheless, his historical importance cannot be denied. He bought Rancho Los Medanos and settled on the Valley side of Mount Diablo in 1837. He was the area's first practicing doctor—although not formally qualified as such—and is reported to have demanded cattle in payment for his medical services, the number of cows increasing with the mileage he traveled for appointments.

"It was John Marsh's reports on the climate of Northern California," writes W. H. Hutchinson, "that prompted the first avowed party of overland immigrants to quit Missouri's chills and fevers." That was the Bidwell-Bartleson party of 1841, and it was Marsh who convinced the Mexican governor, Mariano Vallejo, that the newcomers posed no threat, thus gaining them the right to settle. On the other hand, Marsh demanded high prices from party members for hospitality and supplies, something that did not endear him to the group he had lured west.

Today tourists visit Marsh's "Stone House" near Brentwood, a grand domicile built for his wife, who died before it was complete. The San Francisco *Daily Evening Bulletin* in 1856 described it as "the old English domestic style of architecture—a pleasing and appropriate union of Manor House and Castle....[It] must be acknowledged a most felicitous deviation from the prevailing style of rural architecture." It is today surrounded by fruit and nut orchards, by cultivated fields and scattered oil and natural gas pumps, and by encroaching suburbs, but the nearby Diablo Hills retain the spring splashings of wildflower colors that moved even the dour Marsh.

To the northeast of that pioneer's holdings, the San Joaquin's channel led into a region that developed later than the Sacramento River's environs—more twisted, more tangled, slower to submit to human manipulation, its interior the site of almost no significant communities save French Camp. Here was a watery dominion of reedbeds, rushes, swirling birds, and burrowing muskrats, a private place through which paddlewheel steamers splashed toward Stockton from 1849 until 1932. Despite its slower settlement, this region is thoroughly planted and harvested now.

French Camp was named for Hudson's Bay Company trappers, many of them French-Canadians, who camped and hunted fur-bearing animals—principally the golden beaver—in this vicinity from the early

Delta Levee, 1983. Stephen Johnson.

1830s until the Gold Rush. They should perhaps have trapped another species: "As we are here nearly surrounded by water, we are likely to be devoured by mosquitoes," wrote John Work in 1833. The region was infamous for its swarms of the pests, said by frontiersmen to be as large as eagles and far more aggressive.

Some of the water filling the San Joaquin's sloughs today, like that filling the Sacramento's, is increasingly brackish—salt from San Pablo Bay penetrating sweetwater marshes when extreme high tides can no longer be held back by the currents of rivers depleted by drought, urban use, and irrigation. With politicians from the natural deserts in the Tulare Basin and Southern California scheming for more and more local drainage, Delta farmers worry about increased saltwater encroachment and environmental alteration, but an older, enduring threat also concerns them: floods.

This region requires its maze of levees, employed originally to protect more than sixty low-lying islands from high water, if it is to be agriculturally viable. Terrible toil was required to build levees in the early days. In areas of peat soil, only humans could work, because the soft surface could not support the weight of horses. Much of the back-breaking reclamation work in this region was performed by Chinese laborers.

In the mid 1860s a significant period of levee building began. An irony of that project is revealed by John Thompson:

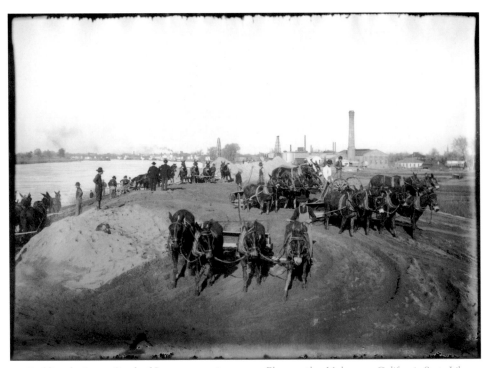

Building the Levee, South of Sacramento, circa 1900. Photographer Unknown. California State Library.

The construction of levees requires large volumes of fill, a need that was met by moving material from the areas to be reclaimed, or when dredges were used, from channels. In either case, protection was not achieved except at a fairly high cost to the delta; the removal of material from inside levee lines contributed to the subsidence process, and the dredging of material from outside the levee lines often resulted in levee instability.

Once completed, the vulnerability of the barriers became evident immediately. It is an ongoing and expensive problem. "Of the thousands of miles of levees holding the Delta together, only about half meet minimum federal standards," despite the fact that they are the core of the state's water-delivery system, Eileen Campbell points out. How shaky is the system? Thirteen Delta islands have been flooded in the 1980s, costing over $100 million in disaster relief.

The reclamation of the Delta was part of another, even more significant transformation the Central Valley was undergoing. As biologist Felix Smith explains:

California, at statehood, had an estimated five million acres of permanent, seasonal, and tidal wetlands with about four million in the Central Valley. Flood control, drainage and water development projects stimulated wetland conversion. Wetlands were diked, leveed, and drained to provide agricultural land....Today only about 250,000 acres of wetlands remain in the Central Valley.

Those few remaining wetlands—only about 6% are left—constitute the heart of the wintering grounds for migrating birds of the Pacific flyway, scattered sanctuaries threatened by chemical pollution and toxic salts in agricultural wastewater.

Even in the nineteenth century, when the levees were built, there arose unforeseen difficulties in constructing and maintaining them here. For example, the Gold Rush and the hydraulic mining that followed had filled up river channels with silt and debris, limiting navigation and increasing the constant danger of flooding, since the shallower beds still had to carry the same volume of water. "Steamboat Slough," historian Joseph McGowan points out, "which had been twelve feet deep in 1853, was only five feet deep by 1879....Suisun Bay, which had been fifteen feet deep in 1859, was so filled with debris by 1879 that tules were growing in it." The massive flood of 1878 finally led to demands that hydraulic mining upstream be restricted. Progress then, as now, had to be evaluated in terms of what an apparent short-term good—gold, in this case—cost in the long run: silted rivers, floods, and untold human misery. Then, as now, those in a position to reap short-term gains did all in their power to resist anything that threatened their aggrandizement.

If the river beds were filling up, the peat islands of the Delta were doing almost the opposite, subsiding—some are now more than twenty feet lower than they were 130 years ago when this area was settled, which is to say that they are about twenty feet *lower* than the river channels surrounding them. The very name "island" must, as Campbell suggests, be considered vestigial, "left over from a time when they actually rose above the level of the water. Today, the islands are more like basins." As a result, vacationers sail *above* cultivated fields on various diked channels that rim them. Levees are no longer required only for protection against winter floods; they are necessary for day-to-day existence. Over the years, whole islands have had to be abandoned to the rivers.

Not only might breached dikes inundate the islands they protect, but the levee system is expensive to maintain. The levees are vulnerable to everything from earthquakes to muskrats, so the dikes are the focus of a sizable local industry maintaining them. In the winter of 1986, for example, the Mokelumne River, the San Joaquin's major tributary, flooded three islands: Tyler (8,000 acres), McCormack Williams (1,500 acres), and Dead Horse (200 acres), plus areas of the Valley floor near Thornton, which caused closure of Interstate 5, the state's major north-south artery.

The human damage done by that flood is difficult to exaggerate. On Tyler Island, Bill Slowson, superintendent of the local water reclamation district, describes one neighbor's plight like this: "He's farmed all his life, and it's none too good in the best of times. Now [he's] just sicker than hell." Jack Mello, a farmer born on Tyler Island nearly seventy years before, says, "I been there all my life, and I went through [high water] so many times. But this time the water raised so quick it topped the levees right in front of the house....When we finally saw the water taking off chunks of the levee, we just barely did make it out of there." Having dwelled all his life along the river and the levee, Mello—like most Delta dwellers—remains philosophical about the vicissitudes of life in a land of margins. "Oh, it's upsetting," he admits, "but you've got to keep your cool." His 175-acre wheat and pear spread on Lost Slough was inundated.

Critics suggest that the whole arrangement may have outlived its usefulness. Not only are small farmers on the Delta vulnerable to the currents of the river and the ambitions of massive farm corporations, there is also a constant debate about who is financially responsible for the complex and expensive system of dikes and channels that allows the islands to remain productive at all. The question of whether the system is simply a bottomless pit and should be abandoned is as old as the levees themselves. Islands subside; levees become increasingly necessary and vulnerable—and more expensive. Serious questions are being raised about whether the present scheme's benefits to taxpayers are commensurate with their cost. In 1977, James Cook, head of the Bureau of

Placer Mining and Delta Flooding

Hydraulic mining for gold in the Sierra Nevada mountains filled Central Valley rivers with silt and debris. As debris accumulated in the river channels, even the smallest rise in water level caused flooding. Delta islands were particularly hard hit. After years of lobbying by farmers, and over the objection of powerful mining interests, legislation prohibiting placer mining was finally enacted in 1880. Moves were immediately made to have the legislation overturned.

In Defense of the Drainage Act

In defense of the embattled Drainage Act of 1880, on the thirteenth of January 1881, Governor George C. Perkins sought to set the tone for the legislative sessions by sending the Senate and Assembly a powerful message on the problem of the Sacramento River. "The very existence of one of the most fertile portions of the state is imperiled," he wrote.

The State Engineer estimated that there had already been at least $6,000,000 lost to the farming community, not including indirect problems. He pointed to the arduous labor and millions of dollars that had been poured into the attempted reclamation of the broad islands in the Sacramento's delta, all of it ruined because mining debris has so raised the river that catastrophic floods were impossible to prevent. Such a fate was sure to come to the lower San Joaquin and the bays. River navigation was almost ruined.

Moreover, "There is a mass of mining debris now collected in the canyons of the mountains sufficient to cover the Sacramento Valley completely a couple of feet deep..." It was, therefore, absolutely necessary that a comprehensive program of river control be maintained.

–Robert Kelley, *Gold vs. Grain*, 1959.

In the southern Delta, not far from where native wetlands have been protected by duck clubs, may be found the Clifton Court Forebay, core of one of the state's most spectacular unnatural attractions, the California Water Project. Great pumps here pull Feather River water across the Delta thirty miles into the California Aqueduct; at 444 miles, the longest stream in California—a man-made, concrete-lined channel that is visible from outer space. The aqueduct is an Interstate 5 of water, an artery that slices directly down the southwest side of the Valley, regulated not by a 65-miles-per-hour speed limit but by political manuevering, which apparently knows few limits.

Some of this water is eventually pumped 3,400 feet uphill, a feat that climaxes with the world's highest reverse waterfall in the vast pipes leading from the A. D. Edmonds Pumping Plant in the desert hills south of Bakersfield. Pumps at the facility, which is named for the engineer who ramrodded it, thrust water from the southern Cascades and northern Sierra 1,926 feet in a single stage up the Tehachapi Mountains, whence it flows downward into the Southern California megalopolis, a great distance in style and mileage from the Delta.

In this thirsty state, the Delta is seen by many as primarily a source of water for use elsewhere, despite its importance as a recreation area for boaters and fishermen, its significance as an agricultural region in its own right, and its intrinsic natural value. Nonetheless, visions persist of the place as it was before human will was imposed upon it, before its wildlife was so thinned by habitat alteration, before so much of its fresh water was exported. The question of what was gained and what was lost in the process lingers. Harold Gilliam has suggested that if the "Delta were almost anywhere but California—in the Midwest, for example—it would no doubt have been heralded as a major scenic wonder and perhaps would be protected as a national park." Elna Bakker writes: "Before these reclamation efforts, there were many square miles of tule-choked marsh. When the problems were removed so was much of this wetland which, when drained, made an excellent place for crops. Today only a few sloughs and a basin or two still resound to the calls of red-winged blackbirds."

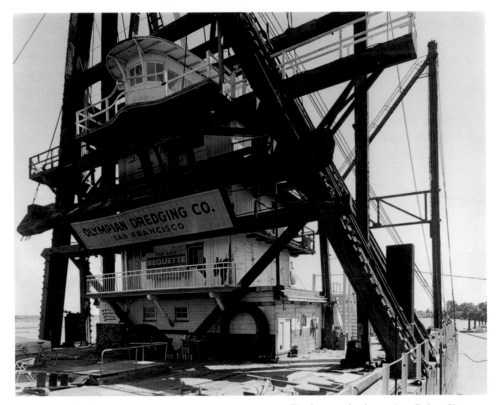

Dredge near Locke, 1985. Robert Dawson.

Reclamation's planning office for California, said to Steven Capps, "We can do without this agriculture. I am not so sure we couldn't get a lot more out of this Delta if we buy the goddam thing and turn it into a recreation area."

But such a plan would clash with political schemes projecting a greater diversion south of Northern California water, which would require the elaborate levee system. In 1985, Governor George Deukmejian proposed sending more water south, and his plan included a program for rebuilding levees. When it comes to juggling water, solutions are rarely simple in thirsty, perhaps insatiable California.

There are still small reserves of relatively untouched Delta—usually places that were not potentially prime farmland or that were too expensive to reclaim—but they arc remote. In them, though, can be found plant communities of amazing complexity, as well as the aquatic domain of worms and snails and minnows, of bass and muskrats and coots: the natural ecosystem revealed. "Energy flow routes, through food webs, are not too difficult to discover in the microcosm of a marsh," points out Elna Bakker. "It is no wonder that a marsh, with all its generosity of food sources, is a community rich in animal residents."

Blackbirds flew over the outskirts of Stockton when William Brewer visited, and they still fly there. The city is California's major inland port, located near the Valley's midsection, where the San Joaquin Plain meets the Delta. It effectively terminates this wet realm's deepest incursion into the prairie, the edge of both regions. Brewer noted in April 1862:

The great plain around Stockton is some forty or fifty miles wide from east to west, and to both north and south stretches to the horizon, literally as level as the sea and seemingly as boundless. In the west and southwest lies the rugged Mount Diablo Range, to the

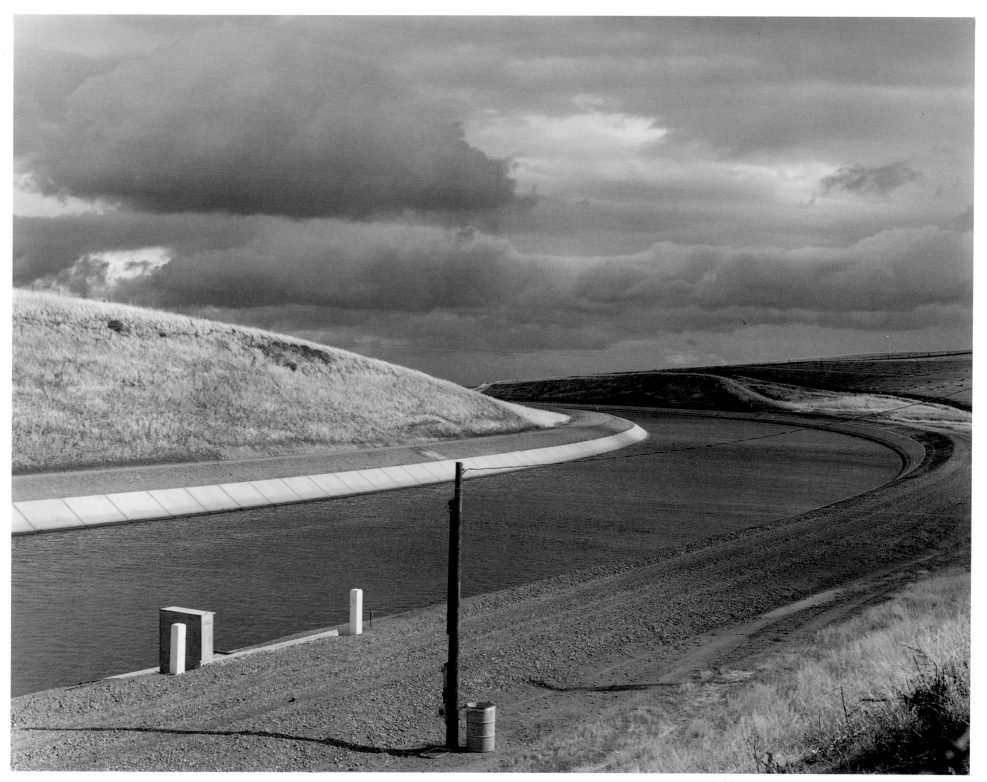

California Aqueduct near Tracy, 1984. Stephen Johnson.

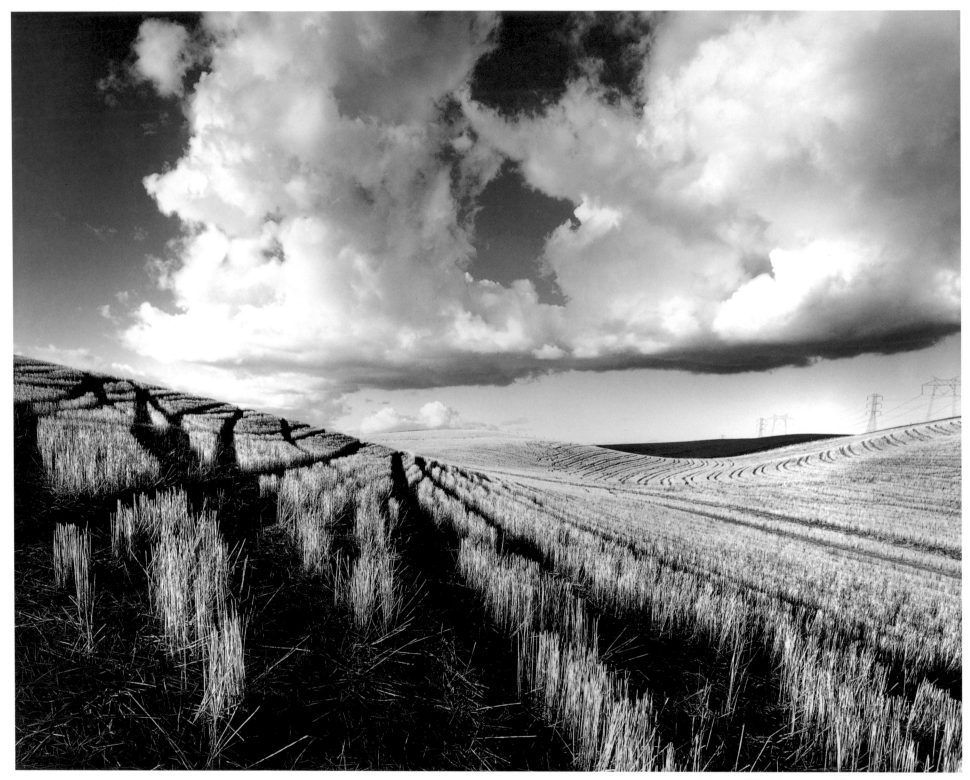

Wheat Stubble, Montezuma Hills, 1984. Robert Dawson.

northwest lie the ranges north of Napa, while along the eastern horizon the snowy "Sierras" (Sierra Nevada) stretch away for a hundred miles, their pure white snows glistening in the clear sun.

Captain Charles M. Weber, who came to California in the same 1841 party that included John Bidwell, is generally credited with having founded Stockton. Originally, the region between the Calaveras and San Joaquin rivers—some hundred square miles, known as Rancho Campo de los Franceses—was granted to William Gulnac, who settled a $60 grocery bill by giving the entire tract to Weber in 1845, a bargain rivaling the purchase of Manhattan Island. However, Weber didn't actually live on the site of Stockton until it became a profitable supply point for miners in 1848. The following year, he surveyed the town and, although the original settlement had been called "Tuleberg" and "Mudville," he named it for his friend Commodore Robert Stockton.

The Gold Rush created an instant city in this, the harbor closest to the Mother Lode diggings. Bayard Taylor described Stockton in 1849 as "a canvas town of a thousand inhabitants, and a port with twenty-five vessels at anchor!…Four months had sufficed to make the place what it was." By 1850, the population had swelled to 5,000, and the bustling city became county seat. In 1862 Brewer, perhaps signaling the birth of an enduring California stereotype, noted of Stockton: "The State Lunatic Asylum is there….There are more insane in this state, by far, in proportion to the whole population, than any other state in the Union."

Today, the Gold Rush boomtown is a burgeoning city, home of University of the Pacific, the state's first chartered institution of higher education (1851). Ethnically diverse "greater Stockton" has over a quarter million inhabitants and most of the urban problems attendant on rapid growth and a fluctuating economy. Seventy-seven nautical miles east of the Golden Gate, it is also one of two major Valley shipping centers—Sacramento is the other—with a deep-water channel extending into the city's center.

That channel is thirty-two feet deep and provides access to the Pacific Ocean; it was completed in 1932, and its turning basin is large enough—thirty-three acres in the heart of the city—for oceangoing vessels to maneuver under their own power. As a result, it can be startling indeed, one of California's wonders, to spy a huge freighter en route to or from Stockton moving through flat farming tracts far inland, appearing to slice the rich peat soil like the world's largest plow, while strawberry pickers, dwarfed by the great ship, stand in the fields and wave at sailors from distant lands.

Since the decline of nearby gold mines, the introduction of irrigation, and the coming of the railroad—all in the 1860s—this has been the Valley's major agricultural shipping point. The Port of Stockton handles millions of tons of grain annually, and huge storage elevators can be seen from downtown streets. Shipping was the key factor in the

Delta Drawbridge, Three Mile Slough, 1985. Stephen Johnson.

city's accelerated growth during World War II, and today an estimated 85% of California's exported grain passes through it. In addition, much of the state's bulk wine exports move through Stockton, which was for years the home port of the *Angelo Petri,* the world's largest bulk wine tanker, capable of carrying 2,500,000 gallons in its stainless steel tanks.

Because so many Valley crops funnel through Stockton, it is also a center for migrants seeking to reap California's rewards. This city is a cusp where Valley and Delta meet, and its streets have long been stalked by people of all colors speaking myriad tongues and seeking not only survival but an eventual escape from poverty's withering grip.

Between 1900 and 1930, for example, many Italian migrants moved into the Valley, often to the two inland ports, then out onto the plain, where their skill and hard work made them prominent agriculturists. And the migration continues, Southeast Asians today join Blacks and Mexicans in sections that have also housed Chinese and Filipinos, Okies and East Indians, Japanese and Greeks, plus a great many hopeful or hopeless others, constantly renewing the bottom of the barrel upon which the agricultural economy depends, and beginning to democratize the barrel's upper reaches too.

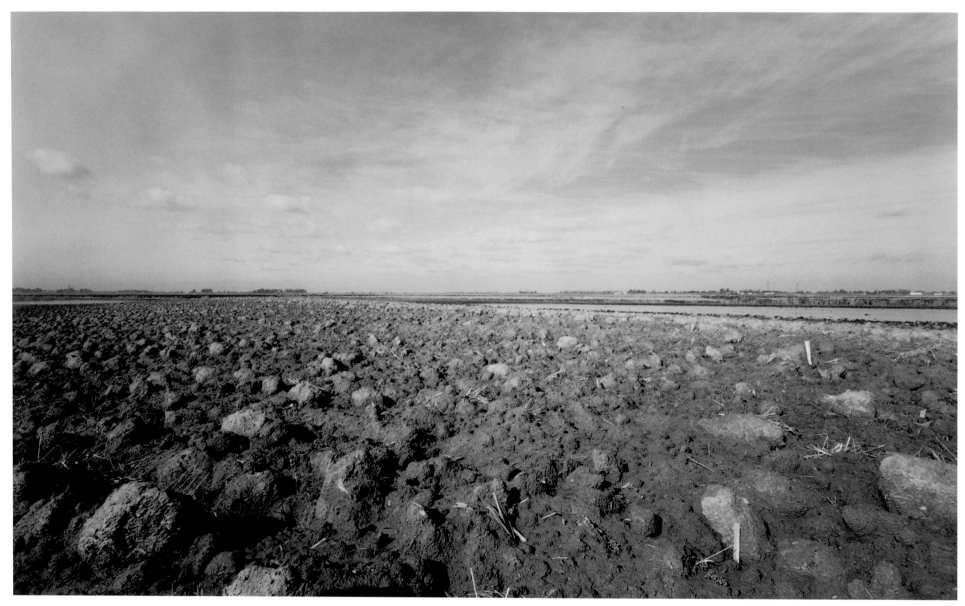

Field near Terminous, 1984. Stephen Johnson.

Brewer's boat steamed not toward Stockton but north toward the Delta's border with the Sacramento Valley. It had veered away from the San Joaquin River's channel at Sherman Island and had entered the Sacramento River, slicing upstream past a town devastated by the previous winter's floods, Rio Vista. Founded in 1857 by Col. N. H. Davis, who built a wharf there, it was first known as Brazos del Rio. The community grew quickly, but in January 1862 inhabitants had to flee to nearby high ground, then watch helplessly as house after house was washed downstream. It was being rebuilt when Brewer passed, higher and farther away from the river than before, on the rolling Montezuma Hills.

In recent years, the Rio Vista area has been renowned for its striped bass fishing, and every October a Bass Derby is held locally. But striped bass have of late been revealing the types and intensities of contemporary environmental pollution, thanks to the work of the marine ecologist Jeannette A. Whipple, who has developed what is called the Striped Bass Health Index. Whipple and her associates are exploring the long-term effects of chronic chemical pollution and the diversion of fresh

water from the Delta. (The State Water Project and the Central Valley Project are reported to draw nearly five million gallons of fresh water *per minute* from the Delta.) In years when heavy rainfall amplifies the flushing action of fresh water, Whipple's studies have shown, striped bass absorb fewer toxins and suffer less egg damage than fish examined in drier years, when more impurities remain in the Delta's water.

In the drought of 1931, for instance, Delta water grew too salty to drink or to use for irrigation, but it did not carry the abundance of pollutants now generated in the Bay Area. Today, more than half of river flows have been diverted, and the diminished current not only limits the Delta's ability to halt penetration by salt water—carrying considerable industrial and urban waste from the Bay Area—but also prevents it from flushing away such local threats as the dregs of agricultural chemicals.

"The chances are very good that petrochemicals are involved [in the decline of bass]," explains Whipple, and they almost certainly are pulled into the region principally by tides flowing upstream through the Carquinez Strait—where large petroleum refineries are located—now that the all-important freshwater barrier provided by streams has been so diminished.

The other obvious source of pollution is the chemical-intensive farming in the Valley itself, where residue from irrigation increasingly contains trace toxins. Some chemicals seep through the soil, tainting groundwater, while the rest make their way via ditches and canals to the rivers, then to the Delta, to the Bay, to the sea. This is a cumulative, potentially devastating problem since, as a state assembly investigative report points out, billions of pounds of insecticides, weed killers, and fungicides have been applied to Valley fields.

Whipple's work also reveals that fish caught in the San Joaquin River above Antioch and in the Sacramento above Clarksburg contained selenium and polychlorinated biphenyls (PCBs). Moreover, the banned pesticides DDT and chlordane were found in fish from both rivers in 1984, albeit in lower concentrations than in 1981. Trace metals such as zinc, chromium, and mercury were also found at lower levels, but cadmium levels had increased. In fact, the California Department of Fish and Game warns fishermen to eat no more than one meal of striped bass per week, and advises that children and pregnant women should not eat stripers at all. The diminished run of stripers may have become California's version of the miners' canary, and the Delta's dilemmas cannot be dismissed as merely local, for this region is a major component in a wide, delicate ecological web. As John Beuttle of United Anglers points out, "When you export 50 to 60% of the water, you export the food chain along with it."

Just north of Rio Vista is the entrance of Steamboat Slough, where, in 1986, a wayward whale nicknamed Humphrey captured the public's imagination. Only three miles upriver lies Isleton, founded in 1874 and

now known as "the Asparagus Center of the World." Many Filipino-American workers travel from Stockton to work these fields, which produce nearly half of America's asparagus crop. Seven miles farther upstream, on Grand Island, largest of the Delta "islands," is Ryde, a town surrounded by the levees that restrain Steamboat Slough on one side and by the mighty Sacramento on the other. Grand Island's fields are irrigated by raising floodgates in the levees.

The Sacramento's channel veers east, then north; at the point of that turn sit Walnut Grove and Locke, virtually twin communities. The former is the only town below Red Bluff to occupy both banks of the river; all the rest are located on one side or the other, as is Locke, sitting on the eastern bank. These towns illustrate the interesting local "levee architecture": two-story frame buildings, with the top floor facing the river and the road atop the levee, while the lower floor faces away from the stream on a ground-level street behind and below the dike. Some of these buildings once housed shops facing both roadways; others contained a business on one level, a home on the other.

Although much of the Central Valley has benefited from the presence of Asian American immigrants, these two towns in the heart of the Delta particularly exemplify the importance of Asian settlers and settle-

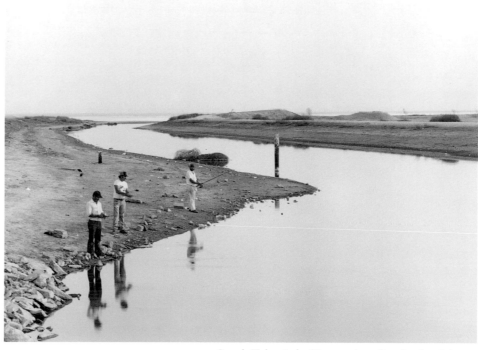

Canal, Tulare Lake (Remnant), 1985. Stephen Johnson.

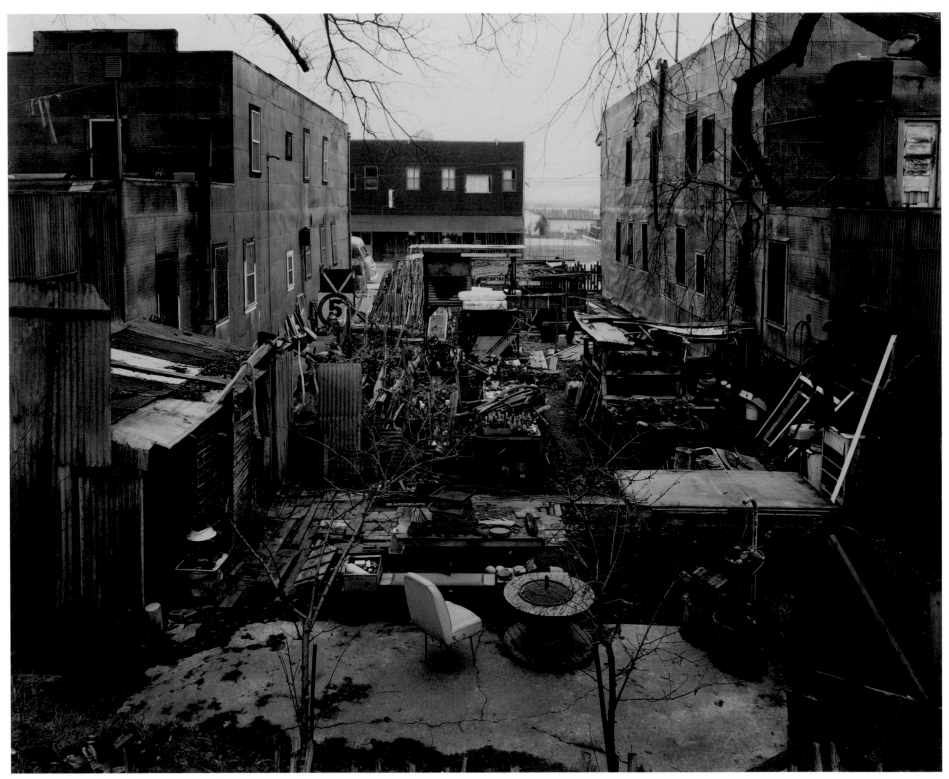

Back Lot, Isleton, 1986. Robert Dawson.

ments. Walnut Grove, which gained some fame as a result of Joan Didion's mention of the local Bank of Alex Brown in one of her widely read essays, long featured a prominent Chinatown, but after a fire in 1915 wiped it out, the Chinese community relocated a mile up the levee on property belonging to George Locke. Japanese immigrants, in turn, reconstructed Walnut Grove and settled there.

Locke became the Valley's—and the nation's—only Chinese-built, Chinese-inhabited town. Richard Dillon explains:

> Lee Bing leased land from the estate of George Locke, who had arrived on the Sacramento in 1852. The oral agreement was "notarized" with the customary Delta handshake. Lee, backed by the Yeung Wong tong, built six two-story, $1,200 houses. In its prime, Locke boasted a hotel, bakery, barbershop, candy store, saloons, rooming houses, a flour mill, a slaughterhouse, gambling dens, and a Chinese-language school for kids to attend after public school. The peak permanent population may have been four hundred, the seasonal high fifteen thousand.

During harvest seasons until the 1950s, Locke's levee road was crowded with workers, tones of Cantonese and Tagalog and Spanish carrying far across the river as tired laborers wandered from saloons to gambling halls, from restaurants to bordellos, for it, like many other Delta communities then, was at least temporarily a tough, wide-open town. Today the quiet community, with about fifty residents, is a state historical park; as Sucheng Chan has written, "Locke is the most visible monument to the extraordinary efforts made by the Chinese to develop agriculture in California and establish communities in rural America."

Chinese immigrants originally entered the Valley in significant numbers during the 1850s, a decade during which they became the largest foreign-born group in the state. By 1860, one Californian in ten—35,000 according to the census—had been born in China. In the Delta, Chinese settlers arrived in numbers somewhat later. A population study by John Thompson reveals that Georgiana and Merritt townships had only 2 Chinese residents in 1860; their numbers rose dramatically to 635 by 1870, and increased to 933 by 1880. The latter figure represented 42% of those two townships' combined population that year, far outstripping the next largest immigrant group, Azorean Portuguese, who constituted 7% of the population in 1880.

Nonetheless, Azoreans were soon able to become a force locally because they could both legally own land and establish families—two rights that Asians were statutorily denied. The Chinese, virtually all males, hoped to return to their homeland to establish families, and their perceived clannishness militated against them almost as much as their "exotic" appearances—rationalization for racism. In general, they—along with the Portuguese and Irish during those

early years—constituted a vast labor pool, and many early migrants from China originally worked in the mines. Later in the decade, as many as 10,000 helped build the region's railroads. By the mid 1880s, half of the Valley's farmworkers were Chinese, and in 1886 the first of a series of discriminatory legal statutes, the Chinese Exclusion Act, was passed.

Dependent upon seasonal laborers even at that early date, Valley farmers had found the Chinese nearly perfect workers, since they not only performed well but also worked for less pay than others. It is not surprising that the Chinese were looked upon as a godsend by many Valley growers. The fact that they accepted lower pay, however, contributed to a campaign to drive them from the fields, and in 1885 widespread anti-Chinese riots erupted, riots that not uncommonly involved their erstwhile fellow laborers, the Irish.

What can fairly be called pogroms were mounted against Chinese in Chico, Redding, Red Bluff, Anderson, Merced, Yuba City, Wheatland, Dixon, and Sacramento. Many survivors retreated to urban areas, where a concentrated population offered safety, and they began exploring other means of making a living. Their places in the fields were taken principally by Japanese emigrants, but also by white workers—

General Store, Walnut Grove, 1985. Robert Dawson.

CHAPTER VIII.

CHINESE LABOR.

It is difficult to overrate the effect and influence of the Chinese upon the industrial condition of our State. At a rough estimate we have about one hundred and four thousand of them here at present. Eighty per cent of that number directly competing with white labor, and the remaining twenty per cent engaged in trading with China and the Chinese, supplying the wants and requirements of the latter, whether of clothing, food, or anything else, almost entirely with Chinese products. It is at this place that I desire to make a suggestion. Why may not Congress be asked to lay heavy import duties upon such Chinese goods as are used by Chinese only? If it is a bad thing for the country that our money should be drawn away to a foreign country without a commercial return, as is done by the Chinese, then a heavy protective tariff on those goods would be just the thing. It would keep at least a portion of that money here. As will be seen by the accompanying table but twenty-five per cent of the food used by the Chinese is of Californian production, the other seventy-five per cent coming from China. In like manner these aliens bring eighty per cent of their clothing from the Flowery Kingdom; and as for drugs, and the other thousand and one things used by Chinese, all these things come from their native land.

Again, a protective tariff of the kind I have referred to would affect the American laborer most beneficially. It would raise the Chinaman's cost of living, thereby causing an increase of his pay, and in that manner the difference between the Mongolian's and the white man's wage would be lessened, and the latter would be the better able to compete with him. In my humble opinion, the matter is worthy of your legislative consideration.

It is not good policy for this State to cease agitating the Chinese question, although popular expression on the subject has recently become less pronounced. The Restriction Act gives us little more than a breathing spell and an opportunity, and unless that opportunity is made use of, ten years hence the portals will open once more to the myriad sons of the Celestial Empire. The State should act vigorously and to the full extent of its power. It is only by deep reflection that the influence of this evil, as it now exists and has existed for years past, can be fully comprehended. Nobody who does not actively and intimately mingle with the industrial classes can judge rightly of the influence for evil of one hundred and four thousand heathen workers, crowding out a like number of heads of families, upon the industrial and political economy of the commonwealth. Their presence keeps away half a million people directly, and another half a million indirectly; it leaves our daughters without husbands and our boys with diminished chances to earn a livelihood; it reduces the wage earning power of all, and, as experience has shown, inflicts irreparable damages even upon those who once encouraged and lived by Chinese labor. Whatever may have been the case heretofore, there is now no longer a necessity for coolie labor in this State, from the wealth of which they take annually about $28,000,000 to send into that sink of all wealth, the Chinese Empire. So much has been written upon the subject of the Chinese, that I feel I may safely leave it with these few remarks. The popular mind on the subject is fully made up, and nothing that I could add would increase the conviction that the Chinese are an unmitigated evil in and to California.

–John S. Enos, Commissioner of Labor Statistics.
First Biennial Report of the Bureau of Labor Statistics of California, 1883–84,
pages 166–167.

Anti-Asian Legislation

1852 **Foreign Miners Tax** applied to Chinese (California Legislature)

1854 Prohibition of Negroes and Indians from testifying in court either for or against whites made applicable to Chinese (California Supreme Court)

1860 "Mongolians, Indians, and Negroes" barred from California public schools (California Legislature)

1872 Chinese barred from owning real estate or securing business licenses (California Legislature)

1879 Chinese excluded from employment with corporations, and with state, county, municipal, or public works projects (California Constitution)

1882 Congress passes **Chinese Exclusion Act**, barring Chinese laborers from immigrating for ten years. Chinese officials, teachers, students, merchants, and travellers exempted. Naturalization forbidden to all Chinese.

1888 **The Scott Act** invalidates Chinese reentry visas, stranding over 20,000 U.S. workers overseas

1892 **Chinese Exclusion Act** extended for ten years. Chinese laborers already in the United States required to carry certificates of residence.

1904 **Chinese Exclusion Act** extended indefinitely, and expanded to cover Hawaii and the Philippines

1906 Anti-miscegenation law extended to Chinese (California Legislature)

1913 **Alien Land Act,** prohibiting persons ineligible for citizenship from owning land (California Legislature). Declared unconstitutional in 1952.

1920 **The Alien Land Act of 1920** was passed wherein California tried to seal the loopholes in the 1913 Alien Land Law by forbidding the Japanese Issei to buy land in the name of their American-born children, the Nisei.

1922 **Immigration Act** excluded "Chinese women, wives, and prostitutes" from coming to the United States. It also provided that any woman citizen who marries an alien ineligible for citizenship (e.g., Chinese) shall cease to be a citizen of the United States. This act *limited* all immigration to the United States, but *denied* all immigration from Japan.

1942 **Executive Order No. 9066,** Authorizing the Secretary of War to Prescribe Military Areas, signed by Franklin D. Roosevelt....

(3) California. The Japanese population in California aggregates approximately 93,500 people....They live in great numbers along the coastal strip, in and around San Francisco and the Bay Area, the Salinas Valley, Los Angeles and San Diego....Inland they are disposed in the Sacramento, San Joaquin and Imperial Valleys. They are engaged in the production of approximately 38% of the vegetable produce of California. Many of them are engaged in the distribution of such produce in and along the waterfronts at San Francisco and Los Angeles.

Recommendations: 1. That areas in Washington, Oregon and California be designated military areas; 2. that Japanese aliens, Japanese-American citizens, and alien enemies other than Japanese aliens be excluded from these areas; and 3. that the evacuation of these people "be initiated on a designated evacuation day and carried to completion as rapidly as practicable.

–Jeff Gillenkirk and James Motlow, *Bitter Melon,* 1987.
Masako Herman, *The Japanese in America, 1843-1973,* 1974.

bindle stiffs and hoboes, as they were called—driven to farm work by a depressed economy.

But it was legislative pogroms that most hurt the Chinese. The Geary Act of 1892 not only excluded immigration from China, for example, but also denied bail to resident Chinese and required that they produce certificates of residence or face deportation. "The effect of the Geary Act," explains Carey McWilliams, "was to drive many Chinese from California and to terrify those who remained." Finally, they were denied the right to become citizens and to own land.

Such events contributed to the creation of Chinatowns and a society composed of sojourners, lonely men trapped in a nation that utilized but did not truly accept them. Owing to exclusion laws, it was not until the 1930s that enough women reached the United States from China to allow the general development of families with a second generation.

A member of that generation, Stockton-native Maxine Hong Kingston, has become one of America's most innovative literary voices, and her books so far have dealt exclusively with Chinese America. "I grew up in a big nest. There were always people around, including a lot of old men who didn't have families of their own," she says. Her books reveal not only the complexity of her own family's social setting, but also the great gap between the two cultures that shaped her. When, in *The Woman Warrior* (1975), her mother suspects that a white druggist has placed a curse on the family, Maxine is sent to the drugstore with these orders:

> *"You get reparation candy," she said. "You say, 'You have tainted my house with sick medicine and must remove the curse with sweetness.' He'll understand."*
>
> *"He didn't do it on purpose. And no, he won't, Mother. They don't understand stuff like that. I won't be able to say it right. He'll call us beggars."*

The young girl—American and Chinese—was the locus of clashing cultures. Certainly, no other major group of immigrants have been so forced to remain strangers in what was not a strange land, a land that they had substantially helped to build.

The Sacramento–San Joaquin Delta in particular is theirs, since most of the initial reclamation in this realm, the elaborate system of pumping plants, drainage canals, and the ever-present levees, was constructed by Chinese laborers. Toiling with little more than shovels and wheelbarrows, those pioneers constructed the first dikes, helping to create this place as it is now, but, until recently, that has rarely been acknowledged. Phenomena such as school segregation in the Delta following World War I reveal how effective the insidious "Yellow Peril" campaign actually was. "Japanese, Chinese, and Filipino children attended a grammar school for Asians while…blacks and Mexicans were sent to

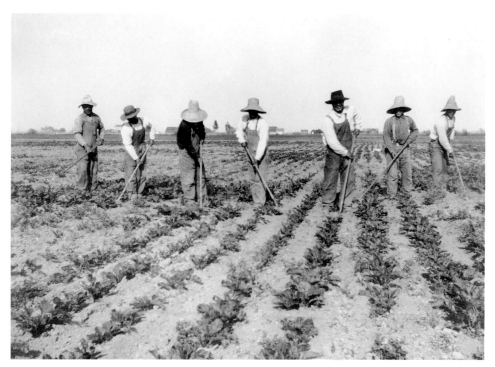

Chinese Farmworkers, circa 1925. Bancroft Library.

the white school," writes Dillon. After World War II, Delta schools were integrated over the objections of some old-timers.

Japanese arrived a generation later, in the mid 1880s, and at first replaced the Chinese, with whom they soon came to be identified in anti-Asian campaigns. Most of the new arrivals came from Hawaii, then from the Hiroshima area of Japan. They were more likely than Chinese migrants to consider America their new home, and they established families as soon as possible. Isleton and Walnut Grove accommodated communities of both Chinese and Japanese settlers, and for a time they mingled in existing "Chinatowns." The "Japantown" that developed in Isleton was locally famous; like Walnut Grove's, it included a bathhouse and hosted an annual festival. "The immigrants from Nippon could not own land after 1913," Dillon points out, "but Alex Brown…leased land [in Walnut Grove] to the Issei [first-generation Japanese Americans] in an agreement secured by only a handshake."

Excluded from many urban jobs by trade unions, Japanese immigrants for a time became indispensable cogs in seasonal agricultural labor throughout the entire Valley. But they were not content to remain migrant laborers. "Quite gradually…they began to leave farm employment…for tenant farming," Carey McWilliams explains. The next stage was the acquisition of their own farms, often as renters,

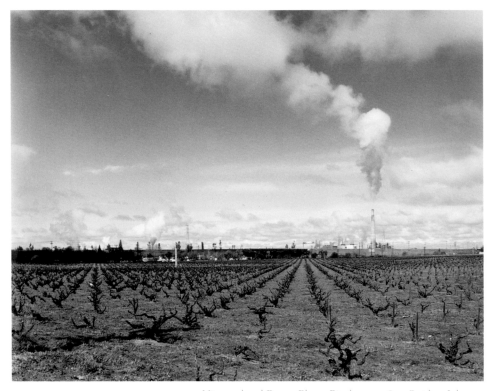

Vineyard and Power Plant, Pittsburg, 1984. Stephen Johnson.

then as owners. Between 1910 and 1920, acreage owned by Japanese immigrants doubled, and the *San Francisco Chronicle* observed: "The most striking feature of Japanese farming in California has been the development of successful orchards, vineyards, or gardens on land that was either completely out of use or employed for far less profitable enterprises."

The very success of Japanese Americans seems to have fueled racism. As Joseph McGowan has written, "One of the persistent themes in the history of the Sacramento Valley and the state as a whole has been nativism, a philosophy or attitude which held that Anglo-Saxons were entitled to the first fruits of the land and other groups should be content with the left-overs."

Unlike Americans of German and Italian ancestry, Japanese Americans were highly visible to their predominantly white neighbors, and following the bombing of Pearl Harbor, they became overt targets. Matters culminated with Executive Order 9066, which forced Japanese Americans and Japanese nationals alike into concentration camps during World War II, altering the Valley's social and economic balance. Forced to liquidate assets within only seven days before internment, many Americans of Japanese extraction suffered severe financial set-

backs, and there was no shortage of white "patriots" who also happened to be opportunists. Over half the farms owned by Japanese Americans in Sacramento County, for example, were sold cheaply or otherwise lost by their owners during that chaotic week.

A candid complaint that appeared in the *Sacramento Bee* on January 20, 1942, reveals a good deal about the economic roots of much bigotry in the Valley: "They [Japanese Americans] are monopolizing the agricultural industry and are forcing other people off the land, including whites from pioneer families." McGowan puts this sad American epic into perspective:

> *This story of the Japanese evacuation of 1942 may seem to be an unnecessary one to many, but there are few who lived through that year in the valley who were not deeply affected by these events. In a sense this story was only another chapter in the history of nativism, comparable perhaps to the fate of the Indians in 1850 and 1860, or the Chinese in 1876–79 and 1886.*

Those internment camps were the zenith of anti-Asian sentiment, a final bitter harvest of the "Yellow Peril" campaign. Small Delta towns were not immune to racism, and tension was great indeed; some Issei and Nisei (second-generation Japanese Americans) did not return. But this is not entirely a tale of dishonor, since many other Valley residents did everything they could to aid their neighbors of Japanese extraction, cared for their property, and were there to welcome them home when they were finally released. In Walnut Grove, for instance, the redoubtable Alex Brown's family honored its commitments to Japanese American neighbors, taking care of their property until they returned.

B rewer's steamer continued past the sites of Isleton, Walnut Grove, and Locke, past Courtland, Clarksburg, and Hood—the route followed today by State Route 160. The latter three communities are shipping points for fruit growers, truck farmers, and agriculturists generally. Although it has been nearly half a century since steamers such as the one in which Brewer traveled have been a major factor in local transportation, these towns retain their riverfront atmosphere and each reflects a distinct, interesting history.

Courtland, for example, founded in 1867, was a port for steamers and the home of Dwight Hollister, a Gold Rush hopeful who became a pear grower, an important local pioneer, and an early spokesman for horticulture in the Delta. Clarksburg, sitting on Merritt Island, west of the river, boasts a large Portuguese American community. It, too, was named for a forty-niner, Judge Robert Clark. Once a steamer port, in the 1920s it became a "model town"; writes Dillon, "1,500 acres were sold in eighty units for $4,125,000. The buyers were screened, not only for agricultural ability but also for civic responsibility."

Courtland, 1985. Robert Dawson.

Nearby Hood was a stop for the Sacramento Southern Railroad, and was named for William Hood, construction engineer for that company. It was also the place where the late and little lamented Peripheral Canal—a major political issue of 1982 that still hovers just out of sight— would have diverted up to 70% of the Sacramento River's water toward the insatiable and inefficiently irrigated fields of Tulare and Kern counties and, ostensibly, to Southern California (which in fact then had little need for more water, except as a lure to attract increased population so that, in turn, still greater demands for water might later be initiated—a scheme that is California's political version of the perpetual-motion machine).

Voters rejected the entire proposal in 1982, but it continues to appear in various incarnations—most recently in the State Water Resources Control Board's 1991 "Delta Plan"—illustrating as clearly as any recent issue not only continued ignorance of the complexity of ecosystems but also politicians' disregard for long-term environmental conse-

quences. William Kier, a fisheries biologist, asserts that the Delta is already receiving 1.5 million acre-feet less than it needs because of existing water diversion.

Many politicians refuse to recognize that Delta water is not an infinite resource, or that the convenience of a bloated population on the Southern California desert or an unnatural agriculture in the Tulare Basin is not sacrosanct. As Craig Denisoff, a legislative consultant to the Senate's Joint Committee on Fisheries and Aquaculture, explains, "there just is not enough water in the system to satisfy the agricultural industry, increasing Northern and Southern California populations, as well as the stream flows necessary to meet ecological needs."

As Harold Gilliam points out, "the [San Francisco] Bay and the Delta together are a single estuarine ecosystem, providing a gradual fresh-to-salt water transition that has historically supported a rich community of life." To divert much more Sacramento River water would allow the destruction of the natural environment, not only of the Delta, but of already-ailing San Francisco Bay, a high price indeed to pay for flood irrigation in the Tulare Basin and lush lawns in Los Angeles.

All those Delta communities—the Isletons and Hoods and Walnut Groves, as well as the ghost towns—were places where on Saturday nights men brown or white or black drank hard, paid sweat money for the services of retreaded prostitutes with eyes like nickels—the ubiquitous "Big Blondies"—who could cause knives to flash and blood to flow, then be gone with the money their attentions demanded. They were places of heroes and victims like the rest of the Valley, never quite as genteel as its moneyed residents asserted because they were built on the jobs farmers provided, on the sweat that Big Blondie exploited, and on her sweat too.

Today, all Sacramento River towns are closer to the state's capital city than they were a century ago, but not because of land subsidence or Valley wind or Delta floods. No, they are nearer because Sacramento is spreading in all directions like pancake batter on a cold griddle, its suburbs extending toward and into the Delta it once bordered.

Fruit Box Label. California State Library.

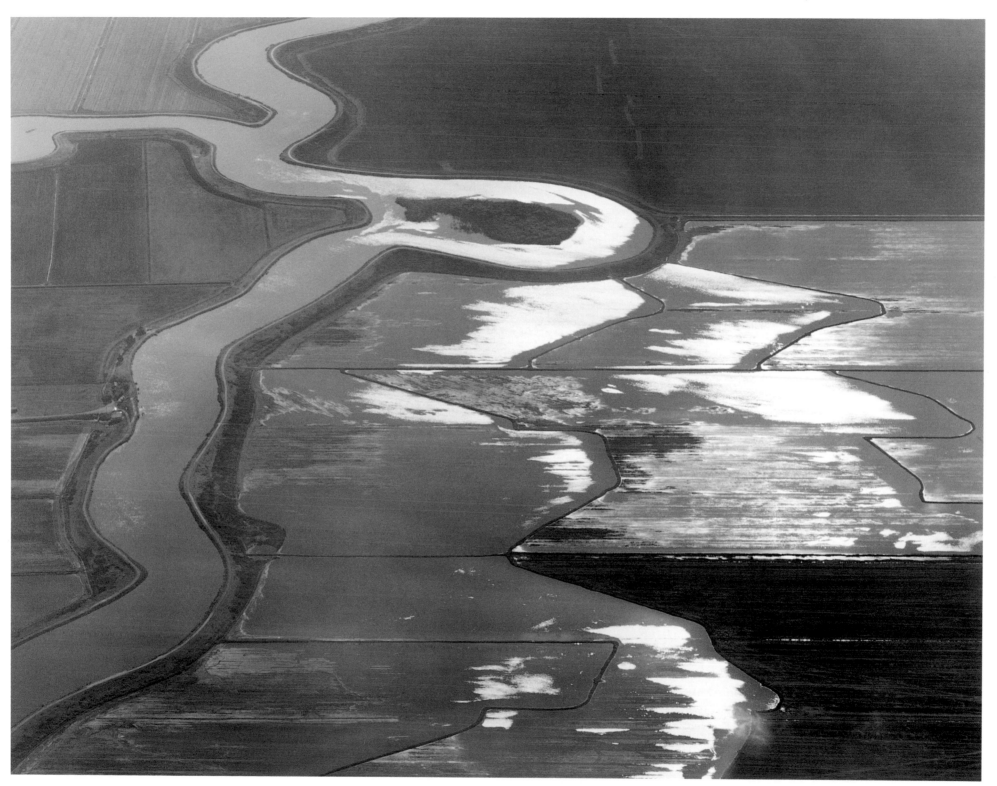

Aerial, San Joaquin Delta, 1985. Stephen Johnson.

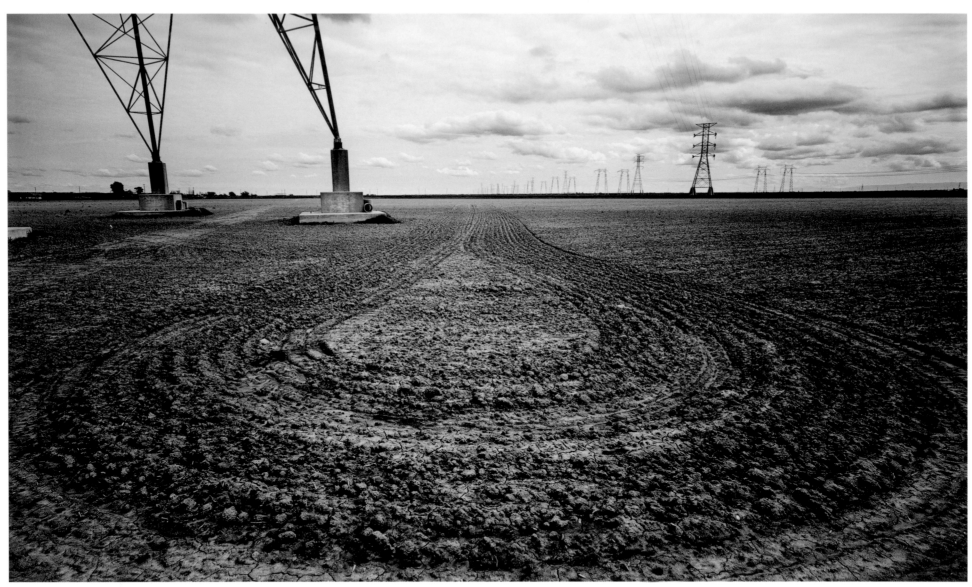

Plow Patterns and Power Poles, Sherman Island, 1982. Robert Dawson.

Three Mile Slough Bridge near Rio Vista, 1986. Robert Dawson.

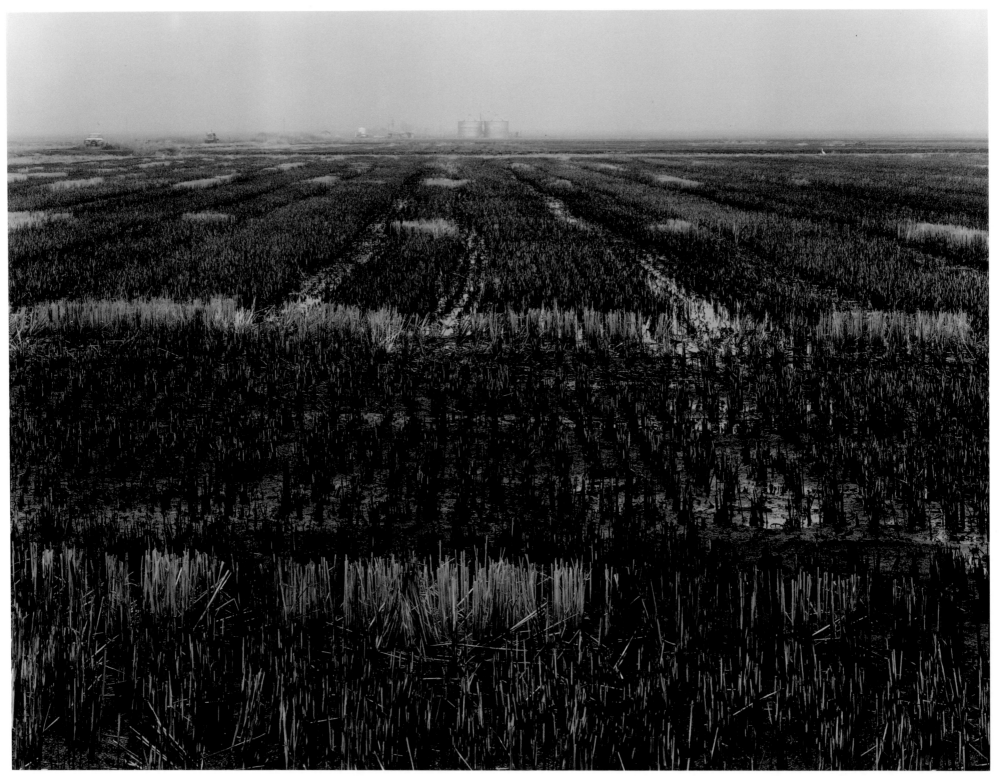

Rice Stubble, Sacramento Valley, 1985. Robert Dawson

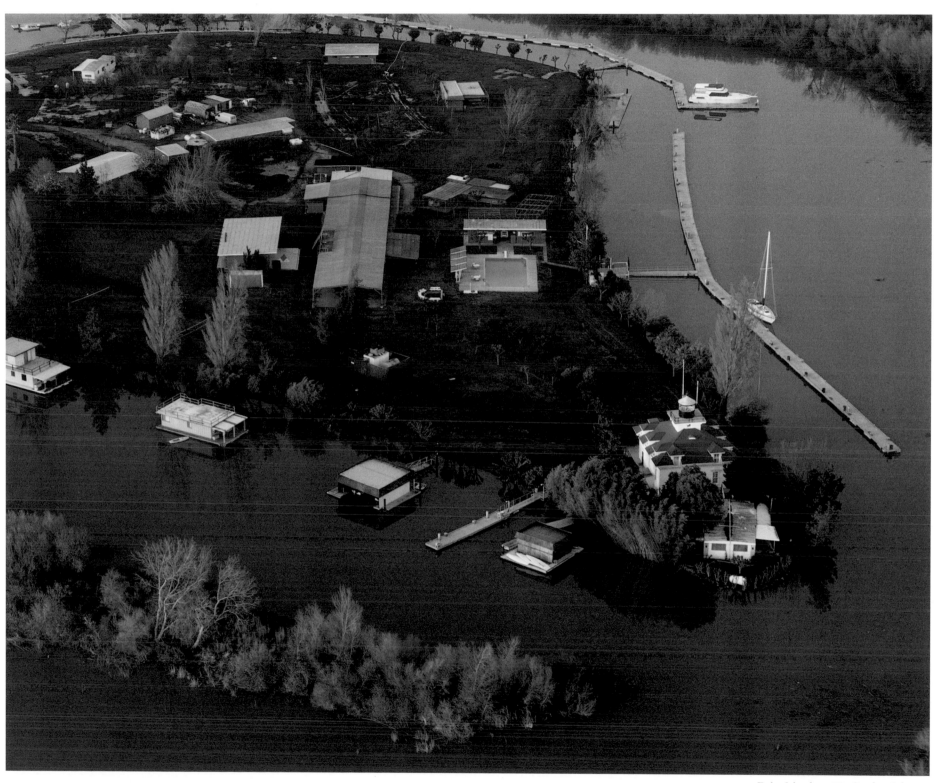

Delta Island, 1986. Stephen Johnson.

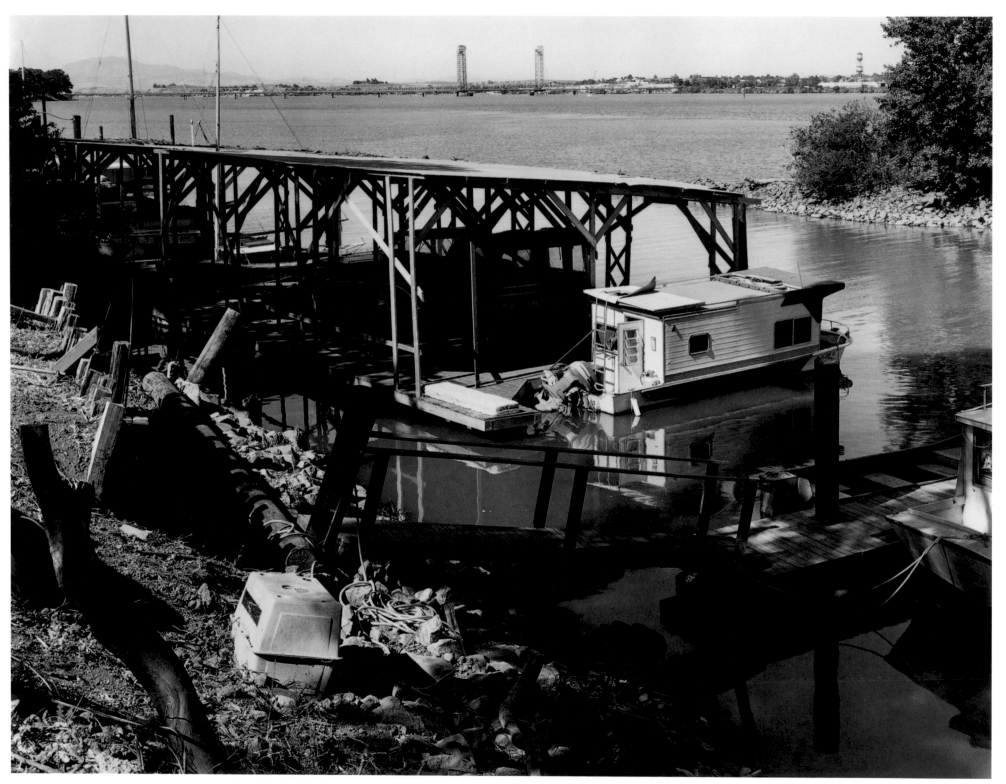

Houseboats, Sacramento River near Rio Vista, 1984. Robert Dawson.

Riparian Woods, Sacramento River, 1984. Stephen Johnson.

Walnut Orchard near Bear River, Yuba County, 1984. Stephen Johnson.

Chapter IV: The Sacramento Valley

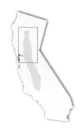

The great central valley of the state is under water.... Although much of it is not cultivated, yet a part of it is the garden of the state. Thousands of farms are entirely under water.

William H. Brewer, January 19, 1862

The winter of 1861–62 was exceptionally wet, and Sacramento was engulfed in a gigantic puddle. Towns in the Delta and on the prairie were also soaked: Rio Vista had washed away, and Stockton's streets were navigated by boats. Far to the south, Tulare Lake had swollen to its maximum recorded size—nearly a half million acres. In fact, much of the Valley was inundated, creating a long, shallow sea.

Brewer and company were in San Francisco on January 19 when he recorded, "The rains continue and since I last wrote the floods have been far worse than before." The young men wanted to chart the Sacramento Valley—that vast vale of nearly seven thousand square miles extending from the Delta toward Mount Shasta. At its far end, some two hundred miles north of the Bay Area, the valley of the Sacramento River narrowed from over fifty miles to less than ten, pinched closed by the Trinity Alps to the west, the Cascades to the north and east.

The river itself was and remains the north Valley's most singular element. It rises in the distant Klamath Range near the Oregon border and runs nearly four hundred miles to the Delta and San Francisco Bay. It also drains almost thirty thousand square miles, providing nearly one-third of the state's annual runoff. That runoff and annual spring flooding carried soil and helped create riparian forests, an exceptionally rich ecosystem on the river's banks; a junglelike wall of riverine vegetation astonished Brewer when he traveled upstream by steamer.

The young scientist also marveled at the Sacramento River's extraordinary salmon runs. Even today, points out Ethan Brown of the Nature Conservancy, "Seven of every 10 salmon caught on the California coast are spawned in the upper Sacramento and its tributaries." But that is deceptive, because far, far fewer are caught nowadays. In fact, if salmon are seen as indicators of the river system's health, then it is sick indeed; only two feeder streams, Mill Creek and Deer Creek, now sustain its remaining pure populations of wild, spring-run chinook salmon, a decrease unimaginable in Brewer's time.

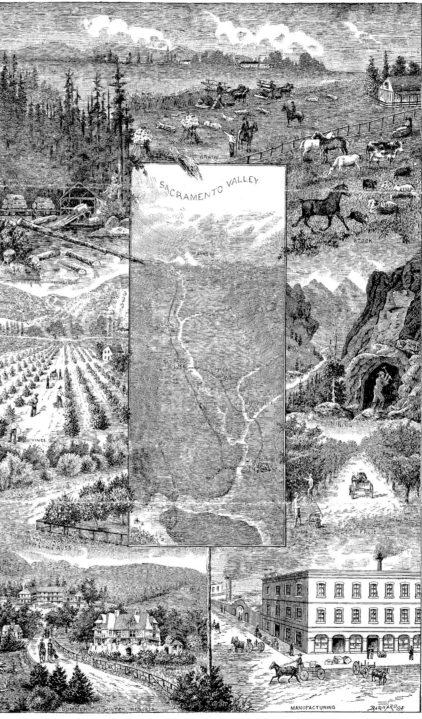

Sacramento Valley Engraving, circa 1905. California State Library.

Sacramento Flood, 1862-63. California State Library.

The river was broader than ever in recorded history in 1862, extending miles onto the surrounding prairie. The flood that year is said to have initiated local dwellers' preoccupation with bringing streams under control, a preoccupation that endures. Although they could not know it, Brewer and his companions were traveling into the Valley during a period that also marks the beginning of the region's shift from pastoral empire—cattle and sheep—to agricultural domain. The deluge that stranded the survey party in San Francisco was one important reason for that change, countless head of livestock being drowned at a time when farming was already encroaching on the open range. Flooding had been made worse because so many rivers had been shallowed by silt and debris from hydraulic mining upstream. That, in turn, forced a great volume of water out of streambeds onto the surrounding prairie.

The flood was followed by a long and devastating drought. Together, those disasters killed hundreds of thousands of cattle and ranching received a jolt from which it never fully recovered. But the Sacramento Valley was already on its way to becoming a farm region when Brewer and his party sought to map it.

As early as the 1830s, according to Joseph McGowan, it had been "so well explored...that it was no longer an unknown land." By 1843 it was already a mixture of the wild and the domestic; John Bidwell found it roamed by antelope, by elk, and by vast numbers of Spanish cattle. The latter, in particular, were preyed upon by grizzly bears. Bidwell once saw sixteen grizzlies in a single group, and he said they were common in riverine forests. It was not unusual to sight thirty or forty in a day, he reported.

The fact that Bidwell was there at all, however, augured the coming demise not only of elk, antelope, and grizzlies but of Hispanic control too. In 1846 the Mexican governor of California declared:

We find ourselves suddenly threatened by hordes of Yankee emigrants, who have already begun to flock into our country and whose progress we cannot arrest. Already have wagons of that perfidious people scaled the almost inaccessible summits of the Sierra Nevada, crossed the entire continent, and penetrated the fruitful valley of the Sacramento....What are we to do?

They were able to do very little, as it turned out, but early American settlers did not feel entirely comfortable in the regions of California where Mexican authority held sway, so most remained away from the coast; the Sacramento Valley was a haven for them.

The northern Valley had, as a result, been largely explored, but it had not been entirely settled, because "Indian troubles" persisted. Such problems little concerned the Geological Survey Party that winter, however, for the young men remained stranded in San Francisco, trying to outwait the deluge—nearly thirty-three inches in two-and-a-half months, and still the rain fell. "All the roads in the middle of the state are impassable, so all mails are cut off....The telegraph also does not work," Brewer noted on January 31. The flood's magnitude astonished him. In the region they hoped to visit, the tops of some telegraph poles were under water. On February 9, he wrote:

An old acquaintance, a *buccaro*, came down from a ranch that was overflowed. The floor of their one-story house was *six weeks under water* before the house went to pieces. The "lake" was at that point sixty miles wide, from the mountains on one side to the hills on the other. This was the Sacramento Valley. *Steamers* ran back over the ranches fourteen miles from the river, carrying stock, etc., to the hills.

In March, travel on the Valley's floor remained impossible. There were two principal winter roads in those days, one along high ground on the west side, the other near the foothills to the east, because during the rainy season the region's central prairie was characteristically impassable. Finally, on March 6, Brewer left the Bay Area by steamer for Sacramento. He had visited the city the previous fall when it was dry, and he was not prepared for the sodden scene that greeted him: "Most of the city is still under water, and has been for three months."

The people of Sacramento had been astounded when their city was inundated, for they had long recognized the threat posed by the silt-shallowed rivers and had both raised and strengthened the levees surrounding the state capital. Ironically, when the American River breached an eastern dike and swept into the town on December 9, 1861, those same barriers became the sides of a churning pond of trapped water, a torrent that rose with astounding speed. As Alice Madely Matthews,

a local pioneer, recounts, "within an hour the parts of the city visible above the raging flood were the levees along the Sacramento and the high ground along Poverty Ridge and I Street." It became necessary to blast a hole in another section of the dike system in order to drain American River water from town into the Sacramento River to the west. The torrent rushing through the man-made hole is reported to have carried a number of houses with it as it poured into the lower channel. Eventually, the water receded, but that was just the beginning.

The rains persisted, and rivers continued to rise; as a result, the town was never able to dry out that season. Nonetheless, Matthews reports, life went on in soggy Sacramento:

Merchants raised their goods onto high platforms. Stock owners drove their cattle to the high ground....The large two story houses were open to the neighborhood, and the women and children were moved to the upper stories while the men did the cooking, walking raised planks from the stairways to the kitchen ranges which had been set up on bricks to keep the water out of the fire boxes.

Just when it seemed that the city had survived its wettest winter, the China Slough levee collapsed on January 22, 1862, and the events of the previous December 9 were replayed. This time the state legislature bailed out, relocating in San Francisco, while streets were filled with a

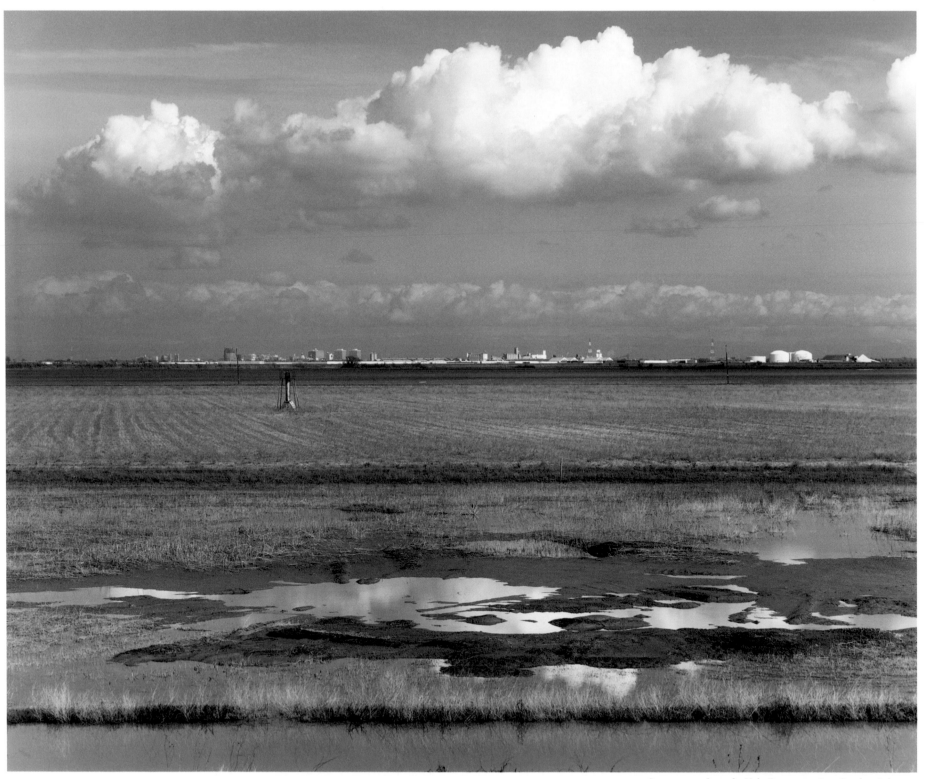

Sacramento from the Yolo Bypass, 1984. Stephen Johnson.

variety of boats, leading some local wits to compare the town with Venice. Little wonder, then, that Brewer and company retreated from Sacramento and did not return until the following August, when they once more traveled by steamer.

Today Sacramento, that erstwhile soaked city, borders the Delta, but well beyond the tidewaters that are still factors in that area's life. The future state capital mushroomed during the Gold Rush at the juncture of the American and Sacramento rivers after John Sutter built his fort here. Its heart is a tree-shaded, nineteenth-century town with a gilt-domed capitol building at its core. But it is also a modern city, spined by downtown redevelopment and surrounded by housing tracts spreading in all directions.

Nonetheless, it retains a certain sense of the past. As Joan Didion, a native, has written:

> I said that Sacramento was the least typical of the Valley towns, and it is—but only because it is bigger and more diverse, only because it has had the rivers and the legislature; its true character remains the Valley character, its virtues the Valley virtues, its sadness the Valley sadness. It is just as hot in the summertime, so hot that the air shimmers and the grass bleaches white and the blinds stay drawn all day, so hot that August comes on not like a month but an affliction; it is just as flat, so flat that a ranch of my family's with a slight rise on it, perhaps a foot, was known for the hundred-some years which preceded this year as "the hill ranch." (It is known this year as a subdivision in the making, but that is another part of the story.) Above all, in spite of its infusion from outside, Sacramento retains the Valley insularity.

Valley communities are often scored for both insularity and xenophobia; they seem easy targets to sophisticates. But another noted author from Sacramento, Richard Rodriguez, credits the place with igniting his imagination. Rodriguez's Sacramento was different from the one Joan Didion knew. His was not an "old family" in the peculiar Valley sense of that term. They came from Mexico and owned no ranches. His life was filled, not with luncheons in the Sutter Club, tennis weekends, and ski holidays, but with long afternoons in the pervasive heat or velvet fog that the poor know intimately. "I used to hate Sacramento when I was growing up there," he admits. Then his voice softens:

> In almost all of my memories of the city it is always warm, it is always sunny, it is always cloudless….I see myself as a child, always on a summer day. In some sense Sacramento nurtured me…the afternoon stretches out all energy and you are left listless with only your imagination running wild as you sit on the front porch. And I dreamt a lot in Sacramento. It became the scene of an extraordinary imagined life.

Older Valley towns, of course, bespeak a far greater possibility of remembered history than do freshly built suburbs. You can touch the stone marking your great-grandmother's grave and realize that she lives in you, and that so do Europe and Asia and Africa. The rough granite of her monument evokes layers of life in which you participate. There is no need to reinvent yourself in this place that spawned you, and such truth wars with California's larger image. Writes Didion:

> A few Sundays ago I was in a town like that….It was the golden anniversary of some of my relatives and it was 110° and the guests of honor sat on straight-backed chairs in front of a sheaf of gladioluses in the Rebekah Hall. I mentioned visiting Aerojet-General to a cousin I saw there, who listened to me with interested disbelief. Which is the true California? That is what we all wonder.

Now the Valley is being paved, engulfed by ranchettes and stucco houses. Real estate developments are inexorably erasing an already-fading strand of history, planting wooden stakes topped by mylar ribbons to mark the death of a ranch, gouging it with massive earthmovers, then erecting signs promising no-money-down for veterans.

Fog, Downtown Sacramento, 1989. Stephen Johnson.

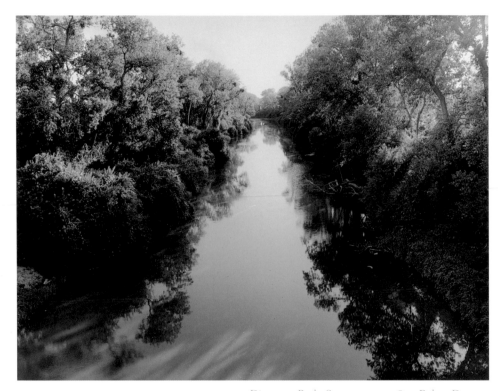

Discovery Park, Sacramento, 1985. Robert Dawson.

tory—the romantic Spanish era, the frolicking Gold Rush—any sense of the actual past seems miraculous. "California was the Fourth of July parade in Sacramento with the overweight real estate men dressed up as Spanish rancheros and their wives riding sidesaddle in the golden sun," Rodriguez recalls. "And there I was watching them go by on their palominos, the horse club, none of them Mexicans, none of them Spanish."

But history does exist, however blurred it may be by illusion, and the farther removed one is from those centers where the state's stereotype becomes performed reality, the closer one may approach the past. In the vast rural stretches that extend north from Sacramento—and south as well—boots rather than stylish sandals are the rule, and weathered brown faces with white foreheads (or weathered brown faces with brown foreheads) replace modish tans. This region's farms and towns are frequently bypassed by media-sanctioned "California trends," so a Valley boy like Richard Rodriguez suggests, "When I define myself as a Californian, I must be totally willing to leave that term vague." Much of the Valley is a long way from sprout sandwiches, designer glasses, and hot tubs.

But the dynamic state of which the Valley is heart requires the steady beat of this rural reality, for California is the place where the United States is at last becoming a part of the Americas, where Mexico is finally becoming a Pacific nation, where Africa's western thrust and Asia's eastern urge coincide with European expansion and the remnants of indigenous bloodlines.

It doesn't end there, because a by-product of the loss of farmland is that poorer-quality soil is pressed into cultivation. And that, in turn, requires more equipment, more water, more petrochemicals, with commensurately greater potential for pollution and desertification, an insidious cycle. But development—in one form or another—is an established local tradition; already in the early 1860s, Brewer refers to real estate speculation as "the old California story." And, indeed, those rows of stucco houses are often ports of entry into the middle class, where the children and grandchildren of migrant laborers may finally reap some part of the California promise for which they and their families have toiled.

The question of history cannot easily be avoided in this Valley, for the past visibly abuts on the present here—change is difficult to deny—and the long horizon hides little. If, as Didion persuasively suggests, local memory is parochial—"My own childhood was suffused with the conviction that we had long outlived our finest hour," she writes—it is less so when one escapes the self-serving volumes of local history produced with the sponsorship of old families and penetrates the deeper sagas of emotion and blood and social complexity that only the home place can evoke. In this state, with its habit of accepting myth as his-

"The hotel where we stopped showed a truly Californian mixture of races—the landlord a Scotchman, Chinese cooks, Negro waiter, and a Digger Indian as stable boy," Brewer notes at one point, reflecting the growing class system and ethnic richness—and, indeed, the intermingling and stereotyping of class and ethnicity—of the Valley. "Here," observes Rodriguez, "it is much easier to remember that the world is not simply derived from Europe."

In Sacramento today, more than ninety ethnic groups have been identified, from South Sea Islanders to the few surviving native Indians. A great many residents are of European descent, of course, Slavs and Germans, Norwegians and Dutch. Each group has its own story to tell. Portuguese immigrants from the Azores were perhaps unusual in that they were early on often identified with a single vocation, dairying.

Most Portuguese originally entered the Valley as farm laborers, and most still do: there is a continuing stream of newcomers. Frequently they have progressed to renting farms, then to ownership, a pattern followed by members of many other ethnic groups. Economic conditions in both mainland Portugal and the Azores islands were not promising at the turn of the century, and overpopulation was already a problem on those Atlantic isles, so from 1907 until 1930 migration was steady, so

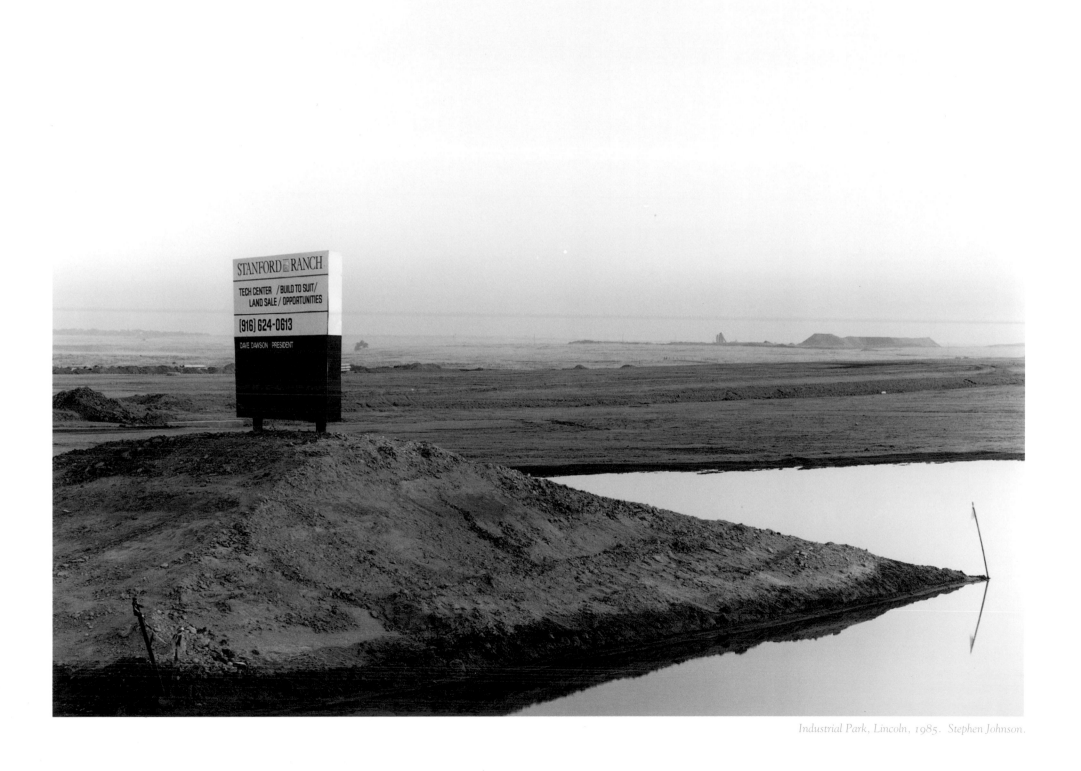

STANFORD RANCH

TECH CENTER / BUILD TO SUIT /
LAND SALE / OPPORTUNITIES

(916) 624-0613

DAVE DAWSON PRESIDENT

Industrial Park, Lincoln, 1985. Stephen Johnson.

The Marysville Buttes, circa 1871. R. Swain Gifford.

The Picturesque Sacramento, 1872

The valley of the Sacramento, at first with an undulating surface, and diversified with earth-waves crowned with noble oaks, as we ascend northward spreads out into treeless prairies, as flat as those of Illinois. The first break in the monotony of the expanse is made by the Marysville Buttes—a short range of low, volcanic hills, which rise suddenly out of the prairie. The town of Marysville is at some distance, and is on a tributary of the Sacramento, called the Feather River; but the Buttes loom up from the eastern bank of the Sacramento, which here is lined with alders and cotton-trees. The latter are broad and umbrageous, but not high, and their dark-green foliage contrasts pleasantly with the gloomy brown hues of the fire-born hills. Native grape-vines trail along the ground, and cling around the trunks of the trees, hanging like Arcadian curtains, and making picturesque bowers, unheeded by the inhabitants of the various ranches, who are somewhat prosaic in character, and given much to considerations of profits in wheat-raising. Between these one catches glimpses of the river, flowing onward with a still, deep current, reflecting placidly the masses of green foliage, and the trailing vines, and the white sails of the small vessels gliding downward with the tide. Deep pools here and there give back the blue of the cloudless sky; and, as a bass accompaniment, come in the dark shadows of the Buttes, with their sharply-drawn angles and their truncated cones. The slopes that rise from the banks have a very gradual ascent, and are dotted with ranches, pleasantly hid by orchards and vineyards. High up as far as vegetation goes the cattle graze; but, from the acuteness of the sides above the slopes, little earth can cling to them, and therefore they present a bare and hungry appearance, intensified by contrast with the smiling river, and the slopes blessed by Pomona and by Ceres. Not altogether deserted are these barren crests; for, where the cattle do not care to stray, the sportsman is sure of finding the California hare, whose numbers seem infinite. The flesh is capital, save where the animal feeds entirely on the wild-sage, which gives it an intensely bitter taste. Looking from the cones of these hills to the right and left, the eye glances over miles upon miles of flat plains, where fields of wheat succeed to vineyards and to groves of oak, broken only by the wooden buildings of the settlers. In the far distance can be faintly discerned the undulations of the foothills on either side—the first indications of the Coast Range to the left and the Sierra Nevada to the right.

—R. E. Garczynski
Picturesque America, 1872.

steady that today there are said to be more Azoreans in California than on the home islands. As early as 1903, a Portuguese-language periodical, *O Imparcial,* was founded in Sacramento; two years later *Portugal America* was begun in Fresno. By 1920, only German and Italian immigrants owned more California land than did Portuguese, who possessed a total of 497,933 acres. Merced County today shelters the largest rural population of Portuguese immigrants.

Gerald Alves, who was raised in Galt, south of Sacramento, remembers that "the various Uniãos Portuguesas or religious groups like the Holy Ghost Society were big deals, kind of cultural centers, especially for older people who wanted to speak Portuguese and live here as though they'd never left the old country. I suppose it was a typical immigrant's dilemma, wanting to have the best of both places: the culture of Portugal, the economy and opportunity of America." He nods and continues, "Unfortunately, it didn't work out that way, not for the second or third generation anyway."

Today a university administrator in Northern California, Alves smiles at a memory: "Some of the old-timers sure didn't like it when we kids spoke English, let alone dated Okie girls or Mexican girls and when we listened to popular music instead of 'Voz dos Açores' or 'Ecos de Portugal.' They'd stand around in black dresses or double-breasted suits and shake their heads when they talked about us, and all we wanted to do was to make the football team and date the prettiest cheerleaders. We were already Americans," he acknowledges. It is a pattern common to migrants here.

On August 14, 1862, Brewer described the riparian forest that characterized the Sacramento Valley's core, an ecosystem now tragically diminished by man-made riprapped banks and cement-lined channels.

A wide plain borders the river on each side. We caught distant views of the mountains, but generally we saw only the river and its banks, which were more or less covered with trees—willows, cottonwoods, oaks, and sycamores—with wild grapevines trailing from them. Some of the views were pretty indeed.

With the loss of these forests many animal species are vanishing as well: the wood duck and the yellow-billed cuckoo, for example. As historian Donald Worster observes, "the modern canal, unlike a river, is not an ecosystem."

Recent discoveries by ecologists studying rivers underline Worster's observations, considerably enlarging the concept of what a river is: a rich world of shrimps, worms, insects, and other microscopic organisms has been discovered living in groundwater below stream channels and sometimes for great distances on each side. "River ecologists have traditionally dealt with what the eye can see," points out Garth Redfield of the National Science Foundation, "but we may have been ignoring one of the most important components of a river system—what is happening underground." Subterranean aquatic organisms are integral to a food chain that extends all the way to large fish and animals that prey on them—including anglers. Once groundwater organisms die, simply rehydrating a channel will not soon restore its complex ecological web.

In its endless quest to govern nature, the Bureau of Reclamation now seems determined to riprap the banks of the great river—clear them and pile them with rocks—in order to control the channel completely, but groups such as the Nature Conservancy work just as hard to purchase as much remaining unspoiled riverine habitat as possible for a Sacramento Valley Wildlife Refuge. "The river continues to meander, and the farmers continue to want more control (in the form of riprapping)," Robert Speer writes. Meanwhile salmon, striped bass, and steelhead populations are dropping; a native crop, fish, is diminished so that alien crops such as rice, alfalfa, and almonds may flourish. Two visions—nature as ally, nature as adversary—continue clashing here.

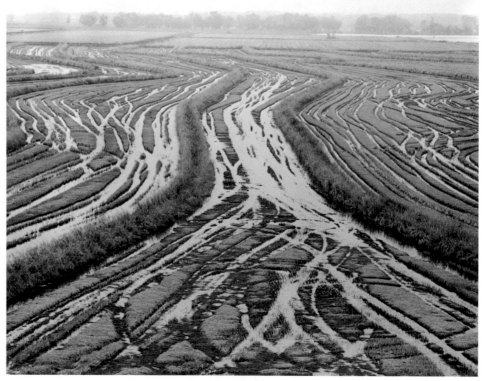

Rice Field, Sacramento River near Colusa, 1984. Stephen Johnson.

Despite occasional complaints that this species or that is standing in the way of "progress"—which means it is preventing someone from making money—the occasional, much-publicized prohibitions on development of a few tracts are enforced not merely to save an endangered species, but to salvage some remnants of the Valley's natural habitats, that is, the very ecosystems into which human beings once fit without technology. Ecologist Arjan Singh points out that while most animals—whether condors or kit foxes or cuckoos—require specific habitats to survive, people can and do breed anywhere. Many humans still appear to suffer from the persistent illusion that they are somehow above nature, but saving endangered animals may be an indirect way of protecting ourselves by preserving the environment. The substitution of cement channels for the generative complexity of streambeds is one of the world's most dramatic examples of a habitat's ruin.

Environmental scientist Ann Sands suggests that another habitat, the Valley's remaining riverbank jungle, is the closest thing to tropical rain forest California contains—wet, warm, and lush. These riparian forests actually contain three habitats: an upper story of tall trees, a middle story of shorter trees and tall shrubs, and a lower story of dense undergrowth. At least seventy species of birds, thirty-nine of mammals, nineteen of reptiles and amphibians, plus hundreds of insect species thrive here.

At one time, virtually every mile of Valley riverbank was lined with such growth. These riverine woodlands were the major animal habitat in the Valley, home to everything from garter snakes to grizzlies to yellow-billed cuckoos. The forests were also important factors in soil conservation and flood control. Today they are nearly gone, an estimated 800,000 acres diminished to less than 14,000.

In 1837 Captain Edward Belcher sailed up the Sacramento River and noted, "Within, and at the verge of the banks, oaks of immense size were plentiful." He was observing the elegant valley oak, the largest of any of the sixty species of North American oaks, with a life span of up to four hundred years. No other tree—some say no other life form—so characterized the Great Central Valley, yet the steady alteration of the natural landscape and water table threatens even these ancient natives. The valley oak, whose acorns were once the indispensable staple in the diet of local Indians, and whose tangled branches have come to symbolize the Valley, has now become an endangered species.

Heading north up the river on a steamer while the remainder of his party rambled overland, Brewer noted that the effects of human exploitation could be observed in the stream itself. "Previous to 1848 the river was noted for the purity of its waters....Since the discovery of gold, the 'washings' render it as muddy and turbid as the Ohio at spring flood." The same refuse from hydraulic mining that filled streambeds stained the water.

That year all the feeder streams were flooding, even those from the relatively dry western mountains. Such overflow did notable damage because of the tendency to establish communities close to watercourses. Many of those streams tended to flood to some degree nearly every year, helping produce seasonal swamps that occupied from two hundred to eight hundred square miles and were vital replenishers of the soil, as well as prime habitats for waterfowl, for beaver, and for both Roosevelt and tule elk. Eventually, the streams that were overflowing in 1862 would become vital sources of irrigation water.

Today, the northern region through which Brewer journeyed includes all or parts of nine counties. It is both smaller by a third and less densely settled than the southern reaches of the Valley. The vale of the Sacramento supports a primarily agricultural economy. Field crops such as rice are dominant, although fruits, nuts, and alfalfa are also widely raised. While there are no vast cities north of the state capital, Chico, Marysville–Yuba City, and Redding are growing rapidly.

Nonetheless, the ghostly flight of an egret rising from rice fields near Willows, or the startled stare of a four-point buck watching Interstate 5's traffic from a dry streambed south of Red Bluff, is a reminder that this remains a land people share; nature, while presently tamed, has not wholly abdicated this rich domain.

Wheat Barges, Sacramento River, circa 1890. J.O'H. Cosgrave II.

The abundance (and pestilence) of "water grass" illustrates the tentativeness of human domination. While many plants have been assigned that generic name, in the Sacramento Valley what is locally called barnyard grass, both red and green varieties, is the prime and most troublesome villain. There is also a "rice mimic," another water grass, transplanted from Japan with the crop it now hinders. Add Johnson grass and Bermuda grass, also followers of irrigation, and farmers have formidable, tenacious adversaries, just as both herbicide and hoe companies have guaranteed incomes. An uneasy balance endures.

Long before national rail companies opened the inland valley and far coast, the new state capital was the location of the first line west of the Mississippi, the Sacramento Valley Railroad. Incorporated in 1852, two years before Sacramento became the seat of state government, the SVRR in 1856 carried its first passengers on a free ride to Folsom, beginning its short, financially desperate life. The SVRR, described by Walter Frame as "an independent, scrappy, chip-on-the-shoulder outfit," finally succumbed to economic pressure created by the far more substantially capitalized Central Pacific a decade later. Nonetheless, this local outfit, however short-lived, was remarkable, and it presaged the age of rail transportation that would allow the entire region to burgeon later in the century.

During the period of Brewer's visit, the Sacramento River itself was the north Valley's major highway. The first steamboats to travel it, reports Joseph McGowan, "were little more than barges with a small steam engine on deck and a paddle wheel attached to the stern." By 1849, however, some of the ships that had carried miners around the Horn—most of them side-wheelers—were then plying the river, and that year new side-wheel steamers were commissioned.

A short-lived near monopoly developed when the People's Line's two "river palaces," the *Senator* and the *New World,* dominated; only the independently owned *McKim* was a major competitor. By 1851, however, the Union Line countered with the *Confidence* and the *Wilson G. Hunt.* As a result, rates dropped and service improved. By that year more than thirty steamers worked the San Francisco–Sacramento–Marysville route, most of them by no means "river palaces." Soon travel time became equated with quality, and rival boats raced up and down the stream, sometimes literally jockeying to pass one another, sometimes indulging in dangerous tricks—using volatile fuels such as pitch or oil along with wood in the boilers, zig-zagging downstream to prevent adversaries from passing, even hiring small boats to block a rival's departure. John Caughey and Norris Hundley, Jr., report:

> *Disasters were common. The waters were not thoroughly charted, many vessels were faulty, steamboat inspections were lax, and the passion for racing led to boiler explosions. The first half dozen years saw a score of such accidents with up to 50 people killed. The Californians delighted in impromptu races and the more steam carried the better they liked it.*

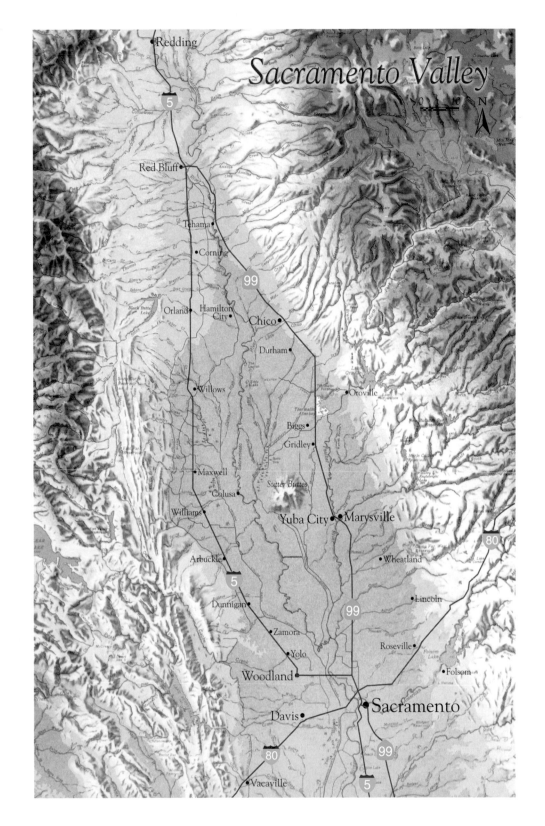

The Salmon Run

Salmon and steelhead runs have declined precipitously throughout the state in recent decades. Since 1945, king salmon runs on the San Joaquin River have dropped by 90% and a similar decrease has occurred on the Trinity River in the last 20 years. Most other rivers have seen a substantial deterioration of king salmon runs. Similar declines have affected most north coast steelhead runs. Silver salmon runs have also fallen by 80% to 90% of the 1940s level...Because of these sharp declines in spawning due to dams, diversions and the resulting poor streamflows, the American Fisheries Society (an organization of fisheries professionals) has petitioned the Secretary of Commerce to list the winter-run king salmon as "threatened" under provisions of the federal Endangered Species Act....

Early California—A Time of Abundance and Balance. As with all living things, it has always been a question of survival for salmon and steelhead trout. These native fishes evolved with the California landscape. Their complex life histories reflect the area's seasons, streams, landforms and natural variations. Their survival is tied inextricably to water.

Salmon and steelhead reach maturity at sea and return to the rivers to spawn. Young king salmon spend the early weeks of their inland lives in rivers and streams, move quickly to coastal estuaries and then, to the ocean. Silver salmon and steelhead trout move downstream more slowly, taking at least a year to reach saltwater.

The upstream migrations of mature fish and the downstream migrations of their young were determined ages ago by the pattern of California's winter rains and springtime snowmelts, by the chilling of streams in the winter months and their warming during the spring. Everything is tied to these cycles. The fertility of the eggs carried within the females depends upon the temperatures of the streams. The vitality of the young fish hinges on the sufficiency of their food—aquatic insects and other small creatures—which is determined, in turn, by stream temperatures and other factors.

In the course of California's natural evolution, variability in streamflow and water temperature patterns shaped the differences in salmon and steelhead. Fish with the strength to travel far upstream, to the cool headwaters, could reproduce successfully even when the rains arrived late. Young fish insensitive to rising springtime temperatures might perish in early-season droughts, while those with keener responses would move safely downstream to complete their life cycle.

In this way, different regions of California evolved different "races" of fish, which entered the streams at different times to spawn. A catastrophe might eliminate one spawning run, but nature had prepared another run, days or weeks behind it, to fill that special niche reserved for salmon and steelhead trout.

The Natural Balance Is Disrupted. The first great threats to this resource came with the discovery of gold. Panning for the precious metal gave way to hydraulic mining, which permanently destroyed miles of critical spawning grounds

Salmon, Merced County, circa 1925. Frank Day Robinson.

During the 1930s and 1940s, efforts to conserve fish through harvest regulations were overwhelmed by the devastating effects of economic growth and development. Californians tamed and cultivated the countryside, harnessed rivers for crop irrigation and hydroelectric power, and developed land for roads, homes and recreation. Huge dams were constructed, vast tracts of timber were removed and whole mountains were pushed aside for highways.

—California Advisory Committee on Salmon and Steelhead Trout,
Restoring the Balance, 1988 Annual Report.

Today, the cumulative effect of these activities threatens to end the salmon and steelhead's ancient struggle to survive. Not long ago, California salmon and steelhead resources seemed limitless. Now, those fish populations have withered and some have become extinct.

In January 1851, the *New World* lowered the downstream record from Sacramento to San Francisco to a remarkable seven hours; soon other boat owners and captains accepted the challenge. Bets were placed by gamblers, and passengers not infrequently found themselves in the midst of a thrilling, if hazardous, sporting event. The eventual and final champion was the *Chrysopolis*, called "the slim princess," launched in 1860 and conceded to be the finest vessel to ply these waters during the golden age of steamers. It eventually lowered the downstream mark to an unchallenged 5 hours and 19 minutes for the 120-mile journey via Steamboat slough, averaging more than 22 miles per hour.

If racing was spectacular, freight was more important, and in 1852 the *Alta California*, San Francisco's leading newspaper, estimated that 167,000 tons of it was transported up the Sacramento River at a cost of $1,506,250. Shallow-draft vessels were by then traveling as far north as Red Bluff and Marysville. Two years later, the California Steam Navigation Company was organized; it dominated both river and coastal trade for the following two decades, and riverboats were the principal connection between Sacramento Valley farms and world markets until rail lines penetrated the region at the end of the sixties. In two more years, the Central Pacific Railroad bought a smaller line, the California Pacific, which had itself previously purchased the steam navigation line; thus the giant railroad completed its domination of transportation.

For many years after railroads became prime, steamers remained romantic, sometimes luxurious links with the past. "From 1926 until 1941," Mike Hayden says, "the *Delta King* and the *Delta Queen* provided daily overnight passenger service between the capital and San Francisco. In 1939 the fare was $1.50 one way, $1.95 round trip, and $3.50 to $5.00 for a stateroom with twin beds and a bath or shower." These two vessels were also the largest and fastest stern-wheelers ever to ply the Sacramento.

Near the capital city one may see fields covered with the green blossoms of one of the Valley's imported plants, hops (used in the production of beer), hanging from lines high above the ground like an engineered rain forest. Such sophisticated and specialized agriculture is typical of increasing numbers of Valley crops. Hop vines grow up along cords tied in V's to cross wires strung from wooden poles. The cords themselves are of a single kind and must be imported from India. From the tough vines a small blossom called a hop cone grows some sixteen feet above the ground, and it is the only part of the plants that is reaped and sold. Most of the year, the plants must be cared for by hand, and there is a relatively brief period when the cones can be harvested, less than three weeks. The expensive equipment required for the harvest is thus idle for nearly fifty weeks a year. As is increasingly the case during this era of capital-intensive agribusiness, it takes a good deal of money just to make a living—or not to make it during bad years.

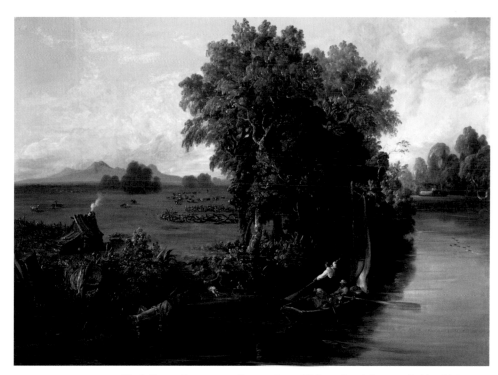

Hock Farm, Sacramento River, 1851. William Smith Jewett. Oakland Museum.

In an area west of Sacramento where once hop ranches could be seen from the road to Davis is the Yolo Bypass, a three-mile causeway over marshlands and a key link in Sacramento's flood-control system. This is where floodwater that might otherwise inundate the city is diverted during wet years. The terrain over which the causeway passes reveals characteristics of this section before it was widely settled and developed. The Federal Writers' Project's *California: A Guide to the Golden State* describes it this way:

> The deeply rutted road that formerly meandered over these swampy acres was impassable in spring when the swollen Sacramento [River] flooded it with a muddy torrent. So yielding was the terrain that the railroad, paralleling the highway on a high embankment, used to sag until the tracks looked like a sway-backed horse. Unnumbered tons of rocks had to be dumped into the swamp before the engineers won their fight.

That causeway between Sacramento and Davis forms an acute triangle with roads to nearby Woodland, with the former a southern base and the latter a northern apex.

Agriculture and Technology

The Central Valley's phenomenal productivity has been made possible largely through innovation in agricultural technology. The University of California, Davis, has been the center of agricultural innovation in California. Although not by design, close ties with corporate agriculture have led to developments of greatest benefit to those with the most capital to invest. New technology has always meant that new sources of money were also needed. Smaller family farms have found themselves the fiscal victims of innovation as often as the beneficiaries.

Flood Control
California's early innovators were hydrologists and engineers who developed irrigation methods to cope with the annual drought and flood cycle endured by most Valley farmers.

Irrigation
As the Valley's natural waterscape was brought "under control," a year-round supply of water could deliver irrigation water where and when it was needed.

Intensification
Intensive agriculture became possible with a reliable source of irrigation water, the development of mechanized farming, and the import of foreign workers skilled in agriculture and willing to work for little money.

Mechanization
The development of agricultural machinery has had a dramatic impact on the Valley landscape and farming. From the Caterpillar track to the Fresno Scraper, this landscape has literally been transformed into a giant agricultural factory.

Plant Breeding
Through techniques pioneered in the nineteenth century, the University of California developed hybrid strains of plants high in yield, easy to ship, and suited to Valley weather.

Fertilizers, Pesticides, Herbicides
The pressure for higher and higher yields, market diversification, and the availability of marginal land helped create California agriculture's groundbreaking dependence on chemical farming.

Genetic Engineering
Modern techniques of gene-splicing have created a whole new industry of bio-technology in agriculture. Initial experimentation has ranged from ice-preventative bacteria to enable crops to resist frost, to completely new engineered plant varieties selected for yield, durability, pest resistance, and even salt-tolerance.

Achievements
The combination of these inventions, research, and engineering has led to an approach to agriculture that in some ways has become a model for modern farming on a global scale.

As Valley agriculture begins to deal with some of the negative consequences of this chemically and technology-intense agriculture, it is likely to once again be a center of innovation.

The challenges—everything from salinization, desertification, the urbanization of prime farmland, and now cancer clusters—may be more than technology alone can provide. A rethinking of values, long-term costs, and the future shape of this rural landscape will be necessary to cope with these growing problems.

Named for James Davis, a farmer who by 1856 had diverse holdings in the area, Davis may be the Valley's and the state's most important farm community, because it is the locus of the University of California's considerable program in agricultural research. As the site of what was once the university's Davis Branch of the College of Agriculture, best known for stock barns, orchards, and greenhouses, U.C. Davis is today a large, diverse, and prestigious institute of higher education. While it has added strong schools in various disciplines, it remains the place where many of the most important innovations in farm technology have been and are being developed. When California's fine-wine industry burgeoned two decades ago, for instance, it was scientists from U.C. Davis who developed new varieties of grapes suitable for Valley conditions and who devised efficient new techniques of wine production.

But, as social ecologist Michael Black suggests, it was the reinvention of the tomato that most dramatically demonstrated the best and worst results of U.C. Davis's research. "U.C. altered the genetic structure of the tomato so that it could withstand mechanical picking," Black points out. "Unfortunately, as folks who grow their own know, that also eliminated the taste. Apparently, if you want 'em to bounce well, they can't taste worth a darn....Designer tomatoes came with the invention at U.C. Davis of the mechanical harvester."

The facts are that since the mechanical tomato harvester became available in 1974, it takes only six harvesters and a handful of workers to reap a crop that a few years back might have required six hundred. Productivity is impressive: in 1940, California's acre yield was eight tons; in 1960 it had grown to seventeen tons; today it averages twenty-four tons. Economic forces have concentrated tomato farming, so that not only are fewer laborers employed, but fewer farmers do the employing: in 1940 tomato farms averaged 45 acres; today the average is 350. That is, the human crop grows smaller as the yield of hard, flavorless tomatoes grows larger. "Do you want to know what has gone wrong with technology and science in America?" Black asks. "Eat a California tomato."

It should be noted, however, that U.C. Davis has of late begun, however slowly, to move away from its large-scale, capital-intensive, petrochemically driven model toward more durable, less damaging forms of farming—what has come to be called "sustainable agriculture," which Wendell Berry describes as a system that "does not deplete soils or people." This is a momentous philosophical change, which, if pursued, could have equally momentous effects, for it implies a way of life for consumers as well as growers. Writes Bruce Colman: "What this agriculture features is relatively large numbers of people getting their livelihood on the land, growing crops that act like wild ecosystems— that is, that build the health of the soil even as they deliver the seeds (grains), leaves, fruits, meats, and roots that compose a healthy diet."

New Orchard, Ripon, 1982. Robert Dawson.

Although to some this movement smacks of hippie, back-to-the-land utopianism, in fact the U.C. version recognizes the finite future of present commercial techniques and seeks to find more enduring methods of commercial agriculture: less annual yield, but many more years of production.

Davis is tree-lined and famous for its large number of bicyclists. Students have a major impact on local politics—it is, for example, a "nuclear-free zone"—and some old-time Yolo County residents look askance at recent events. "Sometimes it seems like they're developing a lot of nuts at the agricultural university," said one of them, Isabel Plank. She smiled and her eyes twinkled.

One of the few towns passed by Brewer when he journeyed up the river was Woodland, northwest of Sacramento, and west of the river. Founded in 1853, this is the seat of Yolo County and was originally named Yolo City, although some wags called it "By Hell"—the favorite expression of a locally famous barkeep. Its present name honors a grove of native oaks that once stood here. Cache Creek, a large stream, unusual because it flows *east* into the flat country from mountains near Lake Berryessa, once created marshes near here. As early as 1856, irrigation from Cache Creek had begun. Today Woodland is a commercial center, with fruit packing, food processing, canning, and other related industries. It remains a pretty, wooded town.

Overpass, Zamora, 1983. Stephen Johnson.

Mrs. Plank, a gracious, handsome woman, active in civic and club work, was a native daughter of Woodland; her husband was a native son, and three of her children—plus many grandchildren—also lived in Yolo County. She had observed change without dismay and summarized, "Well, Woodland's grown tremendously. I guess it's only normal to wish it had stayed smaller, the way it was, but you've got to live in the present." She smiled. "Out west of town where Uncle Henry and Aunt Jess had their farm, it's all houses now, nice places, neat, and nice young families right where Uncle Henry grew hay. We used to go there for haying and to have picnics. Nice young families though.…" Her smile grew pensive.

West of Woodland rise the Yolo Hills, and north are the Dunnigan Hills, wrinkles in this vast trough's otherwise flat landscape. Drivers motoring north on Interstate 505, surrounded by rounded slopes and swooping up and down rolling rises that hide intervening prairie, see looming ahead of them the rugged Sutter Buttes and, for a moment at least, wonder if they can actually be in a valley at all.

Sparsely settled, the Yolo and Dunnigan Hills are covered with cattle ranches, wheat farms, some vineyards, and, to the north, villages such as Zamora, Yolo, and Dunnigan. Esparto, to the southwest, is the gateway to Cache Creek Canyon, a recreation area favored by whitewater enthusiasts. Farther south, another major east-flowing stream, Putah Creek, runs from Lake Berryessa, where it is impounded, toward Winters, the small town that is portal to recreation in the volcanic range that separates the Sacramento Valley from the much smaller Napa Valley within those hills.

To Woodland's north, the land opens into flat-to-rolling prairies, once dotted with white oaks, now much developed for agriculture, clusters of domestic trees hiding farm buildings and small communities, most of which didn't exist when Brewer traveled north up the Sacramento River. Robert Speer finds it "a softer place than the San Joaquin Valley, less profoundly altered. The northern end of the Valley narrows, so you can see the mountains, and the great river dominates." This end of the Great Valley seems less expansive than it is because the stream divides it lengthwise into two parallel plains. James J. Parsons, a geographer, characterizes it as "smaller and better watered, more Anglo-Saxon, and much less populous than the San Joaquin portion."

Towns here seem to retain more of their traditional flavor than those in the rapidly filling south: Arbuckle, founded in 1892 by the almond grower C. H. Locke; Colusa, seat of Colusa County, standing on the site of a Ko-ru-si Indian village and a major shipping center; Williams, founded by W. H. Williams in 1876 and known as a town that in 1914 refused to be riled by a roving band of "Wobblies"; Willows, so-named because a large cluster of trees here was once the major landmark between the Sacramento River and the western hills, seat of Glenn County, and the place where the Sacramento Valley Irrigation Company pumps water from the stream. Each evinces its own unique history, its unique personalities, its unique memories.

When Brewer boated up the Sacramento Valley, of course, the region's indigenous Indian population was in the process of being decimated by recently arrived Americans. The young geologist's boat passed the apparently unsettled region between Williams and Willows, already considered a historical setting, because whites and Indians had worked together there at a rough rock enclosure known locally as the Old Stone Corral, where Granville Swift's cattle, which grazed all over the Valley, were rounded up by Indian vaqueros, many of them debt peons.

The cattleman himself was among California's most interesting American pioneers. Swift came to the state with Benjamin Kelsey's party in 1844 and later headed one of three companies during the Bear Flag Revolt. Later still, he served in John C. Frémont's California Battalion of Mounted Riflemen during the Mexican War. Following the conflict, he mined, then became a stockman, running cattle over the Valley's undeveloped expanse.

Rice Mill, Woodland, 1985. Robert Dawson.

Open Lot, Zamora, 1982. Robert Dawson.

Swift's cattle business foreshadowed another major local issue: the transition from ranching to farming, characterized by a struggle over fenced farmland that was going on at the very time Brewer visited. The existing Trespass Act absolved ranchers from responsibility for damage done by their cattle to unfenced farmland. Since barriers— until the 1874 introduction of barbed wire, anyway—were costly, farmers were helpless before the wanderings of the more than 200,000 head of cattle that ranged the Valley, and the development of agriculture was effectively slowed.

James McClatchy of the *Sacramento Bee* was a powerful voice against the "Fence Law" that handicapped farmers, which he called "the greatest outrage, after the land monopoly." In 1862, he wrote: "The claim of the stock owner that they should be allowed to eat the grasses from other people's land is preposterous. They might as well demand the right to enter a man's granary if they found the door open and feed his grain to their cattle." After much controversy, a "No Fence Law" was passed in 1874. It allowed farmers to confiscate stray cattle and to sue ranchers for damage to their fields, whether fenced or unfenced,

closing the free range and greatly stimulating the development of agriculture on the prairie.

The thinly populated region between Williams and Willows, where only Colusa and tiny towns such as Maxwell and Princeton have arisen, is nonetheless much developed, the heart of California's rice industry. Flooded fields glisten here, highlighted by wading snowy egrets that sit starkly against the crop's lush green. More subtly, and perhaps even more beautifully, those shining surfaces are textured by the lines of miniature dikes that curve through them like swimming snakes. Today, laser land-leveling is obviating the necessity for contoured dikes, so one of the Valley's most striking introduced landscapes—panels of water divided by those low, sinuous dams—is itself threatened by technology.

Rice replaced wheat, barley, and other dry-farmed grains as the area's major product, and nearly 80% of the state's rice crop is produced in the Sacramento Valley, where abundant water from the river is employed for flood-irrigation. This became possible only after the seasonal swamps were controlled by trenches and levees that radically altered this area's drainage pattern and natural environment. Rice growing, probably first attempted hereabouts by none other than John Sutter at his Hock Farm during the Gold Rush, well illustrates the importance of irrigation to Valley agriculture, as well as reliance on mechanization. It began commercially, or so goes the tale, not as a corporate experiment, but as a single individual's gamble in 1911.

A cook from Japan who was employed by a Colusa farmer is reputed to have imported "wataribune" rice from his native land, then planted thirty acres of it. Certainly the rice was from Japan, whether or not that first farmer was. Water was plentiful and cheap, the soil was right, and so was the weather; the cook's crop produced abundantly, and the news spread fast. The government set up the Biggs Field Rice Experimental Station, and before long, more efficient types of rice were found or developed—notably the Colusa 160 C variety—that increased production.

Like many crops in the Valley, rice is expensive to grow and does not lend itself to small farming operations. "Seeding, fertilizing, and pest control are done by air, harvesting by self-propelled machines on very broad treads," W. H. Hutchinson points out. "The paddy layout is also accomplished by machinery, as is the drying of the harvested crop." It is among the state's most mechanized agricultural operations.

Year in and year out, the greatest threat to the rice crop is a fact of the region's traditional ecology. Much of the wetland now converted to rice growing was once marsh, and it is still the heart of the Pacific Flyway for migrating waterfowl: millions of geese and ducks winging north or south. "Today, the Central Valley hosts half the flyway's Pintail and Wigeon, 80% of the Northern Shovelers, 60% of the Gadwalls, 82% of the Snow Geese, 86% of the Tundra Swans and all of Cack-

ling Canada, Ross's, and Aleutian Canada geese," Peter Steinhart points out. "It hosts huge numbers of phalaropes, grebes, sandpipers, egrets, herons, and rails as well." Elna Bakker calls these birds "winter gleaners of the grain and croplands," but many species dine year-round.

In any case, no one consulted the waterfowl before planting rice, and they seem to view the area as a mighty salad bar; since farmers are no longer free to kill the winged diners, a variety of devices are em-

The Extermination of Wild Geese, Colusa County, 1882. Frank Leslie's Illustrated Newspaper.

Yankee Slough near Rio Oso, 1984. Robert Dawson.

ployed to frighten the birds away: low-flying airplanes, flares, star shells. In earlier times, men with eight-gauge shotguns were employed both to protect rice and to harvest waterfowl.

There do remain in the Sacramento Valley a few small pockets of native wetland—no more than 10% survives—in preserves and hunting clubs mostly; along with somewhat larger reserves in the San Joaquin Valley, they constitute what's left of the original Pacific Flyway wetlands. These seasonal and permanent watery areas are surrounded by a sea of agriculture—islands of refuge for migratory birds and other habitués. These surviving water areas remain major wintering grounds on the flyway, and without them the ecologies not only of the Valley but also of both Canada and Mexico would be severely affected. In yet another case, local actions have broad consequences.

Just north of Willows yet another prominent non-native species surrounds Interstate 5. The area known as Blue Gum is named for trees—formally labeled *Eucalyptus globulus*—that, in the eyes and minds of many, characterize much of California. In fact, the genus was introduced into this state from Australia in 1853 by Robert Waterman, who settled in the Valley's Suisun region. "By the 1870s," points out

Roberta Friedman, "visitors were remarking on the trees as part of the state's landscape." Later in that century, thirsty eucalyptus—there are more than 500 varieties—were employed to help drain malarial marshes from the area around Bakersfield. Other groves were planted in the largely futile hope that their wood could be harvested for lumber, and others still as windbreaks.

Today, although sometimes pestiferous, these fast-growing trees are proving useful in unexpected ways. In 1987, for instance, a timber company planted 250 acres of eucalyptus—with considerably more scheduled to be seeded later—south of Redding, the lumber crop to be used in the production of paper. Increasingly, varieties of eucalyptus are being favored by home wood burners and professional woodcutters, and now wood-burning power plants are turning to the quickly maturing trees as a fuel source.

An even more intriguing contemporary use for the Australian natives is suggested by Friedman: "The rapid transpiration of groundwater that gave eucalyptus a reputation for drying marshes at the turn of century may do a good turn for central California today." The trees seem capable of sucking trapped brackish water from beneath Valley topsoil—reducing the chance of farmland being lost to salinity—while producing a cash crop of wood. The state's Department of Agriculture has planted test tracts in Kern, Kings, and Fresno counties. At the same time, other state agencies, struggling to restore some semblance of California's natural landscape, are eradicating eucalyptus that compete with native vegetation.

Like most of the Valley, this section is often thought of as little more than a vast, flat prairie, yet its most arresting physical feature is a cluster of four rugged peaks thrusting unexpectedly from level territory between the Sacramento and Feather Rivers: the aforementioned Sutter Buttes—called the Marysville Buttes in Brewer's time. He wrote in 1862,

> **On the north are the Marysville Buttes, rising like black masses from the plain, over a hundred miles distant; while still beyond, rising in sharp clear outline against the sky, stand the snow-covered Lassen's Buttes, *over two hundred miles in air line distant from us*—the longest distance I have ever seen.**

These peaks, which rise to 2,132 feet (South Butte), are actually the eroded remnants of ancient craters that once rose nearly 5,000 feet. "The Buttes are a circular cluster of old volcanoes, 10 miles in diameter and round as my hat," explains naturalist Ira Heinrich. These surprising peaks constituted a powerful spiritual setting for the Maidu and Wintun (Patwin), who resided in the area, and were mentioned specifically in their creation tales. The Buttes dominate the flat vista roughly one-third

of the way up the Sacramento Valley, well below the pinnacles of Mount Lassen (Lassen's Butte) and Mount Shasta.

A few miles south of the Sutter Buttes, the Feather River angles into the Sacramento. Above that junction of large streams, after the Feather emerges from the mountains near Oroville, may be found small, pretty towns such as Gridley, Live Oak, and Nicolaus. Only six miles east of the Buttes are the twin communities of Yuba City and Marysville, which today share the region's agricultural bounty and a diverse and growing population. A devastating flood that struck them in 1955—reputed to be the worst since the 1861–62 deluge—is credited with guaranteeing that the Feather River would be harnessed by the California Water Project.

Yuba City, called "the Peach Bowl of the World," was platted on the west bank of the river in 1849. It is the seat of Sutter County and the core of an area where considerable irrigation produces a variety of crops: not only peaches but beans, peas, walnuts, corn, and especially prunes. The local Feather River Cooperative is the country's largest prune dryer.

Just across the Feather, at its confluence with yet another Sierran stream, the Yuba River, is Marysville, the seat of Yuba County, which Brewer described as "quite a smart city." It has sprung up where Theodore Cordua built a trading post in 1842. This site was also laid out in 1849, and the town was named for Mary Murphy Covillaud, a survivor of the Donner Party. During the Gold Rush, Marysville became the port through which thousands of miners moved to the diggings on the Yuba and Feather rivers. By 1851 twenty freighting outfits with 400 wagons and packers using 4,000 mules were reported to be operating in the area.

There was, however, a dark side to that prosperity. Hydraulic mining in watersheds above the town sent so much sediment downstream that the river beds were raised as much as seventy feet—by 1868 the channels of the Yuba and Feather rivers were *higher* than Marysville's streets—making levees necessary and leading to floods nearly every wet year that followed. In 1862 a torrent had turned the town into a lake, and the levees were breached once more by the great deluge of 1875, rendering Marysville once more a lagoon; when the community was at last drained that year, a wilderness of mining debris remained.

Enough was enough. "What right have five or six individuals to destroy the landed property of as many thousands? It is time the matter was contested," C. D. Dawson, editor of the *Marysville Appeal*, demanded. All sections of the Valley that were situated downstream from hydraulic mining were affected to varying degrees. Hydraulic gold mining in the northern Sierra, for example, vomited such vast quantities of mud, sand, and gravel into rivers that spring runoff annually washed tons of debris into the Valley and not only caused floods but halted river travel and actually entombed some farms.

Fruit Box Label, circa 1920. California State Library.

Army engineers revealed that 39,000 acres of land along the Feather River were buried under detritus, and 14,000 more were damaged; 12,000 acres were covered along the Yuba River, and 8,000 more were buried on the nearby Bear River, which eventually evacuated its clogged channel and cut a new one. About sixty million yards of waste spread out between the mountains and the Yuba's juncture with the Feather—a two-mile-wide sheet of mining debris that choked farms and broadcast flood water each spring.

The struggle that followed is often credited with having led directly to legislation that would swing the balance of political power in the state from mining to agricultural interests, so the implications of this ostensibly local debate were profound. Moreover, as the historian Robert Kelley documents, outrage over the negative impact of hydraulic mining thus led to one of the first successful attempts in modern American history to use the concept of general welfare to limit laissez-faire capitalism.

The interests of Valley dwellers, both townsfolk and farmers, had been pitted against powerful mining interests as early as 1862, but not until the controversial Drainage Act was hammered out in 1880 were the rights of the general public recognized as being more important

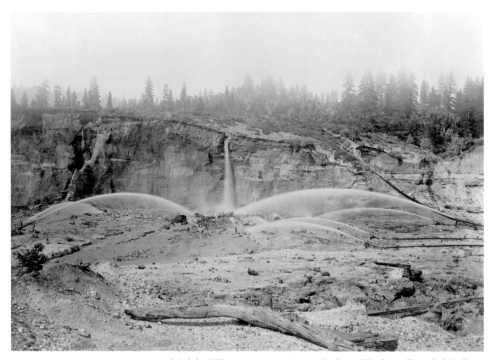

Malakoff Diggings, circa 1871. Carleton Watkins. Fraenkel Gallery.

than those of miners. The legislation also indirectly acknowledged the fragility of the natural environment and sought to protect it, creating a government agency to control and safeguard rivers. Another, perhaps ironic, result followed: restoring ravaged watersheds and riverine environments produced the first significant sally of the federal government into California's internal affairs. Moreover, the Drainage Act also led to initial engineering studies of the Sacramento Valley's river systems, beginning the accumulation of knowledge that would later lead to vast irrigation projects.

Southeast of Marysville, at a hop ranch near Wheatland, another major controversy arose on August 3, 1913. It is galvanized in memory as the Wheatland Riot, perhaps the most dramatic single event in this state's tangled history of farm labor. Two pickers, the sheriff, and the district attorney of Yuba County were killed after a grower sought to manipulate workers for profit. Ralph Durst had advertised for 2,700 laborers when he needed only 1,500. Thirty nationalities were said to be represented among the workers, and the two killed were from Puerto Rico and England.

Durst sought to take full advantage of the labor surplus, not a new ploy for Valley growers. As historians Walton Bean and James Rawls bluntly put it, "Conditions in his work camp were barbaric." The grower restricted drinking water in the 100-plus-degree heat and sold

lemonade; limited deliveries from Wheatland's merchants so that his ranch store could sell to workers; and provided inadequate sanitation so that some workers would leave before the season was over, thus allowing him to withhold 10% of their earnings. All these facts were revealed to a commission of inquiry appointed by Governor Hiram Johnson. Despite the workers' outrage at such circumstances, leadership was necessary to prompt organized resistance; it was provided by members of and sympathizers with the Industrial Workers of the World—the "Wobblies"—who called meetings and sought to organize resistance.

Local authorities—Bean and Rawls describe them as a posse—arrived from Marysville to break up a protest meeting and arrest agitators. When a deputy fired a shot into the air "to sober the crowd," violence erupted. Carey McWilliams asserts that "Wheatland was not a strike, but a spontaneous revolt." Predictably, two Wobblies, "Blackie" Ford and Herman Suhr, were arrested and convicted of second-degree murder, while Durst, who was as responsible for the tragedy as any other individual, was not punished. Nonetheless, the symbolic importance of the Wheatland Riot can scarcely be overestimated. "For the first time, the people of California were made to realize, even if vaguely, the plight of its thousands of migratory farm workers," McWilliams points out.

Twelve miles north of Marysville on the Feather River is Oroville, a Gold Rush town at the edge of the Sierra foothills. Originally called Ophir City, it was then a collection of tents that boomed in the late forties, busted in 1852, then boomed once more in 1856 when a canal brought water to the dry diggings. "This is a smart mining town, purely mining, surrounded by claims on every side," Brewer said of Oroville in 1862. It was here that dredging for gold began in 1898, and nearly $30,000,000 in ore was produced during the twenty years that followed. As many as forty-four floating-bucket elevator dredges operated on the Feather River at one time, and one company is reported to have offered to move and rebuild the entire town if it could have the right to the gold-bearing gravel beneath it. Today the site is best known for Oroville Dam, constructed in the foothills six miles northeast, and for its citrus groves, fruit orchards, and olive trees.

It is also known as the site of a significant ecological disaster that occurred on April 6, 1987. A fire raged through a Koppers Company plant, one that was already on the Environmental Protection Agency's Superfund list of the worst toxic spots in the United States. It had previously contaminated more than two square miles of groundwater with pentachlorophenol, or penta, a deadly chemical used to treat wooden poles. The plant was a proverbial disaster waiting to happen, and when part of it burned, the heat is suspected to have catalyzed and released dioxin, among the most deadly and persistent of all toxic chemicals, as well as a dangerous carcinogen, which was then spread by the wind over the surrounding area.

Sacramento Valley from 60,000 feet, looking north over the Sutter Buttes, 1968. USAF.

Old Farm Machinery, Ripon, 1987. Stephen Johnson.

For an impecunious county without a hazardous-materials team, it created a long-term problem. The wind reportedly carried 95% of the dioxin to the north, according to Bob Stephens, a state expert, while the remainder fell within six miles of the plant, which is now closed. Nearly five hundred local residents required treatment in the first few days. No one knows what the long-term health effects will be, but as Jane Kay points out, scientists "will continue to test the milk and eggs from Oroville, check the newborn calves for deformities and probe soils for dioxin contamination miles from the Koppers fire." Another sad reality of life in this economically beleaguered area is that many of the hard-working men and women laid off as a result of the conflagration don't blame the company; they blame the Environmental Protection Agency.

The fallout, both literal and figurative, from the Koppers fire symbolizes well the downside of technological development. The entire Sacramento Valley—like the rest of the Great Central Valley—must be constantly monitored: to the north, west of Redding, Iron Mountain Mine is an alleged toxic site; to the south, near Sacramento, both McClellan Air Force Base and Aerojet General are suspected of polluting the area.

Oroville Dam, thought to have been in the path of dioxin smoke from Koppers, is key to the California Water Project, the greatest endeavor of its kind ever funded by a single state and a major reason why the dry western side of the distant San Joaquin Plain and Tulare Basin are now covered with cultivated fields. Feather River water flows from this dam to the Delta, then south down the Valley's west side and over the Tehachapi Mountains into the Los Angeles Basin—a remarkable engineering feat, but also a classic example of water gluttony and political chicanery, according to critics.

Far to the west and north of Oroville, on the Valley's floor, wheat and barley were first grown in the late 1850s near Corning and Orland. Because virtually all rainfall locally was concentrated in the winter, only the dry-farming of grain was then commercially possible. By 1872 Dr. Hugh Glenn had produced a million bushels of wheat in one year from his own vast Sacramento Valley holdings. From 1874 until his death nine years later, Glenn, who owned 55,000 acres, was considered the nation's leading grain farmer. Hutchinson describes "great reapers drawn by as many as thirty mules each, moving like an army through the square miles of waving wheat. Threshing crews worked from sunup to dark, their cooks even longer; and the mountains of chaff rose high enough, it seemed, to tower above the Sutter Buttes." On the river, shallow-draft steamers called "dew-skimmers" carried Glenn's grain to San Francisco Bay and the world.

Today Corning is a major olive-growing center. From its tree-lined streets, on clear days one can see the massive volcano—as impressive in girth as in height—that dominates the Sacramento Valley for over a hundred miles south. "Before the night we saw Mount Shasta rising above the horizon, clear in outline, although its snowy crest was 150 miles distant in air line," wrote Brewer on April 14, 1862. Because it seems to rise like a great sentinel from the level plain, Shasta is the state's most impressive mountain. It looms 14,162 feet above sea level through flatland haze, a snow-capped shoulder of the Cascades; this massif has dominated American perceptions of the north Valley, as it did Indian visions. "Lonely as God and white as a winter moon," Joaquin Miller called it.

Many small towns are situated within view of Mount Shasta and nearby Lassen Peak—communities such as Anderson, Hamilton City, and Los Molinos—and visiting them may seem to strangers a journey into the past: Fourth of July picnics, outdoor dances, hayrides, and baptisms in the river. Morning coffee at the local cafe remains a tribal ritual. Those comforting realities do indeed endure in the Valley, as do less admirable traits such as restricted clubs and a persistent, sometimes dogged reluctance to consider possible negative effects of local agriculture. The farmers and businesspeople of these towns are so deeply in-

volved in the local vagaries of existence that they do not always see—or at least acknowledge—the larger picture: Could their Valley be in jeopardy? Could their own short-sightedness be a reason?

John Bidwell built Chico southeast of Corning on the site of a Maidu village. "Major Bidwell left the 'States' in 1840, and arrived here in 1841," Brewer noted on November 2, 1862. "He *is* Chico. He is very wealthy now, very public-spirited—owns a ranch of five leagues (over twenty-two thousand acres) of fine land in the Sacramento Valley, a large mill, store, etc., and is the spirit of the growing town of Chico." Called "a thriving little place" by Brewer in the 1860s, Bidwell's town is today still thriving but much larger, home of Chico State University and a center of regional commerce. In a pattern increasingly common in this Valley, it has grown beyond expecta-

tions, and nearly 100,000 live in "Greater Chico," spreading toward nearby Durham, with malls sprouting like concrete orchards on its periphery. "While we see Chico today as an awkward, ungainly, lubberly adolescent of a city trying desperately to find the core it once had, or a modern equivalent, Californiacs elsewhere see what we saw 40 years ago," recalled Hutchinson in 1986, forty years after settling here. "To them today, Chico is nirvana, a Shangri-la of bucolic simplicity, the Big Rock Candy Mountain of their childhoods." What newcomers find, however, is actually something other than small-town America, 1946.

This complicated community reflects its history and setting. And it is, of course, a university town adjacent to many natural wonders and set in a man-made garden. It is also a community where many old-timers distrust recent arrivals—"hippies and liberals," grouses a diner at a cof-

fee shop. Chico's old-time provincialism frequently bumps heads with its recent accelerated growth. But qualitative rather than quantitative change here most strikes Frank Viviano:

> The growth of what might be called "post-60's" communities in cities like Chico speaks to the aging of the generation that held center stage in that decade....These survivors of another era have seen many of their ideas become palatable to the larger middle class—especially and overwhelmingly, the ideas born of the environmental movement. Chico has some of the nation's toughest conservation laws as well as one of its first anti-nuclear statutes.

Chico is certainly built in an environment well worth saving. Almond orchards surround the community, and range cattle graze nearby foothills. In town, trout may be seen dimpling the water of Big Chico Creek where it crosses the university's wooded campus. On the community's edge, the same stream slices Bidwell Park, a recreation area of oak-studded, rolling hills, the streambed revealing layers of lava lying beneath topsoil.

Brewer and Company were much intrigued by the volcanic nature of the area. Tramping the region, they found themselves surrounded by ancient lava flows, hot springs, and cinder cones: the fire wall of the southern Cascades. "That whole part of the chain…is a gigantic, extinct volcano," Brewer observed. One nearby example of it, Lassen Peak to the east, would erupt mightily on May 30, 1914, in full view of Valley dwellers and continue erupting—over 150 events—throughout the next year. Brewer experienced sunrise on Mount Lassen's summit and, on October 5, 1863, described it in one of his most lyric passages.

> **The arch of dawn rises and spreads along the distant eastern horizon. Its rosy light gilds the cone of red cinders across the crater from where we are. Mount Shasta comes out clear and well-defined....The shadowy mountain forms rapidly assume distinct shapes, and day comes on apace.**
>
> **As we gaze in rapture, the sun comes on the scene, and as it rises, its disk flattened by atmospheric refraction, it gilds the peaks one after another, and at this moment the field of view is wider than at any time later in the day. The Marysville Buttes rise from the vapory plain, islands in a distant ocean of smoke, while far beyond appear the dim outlines of Mount Diablo and Mount Hamilton, the latter 240 miles distant.**

"We had anticipated a grand view," he wrote after returning from the climb, "the finest in the state, and it fully equaled our expectations." He

had viewed the entire Sacramento Valley—or as much as smoke and haze allowed—and it was a vision he would never forget.

Many years earlier, in 1817, a party of Spanish explorers led by Captain Luis Arguello ventured up the valley of the Sacramento as far as the Sutter Buttes. In that area, on May 20, Fray Narciso Duran, the chaplain, wrote in his diary,

> At about ten leagues to the northwest of this place we saw the very high hill called by the soldiers that went near its slope Jesus Maria. It is entirely covered with snow. They say that a great river of the same name runs near it and enters the Sacramento river, and they conjecture that it may be some branch of the Columbia. This I have heard from some soldier; let the truth be what it may.

Since there is no great snow-covered mountain presently visible to the northwest of the Buttes, historians amateur and professional have since speculated and debated over what, exactly, the Spaniards saw. Consensus is that, from a point ten leagues northwest of Sutter Buttes, scouts probably glimpsed the 10,400-foot Lassen Peak, but it is also possible that they had sighted California's most imposing peak, Mount Shasta itself, looming some seventy miles farther north.

That higher peak is certainly visible from the area between Chico and Red Bluff to the north, where one of the Valley's more interesting ghost towns, Benton City, is today marked by a monument. It was laid out in 1847 by Peter Lassen on his 26,000-acre Rancho Bosquejo. He named the community after Missouri Senator Thomas Hart Benton, whose daughter Jesse Benton Frémont played a considerable role in California history. Lassen lived here and brought the first Masonic charter to the state, but the community never progressed beyond a partial survey of town lots.

From the riverboat, about seven miles north, in the area of Tehama, Brewer sighted the rest of his party, its overland division, camped on the Sacramento's bank, and he was assured that the Geological Survey team would indeed reunite—"three hundred miles above Sacramento by the river, but only half that distance by land." He disembarked from the steamer in Red Bluff, a town that spreads along the river high on rosy banks, and a major trading center in the upper Valley. It was here that the erstwhile president of the Bear Flag Republic, William B. Ide, built his Rancho de la Barranca Colorado, for which the town was named. Brewer described the community as "a stirring little town of a few hundred inhabitants—saloons, taverns ('hotels'), and corrals being the chief features, for here pack trains and teams start for the whole northern country, Oregon, etc. But, oh, how hot it is!" Heat, indeed, is a characteristic of the Valley, north as well as south—and cold can be too; in 1990, Red Bluff recorded a summer high of 117° and a winter low of 14° Fahrenheit.

Bridge, Sacramento River at Redding, 1986. Robert Dawson.

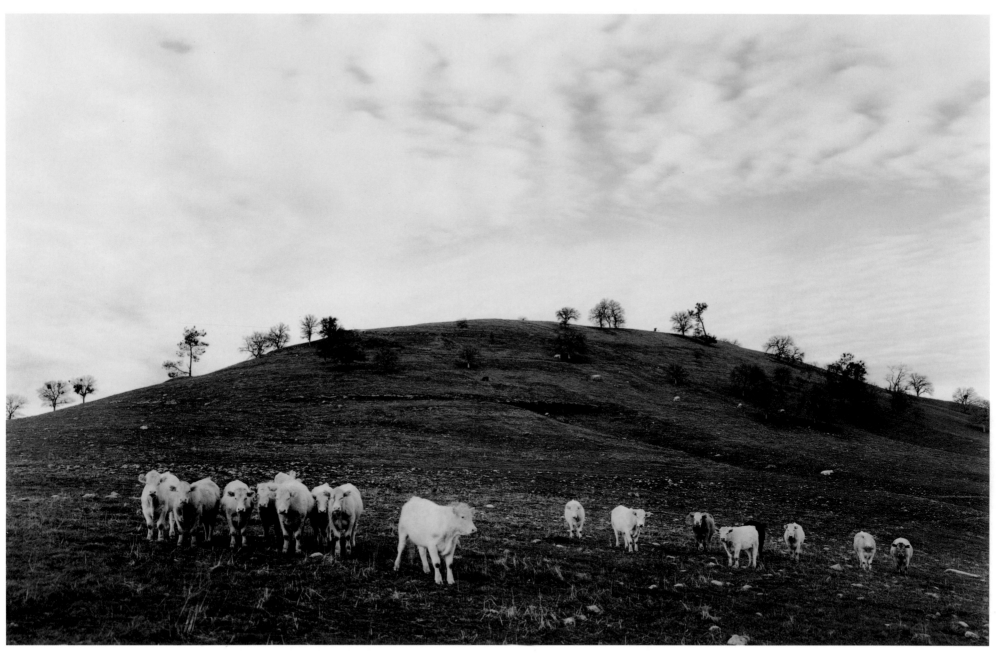

Assembled Cattle near Valley Springs, 1984. Robert Dawson.

The great river's chilled water mitigates the summer's heat, but far more important has been its commerce: Red Bluff thrived as a shipping center when the Sacramento River was the state's major inland transportation artery. Now Interstate 5, the freeway that runs along the town's edge, carries the bulk of traffic, commercial and otherwise, and Red Bluff remains a pretty, old-fashioned community not yet swept by the rapacious growth that increasingly fills California. The plain of the Valley is narrowed here by volcanic encroachment, but widens to the north until it is again some thirty miles across.

Redding is the Valley's northernmost large town. One hundred and sixty miles north of the Carquinez Strait, where the Sacramento River enters San Francisco Bay, it is located on rolling land at the edge of the Cascades and is bisected now by the interstate highway. Because of its site at the Valley's top, near Lassen Park and the Shasta-Trinity National Forest, as well as Shasta Dam and the huge lake it impounds, Redding has become a major tourist center and remains a shipping point for ranching, farming, and mining interests.

The town's name illustrates an odd coincidence, or perhaps the importance of rail lines in the Sacramento Valley: although situated within the boundaries of the northernmost Mexican land grant, Pierson B. Reading's Rancho Buena Ventura, the municipality's moniker actually refers to a land agent for the railroad, B. B. Redding, not the rancher.

One of the Valley's most vital entities, Shasta Dam, is not actually located in this great trough. It is set in rising mountains ten miles north of Redding, and among other streams, it blocks the Pit, McCloud, and Sacramento rivers. This is one of the world's largest dams—602 feet tall, 3,500 feet long—and it impounds the reservoir known as Lake Shasta, which encloses 29,500 acres within 365 miles of shoreline. It also contains the largest hydroelectric plant in the state and, more important, is the linchpin of the vast Central Valley Project.

The CVP, as it is often abbreviated, utilizes northern waters in a hopscotch fashion—Sacramento River flow replaces Delta water sent south to irrigate the much drier San Joaquin Plain and Tulare Basin, allowing former deserts to bloom. Said another way, the thirty inches of rain that fall annually in the Valley's north end—plus, of course, snowfall in the southern Cascades and northern Sierra—are eventually shared with places in the Tulare Basin, where a mere five inches is common.

Authorities had long recognized that the Sacramento Valley contained only one-third of the Great Central Valley's arable land but two-thirds of its water. It seemed to them that millions of acres of potential farmland could be found in the Valley's dry southern reaches, while the Sacramento River annually poured billions of gallons of "wasted" water through the Golden Gate into the Pacific. The technological challenge was obvious and led to solutions so successful—in the short term, at least—that environmental scientist

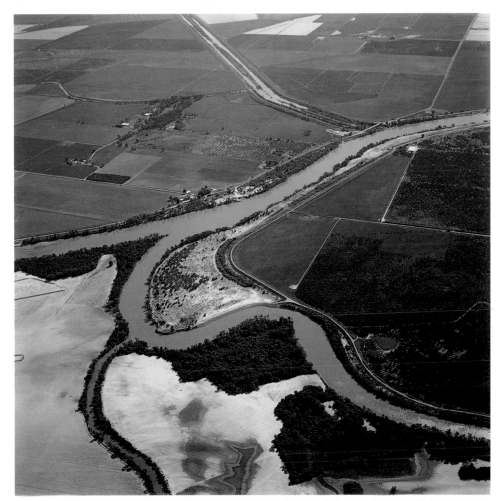

Sacramento River and Farmland, 1985. Robert Dawson.

Garrison Sposito calls this Valley's fertile fields "one of the gems of Western Civilization."

Donald Worster does not necessarily disagree with Sposito, but he is less than enchanted with the Central Valley Project, asserting that it "threw a little water and a great deal of electrical power at many consumers to enlist their support, but primarily it was, in design and rationale, a faucet for irrigation farmers." In his view, the project is an extension of the Bureau of Reclamation's own life and ambition, not California's need. "As a bureaucracy, it wanted first to survive and then to augment its own power. Its natural ally was whoever held power in rural California, and that meant the farm owners, not the laborers." As such, it may stand not only as a monument to modern technology but as

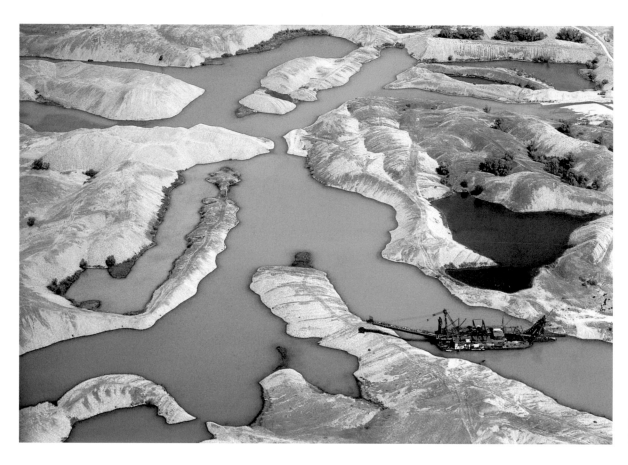

Dredge and Tailings near Feather River, 1985.
Stephen Johnson.

an appropriate symbol of the Valley's traditional—conservative, some say self-serving—social and economic order. However, that social order is slowly changing.

As one gazes back from the rising land between Shasta Dam and Redding on a summer day, the Sacramento Valley lies burnished below, with a spiral of smoke to the west where rice stubble is being burned. The river's channel is a serpentine forest winding through the prairie, and dark clusters of trees mark farms and communities. The north Valley is far more than a technological miracle and an agricultural bonanza. It is finally a place where people choose to live, to raise their families, to die, a place where experience tempers change. It is not without problems. Smog is an increasing threat. The region's traditional ethnocentrism is being menaced by the reality of southeast Asian immigrants, plus growing latino and black populations demanding their own fair share of the American Dream. Farm economics remain volatile here as elsewhere.

The Sacramento Valley retains its own varied sense of the past, its own unique sense of the future. As publisher C. K. McClatchy, scion of a pioneering family, told Stephen Birmingham, "The Valley has *kept up* with its history like no other place I know of. Just go and stand on the rim of the Shasta Dam and see the thing that is the source of so much that has happened in the Valley, and beyond it, and you'll see what I mean, why I find this Valley—plain and flat and conservative as it is—one of the most thrilling places to be alive in that I know of."

It is indeed a place where people live—fourth-generation Anglo farmers in Willows and newly arrived Hmong teenagers in Chico, desperate black parents in Del Paso Heights and comfortable white burghers in Sacramento—a twentieth-century Californian mosaic that is neither as bucolic nor as parochial as outsiders imagine.

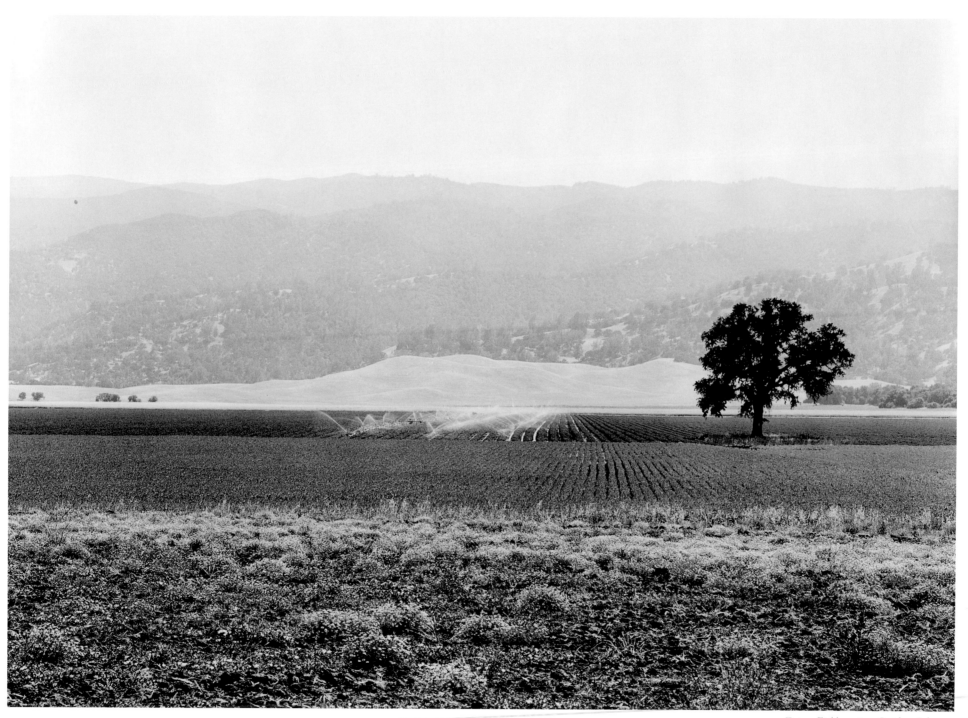

Capay Field, 1982. Stephen Johnson.

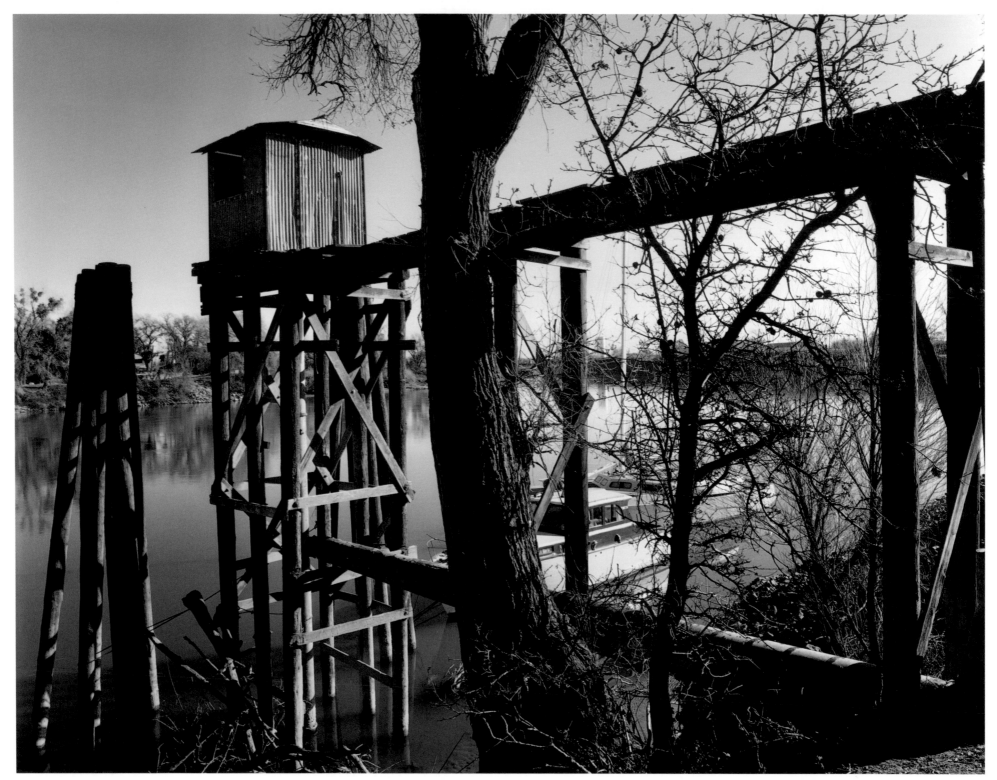

Irrigation Works, Sacramento River, Broderick, 1985. Robert Dawson.

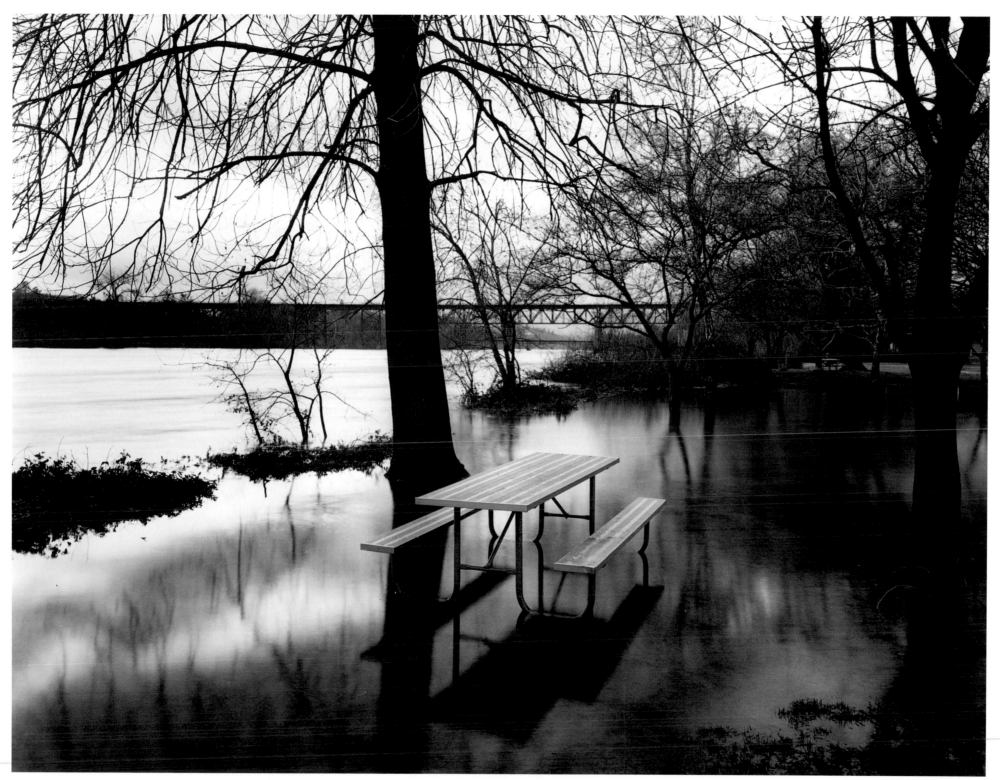

Flood, Sacramento River near Redding, 1985. Robert Dawson.

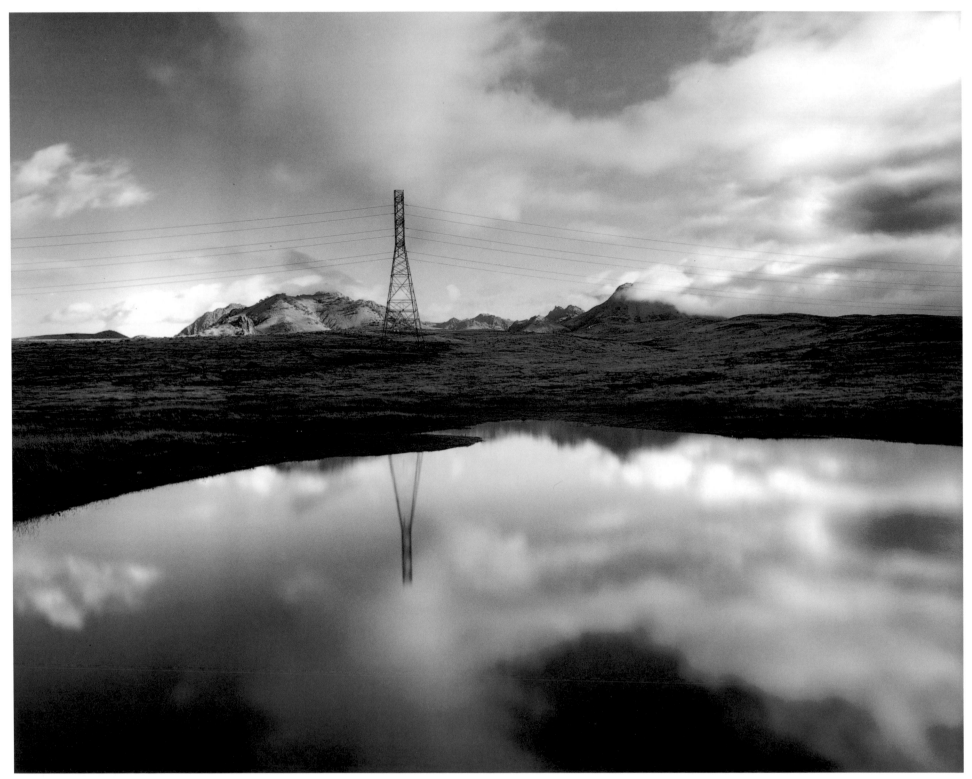

Sutter Buttes, 1985. Robert Dawson.

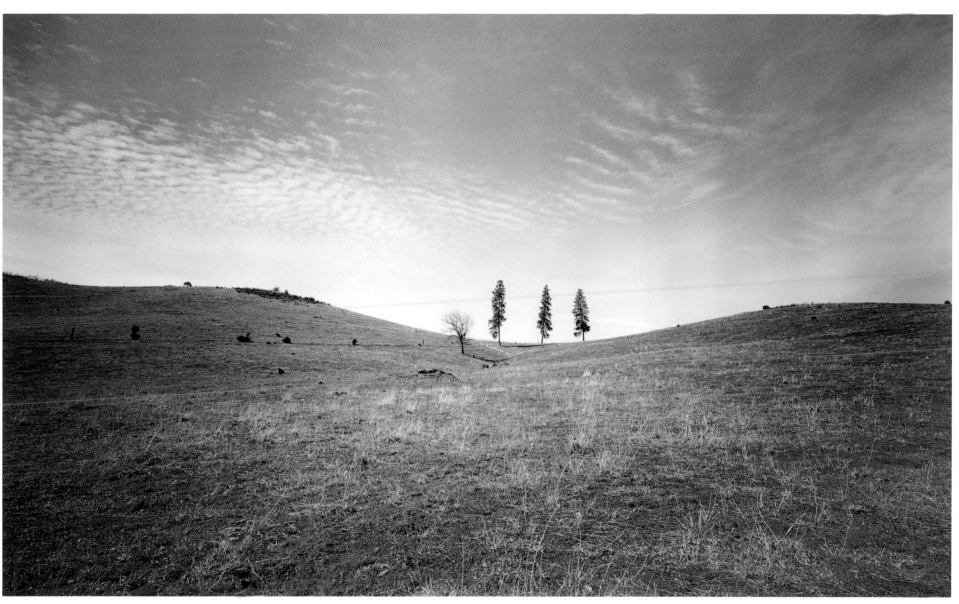

Hills and Trees near Wallace, 1982. Robert Dawson.

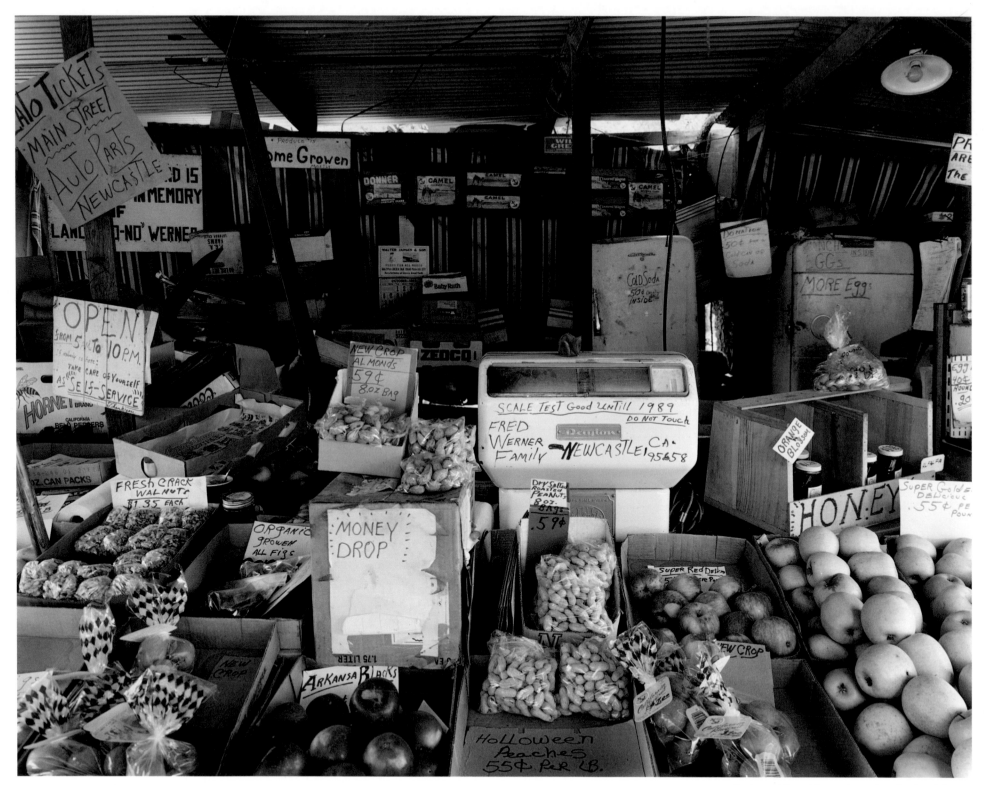

Fruitstand #33, Newcastle, 1985. Stephen Johnson.

Industry, Lincoln, 1985. Stephen Johnson.

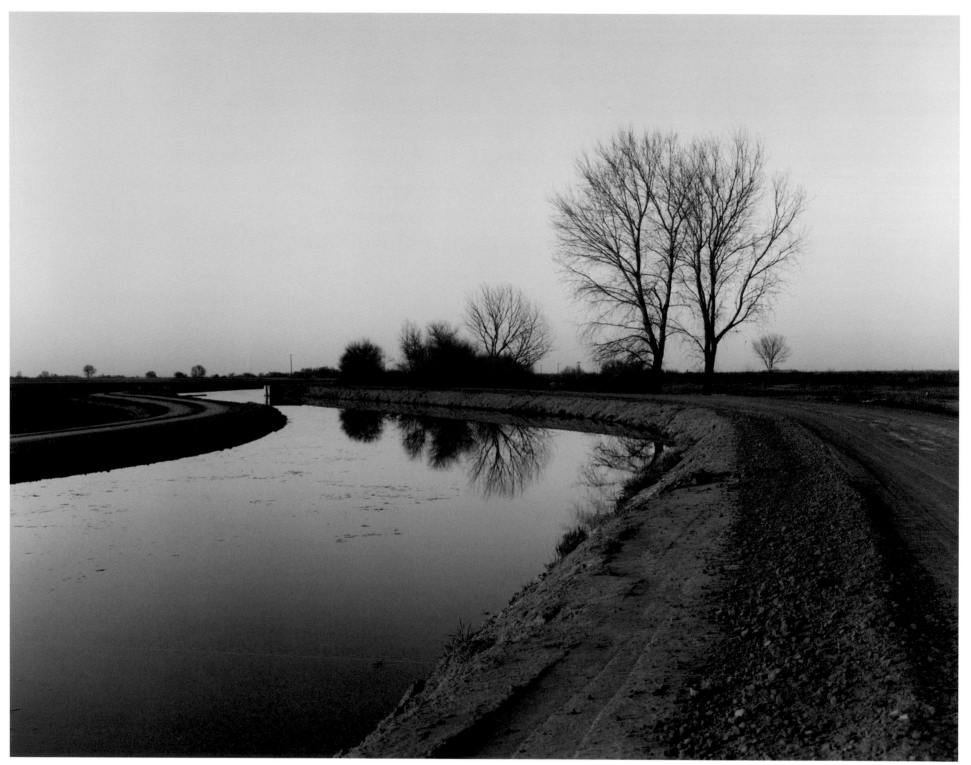

Canal, San Joaquin River, Fresno County, 1984. Stephen Johnson.

Chapter V: The San Joaquin Plain

The San Joaquin (pronounced *San Waugh-keen*) plain lies between the Mount Diablo Range and the Sierra Nevada—a great plain here, as much as forty to fifty miles broad, desolate, without trees save along the river, without water during nine or ten months of the year, and practically a desert.

William H. Brewer, October 13, 1861

The geological survey party first ventured onto the then-forbidding San Joaquin Plain almost accidentally. After visiting the house of Dr. John Marsh near Mount Diablo in 1861, they sought to explore the surrounding hills and canyons, but found the Diablo Range too rugged. Instead, they veered onto the flatlands to the east, an area near Altamont Pass. That locale now contains the largest wind farm in the United States, an example of innovative, low-impact technology. It captures coastal zephyrs sucked into the Valley when heated air rises in the interior, and various configurations of large windmills—over 4,000 of them—stand today against the sky like monuments to fallen giants.

"There's no question that wind power has moved beyond the experimental stage," points out Charles Imbrecht, chair of the State Energy Commission. "It's clearly a proven technology, and it has been for years." This state produces nearly 90% of the world's wind power, enough energy annually to meet all the needs of San Francisco, so "gust-catchers," as some locals call them, are producing one more important crop.

Long before those computer-monitored blades began twirling in Altamont Pass's considerable drafts, Brewer recognized the region's major characteristic: "The wind is roaring down the canyon, a stiff breeze, and not comfortable for sleeping." The young men of the geological survey party, still new to California, were most impressed and somewhat depressed by what they saw as they ventured onto the San Joaquin Plain for the first time; its very size astounded them as they edged along its west side: a vast, bleached veld opened up just beyond the San Joaquin River's riparian forest.

The area's indigenous wildlife in particular merited notice. The plain "is unhealthy and infested with mosquitoes in incredible numbers and of unparalleled ferocity." And those beasts weren't the most threatening: "The dry plain…abounds in tarantulas by the thousands." Delighted to escape such menaces, the youthful scientists—still dudes, after all—soon returned to the relative safety of coastal valleys near the bay.

Less than a year later, Brewer and company once more ventured into the region and, in that wet year, it was forbidding in a different and unexpected way. Although the rainy season was well behind them, all the Valley's rivers were engorged with Sierran snowmelt from the previous winter's record-setting precipitation; even in June the group could not cross the swollen San Joaquin River: "To get to Stockton was practically impossible," Brewer noted.

The survey party's scheme had been to work its way down the Diablo Range along the Valley's western edge, cross the river, then bisect the prairie—unbroken for nearly sixty miles there—to meet the leader of the geological survey, Josiah Whitney, at the first foothills of the mighty Sierra Nevada range on the east. The plan had to be abandoned because the young men, from very different climes than this, simply had not imagined that flatland streams could be so enlarged and roiled during the rainless season; they did not yet understand the long-term effect of melt from the previous winter's snowfall in distant mountains. Nor were they prepared for the expanse of the plain itself.

Here the San Joaquin River edged along the west side of the great inland realm—no stream divided the prairie as in the Sacramento Valley, no large lakes broke its surface as in the Tulare Basin, nothing relieved the broad, level perspective: this region was dominated by the vast parched *llano,* as the Spanish had called it—the flatland itself—shimmering with mirages during summer, obscured by dense fog during winter. It was a region few considered beautiful, and Brewer's group found it not only unattractive, but impossible to cross. "The morning was peculiarly clear. The plain looked like the sea, or rather a bay, the snowy Sierras seemed scarcely ten miles distant, instead of sixty to a hundred as they really were. We passed out upon the plain."

Most years traversing the prairie would have been a plausible strategy, although the region did flood annually, producing one of the most productive seasonal wetlands in the state. The river overflowed its banks each spring, producing vast puddles as much as fifteen miles across.

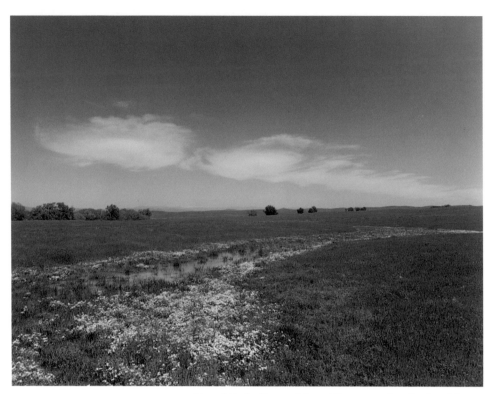

Vernal Pools, Eastern Merced County, 1983. Stephen Johnson.

Countless geese and ducks, plus other waterfowl and shorebirds—herons, egrets, rails, and bitterns, for example—swooped onto the resulting marshes. Today it is only at private hunting clubs, such as those affiliated with Ducks Unlimited, and at public wildlife preserves, such as the 3,200-acre Los Banos Refuge, that remnants of the San Joaquin's virgin wetlands can still be found on the drained and cultivated plain. These preserved stretches of the Valley as it was before development remain small wonderlands.

During the waterless season of 1983, naturalist David Rains Wallace explored one such reserve, San Luis Island in Merced County. "I spend the afternoon walking southward," he wrote, "through an almost uninterrupted green grassland. There's nothing but grass, sky, and a few clumps of iodine bush before me, no orchards, plowed fields, grain elevators, utility lines, or other artifacts of valley civilization." Wallace also observed examples of a unique phenomenon of Valley grassland:

> *A patch of blue catches my eye in the grass. I turn and find a vernal pool in full bloom beside the road. The cracking mud bottom of the recently dried pool is covered with* Downingia, *heavenly blue flowers (marked with*

yellow and white) characteristic of vernal pools. They share the mud with a bewildering variety of exotic-looking, bright green plants—a plantainlike grass; a big, spiky plant not yet in bloom; tiny mosslike quilworts; and pillworts and liverworts. Around the pool's edge is a yellow ring of goldfields, a miniature sunflower relative, mixed with white popcorn flower and yellow owl's clover.

Explorers and early settlers of the Great Central Valley noticed that it was filled with flowery depressions of various sizes. Some called them "hog wallows." Despite that unpromising nickname, vernal pools, with their rings of varicolored flowers, constitute a unique, dazzling, and, unfortunately, threatened environment. As naturalist Helen Witham explains, "With luck you may find one that shows four or more distinct bands or rings, since each micro-elevation of a few inches has its own special plants which flower in profusion, and all at once." The bands are formed by gradually evaporating water, which allow small communities of plants to blossom. These small plant communities mirror the Valley's original botanical complexity.

Even vernal pools were flooded in 1862, so Brewer and his mates could not penetrate far into the seasonal wetland. Instead they traveled south down the west side, a zone that would remain unknown even to most Californians until Interstate 5 opened during the 1970s. Theirs was a route similar to the one followed by Gabriel Moraga in 1819, when he had sought possible mission sites. Brewer's company edged along the plain with emerald hills on their right—hills that would soon turn tawny. To their east lay the swollen San Joaquin River, where Moraga had earlier in the century observed Indians fishing, and where Brewer's group found all fords impassable; beyond opened the vast, preternaturally green savanna.

Near here the town of Tracy would be platted in the early 1870s by the ubiquitous Southern Pacific Railroad. Eventually a barge canal would also extend from Tracy to the Delta and the Bay, canneries would be built, and it would become a crossroads and a major stop for truckers. Today this area east of Altamont Pass illustrates an unexpected phenomenon: here California's populous coastal strip is visibly spilling into the Central Valley.

Communities such as Tracy, Ripon, Manteca, Patterson, Stockton, Turlock, and Modesto are experiencing surging growth fueled in large measure by commuters willing to travel across two ridges of the Coast Range to work each day in the Bay Area. Sixty-two percent of all commuters leaving Modesto in 1988 were heading for jobs in the Bay Area.

Early in 1990, Doyle Dodd, executive director of the Stanislaus Area Association of Governments, wrote a letter to Bay Vision 2020 suggesting that his county be included in future planning decisions because "it is our feeling that any consideration of 'Bay Area' can no longer be limited to the traditional nine counties."

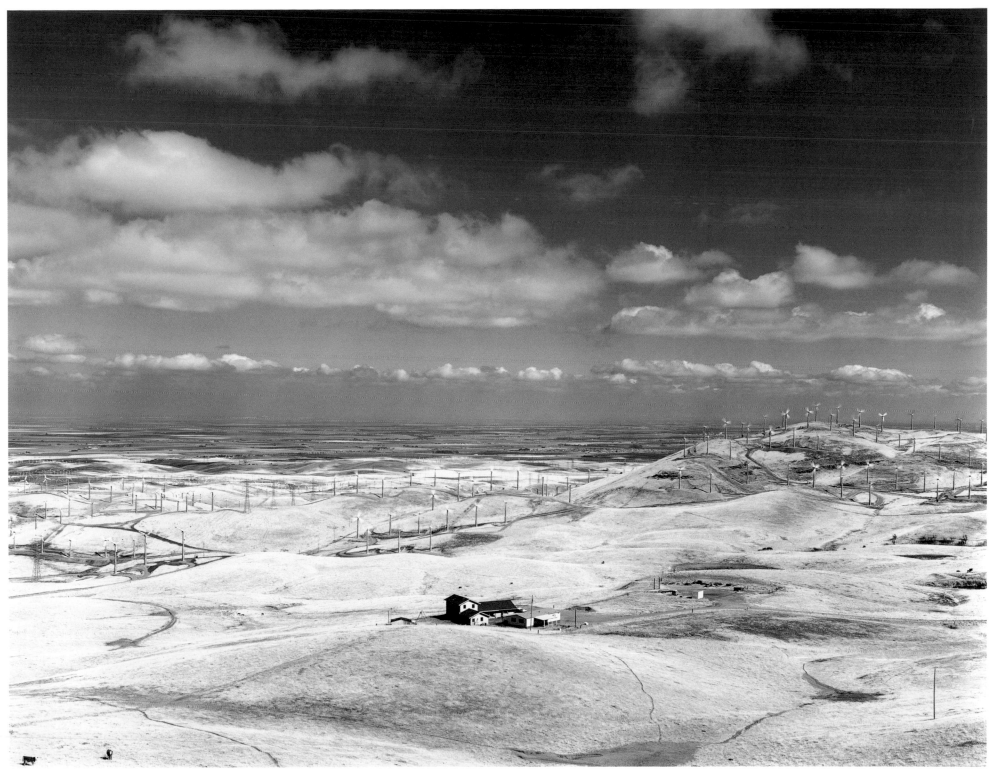

Farm and Windmills, Altamont Pass, 1986. Robert Dawson.

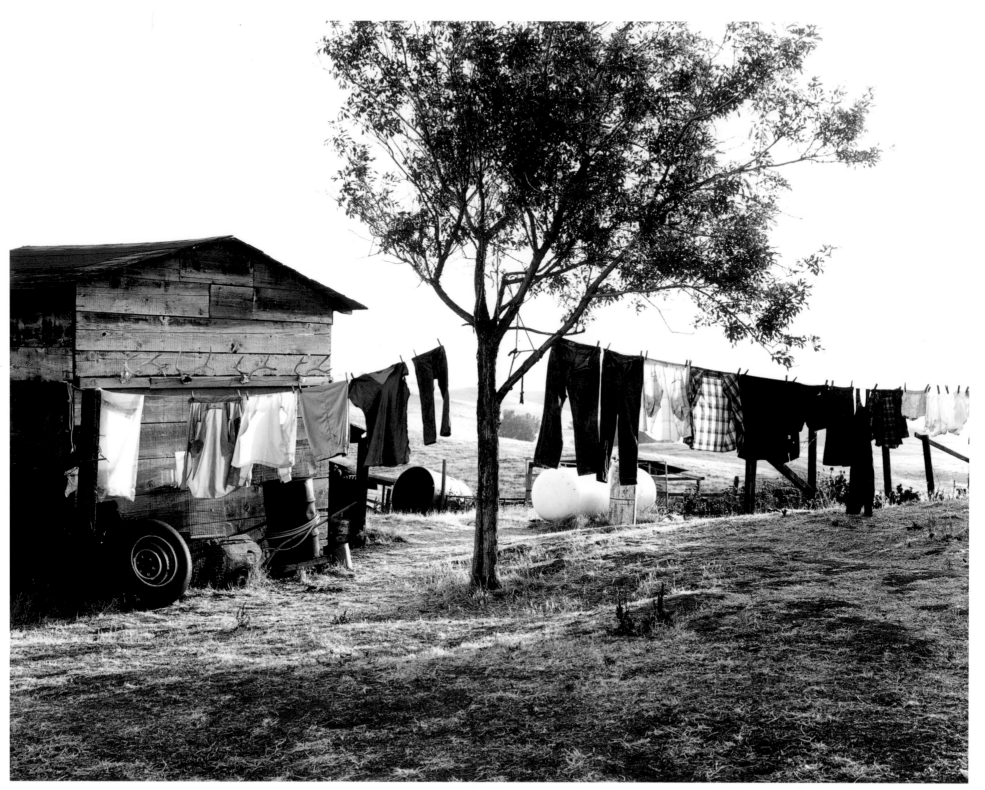

Yard, Le Grand, 1984. Stephen Johnson.

Why is this redefinition of region taking place? "The farmers are selling and the developers are buying and the commuters are moving in," explains Brad Bates, mayor of Turlock. By early 1990, 5,000 acres of land in the Stockton area alone were being covered with new subdivisions. With the average price for houses in the Bay Area swelling to over $200,000, many families were roaming far afield to find affordable domiciles. Sheridan Beuving, a Modesto real estate salesman, explains, "We have a rule of thumb that for every extra mile you drive to the Bay Area, you save $1,000 in the price of a house."

One commuter, Dave Masterson of Ripon, works in faraway Sunnyvale, and he says that beyond lower prices, he likes the quality of life in the Valley: "It's nice to be able to walk down the street and wave at people you know." Not everyone waves, however, since the new, relatively affluent commuters add one more dimension to the existing social and economic tension.

Longtime working-class and poor residents alike, many of whom are Hispanic, have seen local housing prices rise dramatically and are, as a result, that much farther from their own hope of owning a home. "I see a lot of class tension in these areas," observes Alex Saragoza, a professor at U.C. Berkeley. "It's a growing rigidity, a stronger series of bound aries between the kids who come from the different groups."

Even those problems haven't slowed the process down. "Populations in most towns in southern San Joaquin County and northern Stanislaus County," reports John Flinn, "have swollen by nearly 50% since 1980." In a sense, the communities are already realigning themselves, beginning to leave the agricultural Valley and to join the industrialized Bay Area without physically relocating. That, in turn, challenges previous economic, geographic, and demographic assumptions: What is the Valley? Where is the Bay Area? "Whether we like it or not, our region is now far more closely linked to the Bay Area than it is to the rest of the Central Valley," asserts Modesto's mayor Carol Whiteside.

In 1862, when overpopulation was unimaginable, Brewer's party struggled to leave the hills of the Diablo Range and cross the swamped plain to Stockton, an island of semi-civilization in a relatively lawless land. A decade earlier, that community had witnessed one of the most celebrated—although perhaps apocryphal—events in the state's history. The famed bandit Joaquin Murrieta is said to have ridden into town from the San Joaquin and spied a poster offering $5,000 reward for his capture, dead or alive. In full view of the populace, or so the story goes, he crossed the figure off and wrote below it, "I will give you $10,000—Joaquin."

The hills and plains over which the geological survey party traveled were in those days still considered "the grand retreats of the desperadoes of the state," according to Brewer. The young scientist confided that "knife (newly ground) and six-shooter are carried 'so as to be handy.'" It is unlikely that even such armament would have protected them a decade earlier when Murrieta and at least four other Joaquins had ridden through the Valley as freely as Yankee fur trappers had before them. They even established semi-permanent camps in the western hills. There was good reason for this: while habitable reaches of the Sierra Nevada bordering the Valley's east side had been largely penetrated by miners seeking gold, the western range remained dry and little-settled, "a labyrinth of ridges, furrowed and separated by deep canyons…almost a *terra incognita*," wrote Brewer.

The hidden canyons of those mountains had long served as sanctuaries for outlaws of all sorts, and it was there that Murrieta (the name is spelled several different ways in records) and others divided spoils, branded stolen horses, or laid low. In Arroyo Cantua near Coalinga, south of where Brewer and his party camped, Captain Harry Love and his "California Rangers" in 1853 jumped a group of Mexicans and killed a man whom they identified as Murrieta, as well as another fugitive known as Tres Dedos (Three-fingered Jack). They decapitated the former and cut a hand from the latter, and used those items as proof that they had indeed dispatched the bandits.

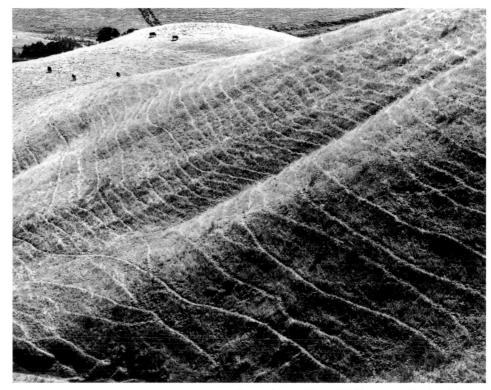

Cowtrails near Mount Diablo, 1982. Stephen Johnson.

Recent studies cast considerable doubt on Love's claim since, as Frank Latta has written, "all who had known him [Murrieta], *including the California Rangers,* describe him as blonde (or *huero*), with blue eyes, light brown hair and fair skin." The head used by Love and company to collect the reward was from an Indian, dark-skinned and dark-haired, claims Latta; it may have belonged to a hapless *mozo* named Chappo. Since that famous noggin—pickled in a clear jar—was displayed in San Francisco for many years thereafter, there exists no question about its complexion.

Or does there? Recently William Secrest has consulted historical newspaper accounts and has himself offered compelling evidence that the bottled head was in fact that of a fair-skinned man, and that it might have belonged to Murrieta, but he suggests still another possibility:

> *Although a case certainly could be made (as Latta did) that Murrieta had not been killed by the rangers, it is impossible to reconcile those contemporary descriptions with Latta's contention that the head was the Indian Chappo's. Far more likely than the Chappo scenario is the possibility that the head belonged to one Joaquin Valenzuela.*

And who was Valenzuela? He was one of the "five Joaquins" Love's Rangers were empowered to bring in dead or alive, a notorious bandit in his own right and a man frequently confused with Murrieta in news reports of the time. *Quien sabe?* Of such confusion are legends born.

California Grizzly Bear, 1850. Charles C. Nahl. Coulton Hall Museum, Monterey.

Harry Love—himself later killed in a gunfight—can, in any case, be credited with helping create the Golden State's most famous legend, since there were reports of Joaquin (or at least of *some* Joaquin) being seen all over the Valley after his "death," and many an old-timer has told true—or at least truly believed—stories about the famous bandito ever since ("My grandmother didn't lie, and she said…"). The 1854 publication of *The Life and Adventures of Joaquin Murieta, the Celebrated California Bandit,* a fictional account by John Rollin Ridge, codified the core of California's version of Robin Hood.

Not only outlaws were hunted in the San Joaquin; its abundance and variety of game amazed early visitors. "Once we came upon a herd of thirty or forty antelope, a kind of small deer," wrote Brewer in 1862. "They are most beautiful and graceful animals, with slender legs, large ears, and erect heads." Over the prairie's level surface, perennial bunchgrass was the major cover. Across the grasslands, three large ruminants grazed: pronghorn "antelope" (not a true antelope) and tule elk were lowland natives, and mule deer roamed down from the foothills. By 1844 John C. Frémont reported substantial herds of wild horses in the San Joaquin area, especially the west side. A. B. Clark visited the Valley in 1852 and wrote: "I have no where seen game as plentiful as in this valley. We killed an antelope in the morning. We could frequently see herds of deer and elk in different directions around us, as well as wild horses." The latter, like the ubiquitous European annual grasses that by then constituted much of their feed, were inadvertent Spanish donations to the region. On occasions, early settlers reported seeing mixed herds, like those observed on the African veld, grazing the grasslands.

The fate of those great herds was predictable once American settlement of the Valley began in earnest. Pronghorns had flashed across the prairie, but, despite their fabled speed, they were especially vulnerable. Fences, habitat destruction, and their inability to outrun bullets all contributed to their demise. Wrote T. S. Van Dyke in *The Deer Family,* "By 1875 the antelope were a curiosity on the great plains, where so many thousands lately glimmered through the dancing heat....By 1885 only one band was left, and that in the upper part of the valley, some twenty miles from Bakersfield." The last pronghorn in the Central Valley was seen and, of course, killed during the 1920s. In the late 1980s a small herd was reintroduced on the Carrizo Plains west of Taft.

Indigenous elk fared little better, as Van Dyke explains: "Elk retreated from the open plains with the advent of the American, and hid in the vast tule swamps....Here they made great trails that ramified until lost in myriad mazes, while hogs that had gone wild made it extremely interesting for the hunter who dared enter on foot." Of course, the tule swamps themselves were doomed and when they were drained

and cleared, the large ruminants were killed off too. Soon "elk were almost as rare as the great tule swamp that so lately seemed inaccessible," writes Van Dyke. A few elk were saved on a small reserve in the Valley's southwest corner, near Taft.

The intimate interrelationship between predators and prey was obvious to early observers in this area. While camping on the banks of the Kings River, near present-day Reedley, in 1848, John Woodhouse Audubon made the following entry in his diary:

> Today I ran on to herd of about 1000 elk; so close was I that I could see their eyes perfectly; these elk must be greatly harassed by wolves, which are very numerous, and so bold that we have had several pieces of meat, and a fine goose stolen from over my tent door. Their long, lonely howl at night, the cries of myriad of wild geese…and the discordant note of the night herons, tell the melancholy truth all too plainly, of the long, long distance from home and friends.

Audubon's howling canines were almost certainly coyotes (called "prairie wolves" in those days) and they were indeed prime predators, as were mountain lions and bobcats. Although a few reliable reports of true wolves in the Valley exist, those major canids—probably gray wolves—appear to have been visitors, not significant elements of the ecosystem. Large ruminants were also occasional prey—more commonly carrion—for black bears browsing down from surrounding hills. But the principal predator, one that would even prey upon the other carnivores, was the grizzly bear, eventually designated as California's state animal.

Grizzlies were the Valley's most conspicuous predators. Immeasurably more dangerous and audacious than bobcats or coyotes or even black bears, the great grizzlies were marked for extermination as soon as Europeans entered the region. They were good to eat—bear jerky was a particular treat—and also threatening, so their population was soon decimated, exemplifying the fate of many species—even members of our own—that have impeded development during the American era. "Perhaps few animals have suffered more from persistent and relentless warfare waged by man than this formidable bear," wrote the zoologist Henry Henshaw in 1876. No living specimen of the state animal has been sighted in California since 1927, and none has been reported in the Valley since the nineteenth century, leaving humans unchallenged as the area's most dangerous animals. It was not always so: Brewer recalled, "The event of the day was their meeting, in a narrow ravine, a large she-grizzly with a cub….Both parties escaped unharmed; the two bears leisurely climbing the steep bank of the ravine on one side, the geologists climbing, less leisurely by far, the steep bank on the other side."

Large creatures have not survived American incursion here. Smaller animals have fared somewhat better; coyotes retain a niche, as

Cattle, Hilmar, 1984. Stephen Johnson.

do bobcats and foxes. The guns of hunters or the alteration of environmental conditions have decimated large predators and prey alike. Smaller ones have more commonly been threatened by destruction of natural settings; as ecologist Ann Sands reports, "In an area where I used to see 15 or 20 species of birds, I would see only three or four species. It wasn't people shooting the birds that was causing their disappearance, it was habitat destruction."

To further explain, she points out the abundance of "trash birds," such as European starlings or English sparrows, imports that now seem to fill the Valley, owing in part at least to the fact that they have few natural enemies.

> They push more rare species out of the system. People don't realize that diversity of wildlife is needed. The concept of genetic diversity is important, not only for wildlife but for all living things….If we keep the diversity alive, we're more likely to be able to see all species survive. Threatened species are considered indicators of a system. When you lose them, it's a sign that the system is beginning to unravel.

The system to which she refers is, finally, the web of all life.

As a result of both trapping and habitat destruction, the two species that had prompted the initial American penetration of the region, the golden beaver and the river otter, were in grave jeopardy by late in the last century, but strict control of further trapping, plus the protection of some remaining habitat, have so far saved them—albeit in considerably reduced numbers and with a markedly limited range. Today, many species show the effects of environmental toxins and destroyed habitats, and it may be that like the grizzly and antelope before them, the California condor of the Temblors—with a wingspan of nearly ten feet—and the lowly mud hen of Kesterson Reservoir—with a wingspan of slightly over a foot—are omens for the human beings who now fill the Valley. No one knows the outcome, but this may be one hidden price for the greatest garden in the world.

Jessie Stahl Riding "Glasseye" at the 1916 California Rodeo. Photographer Unknown.

It was not yet a garden in 1862, and Brewer's party could find no place to cross the swollen San Joaquin River, so they followed a southern route, parallel to the line of present-day Interstate 5, venturing into the Diablo Range, then out onto the plains once more, seeking campsites and better footing. An introduced ruminant could be observed clustered on dry areas of the Valley's floor, and the young geologists saw evidence of an industry that was to remain important on the west side for nearly a hundred years: "Tens of thousands of cattle are feeding, but they are but specks save when they cluster in great herds near the water."

Eventually, as more and more land was reclaimed by irrigation and turned into agricultural fields, cattle would be forced onto the Valley's periphery, principally its eastern and western foothills, while farmers plied the flats. A major crop on the plain today is alfalfa, which is sold as hay to feed stock on hills now denuded by grazing. As environmentalist Christopher Swan suggests, "A century of cattle and sheep grazing has resulted in a near wasteland and the development of the feedlot as a more cost-effective method of raising stock." Indeed, today, the state's largest feedlot may be found at Harris Ranch on the Valley's west side, not far south of where Brewer and company trudged.

During the days of great cattle herds on the plain, it was vaquero country: "It takes many *vaqueros* to manage them, all mounted, and with lassos," Brewer observed at a roundup of those nearly wild cattle. Until recently, one man remained a living link with that fabled time. Arnold R. "Chief" Rojas—who rode for J. J. Lopez on Rancho Tejon, rounded up range stock from the vast holdings of Miller and Lux, and doctored horses on the ranges of the Kern County Land Company—lived to see this region, one of America's great cattle kingdoms, become first an agricultural larder, then increasingly urban.

"Except for the lupines and poppies, which covered the Valley in the spring, the country was semi-desert," recalled the ninety-year-old vaquero in 1986. "No one ever thought it would one day be covered with orchards and vineyards. But," he added, "today there are too many people."

If ever a waddy "saw the elephant," it was Arnold Rojas, and he was writing his eighth book about the world of California's vaqueros when he died in 1988. Those riders patrolled ranges seldom mentioned in popular western novels, and few motion pictures feature them, so the general public knows little of their lives and accomplishments. Yet their skills are recognized as having been considerable—perhaps the best—and Brewer observed upon encountering some in 1861 that they "gave us some fine specimens of horsemanship and lassoing." The irony is that at the very time early in this century when Hollywood was beginning to produce western movies, vaqueros still rode the Tehachapi Mountains and Great Central Valley not far to the north.

In the Tehachapis, cattle and sheep grazed the canyons and meadows of Edward Fitzgerald Beale's vast Rancho Tejon. A few miles far-

ther lay the southern reaches of the Valley and the gigantic ranches of Miller-Lux and Haggin-Tevis (later called the Kern County Land Company), which extended far north on the plain. And of course there were many smaller—though not necessarily small—ranches throughout the Valley. Its southernmost town, Bakersfield, early became one of the West's "feeder cattle" centers, surrounded by feedlots and populated by cattlemen and livestock brokers from throughout the Southwest. Vaqueros and cowboys rode its streets and enlivened its saloons for many years.

Despite his advanced years, Arnold Rojas spoke easily and well, his wisdom carried lightly. He had talked to men who claimed to have ridden with the fabled Joaquin Murrieta, and with others who said they ate ostriches and rode camels on Rancho Tejon; still others had seen La Llorona, the fabled weeping woman, on Carrizo Plain. And he had seen numbers of California condors sweep from the winds to strip the carcasses of dead cattle: "They were all over in the old days. They'd soar out over the prairie, huge birds—their wings never seemed to move. Now they're about gone."

"Chief" ran away from an orphanage when he was twelve because he didn't want to be a migrant farm laborer, his anticipated fate. "The only decent work a man of my race could get in those days was as a mule skinner or vaquero, both cheap labor, but with dignity at least." Although Californios and Mexicanos were indeed victims of discrimination in the larger society, Rojas explained that "once you were on the range, you were as good as your work, and there were lots of top white buckaroos in those days, mostly Irish. The white respected the nonwhite because of his skills. It was the white who wanted to adopt vaquero culture."

He smiled then, memories of *hombres del campo* flooding him, and a story emerged: "There was a tough black vaquero in Kern County named Harry Gillem. I saw him one day and he was all bandaged up, so I asked him if he'd been in an accient. He told me of having been in a fight with three men, and said when he had them about whipped, one drew a knife and slashed him. Well, when he got out of the hospital two of them paid him five dollars each not to fight them any more. He was rough."

One story led to another like a magician's endless chain of colored kerchiefs. "Well, this kid was trying to break a horse and he was wearing a pocket watch fastened to buckskin thong. He was mighty proud of that watch." The old man suppressed a grin—this would be a good one. "The watch dropped out of his pocket at the first jump and swung in an arc, hitting him in the nose. The next jump, it gave him a black eye and, as long as the horse bucked, the watch swung. 'If that horse hadn't quit bucking, the watch would've beat me to death,' he said afterwards. He untied the thong and threw what was left of the watch as far as he could." Robust laughter followed.

Plain and Clouds, Merced County, 1973. Stephen Johnson.

In terms of land ownership, little changed during Chief's long lifetime. "When I came here," he reflected, "three big companies owned most of this part of the Great Valley, and the small farmer was poor indeed." His firsthand knowledge confirmed historian Kevin Starr's assertion: "From pioneer days onwards, agriculture in California suffered from a single dynamic, land monopoly."

Rojas continued: "There were no beautiful, bountiful farming areas then, not like we find today. Much of the land was cattle range." He pointed a strong, leathery hand toward the south. "Down there where the state college is now, it was a floodplain and we ran cattle there. The climate was horrible, with pea-soup fog in winter, and one hundred ten degrees in summer—it hasn't changed much." He shook his head. He had observed the ascendancy of the automobile and the omnipresence of television; he had experienced the development of nuclear weapons and seen space walks; but the radical transformation of this valley remained the most amazing to him. "It's hard to believe," he said.

Because Brewer was unable to cross the Valley in 1862 and rendezvous with his boss, Professor Josiah Whitney, his party escaped the endless San Joaquin Plain—so flat, so empty, so consuming of human imagination—and willingly returned to San Francisco via Pacheco Pass, where the weather and landscape pleased them: "It is cooler, and trees are more frequent and green." The next year they once more entered

Kern County Ranch, 1888. Carleton Watkins.

the south Valley and penetrated its vast, lonely reaches all the way to Rancho Tejon in the Tehachapi Mountains. "We passed over the low pass at Mount Diablo and struck down the canyon east," Brewer wrote in 1863. "It began to rain....We struck out on the great San Joaquin Plain, stopping at 'Dutch Fred's,' a shanty in a grove of oaks, dignified by the title of 'Public House.'"

When the geological survey party reentered the San Joaquin region in 1863, the terrain was much drier and the sky less clear. The Sierra Nevada was obscured, "so that the plain seems as interminable as the ocean." In a pattern not uncharacteristic of the area, the devastating rains of 1862 had proven short-lived, and Brewer's group headed south and east into increasingly oppressive sunlight, in turn revealing another regional characteristic: "a mirage flitted around us—a great lake of clear water continually before us for hours." At one point the mirage grew so convincing that they detoured around the "water," only to discover later that it had been an illusion. Brewer was astonished by this experience, considered common by

Valley dwellers. "The eye is so deceived that the understanding refuses to dissent from the apparent truth," he commented.

The truth was that they had entered a land in the early throes of an extended drought only a year after its heaviest recorded rainfall, a drought that would litter the plains with the carcasses of cattle and sheep and, before it was done, discourage settlement.

The area just east of where the survey party camped on their second night on the prairie is now a rapidly growing crossroads town called Manteca. It was probably named for a local creamery that employed either a misspelled version of the Portuguese word for butter, *manteiga,* or, less likely one hopes, the Spanish word for fat, grease or lard, *manteca.* Heading farther east toward the Sierra Nevada across flat farmland, one encounters wooded communities such as Escalon (another crossroads town), Riverbank (still a regional rail stop), and Oakdale. The latter, on the edge of a large cattle range and home of one of the state's finest rodeos, has for years been called the Cowboy Capital; wags have of late designated it the pickup-truck capital of the world in deference to the vehicles of choice there.

South and west of Oakdale, on present-day Highway 99, the Central Pacific Railroad—one more extension of that preternaturally powerful force in the Valley, the Southern Pacific—would in 1870 lay out a town. Railroad officials wanted to name it after the San Francisco financier W. C. Ralston, but when he deferred, they named it Modesto to commend his modesty, or so local folklore claims. Today it is a burgeoning city, a food-processing capital that houses both the world's largest winery and its largest cannery. And, of course, it is becoming a Bay Area commute community.

This setting, like most of the San Joaquin Valley, became an important farming region after the railroad arrived. Wheat was the first significant local crop. A man who knew those days well, Sol P. Elias, describes the region romantically in his pastoral *Stories of the Stanislaus:*

> In the summer the entire country was a wavy wheat-field from one extreme to the other. To the wayfarer as he journeyed along its dusty roads and traveled among its well-kept farms wherein the ancient hospitality still found lodgement, the vibrating fields, animated by the gentle northern breezes, resplendent in the varied tints of the growing sun, gave a rich carpetry to Mother Earth that was charming to the eye.

During the 1870s, wheat did indeed wave in wind across much of the Valley, but an anonymous ballad set in the same region during that same decade suggests—far less romantically—why the fields there vibrated with crops:

*Don't go, I say, if you've got any brains
You'll stay far away from the San Joaquin Plains.
At four in the morning they're hustling up tools,
Feed, curry, and harness ten long-eared old mules.
Plow twenty-four miles through sunshine and rain,
Or your blankets you'll roll on the San Joaquin Plain.*

Today Modesto is the seat of Stanislaus County, a tree-lined community, surrounded by agricultural development, with the Tuolumne River running through town and the extensive holdings of Ernest and Julio Gallo bordering it. Italian Americans like the Gallos have become so closely identified with agriculture in the south Valley that it is difficult to talk about one without mentioning the other.

The Gallos became and remain dominant wine producers, but they were for many years challenged by another son of Italy, Louis Petri. And Kern County's Joseph DiGiorgio was, of course, a giant of American agribusiness. The Giumarra family, also of Kern County, has dominated table-grape production nationally; the influence of Mark Fontana's California Fruit Packing Corporation, the famous Del Monte label, has been profound. Although he did not live here, A. P. Giannini exerted great influence in the Valley through branches of his Bank of America.

Seeing the prominent positions achieved by many Italian Americans, it is easy to forget that most of their families entered this valley as laborers, that they too toiled and suffered under that faded sky, that they too faced discrimination. Called "wops" and "dagos" and "guineas," consigned to low-paying jobs, and said to be uniquely suited for manual labor—that familiar, self-serving generalization that has been leveled at so many newcomers—Italian Americans have succeeded by dint of hard work, determination, and sharpness; nothing was given them.

Modesto also marks—unofficially, of course—entry into the Valley's Southwest, a realm much influenced by one of the region's most dramatic historical events, the so-called Okie migration. Three distinct cultural entities actually merge—or don't merge—here, for Modesto-to-Bakersfield is biscuits-and-gravy for breakfast, chicken-fried steak for dinner; or *menudo para desayuno y chili colorado para la cena;* with neckbone and beans or chitlins readily available. If one wants to watch stock-car races or listen to country music or use a cane pole to catch catfish, if one wants to watch a cock-fight or march in a Cinco de Mayo parade or eat hot-links, this is the right region.

Three Southwestern cultural strands—Anglo, Hispanic, African—enliven life in south Valley towns that seem in many ways closer to El Paso than to San Francisco. Too frequently, when speaking of the "Southwestern flavor" of a place, commentators focus on whites and forget that both latino and black cultures are also vital. As Carey McWilliams points out, "the Spanish-speaking have never been 'immigrants' in the

Ditched, Stalled, and Stranded, San Joaquin Valley, 1935. Dorothea Lange. Library of Congress.

Southwest." And blacks, who toiled in the Southwest's cotton culture and worked as cowboys there, have also been major fixtures here. The intimacy of Spanish-speakers and various English-speakers, which has led to many marriages in this region, is especially visible from Modesto south. Chester Smith, an evangelist and former country singer who came to the Valley as an Okie migrant, acknowledges, "I grew up under the influence of Mexican culture....We worked side by side in the fields."

These three groups, among others, of course, have been important in the San Joaquin Valley, where the repatriation of Mexican laborers in 1931 opened jobs for migrating "Okies, Arkies, and Texies." Subsequently Mexican braceros—along with black migrants and the perennially important Filipinos—replaced the large number of whites who had moved into non-migratory professions during World War II. Whether they like it or not, those cultures have been intertwined like Delta rivers as they have struggled for economic security in these unforgiving, but unprejudiced, fields.

Some Sacramento Valley chauvinists like to point scornful fingers at the San Joaquin's "Okie and Arkie" quality, but to natives of the latter region, it is reason to celebrate. In 1983, Butch and Linda Stewart and their family followed the path that John Steinbeck's Joad family had taken nearly fifty years earlier. "We came across country in U-Haul trucks. When we got to this valley, we'd been on the road for three days, 105, 106, 107 degrees, and the baby was cross," says Linda. "I know we looked like death warmed over....And this little old couple sat down and said, 'Now where are you from, Texas?' And just sat there and helped me get little David satisfied. It was a real homey feeling," she admits.

"I would ask, 'Where are you from?' and they would either say, 'I was raised right here…' or they would name Oklahoma, Louisiana, Texas, or Arkansas. You don't hear a lot of southern accents, but you have a very southern, very friendly flavor."

Celebrated author Sherley Anne Williams agrees. Her parents were black migrants to the San Joaquin, and today she says, "It is the southern quality of the Valley that I most remember." Another writer, Ann Williams, recalls a childhood encounter with Okie migrants that confirms the Stewarts' contemporary opinion. Her family's car had broken down between towns, and they stood by the roadside seeking a ride.

Then an ancient Ford came rattling up with mattress and springs and cardboard boxes strapped to the top, and we were invited to ride. Inside were mother, father, grandmother and several shy children; there was no backseat and we sat on the floor. They had been going too slowly, the overall-clad father said, to pass us with an easy mind. But it was an act of simple goodness, and the family would remain in my consciousness as a model for the Joads when I read The Grapes of Wrath.

At about the same time, James and Flossie Haggard, whose son Merle has emerged as the great bard of California's white southwestern migrants, came to California from Oklahoma. Years later, Mrs. Haggard remembered their journey with mixed emotions:

I remember we broke down in the middle of the desert. We were out of water, and just when I thought we weren't going to make it, I saw this boy coming down the highway on a bicycle. He was going all the way from Kentucky to Fresno. He shared a quart of water with us and helped fix the car. Everybody'd been treating us like trash, and I told this boy, "I'm glad there's still some decent folks left in this world." He rode the rest of the way with us and I still write him—he lives in Fresno now.

The Haggards were among 350,000 Okies who migrated to California during the 1930s, generally endured great hardship, but did not quit. They by no means all came from Oklahoma—"Okie" is used generically and not always thoughtfully hereabouts—but the majority of those newcomers were from devastated areas of the Southwest and Midwest, and they provided abundant farm labor for California growers while they struggled to survive.

It was predictable that the southernmost region of the Valley—the Tulare Basin—would initially absorb the largest numbers of migrants, with the San Joaquin second in the concentration of newcomers, but over the years they have relocated and made their presence felt throughout the state. Far north in the Sacramento Valley, for example, an entire church congregation from Oklahoma settled in Live Oak, while south over the Tehachapi Mountains in the San Fernando Valley there are now over forty Southern Baptist churches and missions, circumstantial evidence at least of southwestern incursion. In any case, no two Okie or Arkie or Texie migrants and their stories are exactly alike.

For example, Clyde Nance was only two years old when his parents left Arkansas to seek better economic opportunities in California. They carried one hundred dollars in their pockets and their children in an old car: "We didn't look like *The Grapes of Wrath*—no mattress on top even if we did have everything piled into a jalopy," he smiles. Now an investment counselor in Northern California, he smiles at the recollection. "When we arrived at Salida near Modesto, my folks still had twenty dollars and my dad got a job pounding in grape stakes for Gallo at 15 cents an hour. It wasn't the pot of gold, but it was work." His is a transitional family: his parents were Arkansans, but his children are Californians. He has just returned from a family reunion in his parents' home state, and such matters are much on his mind. "A little later my dad got a better job as a general farmhand, 25 cents an hour. One month he made a hundred dollars. That's *four hundred hours* of hard work. I tried to explain what that meant to my sons the other day," he shrugs, "but it's just too different, our life is."

Dudley Roach is an administrator at Modesto Junior College. Like so many others, his roots are in the Southwest, but this valley is his home. Like them, he clearly remembers the discrimination, the hardships—in 1939, a sign in a Bakersfield movie theater read "niggers and okies upstairs"—and takes fierce pride in his heritage. He is a large man, whose dark good looks hint at Indian blood. He is also articulate and not shy about rebutting stereotypes. "They said we were shiftless in one breath, then complained we were taking jobs," he points out, the lilting remnants of a southwestern dialect—a drawl common in the south Valley—texturing his words. "They said we were criminals, but we built our own churches. They said we were stupid, but we used the educational system to succeed. We worked our way out of a tough situation and I'm proud of it."

One major component of Great Central Valley legend is the stories of well-known southwestern migrants such as Hollis Roberts of McFarland or Buck Owens of Bakersfield, who struggled into California with only a nickel in their pockets, but managed to acquire fabulous wealth, and there are in fact many examples of exactly that. Owens, an entertainer and entrepreneur, first explains, "We left Texas in 1938, ten of us in an old car with mattresses piled on top," then suggests a major reason why he and others have succeeded: "I can still remember what it was like to be cold, poor, and hungry, and I vowed never to let that happen again. That's what gave me the drive to succeed."

A far more important reality, however, is the vast number of "Dust Bowlers" who, like Nance and Roach, have entered the middle class here. For every erstwhile Okie, Arkie, or Texie unable to escape poverty and every one rolling in money, there are hundreds, maybe thousands, toiling, paying their taxes, sending their kids to school, going to church, doing the work that keeps the Valley operating. As is true of Dudley

Bean Thresher, 1936. Dorothea Lange. Library of Congress.

Roach and Clyde Nance and Flossie Haggard, and thousands of others, they are shapers of the new California, for their presence has changed this state. Not far from Modesto, in Keyes, Frances Walker says proudly, "The Okies were invincible. They won. They are here, they own land, homes, and are comfortable. Their children are here and their grandchildren....I'm part of it."

What of the next generation, the California-born children of those first migrant youngsters? A sixth-grader says brightly, "Oh, my dad used to be an Okie." He smiles, for he is, of course, a Californian, as are the Garcias and Wongs, the Takeuchis and Nguyens, and everyone else rooted in this Valley.

Modesto is a typical San Joaquin Valley town because it seems to be growing exponentially, suburbs spreading in all directions, covering what were once cultivated fields with yards and stucco houses, with parking lots and shopping malls. Valley communities are the fastest-growing in the state, so thousands of agricultural acres are being paved annually. The irony is that agricultural acreage is the basis of the region's economy, so there is finally a limit to how much land can be lost. Chemical-intensive farming might seem to offer an out—more production

Turkey Ranch, Stanislaus County, 1986. Stephen Johnson.

from less acreage—but the threat of cumulative toxicity renders even that a blind alley.

Growers feel trapped. Norman Crow of Crow's Landing explains: "As farmers, we're probably the greatest environmentalists. We see every part of every tree, every acre of land. I'd love it if I didn't to have use these chemicals." There are no simple solutions. Uncontrolled population growth—that worldwide nightmare—demands both more housing and more food. Increasingly, some form of sustainable agriculture seems necessary in this stressed environment.

Driving south from Modesto on Highway 99, the Valley's traditional traffic artery, one immediately passes Ceres—the two towns growing to meet each other. It is a major farm community noted for its date-palm groves. A bit farther south, one reaches Turlock, yet another agricultural center, and also home of one of the Valley's seven universities, Stanislaus State, once referred to as "Turkey Tech" in deference to the area's major poultry product. Of less contemporary importance but of considerable historical interest is the network of irrigation ditches and canals that hereabouts serve one of the region's largest clusters of small farms and ranches.

The vast Turlock Irrigation District was established in 1901. Most methods of watering were prohibitively expensive for individual farmers, so irrigation districts and mutual water companies became common in the Valley after the turn of the century. As it turned out, there was more than water at stake in such associations: "The state," explains Donald Worster,

> pushed the districts toward more professional local water management. Then farmers began to discover too that the district was…"an extraordinar[il]y potent engine for the creation of wealth." By 1921 there were seventy-four such engines in California, covering a third of all its watered acres. Through the power of property taxation, they could force recalcitrant farmers in their midst to improve their lands, grow more lucrative crops, and in general join the march, in the words of a slogan draped across the Modesto railroad depot, toward "Water, Wealth, Contentment, Health."

Finally, Worster argues, such managed cooperative efforts led to a concentration of control on all levels—from crop allocation to marketing to labor recruitment—hardly the American dream of 160 acres and independence. But 160 acres has never been a mystical figure in the Valley, where the quarter-section federal acreage limitation on water allotments was treated as little more than a joke.

Continuing south along the route of Highway 99, more irrigated farmland surrounds the road and prosperous communities are passed: Livingston, noted for grapes, sweet potatoes, and chickens; Atwater, a packing center for a great variety of produce; Buhach, where Portu-

California Aqueduct, Interstate 5, Delta-Mendota Canal, Merced County, 1985. Stephen Johnson.

guese Americans have grown pyrethrum to be used in insecticides. Merced is a major marketing center, on the rail line as well as the highway, and a gateway to Yosemite National Park in the Sierra to the east. Although new uses are being found for cottonseed oil, its gins have recently been undergoing conversion to other uses, principally safflower processing, one more example of innovative agriculture in the Valley.

Merced is also seat of the county of the same name, a county whose economy is entwined with farming—one-third of all its residents are employed in agriculture, the vagaries of which influence virtually every local business. Today, with foreclosures common and a "farm crisis" in full bloom, unemployment hovers near 14% and Merced is the sixth-poorest county in the state. Nonetheless, it is also the county that not long ago defied the region's easy-pickings, business-at-all-costs stereotype, demonstrating once more that the Valley and its people are not always what they seem.

In 1986, United Technologies Corporation, a Fortune-500 defense contractor, announced that it planned to build a rocket-motor plant in cattle country near Gustine, thirty miles west of Merced. Local boosters, were, of course, delighted. But what was expected to be perfunctory approval for the plant was resisted. A grassroots coalition of ranchers and professionals, housewives and teachers, which came to be known as

Used Cans, Crop-dusting Airstrip, Newman, 1984. Stephen Johnson.

the Central Valley Safe Environment Network, dug in and fought. Why? Dr. John Holmes, a Merced physician, explained to writer Barbara Bailey Kelley: "Regulators were silent on [the toxicity at] Kesterson. Now are we to rely on these people to protect us from another group?"

The CVSE pointed out that the county, which was already not complying with federal clean-air standards, now proposed to accommodate a plant that would put 201.4 tons of aluminum oxide particles and 92 tons of hydrogen chloride gas into the air annually.

That was only one of many concerns, most of which dealt with greater ecological deterioration. "The evidence is already in that we have an environmental overload," Jean Wimbley, a housewife, passionately argued. What evidence? A recent report by U.S. Geological Survey scientists noted that DDT, DDD, or their common breakdown product, DDE, were found in every one of twenty-four sample wells from a 120-mile stretch between Modesto and Fresno fifteen years *after* those pesticides were banned.

Eventually, in the face of strong and equally sincere opponents who favored development and new jobs, the CVSE won the day, and United Technologies withdrew its land-use application. The power of local residents working together had been demonstrated. As Barbara Bailey

Kelley suggests, "The Central Valley Safe Environment Network has emerged as the self-appointed watchdog of the San Joaquin Valley."

William Henry Brewer and his party in 1863 followed a route west of present-day Highway 99, crossing what is today a rich farming region, but one with fewer towns than exist to the east, where the establishment of highways and railroads prompted settlement. The Merced River entered the San Joaquin River at a place called Hill's Ferry, an infamous settlement—historian Wallace Smith says it was for a time "the most lawless spot in California"—noted for its saloon and dance hall, where Joaquin Murrieta and other desperadoes once sported.

The scene had not entirely improved on April 6, 1863, when Brewer and his companions arrived; wrote the young geologist, "We stopped the night at Hill's Ferry, a dirty place, where a drunken 'Secesh' made an uproar the whole night." During the Civil War years, the Valley—beyond the reach of federal authorities—harbored many who favored the rebel cause. The Chowchilla River between Merced and Madera was referred to as the region's Mason-Dixon Line, and Union soldiers on the march south from Stockton during those years are said to have loaded their guns when they reached it.

Today the town of Newman stands a few miles south of the site of Hill's Ferry, slightly north of Gustine. Brewer's route then traversed untamed country indeed, an area that would remain uncultivated until in some sections marshes were drained, while in others water was piped in, relatively recent developments in most cases. Another ferry crossed the San Joaquin River at the site of present-day Firebaugh, in what is now a rich farm region that includes Dos Palos to the north and Mendota to the south. It now boasts the greatest rice acreage in the south Valley, among many other profitable crops, but in Brewer's time it was a far edge of civilization. On April 12, 1863, he noted:

Tuesday we came on to Firebaugh's Ferry—a long fifty miles, a weary ride, and we had nothing to eat the entire day....Firebaugh's was even a harder place than Hill's....When we got to Firebaugh's we found more excitement. A band of desperadoes were just below—we had passed them in the morning, but luckily did not see them.

The Mendota area just down the road is now home to one piece in that successful irrigation puzzle known as the Central Valley Project: San Joaquin River water is redirected far upstream at Friant Dam into the Friant-Kern and Madera canals. Between Friant Dam and what is known as Mendota Pool exist thirty cadaverous miles of what was once the Valley's second major watercourse, the San Joaquin; where innumerable salmon and steelhead once struggled upstream to spawn, only

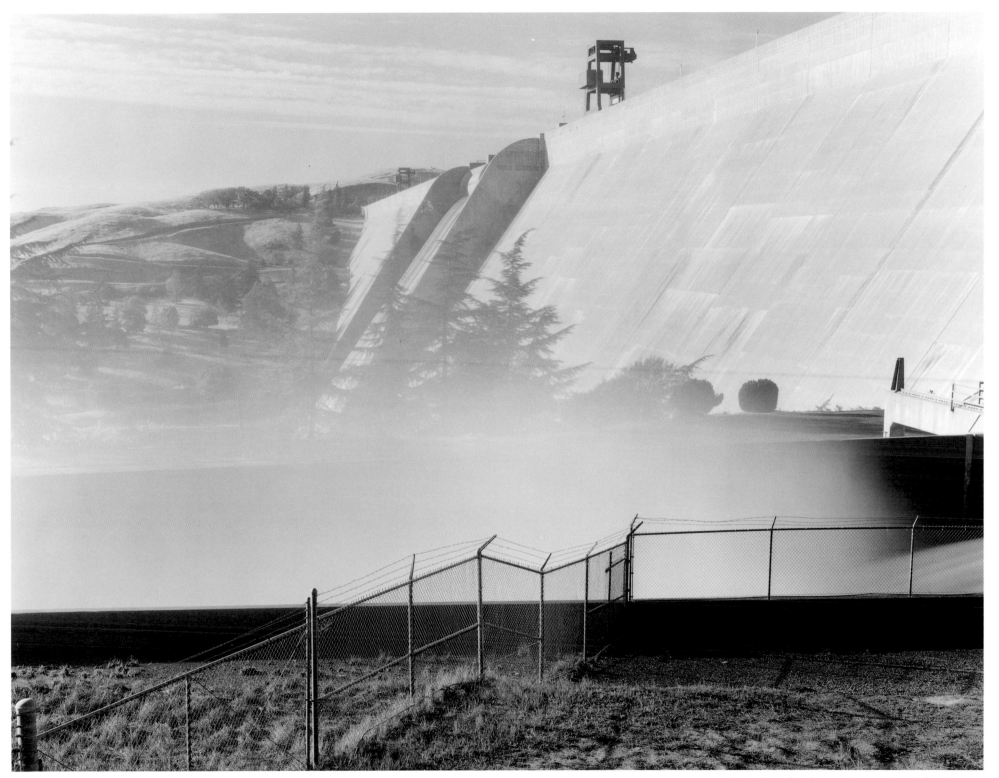

Friant Dam, San Joaquin River, 1983. Robert Dawson.

Reclamation Law: The Unmet Mandates

No right to the use of water for land in private ownership shall be sold for a tract exceeding 160 acres to any one landowner, and no such sale shall be made to any landowner unless he be a bona fide resident on such land, or occupant thereof residing in the neighborhood of such land.

—National Reclamation Act, 1902.

The executive branch of the government has the duty to carry out the policy enacted into law by the [legislative] branch. This has frequently not been done. Reclamation law, for example, requires that the receiver of water shall be a "bona fide resident" on the land irrigated or in the neighborhood. The Bureau of Reclamation ceased enforcement of residency by rulings made in 1916 and 1917. Congress apparently was not of the same mind. In 1917 it acted as if the law was still effective by suspending the unenforced law for the duration of World War I. This it repeated in 1940 to cover World War II then in early prospect. Again in 1947 Senators from three states led by [California] Senator Downey tried to wipe the unenforced residence requirement from the statute books. Thus Congress acted as if residency were a valid law throughout; the executive branch as if it were not.

The judicial branch has moved very slowly to uphold the excess land provision of reclamation law. For one thing, the executive branch has been slow to bring charges of nonenforcement before the courts. In 1944, for example, Congress applied reclamation law to irrigation water from Army [Corps of Engineers]-built dams. Delivery of water to Tulare Lake lands began in 1954 with extensive nonobservance of the excess land law. Not until 1977, thirty-three years after passage of the law and twenty-three years after beginning delivery of water, did the case initiated by the government receive the Supreme Court's final word that the excess land [provision] does apply to Army-built dams. It did this by letting stand an earlier decision to the same effect by the Ninth Circuit Court of Appeals.

—Paul Schuster Taylor, *Essays on Land, Water, and the Law in California,* 1979.

In California, the administration of the acreage limitation provisions has deviated significantly from the law's original intent, as well as its specifications. Provisions requiring the sale of "excess lands" (i.e., lands over 160 acres) before projects could be constructed were never enforced. As a result, in 1976 legal action was brought by National Land for People, a Fresno-based non-profit membership organization, challenging both the administrative process and the bogus land "sales" then occurring in the Westlands Water District. In 1976 the court ruled that the Bureau was in violation of the Administrative Procedures Act and directed the Secretary of the Interior to enforce the law.

With the possibility of enforcement looming closer than ever before, the large landowners in the valley put politics into high gear, and began working (once again) to change the law. At the end of the Carter Administration, while the legal status of the acreage limitation was being deliberated in the courts, politicians worked out compromises with environmental lobbies and farm activists, and came up with the Reclamation Reform Act of 1982 (RRA). The deal struck was between an expansion of the limit to 960 acres, in exchange for the imposition of full costs for the delivery of water to excess lands.

But many major landholders reneged on their part of the deal. Farms of thousands of acres have been divided into 960 acre pieces, each with its own corporation or partnership as the legal owner. And all of these 960-acre pieces are now "managed" together, with the same overall cropping pattern, same equipment and same managers. The most extreme example consists of the J.G. Boswell Company's 23,500 acre Boston Ranch, which was placed in trust for the members of the company's pension and profit-sharing plan. Each member of the plan is attributed, on paper, a proportionate share of the 23,500 acres, thereby staying within the 960 acre limit for each. But the J.G. Boswell Company manages the entire property.

In the summer of 1990 Congress was, once again, asked to consider re-writing reclamation law to remedy these abuses. At this writing the decision of Congress has not yet been made. One proposed law would prohibit these types of trust and joint management schemes. Another would prohibit any recipient of federally subsidized irrigation water from also receiving benefits from USDA's price and income support programs.

—California Institute for Rural Studies.

lizards and squirrels now move, for the erstwhile river is a trickle, polluted and hardly riverine at all: its teeming migrations of anadromous fish are gone, all gone, and its riparian habitat for animals and birds is virtually gone too. To salvage some downstream flows, Sacramento River water is pumped some 120 miles from the Delta to Mendota Pool at 4,600 cubic feet per second, but that is 30 miles too short to restore the stretch of river that actually bisects the prairie north of Fresno, 30 miles too short for salmon and steelhead.

Friant Dam, northeast of Fresno, channels potentially lost spring runoff to irrigate approximately 15,000 small farms (average size, 63 acres) in previously dry regions of Fresno, Tulare, and Kern counties along the Friant-Kern Canal, terminating at the Kern River near Bakersfield, 153 miles away. The Madera Canal carries only about a fifth the volume of the Friant-Kern's 5,000 cubic feet per second, but nonetheless it serves 150,000 acres near the busy town for which it is named. Madera is located on Highway 99 between Merced and Fresno. These are only two examples of the complexity of the Central Valley Project, a plan that—along with the earlier development of the deep-well turbine pump—has fecundated Brewer's "plain of absolute desolation." There has always been water in the Valley, but not necessarily in the right place at the right time for agriculture.

Had Brewer continued down the Valley's torrid west side, he would have remained in a desert, but the California Aqueduct, which began providing water in 1971, has allowed a billion-dollar agribusiness to develop along what was previously considered no-man's-land. Art Cuelho was raised there; his father once dry-farmed 10,000 acres of the west side without threatening to become rich. During Cuelho's youth, the region remained arid, but it was memorable. He recalls:

> Often there was something in the surrounding area [that] made you aware of the Valley's history. Sometimes it was a single tree standing out in a field. Farmers year after year carefully edged around it with their rigs and refused to chop it down to make it easier for them to farm. It marked the spot where the first schoolhouse had been built. The farmers respected remnants of their past.

In an isolated tract with few historical landmarks, such links remain important.

Near the Riverdale region where Cuelho was raised, landowners in 1952 formed the Westlands Water District—called "the Cadillac of American irrigation districts" by Eric Brazil. Today it contains nearly 600,000 acres and is the largest in the nation. It also appears nearly empty of human settlement—vast tracts with no farmhouses or barns visible, and with only two communities of any size located within its generous boundaries: the spacious, depopulated spreads of corporate agribusiness dominate, and feudalistic social consequences may be in-

"I think I would add a few things to the banner, foreiners, Armenians, dust, heat As ever, Marie."
—May 7, 1924.

ferred from the fact that the two towns, Cantua Creek and Huron, are populated largely by Hispanics who provide farm labor for big growers, and that neither community has a high school. Per-capita income in both towns is among the lowest in California.

It is difficult to miss the social significance of such conditions. Although employment in the ten small communities that dot the Westlands is high indeed, researcher Dean MacCannell has found "the incidence of poverty in these town to range between 21.5% and 28.9%." When examining only the fate of the Mexican-American majority in the Westlands, the ratio of the population living at or below the federal poverty standard "ranges from 24.6% to 53.7%." The state figure for destitution is 7% and nearby rural areas average 15%. Agribusiness has required peons and in Westlands it can find them.

If large-scale agriculture has proven efficient for crop production and the generation of wealth in this valley—and it certainly has—it has also frequently proven to be a human disaster for all but a fortunate few, creating third-world colonies within the richest agricultural region ever known. The 1990 census revealed that California's five towns with the lowest per-capita annual income were located in Fresno County: Orange Cove ($4,385), Parlier ($4,784), Mendota ($4,920), San Joaquin ($5,356), and Huron ($5,501). Two other south Valley towns also qualified for the bottom ten—Farmersville in Tulare County ($5,858) and McFarland in Kern County ($6,125), giving this prosperous region seven of the nine poorest communities in the entire state.

Beyond widespread poverty, MacCannell also found low education levels, inequality between ethnic groups and a predictably bipolar society with a small wealthy elite, a vast lower laboring class, and virtually no middle class. It's a grim picture of the hidden costs of agribusiness.

After the Westlands Water District was founded in 1952, the Bureau of Reclamation and the State Water Project built San Luis Dam, completed in 1968 on a creek of the same name that flowed from the Diablo Range to the north. It cost taxpayers over $3 billion. Before water became available, ranches the size of the Cuelho family's were unexceptional, because it took considerable land to eke out an unirrigated existence.

Corporations owned many of the large spreads: Boston Ranch, Southlake Farms, Southern Pacific, Bangor Punta, and Standard Oil, among others. Once irrigation became practical, however, much smaller tracts could profitably have been farmed, and the existing reclamation law required that landowners sell excess holdings within ten years of receiving water. What actually happened, according to Worster, was the "project-aided lands were being reorganized into ever more intricate corporate holdings....Russell Giffen, once described as the largest farmer of irrigated land in the United States, had sold out to a hand-picked circle of cronies and 'partnerships,' many of them giving the same last name and the same address."

"Since the mid-1970's," reports Brazil, "Westlands has delivered an average of 1.23 million acre-feet of Central Valley Project water to 580 farmers." In 1982, however, a new Reclamation Act was supposed to establish a timetable to break up vast corporate holdings, but by 1987, when growers in Westlands used 566,844 acres of land to produce crops valued at $652.7 million, they had also accumulated another $27 million in irrigation subsidies, $11 million of which was sent to a farmer named Southern Pacific Land Company, progeny of the railroad that once dominated life here. This in a region where welfare for the poor is frequently decried.

In the face of charges of water gluttony on Westlands' nearly 600,000 irrigated acres, John Harris of Harris Farms counters, "We're unfairly portrayed as wasters of water....Every drop of water that comes down here is used efficiently." And the district's public information officer, Don Upton, adds, "We have 81% efficiency, compared with about 50% across the country. We're good managers and we're going to get better." A report released by the University of California Water Resources Center nonetheless asserts that up to 55% of the subsidized water used in the western San Joaquin section is lost below the root zone because farmers are applying too much.

Brewer's party angled southeast from Firebaugh toward the point where Fresno, a major city, now sits on a line running roughly from Highway 33 to Highway 99. This is by far the largest Valley community not located on a significant watercourse. When Brewer entered the area, Visalia, a cow town to the south, not Fresno, was the principal settlement between Stockton and Los Angeles.

But in 1872 the power of the railroad created in Fresno a rival that would eventually dominate Visalia and the entire region. "Three things determined the new community's development," Wallace Smith writes, "luck, climate and soil." The climate and soil need no explanation, since both seem nearly perfect for agriculture. Smith describes the luck this way: a landholder named A.Y. Easterby engaged an experienced grain farmer named Charles Lohse to grow wheat on property near present-day Fresno, and

> Lohse planted 2,000 acres to wheat; the success of this venture was insured by irrigation water brought by Moses J. Church from Kings River by way of Fancher Creek. This green oasis impressed Leland Stanford sufficiently in May, 1872, to cause him to locate a railway town near the wheat field which was destined to become modern Fresno.

Today "Greater Fresno" is a city of consequence, home to nearly half a million residents and enduring accelerating growth. Much soil that once produced rich crops here has been paved, and the land where many migrants labored now houses their children and grandchildren in neat tracts. So rampant has been its expansion that its environs have virtually surrounded nearby Clovis, another substantial town, and they are still growing: Watch out, Sanger! Beware, Fowler!

Fresno is the seat of the richest agricultural county in the United States. Its hallmark produce has been raisins; there are more than five thousand growers in Fresno County, and they produce 99.9% of the nation's raisin supply. But lately another, unlikely crop has threatened to overshadow all those dried grapes: poetry. California State University, Fresno, has produced an abundance of esteemed poets. Again, the right man arrived in the right place at the right time. "All I know," recalls DeWayne Rail, one of the Fresno Poets, "is that a whole world of possibilities opened up when I was at Fresno State studying with Phil Levine."

Philip Levine, a gifted poet and teacher from a blue-collar background, joined the faculty at Fresno State in 1958. As a student at Wayne State University in Detroit, Levine had supported his family with a factory job, wearing a shirt to class with "Phil" embroidered on one pocket and a United Auto Workers button pinned on the other. "I thought of myself as a working man," he says.

In retrospect, it seems to have been perfect training, for it allowed him to understand the aspirations and frustrations of Fresno State's largely working-class clientele. "I think I still do best with the people at Fresno because I'm so totally comfortable with them," he told Liam Rector. "They're exactly like the people I went to school with....I've never had a student at Fresno weep in class. One now very famous one

Farmington Reservoir, Stanislaus County, 1982. Robert Dawson.

told me to go fuck myself, in exactly those words....I do better with people who have a little dirt in their teeth."

And the region itself was ready. Life had complicated and enriched here, but generations of workers had continued steeping in frustration until public education after World War II at last offered their children opportunities. As a result, the Fresno Poets include blacks and Japanese and Chicanos, Armenians and Portuguese and Italians—the list could be much longer—and many of them attended Fresno State simply because they could go nowhere else. Big names and small are now associated with Fresno State. By 1987 when Jon Veinberg and

Ernest Trejo edited a second collection of poetry from Fresno, *Piecework,* the sprawling city's literary reputation had become national. Its authors had won—in some cases, many times over—virtually every important award open to American poets. Gary Soto, Sherley Anne Williams, David St. John, and Larry Levis have all gained major literary honors, while Roberta Spear, Greg Pape, Herbert Scott, Lawson Inada, Robert Vasquez, Kathy Fagan, and Luis Omar Salinas, among many others, continue to garner critical acclaim.

The lives of these bards have frequently been tough, and so is their verse—tough, unswerving, and true. Asked how Fresno became her

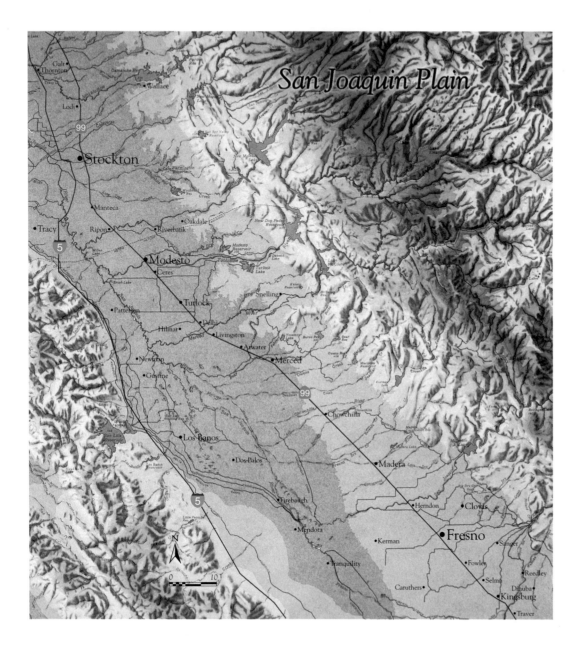

San Joaquin Plain

do in life. That didn't really begin to change until I was a senior in high school in 1962 and I became aware of the Civil Rights Movement. I was always aware of whites—and I had some intense relationships with them as a child—but I knew that their futures were going to be different than mine."

Today she is a novelist, playwright, poet, and essayist, and she is a professor at the University of California, San Diego. What does she miss about her native area? "Well, strange as it may seem, its southernness. This place has many of the characteristics—pro and con—of the old South, and it can be a comfort to come home."

Her face grows pensive and she seems to look inward, then says, "I was in Bakersfield last May and it was sad to hear young black people say to me that the same towns that I had grown up hearing not to go into were still the same ones they had grown up being told not to go into. You want to be able to see some changes, to know the modern world has really penetrated—not just in terms of plumbing or whatever—*really penetrated*, but in many ways it hasn't. Despite the integration of the power structure, the place is still non-progressive in racial terms."

Khatchik "Archie" Minasian, a poet from an earlier generation, was raised in Fresno. His verse reflects well the rural, not necessarily hygienic reality that the poor have known—and still know—in this area. It also reveals where youngsters both cooled and entertained themselves in those days before air conditioners and public swimming pools; in "Valley Ditch," he writes:

In our ditch
> *there are water skaters,*
> *frogs,*
> *tall reeds,*
> *mud bugs,*
> *apple cores and plum seeds,*
> *and little naked children.*

But Minasian, like many another immigrant child raised here, spent less time in ditches than in fields, "picking grapes, turning grapes, making boxes, doing all kinds of menial labor long hours in the heat. This is what life was in the Valley for most of the Armenians—in fact, for most of the people who were willing to work." Fresno received its first Armenian immigrants in 1885, and today it is one of the world's most populous Armenian cities. "The Armenians, who were a proud people, had the temerity to ignore the suggestions that they were not the equals of their American-born neighbors. They were competitive in business affairs and refused to be segregated to a specific neighborhood," Anne Loftis explains. One resident of Fresno during those early days said: "They are the only foreigners…who think they are as good as we are."

hometown, Williams says matter of factly, "My parents were migrant workers, following crops, and my father developed tuberculosis, so we stayed here."

Childhood memories? "I was profoundly aware of racial differences and of what that predestined me to do, of what I, as a black child, could expect. There was a sense of no expectation about what you could

By the time Minasian and his cousin William Saroyan were boys in Fresno early in this century, Armenians already constituted a major cultural presence, and the city was well on its way to becoming the center of Armenian culture in the United States. The land itself, the setting, dominated Saroyan's Fresno. He writes:

A man could walk four or five miles in any direction from the heart of our city and see our streets dwindle to land and weeds. In many places the land would be vineyard and orchard land, but in most places it would be desert land, the weeds would be the strong dry weeds of desert. In this land there would be living things that had their being in the quietness of deserts for centuries. There would be snakes and horned-toads, prairie-dogs and jack-rabbits. In the sky over this land would be buzzards and hawks, and the hot sun. And everywhere in the desert would be the marks of wagons that made lonely roads.

Today most of that desert is covered by neatly plowed crop rows, by houses, by malls. Many residents delight in the city's modern appearance, but natives are not necessarily enamored of the new urban sprawl. "I can't stand the uglification of my hometown," says writer Robert Speer. "It's starting to look too much like Los Angeles," adds artist Clayton Turner.

Fresno is the city closest to the geographical center of California, and Lawson Fusao Inada, a native of Fresno, celebrates it in his poem "California Heartland: The Exact Center":

*It doesn't matter to me
that "the exact geographical center of California"
is located in the back of the Gomez family yard.
Or so they say…*

*The Gomez family, the Inadas,
are exactly where they are,*

*where California starts from
and goes out, and out, and out.*

From here, the going is easy.

Look at our faces, and smile.

Smaller farm towns ray out to the southeast and southwest of Fresno: Fowler, Dinuba, Reedley, Selma, Sanger, Kingsburg—each prosperous, each with its history. Fowler, for instance, resulted when Senator Thomas Fowler had cattle driven from his immense holdings to a point where the Central Pacific rail line ended just south of Fresno. This terminus became known as Fowler's Switch; then it was shortened to Fowler. Thereafter, the site followed a common Valley pattern, as Wallace Smith explains:

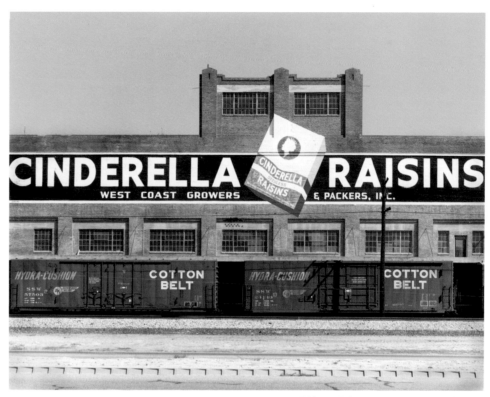

On Old 99, Selma, 1987. Stephen Johnson.

The introduction of irrigation led to colonization of the surrounding territory until the census of 1930 revealed that Fowler was the most cosmopolitan community west of the Mississippi. The first settlers were originally from the midwest but they were subsequently supplemented by almost every race to be found in the universe.

The founding of Dinuba also demonstrates the two major factors in the developments of so many San Joaquin Valley communities, shipping and irrigation. The little town was established soon after the Southern Pacific Railroad came down the east side of Tulare County in 1888, points out another historian, Ed Rice. Then "the Alta Irrigation District was formed and took over the water rights and canals of the 76 Land and Cattle Company." And who owned the 76 Land and Cattle Company? None other than Senator Thomas Fowler.

The open cattle range was before long converted into rich farmland using the water now available, and the railroad made it easy—if at times terribly expensive—for growers to ship their crops. During the thirty years that followed Dinuba's settlement, farmers with names like Gans and Mayeda and Petinak, a microcosm of the Central Valley's rich mix,

San Joaquin River near Fresno, 1987. Robert Dawson.

used Alta Ditch water to grow peaches, melons, grapes, and a variety of other crops.

Reedley was named for Thomas Law Reed, who in 1884 bought land from the 76 Land and Water Company (another division of Fowler's vast holdings) and by 1886 was farming 12,000 acres thereabouts. Reed introduced the first wheat combine to the region, and at one time nearly 500 mules worked on his spread. The exact naming of the town is controversial. One version is that Reed employed a Chinese cook named Li, who was a great favorite. After the man's death, Reed honored his memory by coupling their two names to produce "Reed-li." Wallace Smith adds that it is more likely that a suffix was arbitrarily added to Reed's name by the Pacific Improvement Corporation, a landholding company for the vast Southern Pacific Railroad monopoly.

Sanger was founded in March of 1888 when the Southern Pacific built a town along the tracks and named it for an official of the aforementioned Pacific Improvement Corporation. Later it became famous because a flume sixty-four miles long carried lumber from the Sierra here to be shipped by rail to distant markets. Selma was also named by railway officials—after the daughter of a friend of Leland Stanford's.

With irrigation, this Fresno County town became known as "Selma, the Home of the Peach." Thompson seedless and muscat grapes grown locally for raisins are renowned.

Many communities in the Valley began as colonies of one kind or another. Woodville, for example, was originally called Irishtown because it was settled by a group from Northern Ireland. A Portuguese colony farmed in the Hanford area. Alabama Colony near Madera was settled by migrants from the Old South. In many cases, the names reveal who lived there: Nevada Colony, Nebraska Colony, Scandinavian Colony, even Temperance Colony. "As late as 1910," geographer James J. Parsons notes, "Patterson, a model community with a street pattern reminiscent of Washington, D.C., was established on the west side….Delhi, an unsuccessful state-sponsored colony on the sandy mush soils of Merced County came even later."

One of the most successful of the San Joaquin Valley's colonies was founded in Kingsburg on November 26, 1886, when two families and two single men arrived in Kingsburg from Sweden. "Within a radius of three miles of Kingsburg, 94% of the population is of Swedish descent," E. J. Gearhart wrote in the *Associated Grower* in 1921. Many churches in the town—Lutheran, Methodist, Congregational, Mission, and Baptist—conducted services in the language of the old country for nearly half a century. By the late 1930s this Swedish enclave, like other colonies, was slowly being integrated by other ethnic groups, as is demonstrated by the fact that perhaps its most famous native son is business executive and former Olympic champion Rafer Johnson, an African American.

Another kind of colony was promoted by real estate investors. In 1874 William S. Chapman developed the Central Colony, which consisted of nearly 80,000 acres surrounding the site of modern-day Fresno. This gathering was not only successful in its own right, but also served as a model for later settlements, such as the nearby Malaga, Morris, Pacific, Wolters, and Nevada colonies. In many ways such real estate promotions presaged the commercially controlled present far more accurately than did idealistic ethnic, religious, or social colonies, because today this is the most intensely developed region in the entire Valley. And according to the 1990 census, Fresno is the fastest-growing city in the nation.

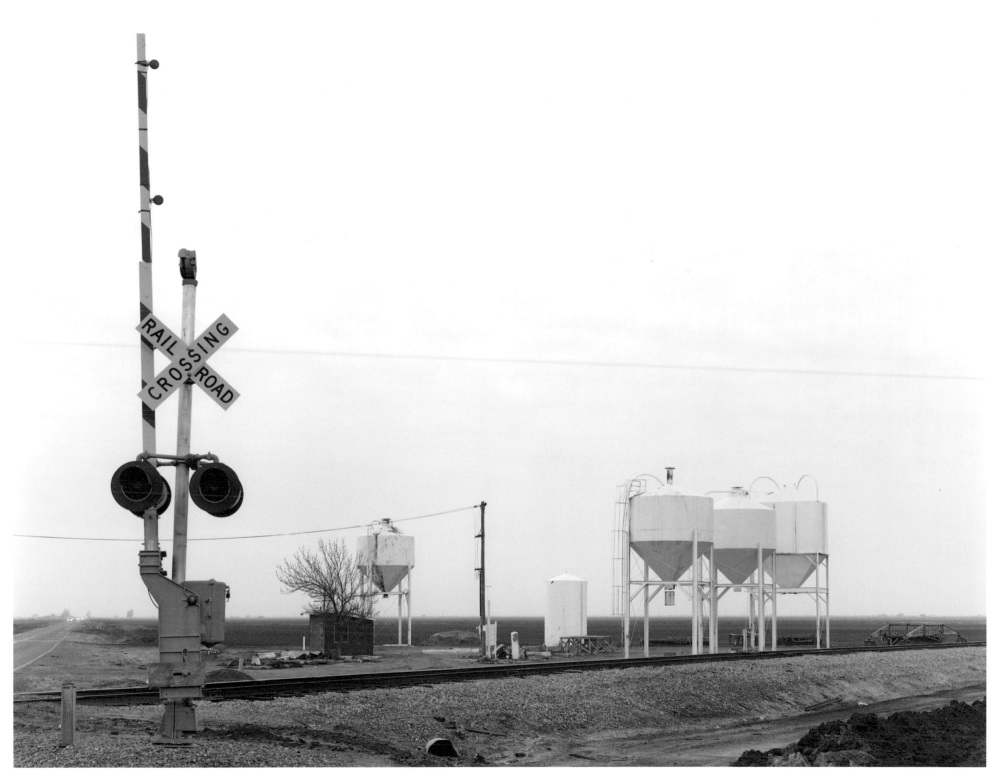

Dusk, Tranquility, 1985. Stephen Johnson.

Manny, Moe, and Jack, Fresno, 1987. Stephen Johnson.

Tex's Used Cars and Towing near Caruthers, 1986. Robert Dawson.

Johnnie, Merced, 1975. Stephen Johnson.

Buck and Tommy, Merced, 1976. Stephen Johnson.

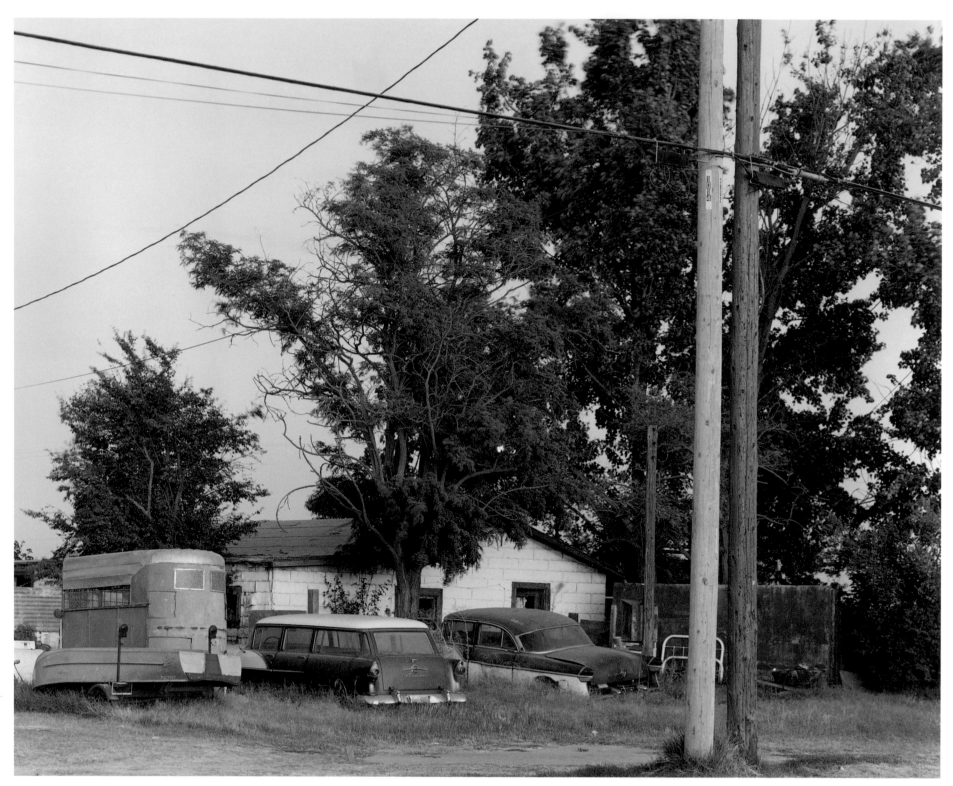

Roadside, Manteca, 1983. Stephen Johnson.

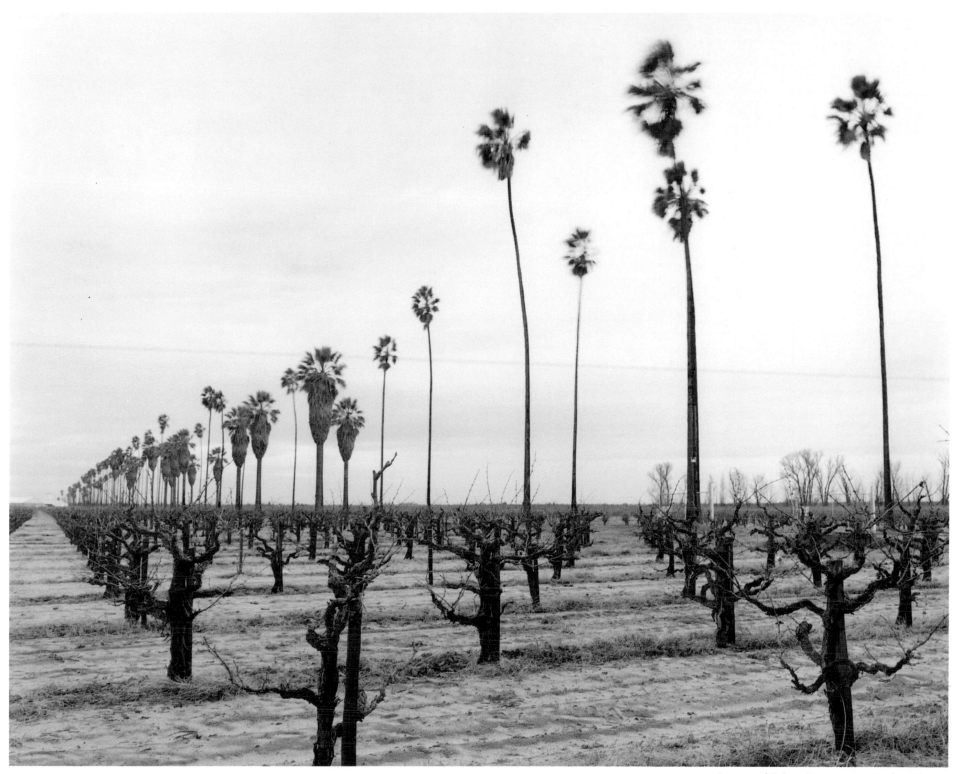

Grapes and Palms, Ripon, 1983. Stephen Johnson.

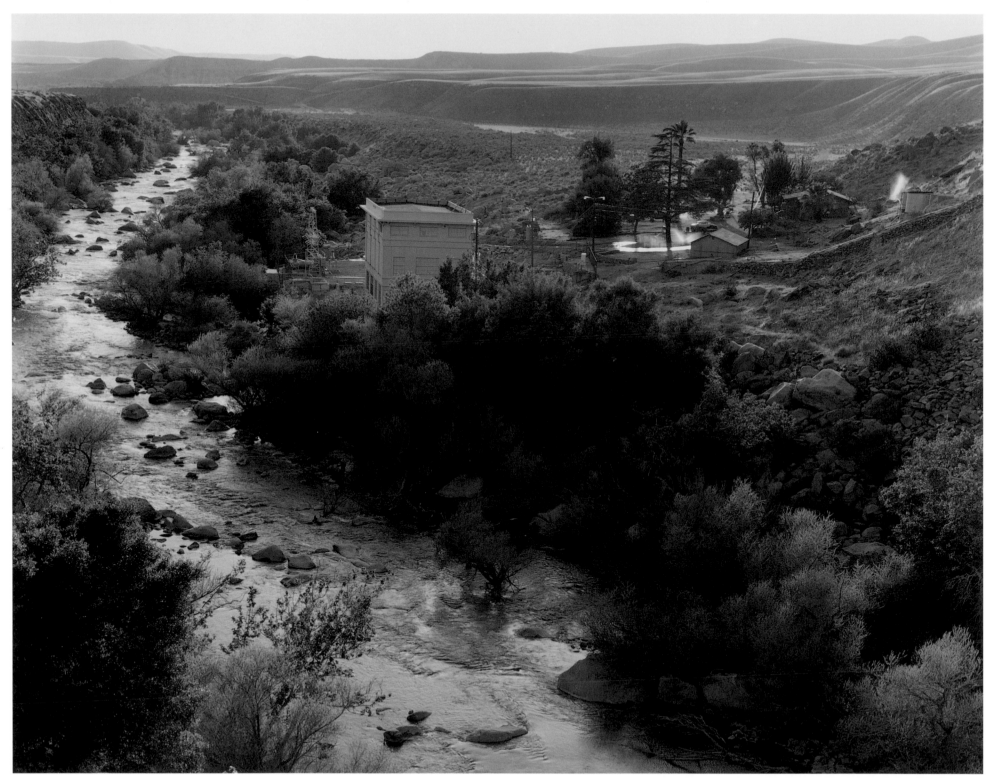

Kern River Entering the Central Valley, 1983. Stephen Johnson.

Chapter VI: The Tulare Basin

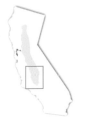

It is surrounded by swamps, now covered with rushes, the green of which was cheering to the eye after the desolation through which we had passed. These swamps extend southeast to Tulare Lake.

William H. Brewer, April 12, 1863

rewer believed his party had visited Tulare Lake during his first venture into the Valley in 1861. It is more likely that the young men really encountered seasonal marshes near present-day Los Banos, almost a hundred miles north of the lake. Two years later, the survey party finally entered the actual realm of the tules, a unique geomorphic domain composed of the Tulare Lake Basin to the north and the Buena Vista Basin to the south. It was then a land of contrasts: vast reed beds, swamps, and lakes surrounded by bleached grassland or land with no grass at all, "full of mystery and malaria," according to novelist Mary Austin. The Sierra Nevada and the Coast Ranges widen to nearly sixty miles here, then join the Valley's southern boundary, the Tehachapi Mountains.

Tulare Lake itself, formed by the entrapped drainage of four rivers that flowed from the southern Sierra, was a fabled setting in the nineteenth century. In flood, it swelled to become the largest body of fresh water west of the Mississippi. Its highest level was recorded in 1862, when it covered 486,400 acres to depths exceeding fifty feet—rising, paradoxically, in the midst of a dry landscape. By 1863, nearly everyone in California had heard of it, although few had seen it.

Riding their horses toward the distant southern mountains, Brewer and his company experienced an increasingly dry climate, although icy Sierran streams and attendant riparian forests sliced into the prairie from the east. Rainfall was—and is—low here in the Valley's southern reaches, where alkali desert, like land crusted with snow, could be found edging miles of tule marshes. There were even desert sand dunes near the lake's south shore.

This area, which extended from the hump formed by the Kings River's alluvial fan far south to the wall of the Tehachapi Mountains, was from 1860 until 1890 known as the Tulare Valley. In its northern section—the basin of vast Tulare Lake—the Kings, Kaweah, White, and Tule rivers emptied to form a complex wetland. The Buena Vista Basin lay just south, below the present Kern County line, near the

locations of Taft and Bakersfield, where two lakes—8,000-acre Kern and 4,000-acre Buena Vista—collected the flow of the Kern River, the Sierra's longest stream, in the middle of a true desert. Between and among those major lakes existed many channels, marshes, and even swamps, as well as another tule-lined pool, called Goose Lake. During wet years, Buena Vista Slough linked the two sub-basins.

As geographer William Preston explains, despite the distinctness of those two sections, "historically the word 'basin' was used to describe the entire southern end of the Valley as a unified landscape." During extremely wet years, a single, virtually unbroken sheet of water might extend from the Tehachapis to the Kings River's fan—as it did in 1862, 1890, and 1938. Then the entire southern end of the Valley resembled a primordial sea, with only an island here, a causeway there, breaking its surface, while its periphery was dotted with displaced rabbits and lizards and its surface was darkened by waterfowl.

Wetlands of all kinds shimmered over great stretches of the region. This water did not drain into the San Joaquin River system, so Tulare Basin was not part of the geographic unit named after the San Joaquin. Trapped by the Kings River's alluvial fan, both rivers and smaller streams here emptied into the basin and puddled. Only in exceptionally wet years might excess water spill over that alluvial blockage into the San Joaquin River's drainage area. Normally, the trapped water formed complicated wetlands; examples of four major types of freshwater aquatic communities—marshes, swamps, ponds, and lakes—could be found here.

The marshes consisted of patches of warm, shallow water clogged with dense masses of sedges, cattails, rushes, reeds—the abundant tules, or *tulares*, after which the region was named by the Spaniards—and other aquatic vegetation. Trees and shrubs in or near water characterized swamps, and wildlife abounded in both habitats. There were also many boggy ponds in this region, some seasonal, all poorly drained. Their surfaces might be decorated by floating "islands" of vegetation,

principally tules; even the bigger lakes hereabouts were poorly drained, and windblown tule isles, some large enough to carry the weight of several people, are reported to have drifted across the choppy surfaces.

Tules, which surrounded the sloughs and ponds and lagoons in unimaginable profusion, died and decomposed in the water, enriching it with nutrients. In 1850, George Horatio Derby, a U.S. Army surveyor, said he could reach the open water of Tulare Lake only with great difficulty, fighting his way through a dense band of tules that was two miles wide but that was, paradoxically, surrounded by arid land. Moreover, the region's long summers—in this microenvironment, the hot season may extend to seven or eight months—created a semi-tropical environment. The cold snowmelt water sat in shallow beds, where it warmed and evaporated, and diseases such as malaria were common. More than in any other part of the Valley, standing water characterized the ecosystem here.

Because the special ecological and geographic features that once delimited the Tulare Basin have been obscured by the damming of the area's major streams, by the draining of its wetlands, and by the planting of their dry beds, many people who live here today are unaware of the basin's uniqueness. Most refer to it now simply as part of the San Joa-

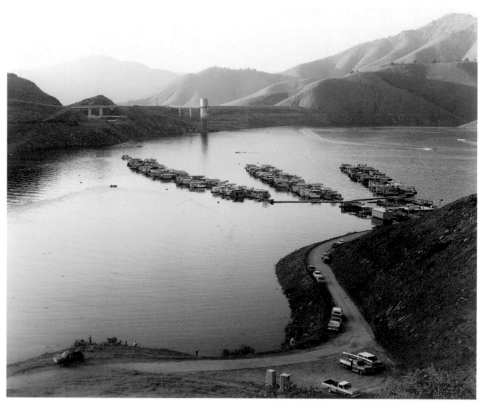

Lake Kaweah, 1985. Stephen Johnson.

quin Valley. In fact, no other section of this great trench has been more dramatically altered by humans than this one, which, in terms of popular perception, has actually ceased to exist.

This region traditionally boasted its own regional identity. "Tulare Valley is better watered, better timbered, and has a more universally level surface than the San Joaquin," asserted an 1888 *Business Directory and Historical and Descriptive Hand-Book of Tulare County, California.* It further advised residents: "All Tulareans should co-operate in giving the name of their great valley a wide and honorable notoriety, leaving the inhabitants of the San Joaquin to look out for the name and fortune of their portion of the state."

In a manner unique to this section of the Valley, local lakes ebbed and flowed, their size and depth determined less by local rainfall than by snowfall in the distant Sierra Nevada, which fed all the west-flowing streams. Most wet years, the lake covered 200,000 acres and measured seventy-five miles from south to north and twenty-five miles from west to east. The dimensions of the deluge in that extraordinary winter of 1861–62 can be better defined when it is understood that all the bodies of water in the basin became one, and that Tulare Lake was, as a result, more than *twice* as large as at any other time in its recorded history.

The pulsing of the lakes was an annual event. Each year, like vast vernal pools, they would swell with spring runoff, then recede considerably by fall and early winter. Pioneer farmers played a kind of agricultural roulette locally by planting grain as water retreated on the erstwhile lakebed, then harvesting before the next cycle's runoff filled the depression once more. It was usually a profitable strategy, but not always.

In 1906, for instance, William Hubbard, who farmed near Delano and annually planted grain on the lake's rich margin, found his expensive equipment trapped when water rose faster and higher than expected. His crew moved their threshing machines to an island they had never seen covered with water, then escaped by boat themselves, but this was a wet year and soon their gear was six feet below the lake's surface, a fitting symbolic depth, since all the machinery was ruined and so was Hubbard. Eventually the rusted equipment was dragged back to the farm, where it stood for years, known as Hubbard's junkpile, a monument to nature's capriciousness.

Those fluctuating Tulare waters were, during most years, plied by steamboats, as well as by various other kinds of commercial vessels, since the lakes sent waterfowl, fish, frogs' legs, and even turtles to faraway dining establishments; an 1883 history of Kern County proudly states: "From Tulare Lake come the turtles that make the rich turtle soups and stews in San Francisco hotels and restaurants....These turtles are sent in sacks to San Francisco. During the Season more than 180 dozen found a ready sale at the bay."

Local Indians had developed buoyant tule rafts with holes in their floors so they could spear fish. After American settlement and control, they sold such fish commercially, and Fred Wells of Tulare told Frank Latta that as late as 1880 he caught trout weighing more than twenty pounds in the lake. Professional fishermen during the 1870s and 1880s claimed to have caught up to eight tons of fish in the lake with only one haul of a horse-drawn seine.

Now cotton and safflowers and almonds are produced where turtles were trapped, where lake trout were once speared, and the existence of the lake itself is only a vague memory...if that. That fact demonstrates as dramatically as any the dimension of human alteration here. Hogs were run on Atwell's Island southwest of Tulare, and no fences were needed because the settlement could be reached only by boat; today it is a dry-land farming town called Alpaugh. William Rintoul tells another revealing story: "An 'offshore' oil well was drilled from a platform on Tulare Lake early in the century. The crew went to work in a motorboat and one guy from the South put out a trot-line and caught fish for market in a sideline to his work on the rig."

Neither motorboat nor trotline would be useful there today. To newcomers and many natives alike, the basin now is virtually indistinguishable from the Valley's other settings. Except for holding areas where water is retained for use in summer, the entire lakebed has been drained. Viewing it from an airplane today reveals the old lake's sinuous outline; it has been replaced by the world's largest and most productive agricultural chessboard: to paraphrase Alvin Urquhart, geometry has overwhelmed geography.

Although Sierran rivers have been dammed and the angles of irrigation channels and property lines now precisely demarcate the beds of bygone lakes, although tractors and pickups often trail great plumes of dust as they travel the erstwhile lakebeds, those ancient bodies of water occasionally reappear during especially wet years: geography reasserts itself, and the illusion that humans can fully control nature is exposed.

Indignant, people fight back, and not always sensibly. In March 1983, Marc Reisner points out, one of the levees keeping water out of Tulare Lake's old bed was breached and 30,000 acres of cropland were inundated. The local irrigation district immediately sought permission to pump the water over the divide into the San Joaquin River's drainage, but there was a complication:

At least one of the reservoirs upstream had been illegally planted with a species of fish called white bass, which got flushed down by the floodwaters and were already flourishing in the reincarnated Tulare Lake. White bass are a voracious, opportunistic, highly adaptable type of rough fish and love to eat young salmon and striped bass.

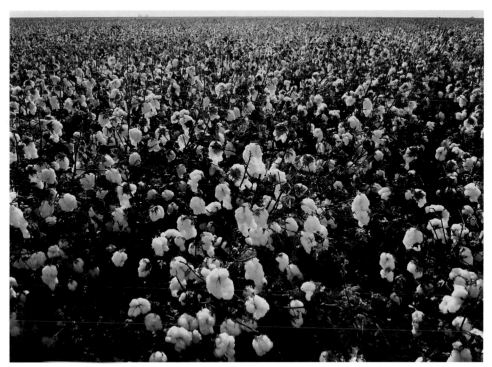

Cotton Field near Five Points, 1985. Robert Dawson.

The following October, Tulare Lake's latest reincarnation was still there and the Army Corps of Engineers issued a permit for growers to pump their land dry, requiring that fish screens be employed. Only twenty-four hours after the operation began, however, white bass had been gill-netted downstream. The pumping had to be halted while, as Reisner explains,

Fish and Game—as if to underscore the catastrophic consequences of releasing white bass—poured a thousand gallons of rotenone...into six miles of river around the fish screen. Everything in that stretch of river...died a ghastly death. A week later, Fish and Game performed a second mass poisoning.

Eventually, despite urgent legal efforts to stop them, growers were allowed to pump the lake into the river, and even today experts wonder if the introduction of white bass may over the long term have doomed the Delta's rich game fishery. Playing with nature, it turns out, is rarely without unexpected cost. With the lake pumped dry, many local residents once more forgot it had ever existed, but some future wet winter it will be back to remind them.

There is another deep irony in the Tulare Basin because this once diverse part of the Valley today more than any other strikes outsiders as

Canal next to Tulare Lake, 1985. Robert Dawson.

homogeneous—fields and towns and roads that look too much alike. (Novelist A. T. Bezzerides, writing in 1938, sent a character driving "through the small towns, Fowler and Kingsburg, Goshen and Pixley, town after town, Famosa and Bakersfield, mixing them up, thinking one was the other.") William Preston, a native son, succinctly sums matters up: "To outsiders and residents alike, the regional identity of the Tulare Lake Basin has been severely diluted by this homogenization within the context of the world farm."

Although it retained some of its unique identity when the first Americans entered it, the basin had already been considerably, if subtly, altered: a paradigm for the entire Great Central Valley. Geographer Preston explains that during the Spanish and Mexican periods, "the composition and distribution of natural communities were altered, and some communities—notably perennial bunchgrass prairies—were almost completely replaced by invasive communities of introduced plants." American settlement has exacerbated change, controlled it, and created one remarkable garden from another.

One introduced plant in particular has come to symbolize the alien invasion: Bermuda grass. Few Tulare Basin dwellers haven't pulled it from their yards, chopped it from their sugar-beet fields with short hoes, or at least seen it widening cracks in their sidewalks. "Bermuda," as locals scornfully call it, is considered an unavoidable menace locally, yet, as Wallace Smith points out, "it did not spread rapidly in the San Joaquin until intensive cultivation and irrigation became prevalent." It is also known as "water grass"—one of the many varieties so designated in popular usage—since its distribution frequently follows irrigation.

A far more positive addition to the south Valley has been the large number of so-called Dust Bowl migrants who settled here during the late 1930s. Between 1935 and 1940, the population of this basin's counties grew remarkably: Tulare County increased by 38.4%; Kings County by 38.5%; and Kern County by a whopping 63.6%. A great many of those newcomers were southwestern migrants, "Okies" in the parlance of the day, and their contributions continue to enrich life here.

In Tulare, poet Wilma Elizabeth McDaniel crosses her arms. "California!" she sighs. After a moment, she says, "Well, my exodus from Oklahoma to Merced, California, took place in 1936 when I was seventeen. We made this move in a magnificent Pierce-Arrow limousine. My unwitting father traded a ramshackle truck for it, even trade." A wide grin crosses her face at that memory. She continues: "The owner told him, 'This beauty can't pass up a gas station,' but Papa couldn't pass up a car with three seats, velour-covered, to convey his brood to the promised land."

McDaniel illustrates the foolishness of stereotyping southwestern migrants. Although she didn't publish a book until she was past fifty, she is now acclaimed. One of her memorable works links the two states in which she has lived:

Cotton Trailers, Buttonwillow, 1985. Robert Dawson

Buried Treasure

Elbie Hayes ruined his
expensive shoes
squashing around the autumn
desolation
of a sharecrop farm
in Caddo County

Okie boy
turned fifty
searching for anything that
had belonged
to his father
when he was fighting the
Great Depression

Tules, Kings County, 1988. Stephen Johnson.

Kicked at a lump
behind the caved-in cellar
and uncovered a rusty
Prince Albert tobacco can
Stowed it away
as he would a saint's bones
in his Lincoln Continental
and headed back to Bakersfield

Tulare, founded in 1872 as division headquarters and repair center for Southern Pacific Railroad, is the largest town on Highway 99 between Fresno and Bakersfield. Like so many other communities in the south Valley, it is growing rapidly, reaping promises and problems. Wilma McDaniel is less than pleased: "The open field where my mother and I had afternoon tea and watched doves eating dove weed," she says, "is now crowded with neat, ugly crackerbox houses."

Buying many of those houses are folks only a generation away from field labor. In turn, such people must market insurance or distribute fertilizer or sell coffee and doughnuts—*do something*—and nearly all, however indirectly, service agribusiness, which in turn requires land. Freshly migrated to this cusp of hope from places offering little, new-yet-familiar faces appear in the fields, as well as on the other side of the tracks, where so many dwellers in those new housing developments not long ago resided: the cycle continues.

McDaniel and the crackerbox houses reside in one of the many communities built according to the needs and plans of the Southern Pacific Railroad, employing that corporation's uniform city plat, a grid aligned with the all-important tracks. Nearby Goshen (1876), Hanford (1877), Lemoore (1877), Tipton (1884), Traver (1884), and Earlimart (originally named Alila, 1885) are also standardized railroad towns. The importance of rail transportation to this region's development is well illustrated by that list.

The relationship between Tulare and the S.P., as well as the latter's agricultural role, were thrown into high relief by the first major novel set in the valley, Frank Norris's *The Octopus* (1901). Like John Steinbeck's *The Grapes of Wrath* (1939), Norris's book is better literature than history, but it nonetheless captures popular attitudes toward the S.P. *The Octopus* is set in the area of Tulare—renamed Bonneville—but much of its descriptive detail is based upon impressions gathered in the much smaller San Benito Valley on the other side of the mountain range to the west.

The Octopus explores what is definitely a Central Valley situation, however. Norris's epic is based on events surrounding the infamous Battle of Mussel Slough, an event that exposed the power and capriciousness of the rail monopoly in California; in the 1870s, settlers had been encouraged to occupy and improve land granted by the government to the railroad. The latter, in return, could and did charge whatever it wished for shipping to and from such holdings, a cause for resentment, and it still owned the land. What finally prompted armed resistance was the railroad's intention to place on the market land already improved by settlers—or "squatters" in the S.P.'s terminology—and to ask prices the farmers could not pay.

Why had those farm families squatted there in the first place? By the end of the 1870s, the railroads had received 11,458,212 acres of land from the government, land that otherwise could have been open to free settlement, an American dream too little realized in this area of huge holdings. In the ensuing battle at Mussel Shoals, five settlers were killed and so was any illusion that the railroad monopoly was benevolent. Norris characterizes it as an octopus with "tentacles of steel clutching into the soil."

Forty miles southwest of Tulare, on an edge of the old lake bed, is located the remains of one of the Valley's most remarkable communities, Allensworth, a short-lived hamlet that died in part because railroad executives refused to staff a depot there, although it had before the town's birth been an established station on the Santa Fe Railroad's route between Los Angeles and San Francisco. The problem was that Allensworth was founded and settled by African Americans.

Groundwater Pump near Allensworth, 1984. Robert Dawson.

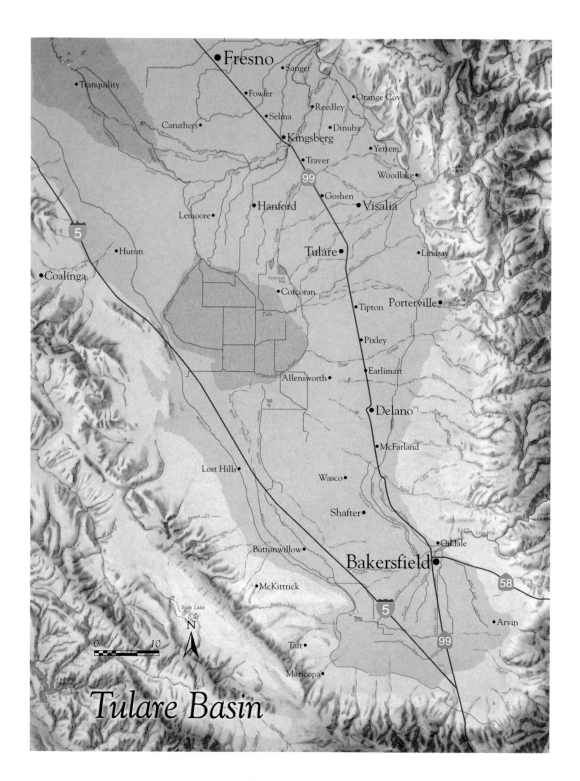

Tulare Basin

A retired army officer, Lt. Col. Allen Allensworth, established the community as an agricultural colony in 1908, a time when racism was rampant; as historian Lonnie G. Bunch III explains, the Santa Fe "refused to hire blacks as the manager or ticket agents of the station located in the colony and…continued to restrict blacks to menial labor." Eventually, the company built a spur to nearby Alpaugh, that one-time island in Tulare Lake, thus denying Allensworth revenues from the drayage and storage of goods.

By 1912, one hundred people lived on the town's flat, usually dry location, and, for the next three years, the settlement thrived; the *Los Angeles Times* called it "an ideal Negro community." Unfortunately, a number of problems arose in addition to the railroad's recalcitrance—principally, the lack of a consistent water supply; as Helatha Smith, a former resident, recalls, the local Progressive Association "mostly talked about water, and more water—the water system in the town area, canals in the colony area, problems with gophers and rabbits damaging ditch walls. Farmers couldn't get water on the days they should." Other reasons why Allensworth failed to survive were inability to gain legislative approval to build a technical school modeled after Tuskegee Institute and Colonel Allensworth's untimely death in 1914.

The Colonel's dream endured less than two decades. Given the currents of the time when it was built, however, the town was by no means totally unsuccessful. As Bunch sums it up:

> *The fact that Allensworth ultimately failed is not the most important fact about the venture. What mattered then is that the attempt was made. And what matters now is that Americans finally discover the depths of character and vision of those who, through their attempt to build a colony, tried to provide an opportunity for men and women to transcend race-based limits and thus control their own destiny.*

On October 6, 1976, the site of Allensworth was dedicated as a state historical park.

The Santa Fe, as locals called it, which contributed to Allensworth's demise, was not the railroad most local residents resented. Visalia was a well-established community when the Southern Pacific penetrated this section, and its residents were hopeful that their town, too, would become a rail stop, but that was not to be. Visalia's citizens refused to pay the extravagant price demanded by S.P., so the railroad created a new town, Tulare, rather than swerve the line toward the existing community.

Just as Modesto is the doorway to the Central Valley's version of the Southwest, Visalia demarks entry into its Deep South. The first substantial settlement in the basin, Visalia was from its founding, according to the geographer James J. Parsons, "a determinedly ranch culture of Southerners"—Brewer's hated "Seceshes." Parsons goes on to point out

that it set a tone for the contemporary region: "Confederate sympathizers, they left a lasting imprint, strongly reinforced by immigration from the Dust Bowl during the great depression." The Tulare Basin remains a realm of okra, greens, and black-eyed peas, of drag racing, country music, and religious tent meetings, and its urban neighbors occasionally assign it a Southern Gothic stereotype; for instance, a reporter for the *San Francisco Examiner* in 1987 described it as "the state's Bible Belt."

Today Visalia, which was founded in 1852, still retains oak-lined streets and an unusually clean aspect. It is the county seat and it remains one of the Valley's prettiest and most dynamic communities, possibly a benefit of its location slightly away from the traditional line of development that has followed Highway 99, which itself runs parallel to the S.P.'s tracks. Visalia's location is of interest for another reason: an imaginary east-west line running from the Coast Range through this town to the Sierra near Sequoia Park marks the Valley's widest point, approximately seventy-five miles.

Visalia has expanded to the north and east—away from Tulare—and it has increasingly attracted industry, in part because it has managed to retain a small-town aspect—no parking meters, little sense of urban sprawl, and many tree-studded parks (the city plants a thousand oak seedlings a year). It is no longer primarily a ranching community, although range cattle still wander the hills east of it. The old vaquero Arnold Rojas remembered that Visalia was, well into the present century, the source of the best saddles and other ranch gear to be found anywhere.

It is not widely recognized that the Central Valley was part of the fabled Wild West, and no area better summarizes that aspect of this region than Visalia, for it was not only a cattle kingdom but a rough-tough arena where outlaws such as Chris Evans and John Sonntag, as well as the infamous Bob, Grat, and Emmett Dalton, met their matches. In 1890, when Eugene Kay took office as Tulare County's sheriff, historian Leland Edwards explains,

> *he inherited the unsolved train robberies and murders that occurred at Pixley on February 22, 1889.... He was also confronted by another holdup which happened on January 4, 1890 at Goshen. Another murder occurred during this robbery when the perpetrators shot and killed Jonas Christiansen.... As in the first, the bandits escaped.*

Shortly thereafter, the Dalton gang hit a train in nearby Alila, and it became clear that the notorious Evans and Sonntag had likely been responsible for both the earlier Pixley and Goshen robberies.

As it turned out, Kay was the man for the task and, in a time when gunfights killed one of his deputies and wounded several others, he managed to chase the Daltons back to Oklahoma and deposit Evans in Folsom Prison and Sonntag in a local cemetery. Posses and smoking

Western Kern County, 1983. Stephen Johnson.

revolvers were for a time as common in the Visalia area as in B Westerns, as were steely-eyed sheriffs and wild-eyed villains.

Southeast of Visalia, Porterville is built against the foothills of the southern Sierra, actually invading some canyons and small valleys as it grows, seeming to follow the orange groves for which it is noted. It was originally a stage station on the Tule River, which has in recent years been dammed to produce Lake Success in the foothills five miles to the east, a favorite of water-skiers and fishermen. For Brewer, writing in 1863, the area was less pleasant:

> **Monday, April 13, we left Visalia and came on to Tule River, about thirty miles along the plain, here very barren, but the Sierra rose quite near us. We stopped at a little tavern and store, with miserable accommodation, but poor as it was, it was to be our last for near a hundred miles.**

From those nearby hills, on a clear spring day, the southern panorama of the Valley presents itself, swaths of wildflowers—lupines, poppies, Indian paintbrushes, bright smears on a painter's pallet—brighten

Porterville, 1984. Stephen Johnson.

the rolling country until they give way to dipping oil pumps and tumbleweeds clustered in squat forests due south near Oildale and Bakersfield. Sixty miles away, on the opposite side of the Valley, beyond stretches of rich farmland and row upon wrinkled row of irrigated crops on the Valley's floor, other desert hills are covered with similar pumps. And beyond all, three mountain ranges—the Sierra Nevada, the Tehachapis, the Temblors—seal the Valley's southern end.

This was once the range of the endangered kit fox, a small, mostly nocturnal predator whose habitat has been disked and plowed and irrigated, or drilled for oil. The large-eared foxes that have managed to hang on along the margins of their former range must now contend with domestic dogs and coyotes, which have adjusted well to human habitation. While the speed of the kit foxes may frequently save them from predators, not even their fabled quickness can protect them from the continued alteration of what was once their natural niche: they and their ecosystem may be sacrificed for that extra barrel of oil, those other lugs of grapes.

In this final region, far from Mount Shasta's thrall, Mary Austin once described deserts, John Steinbeck's Joads first viewed their land of

journey's ending, and contemporary poet Don Thompson observed a winter evening near the Tehachapi Mountains at Mettler Station:

> *The sun has gone down, its glow*
> *clouding*
> *like breath in the chill air.*
>
> *A lamp snaps on*
> *in the window behind me.*
>
> *Far off, across plowed fields:*
> *black smoke,*
> *as if night were rising*
> *from a crack in the earth.*
>
> —*Winter Evening at Mettler*

From the same hills that may have been Thompson's vista, the night lights of Delano are clearly visible, a flare in Highway 99's glowing line. Once the center of the largest cotton-growing region in the state and Bakersfield's rival for southern Valley supremacy, Delano is now surrounded by a variety of crops. In the late 1960s, it was the Valley's best-known town, for it was the center of an international table-grape boycott, and its name became identified with the *huelga* (strike) of farm workers fighting for the right to bargain collectively. Cesar Chavez, leader of the United Farm Workers, explains how the Valley itself influenced his commitment:

> *I thought: I have to see this valley once more. So I started traveling in my old car; I began up in the Tehachapis, then went from Bakersfield to Fresno, just looking at the topography and the system. I went east and west all the way up north to Chico, and I would stop at all the chambers of commerce and pick up the histories of the little towns and at night I would read them. Finally I came back to Delano. I got here about two in the morning and my wife wanted to know all about my journey: did I see anything different? And I said, "You know, it's damn big. It's frighteningly big. But," I said, "it's got to be done," and so we started.*

The struggle to organize farm labor gained national, even international, dimensions when it erupted into public view from Delano in 1966. To many locals, the struggle remains an enduring affront, for it altered the established and comfortable balance of power in this domain. Originally, two farm labor unions—Larry Itliong's Agricultural Workers Organizing Committee and Chavez's National Farm Workers Association—successfully struck grape growers, including the giant Schenley Industries and DiGiorgio Corporation. The results significantly limited traditional grower hegemony.

Desert, McKittrick, 1983. Stephen Johnson.

As used by many Anglos, "Mexican" had deeply pejorative connotations: stoop labor, knife fights, *foreigners*. A ruddy-faced field foreman near Edison pointed toward a crew slowly working its way through a field shimmering in summer heat: "Hell, they don't feel it the way a white guy does," he explained. A Tejon Ranch shop supervisor, praising a tractor for its simplicity, said it was "Mexican-proof." Finally, racism in Delano, as elsewhere in the Valley, has largely been a rationalization, a ploy to obscure the real struggle over who will control what in the fields.

The two unions eventually merged to form the United Farm Workers. In 1967, the UFW struck Giumarra Vineyards, the nation's largest table-grape growers. The following year, a national boycott of California table grapes was launched, a boycott that grew in effectiveness until many farmers were in genuine economic jeopardy. In July of 1970, Giumarra and most of the other major table-grape growers in California agreed to union contracts.

Seven years later, the UFW and the International Brotherhood of Teamsters signed a contract that granted the Delano-based group the right to represent all field workers, while the Teamsters retained the right to organize cannery workers and some truck drivers. For all intents, agribusiness had begun to be organized, and the balance of power had, however slightly, been tipped. Ironically, it was a longtime opponent, John Giumarra, Jr., spokesman for the growers, who best summed up events: "The world will be focused on Delano to determine if this has really been a revolution in labor relations and if social justice will prevail. If this works here, it will work well throughout the rest of the world."

Technology may render such victories at least somewhat pyrrhic. Labor organizer Saul Alinsky predicted in the late 1960s, "In ten years, mechanization will make the historical farm workers obsolete." More than twenty years later, farm laborers remain essential here. If he overstated the case, Alinsky's suggestion was shared by many, but these matters are always complicated, and the mechanization Alinsky predicted requires formidable amounts of a finite resource, fossil fuel.

Any sustainable agriculture implemented locally will certainly minimize the use of such fuel, and Michael Black perhaps reflects an equally idealized vision when he suggests that "farm workers will of necessity be reintroduced into agriculture as a whole....It's the [mechanical] harvester that is the Edsel here, not the farm worker." Many forces are at work in the Valley, and it may be that farmers, in order to *remain* farmers, will escape the assumption that progress and mechanization are inevitably linked. But even if mechanization continues, people will, albeit in diminishing numbers, continue to work these fields for a long time to come.

Jack Stone, who owns a 20,000-acre ranch that once belonged to his father, is an advocate of increased efficiency through technology: "Fifty or sixty years ago one farmer produced enough food for five or six other

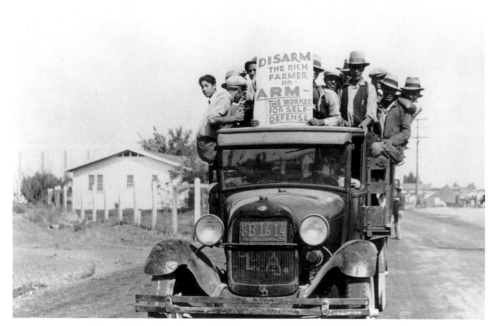

Cotton Strike, San Joaquin Valley, 1933. Paul Taylor Collection, Library of Congress.

Simple realities motivated organizers. Explains Dolores Huerta, a union official, "Field workers had low salaries, no health plans, no retirement, yet they worked as hard as anyone. They were treated as though they somehow didn't have the needs other human beings had. The growers, their employers, simply wouldn't provide those things, so a union had to." Chavez adds a terrible irony: "It is a great tragedy that the men and women who work to feed us haven't enough to eat."

Corporate agribusinesses at the time employed an old defensive strategy by stressing the threat unions posed to small farmers—employing the middle class as a buffer between the wealthy and the poor—but this time it was an overused ploy, one cry of "Wolf!" too many, although small farmers were indeed vulnerable. It is also true that many of the struck farmers were themselves only a generation or two from migration and poverty, the progeny, among others, of Italian, Armenian, Japanese, Yugoslav, German, Portuguese, and Swedish immigrants. In addition, another factor had evolved; as Walton Bean and James Rawls observe, "A new force was at work—the strong and increasing sympathy of a part of the white public for the civil rights of ethnic minorities in general and farm workers in particular."

Much of the white public in the Valley during those years seemed little interested in sharing that sympathy, and race was an omnipresent, if often unacknowledged, element in the battle to organize farm labor.

people. Now one farmer produces enough food for fifty or sixty people, and you're not gonna do that with your hands on a shovel." True enough, but Chavez cautions, "We must never forget that the human element is the most important thing we have—if we get away from this, we are certain to fail."

The United Farm Workers' crusade made Delano a focus of national attention for a while, but George Zaninovich, a professor at the University of Oregon, recalls something far more mundane from his Delano boyhood. "Clods," he says with a wide smile. He is a large man, fit and tan, who looks as though he might pull on boots tomorrow and return to the farm where he was raised. "Most people I know don't understand the dirt clods we valley kids played with and took for granted, big clutches of soil you could throw or even build forts with, that would cast shadows in the fields when the sun was low." There is genuine pride in his speech and his eyes drift a bit. "It's funny what you remember," he concedes, still smiling like a man revealing a deep secret. "That earth didn't look special, but it was."

Delano is a progressive, ethnically rich town, with prominent blacks and latinos and Filipinos as well as whites of many kinds, with beautiful children grinning as they skip toward a public swimming pool—although homes with pools are increasingly signs of middle-class status. It is difficult to imagine the harsh language of racism that echoed these very streets during the strike, and that may still occasionally be heard among gentle chuckles over drinks next to some of those same private pools on long summer evenings, as it can in other communities all over the Valley. It is revealing that such prejudice is not always voiced in English.

In this place, which neither Spain nor Mexico ever really settled, the so-called Anglo majority is rapidly becoming a minority, and the so-called Hispanic minority is itself becoming more Californian than Mexican, a reality some are loath to admit. "Mexico will determine California," says one of the state's distinguished contemporary writers, Richard Rodriguez. "That's what California will become, a mestizo culture. I look at the new generation in my own family; my nieces and nephews are truly Californians, some with Anglo surnames and some with Spanish surnames and all of them a puzzle to each other. The bloodline is incredibly mixed, and we are all Californians."

The very label "Chicano," that epitome of ethnic pride among many people, isn't avoided just by Anglos here. Alberto Huerta, S.J., is one of a number of prominent Californians of Mexican descent who abjures its use. "It's a political term," he argues, "not an ethnic or national one. And it's by no means popular. Get away from colleges, or from barrio gangs, and ask working people around the state if they consider themselves Chicanos and you'll see what I mean."

Whatever they are called, migrants from Mexico continue filling California's urban barrios and rural valleys. The Central Valley is

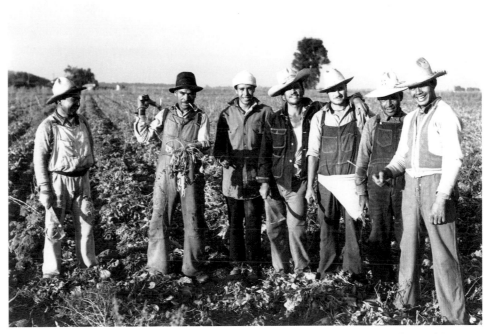

Mexican Agricultural Laborers Topping Sugar Beets, Stockton, 1943. Library of Congress.

bronzing and only now are latinos building a large, influential population base and beginning to assume some commensurate power. Despite all the fuss about closing a border that has never really been closed, California's economy still counts on the availability of the work force Mexico provides, and some employers still justify treatment that borders on exploitation.

Many latinos have been given backbreaking jobs, marginal pay, and second-class citizenship. Today, with farm labor unionized and working conditions subject to government regulation, complaints increasingly come from those who profited directly and indirectly from the old system. A Modesto radio station recently broadcast an editorial on farm labor, in which a commentator opined, "It is time to make sense of our farm labor mess. Workers are making too much money….We must help our growers."

Mexican America is culturally complex, and by no means unified within itself in this rapidly changing milieu—except when racism forces a counterattack. Whereas other migrant groups have arrived in waves and then settled, the proximity of Mexico and the fluidity of mutual history combine to produce a constantly renewed first generation of migrants—some sojourners, most from Mexico's least advantaged

classes—so the local latino society at any point contains an enormous range of cultural variations.

Sojourners are apt to leave their families in Mexico, but many other new migrants take advantage of California's educational system for their children as they seek to escape perpetual peonage. The progeny of others—some of them long-term Californians, trapped in hopeless poverty—retreat into the gang uniform of Pendleton shirts and headbands, into a fierce sense of *carnalismo* or *chicanismo*—asserting desperately their value and a link to their native culture. Still others move into the larger, mixed society, although some—including professionals—remain in the barrio because they prefer it and are dedicated to elevating conditions there. In the eyes of a few, however, upward mobility itself is associated with rejecting one's heritage—so poverty and ignorance perpetuate themselves, a satisfying sense of victimization deflecting ambition. And there are those who demand deep and exclusive allegiance to a home country, Mexico, that offered no opportunity to its poor. But these are not the only options.

Recently Gary Soto, among America's most honored young poets, returned from a trip to Huron, the largest community in the Westlands Water District. The town has no junior high or high school and, according to Don Villarejo, 92% of its youngsters do not graduate from high school, so the cycle of agricultural peonage endures. Soto spoke with deep emotion of that visit: "Kids [there] treated me like some kind of hero. What I've done is really important to them." What he has done is become one of the youngest poets ever included in the *Norton Anthology of Poetry* and escaped that often-confining label, "Chicano writer." His accomplishments mark him as a writer, period.

"They were wonderful kids," he continues, "99% Mexican, so bright, so hopeful. Not many outsiders ever visit there. They've got to learn that they can be more than farm laborers." Soto, who teaches at the University of California in Berkeley, endowed a small scholarship in Huron. "I told them education was their hope, just as it had been mine."

Dolores Huerta, a Stockton native who, as first vice president of the United Farm Workers, is among the state's best known Mexican Americans. "One major goal of the union," she explains, "is to provide the poor, those whose sweat creates great riches in this Valley, a way to escape the cycle of poverty. If we accomplish that, the entire state benefits, it lives up to its promise, but there are those with a vested interest in keeping us poor so they can exploit our labor."

Eddie Lopez is both book and travel editor of the *Fresno Bee*. Like Soto, born in California, he is proud of his heritage and aware of its ambiguities. Named California's top Chicano journalist, he is also certain of his own accomplishments. "I hope my example will lead other kids into journalism, which means I hope they'll get a chance. You can influence the larger audience if you're willing to understand and communicate."

Lopez is a handsome man, his olive features haloed by steel gray hair, and he pats his wife's pale hand—her parents were Okie migrants—as he smiles and says, "Look, I'm just a high school graduate, but I've worked my tail off and managed a satisfying career—a newspaper man for forty years. When I came up, I didn't ask for any special breaks because there weren't any available."

Despite the early prominence of local vaqueros and ranchers, Mexicans did not become major elements in California's farm labor force until the period of World War I, when the Mexican Revolution was creating countless displaced persons. "In 1900 there had been only 8,000 Mexicans in California....But in 1920 there were 121,000 and ten years later 368,000," historian David Lavender explains. It is estimated that 150,000 performed migrant labor in Central Valley fields in the twenties. In 1930, urban relief officials initiated a program of repatriation to Mexico; it is estimated that by 1937, 150,000 had returned.

The next big influx from south of the border occurred during the 1940s with the Bracero program. There has been a steady influx of both legal and undocumented Mexican migrants ever since, many of whom return home. But a large and increasing number choose to remain. As a result, many people of Mexican descent have moved into the middle and, to a degree, the upper classes here in the Valley.

It is also true that a great many more have not had that opportunity. Since it is not members of Mexico's privileged class who migrate, most of the newcomers are not well educated—even among naturalized U.S. citizens, only a third have completed an eighth-grade education. Those who do enter the U.S. educational system have a tough time, in part at least owing to the schools themselves; high school dropout rates suggest that public schools are less than successful preparing Mexican youngsters for higher education than they are with most other immigrant groups. U.S. education, the Mexican family, and neighborhood values frequently clash.

As a result, allegiance to Mexico and La Raza—to abstract notions of those things—and an unwillingness or inability to assimilate into the larger, mixed society are factors in causing too many people to remain trapped in poverty and hopelessness. Those who claim that Hispanics somehow enter the mainstream only by "selling out," that they do not also change it, need only spend time in farm communities elsewhere—Nebraska, say, or Kansas—to realize how influential Mexicans and other latinos have been here.

Fred Dominguez's family moved to this Valley before California was American. An avocational horseman, he is a postal employee in Bakersfield and is proud that his great-grandfather, Ramon, his grandfather, "Chico," and his father, also Ramon, were all noted vaqueros. "Damn rights," he says, "the finest cowboys in the world were Mexicans. And some, like the *charros*, still are." He and his wife, Rachel, are

entertaining guests, family, and friends, and there is much laughter as people of various colors mingle. Jibes fly around the room in two languages, everyone seeming to be at least somewhat bilingual.

Dominguez speaks Spanish, of course, but English is the language of day-to-day communication at home and at work. "I have to talk English," he grins, "or these Okies'll take over," and two fair-skinned men laugh, since both of them are first-generation Californians. It is a style of rough ethnic joshing common in the Valley, old prejudice acknowledged but converted to intimate kidding, although prejudice still thrives. Then Dominguez nods at a heterogeneous group of his own grandchildren—fair-skinned and dark, black-haired and blonde—and his gaze softens. "Let me tell you a story," he says.

> *Twenty-five, maybe thirty years ago, when I was working in the post office in East Bakersfield there was an old Irish cowboy who used to come in there named Justin Caire. He'd ridden with my father and grandfather. Anyway, one day near Christmas he came in holding something behind his back and said, "Dominguez, I want you to have this," and he handed me a beautiful inlaid silver bit. I was shocked because I hardly knew him, and I said, "Are you sure you want to give me this, Mr. Caire?"*
>
> *He looked at me and said that when he was a kid and just breaking in as a buckaroo, my grandfather was his foreman. One day he'd mentioned to Grampa how much he admired his bit. Well, Grampa just climbed off his horse, removed the bit and gave it to Mr. Caire. When he'd said that it was too valuable to accept, Grampa told him, "No, you're my friend, my* compañero, *and what's mine is yours. It's the California way." Mr. Caire said it was a lesson he'd never forgotten, and now he was giving it back to me fifty years later because, although he barely knew me, he knew I was a Dominguez and that I'd appreciate it. He was good old* vaquero.

There are Mexicans of all colors in this Valley; there are Mexicans whose great-great-grandparents were born here and others who arrived this morning; there are Mexicans struggling with tangled tendrils of memory and history, and those intent upon their future in this heterogeneous place. "Ray Gonzales for State Senate," read a roadside sign in Kern County in 1990, and low in one corner swirled with a marking pen was a bit of graffiti: *Chacho de loma con safos*; this last was *un grito del corazon*—a cry from the heart—of the otherwise anonymous Chacho, proclaiming pride in his heritage, pride in his barrio, pride in himself. That proximity of Chacho's *chicanismo* and Gonzalez's *asimilacion* symbolized well the cultural extremes of a dynamic, diverse people, but there is no reason to assume that Chacho more nearly reflects an ideal of La Raza than does Gonzalez.

Six miles south on Highway 99, in an area of frequent chemical fertilizing and insecticide spraying, sits McFarland, a town that once

McFarland, 1988. Robert Dawson.

seemed to have been largely populated by southwestern whites and today is home for many Hispanics. It was something of an oddity in this region, where working men and women have frequently played hard, because its first settlers opposed drinking liquor, and all its early deeds are reputed to have contained clauses prohibiting the sale of alcoholic beverages. Unfortunately, a more insidious brew now seems to be threatening the town. McFarland, like Fowler in Fresno County and Earlimart in Tulare County, is the site of a cancer cluster, many of its children mysteriously afflicted by malignancies.

Not surprisingly, the suspected culprit is environmental pollution caused by the intensive application of various pesticides. In California in 1983, for example, about one million pounds of the fungicide captan was sprayed and spread—over a third of that on grapes. According to Dr. Marion Moses, a specialist in environmental diseases, captan is a carcinogen (causes cancer), teratogen (causes birth defects), and a mutagen (causes genetic changes), and its residues contaminate fruits and vegetables. Methods of spreading fungicides and pesticides are by no means accurate and selective; more than one Valley resident has been sprayed by low-flying crop dusters or has choked as wind-borne

Community Childhood Cancer Clusters

In March 1984 Connie Rosales, a resident of McFarland, contacted the Environmental Health Division of the Kern County Health Department (KCHD) and requested an investigation of an unusual number of cancer cases in children. Rosales' request was based on her concern that there might be a connection between the occurrence of the cancer cases and historically high nitrate levels in the public water supply. Water samples were taken from the homes of the childhood cancer families and tested, along with samples from the drinking fountains at McFarland elementary and high schools; the tests found nitrate levels well below the EPA's maximum allowable contamination level. However, these tests were on water supply in 1984, after the public water system had been modernized and nitrate levels reduced.

Additional childhood cancer cases were brought to the attention of KCHD in early 1985; three more cases had been confirmed by April 23, 1985, increasing the possibility of non-random occurrence requiring further study. On July 2, 1985, the Kern County Board of Supervisors declared a local public health emergency in the McFarland area.

The Department of Health Services Studies

There have been three sets of studies by the California Department of Health Services (DHS) investigating the characteristics of the cancer cluster and trying to determine whether or not an environmental or other cause can be found. In 1989 another cancer cluster was identified in the town of Earlimart, 15 miles to the north; studies of the Earlimart cluster have been folded into the studies initiated in McFarland. As of August 1990, no cause has been identified.

McFarland, Phase 1—The DHS studies began with an examination of the cancer cases to determine to what extent they constituted a "cluster." Both the McFarland and Earlimart clusters contain many types of cancer. Statistical analysis of the cancer rates in McFarland showed more than a three-fold excess of cancer over expected occurrences for the town's population size. In McFarland ten cases of childhood cancer were confirmed in the time frame January 1, 1975 to December 31, 1985. Three additional cases were confirmed between January 1986 and May 1, 1990, bringing the total to 13.

Six areas were investigated as possible sources of carcinogenic substances: water quality, residential soils, household products and housing conditions, air quality, radiation, and electromagnetic output from the Voice of America transmitter in Delano. None of these investigations produced findings of unusual exposures relative to control cases in McFarland.

McFarland, Phase 2—The next phase of the McFarland study examined community-wide rates of fetal deaths, stillbirths, and low birth-weight babies for possible correlations with the cancer cases. DHS hypothesized that if a toxic exposure in the past caused the cancer cases, it could also have produced unfavorable reproductive outcomes. The reproductive outcome rates during the cancer window (1980–1981) were not significantly different than those for the remainder of the period 1975–1985.

Phase 2 also continued to investigate potential environmental sources of both the cancer clusters and reproductive outcomes: the use of pesticides in the McFarland area, and the potential for contamination of the water supply by those chemicals, as well as by nitrates and arsenic. Four agricultural chemicals were identified as requiring further study (dimethoate, fenbutatin oxide, dinoseb, and dinitrophenol) because they were used during the cancer "window."

Earlimart Studies—There have been six confirmed cases in Earlimart, spanning the time period 1985–1990; this cluster was identified in 1989. DHS investigators plan to look closely at family histories, contaminants in the public water supplies, and at agricultural chemicals used in the local area. The emergence of the Earlimart cancer cluster, the potential for other clusters to emerge in the future, and the difficulty and expense of conducting extensive epidemiological investigations of these kinds led DHS officials to initiate a regional study.

Four-County Study—Covering Fresno, Tulare, Kings, and Kern counties, this study examined childhood cancer rates to test whether generalized exposure to agricultural chemicals might produce higher rates overall, compared to urban or non-agricultural communities. The study found the highest rates of childhood cancer in non-agricultural urban areas, the second highest in urban agricultural areas, the third in rural agricultural communities, and the lowest rates in rural non-agricultural areas. Although these findings support the proposition that the McFarland and Earlimart clusters are indeed clusters, and not merely part of some regional phenomenon, it lends no support to the prospect that agricultural chemicals are the cause.

Ken August of the DHS public relations department reports that the State of California has spent a total of $669,000 in funds appropriated for the investigations in 1988–89 and 1989–90.

–Trudy Wischemann, California Institute for Rural Studies.

"When you live in the environment you are working in, you wouldn't want to do anything to hurt your own family."

Mona Pankey, farmer, Mettler

"If it's not the pesticides, what is it? Cancer in children is totally abnormal."

Connie Rosales, mother of cancer victim, McFarland

"My kids live in the middle of almond groves....If you got guts to tell me I'd put money before my kids, you can pretty much go to hell."

Norm Bartell, farmer, Wasco

"My boss asks me how my son is doing. We talked after my boy got sick. I told my boss if he put me spraying pesticides again, I would no longer work for him. He doesn't make me spray pesticides any more."

Luis Hernandez, father of cancer victim, McFarland

"There's nothing worse than seeing a four-foot coffin lowered into the ground. If we thought it was any of our pesticides or practices, we would have changed them."

Bill Tracy, Deputy Director
California Department of Food and Agriculture, Sacramento

–Cited by Sally Ann Connell in "And the Children Keep on Dying,"
San Francisco Chronicle, Sunday Punch, June 10, 1990.

chemical residues drifted from nearby fields. And the number of cancer cases in McFarland—surrounded by cultivated fields—continues to grow.

In the summer of 1988, the United Farm Workers mounted another boycott of table grapes, and Cesar Chavez launched a prolonged fast, demanding that five pesticides—dinoseb, methyl bromide, parathion, phosdrin, and captan—be banned. Aram Kinosian, vice chairman of the Wine and Table Grape Growers of America, pointed out that use of the five compounds targeted was tightly regulated, and Jim Wells, a pesticide specialist with the state Food and Agriculture Department, said they did not pose a threat to consumers. The UFW countered that the Food and Agriculture Department "has been in growers' pockets for years."

It is a bitter, uncompromising struggle, and there is as yet no consensus about what has caused the illness of children in McFarland and Fowler. Hard-working farmers understandably resist the assumption that they are responsible. Dick Ethridge, who cultivates 150 acres of table grapes in Tulare County, says frankly, "They are saying that we are doing bad things, that people are dying. That's not true. And I resent having people say that about us." Then he adds, "Thirty years of eating table grapes doesn't seem to have any great effect on me." But children *are* dying and no one is certain why.

Two more prominent farming communities are located along the rail line southwest of McFarland: Wasco and Shafter. The former, named for the Wasco Colony, founded in 1907, was bordered by grazing lands and desert until the relatively recent past, when imported water became available for irrigation; now it is thoroughly cultivated and known as California's rose capital, although everything from safflowers to kiwifruit may be found in the surrounding fields, and its diversified nurseries ship over 350 varieties of plants.

Shafter was an established farm area before the town was platted. It also housed a colony, 109 families of Adventists and German Mennonites, who originally dwelled a short distance south but were enticed by the Kern County Land Company to settle near the railroad once their community failed. Because the region has for many years been cotton country, it has also attracted many southerners—both blacks and whites—familiar with cotton growing, and each town has produced many locally famous athletes whose parents migrated from the South. Today, Spanish is spoken as frequently as English, and *panaderías* may outnumber bakeries in both communities.

Approximately thirty miles to the west of Shafter and Wasco, along Highway 46, which has carried so many travelers to cool coastal comfort, may be found a dramatic remnant of the south Valley as it once was, Lost Hills. It is a collection of houses built on flat,

Fog, Kings County, 1985. Robert Dawson.

parched land that is said to be so hot in summer that carp climb from the irrigation canals to seek a breeze; so foggy and cold in winter that residents go to church just to hear about Hell; so windy that stacking bricks can be difficult. It is now being surrounded by cultivated fields: the new, irrigated Valley slowly swallowing remnants of the old parched one. It is also true that the hills around this small town are more often lost now than ever before, obscured by smog, the airborne offal that has accompanied development.

In this dry area, another of those seemingly unlikely local alliances is emerging as a new Valley crop develops: water. Ron Khachigian, who heads Blackwell Land Farming Company, and Tom Graff of the Environmental Defense Fund are seeking to sell about 50,000 acre-feet (an acre-foot is 325,900 gallons) of State Water Project entitlement that is no longer needed for irrigation in the Berenda Mesa Water District. About 10,000 acres of the district's land now lies fallow and, since Southern California's cities remain thirsty, the plan looks promising. It is opposed, however, by Kern County's Water Agency, which would prefer to keep the allotment for other farmers, although not at the price being asked.

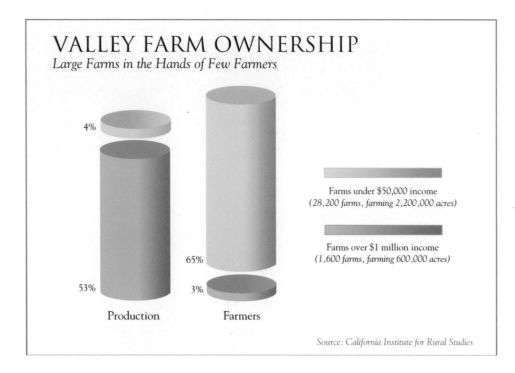

VALLEY FARM OWNERSHIP
Large Farms in the Hands of Few Farmers

4%

53%

65%

3%

Production Farmers

Farms under $50,000 income
(28,200 farms, farming 2,200,000 acres)

Farms over $1 million income
(1,600 farms, farming 600,000 acres)

Source: California Institute for Rural Studies

Edward Bosqui said in 1853 that they "darkened the plains for miles." But as the European and American population of the Valley increased, domestic animals were introduced, and the habitat altered—native grasses replaced by exotics, for example—their numbers dwindled. The impact of hunters was the final straw; surviving elk found refuge in the tule marshes—hence their name. The species was near extinction when this reserve was established; today about 2,000 remain in eighteen sites across the state.

The southern region of the Valley, dependent upon irrigation, was precisely the kind of place the Bureau of Reclamation and the various proponents of the Central Valley Project argued would one day burgeon not only with crops but also with small farms. The first U.S. commissioner of reclamation, F. H. Newell, had declared in 1902, "The object of the Reclamation Act is not so much to irrigate the land as it is to make homes....It is to bring about a condition whereby that land shall be put into the hands of the small owner." What actually happened?

Don Villarejo, director of the California Institute for Rural Studies, points out that Kern and Tulare counties in 1940, prior to the building of the Central Valley Project, contained 8,386 farms of 80 acres or less; at that time there were fourteen spreads of 5,121 acres or more. In 1982, only 4,943 of the small farms remained, while fifteen growers controlled at least 5,121 acres each. In terms of total acreage, large spreads increased their margin from 21,500 acres in 1940 to 103,808 in 1982—a difference that could have created a considerable number of 80-acre farms. Not only did irrigation *not* lead to more family operations, it actually produced a *greater* concentration of land in the hands of a few corporation owners, embodying what Glen Martin calls "the prime shibboleth of American agriculture: Get big or get out."

The concept of water marketing is controversial. On the one hand, it seems to be a way to meet the state's future urban needs without more diversions from the Delta. The profitable sale of farmers' irrigation allotments presupposes that they will continue to be subsidized—and prices for agricultural water fluctuate wildly; some Valley growers obtain it for less than ten dollars an acre-foot, while growers in the San Diego area may pay as much as three hundred dollars for the same amount, making them potential customers for local water. The Central Valley Project charges its users only about a fifth what the water costs taxpayers, so consumers in effect will have to pay twice for it. Moreover, as Harold Gilliam points out, "If water becomes a highly profitable 'crop,' developers might want to build new dams and aqueducts to increase the crop and distribute it." As though to validate Gilliam's projection, a Bay Area company, Bedford Properties, has proposed flooding four Delta Islands each winter to capture 300,000 acre-feet of water to sell to thirsty cities.

South of Lost Hills, not far from Interstate 5, are Tupman and the Tule Elk State Reserve. Many years ago the reserve would have been on the shore of Buena Vista Lake, but that erstwhile body of water is now farmland requiring irrigation. The smallest of North American elk are protected here, where they once ranged the prairie in great numbers;

Brewer wrote in 1863, "We came on thirty-five miles to Kern River, the most barren and desolate day's ride since leaving Fresno....The soil became worse—a sandy plain, without grass, in places very alkaline...no water, no food." In that year of drought, they were seeing this region of the Valley at its barren worst, but the paradox of the southernmost major Sierran stream was not lost on them: "Kern River is a wide, swift stream, here about twenty or twenty-five rods wide, with a treacherous sandy bottom." Thirty-six years later, not far from where Brewer had viewed the river, James and Jonathan Elwood, using a simple auger-drill, struck oil sand only thirteen feet below the surface. Today, the Kern River oilfield remains one of the nation's important oil-producing regions, but it is not Kern County's major petroleum area.

In the dry, treeless hills in the Valley's southwest corner may be found the state's most productive oil field, the Midway-Sunset, which from north to south encompasses the communities of McKittrick, Fel-

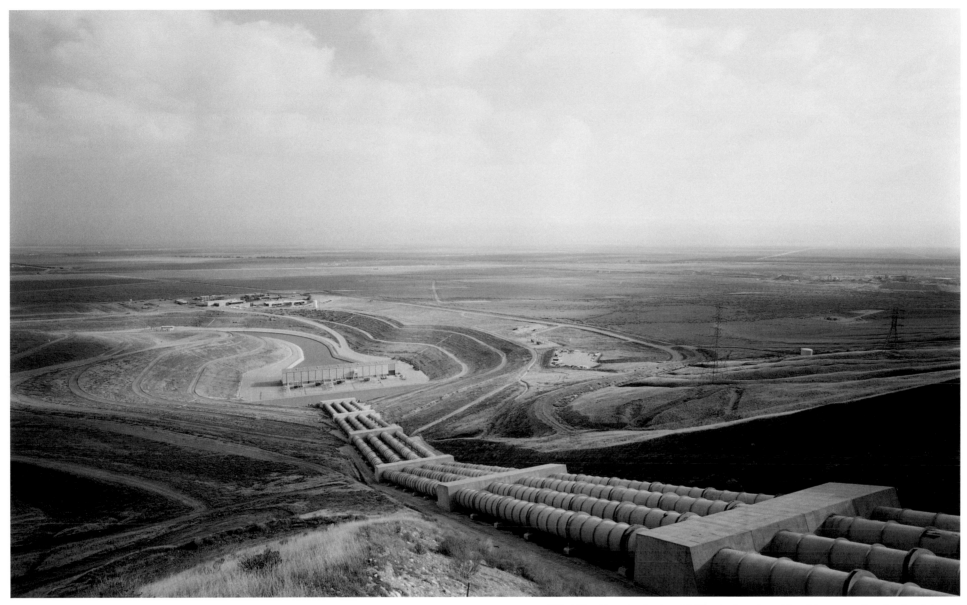

lows, Taft, and Maricopa. "By 1913," points out petroleum-industry historian William Rintoul, "the West Side fields were the center of the oil universe and California had become America's leading oil-producing state." As early as the 1850s, travelers through the southern Valley had occasionally seen black smoke from burning oil seepages in those desert hills as far north as present-day Coalinga. Before them, Yokuts Indians had found uses for local oil—as waterproofing, for example, or as a cement—and there is evidence that they collected and stored it.

In any case, the area around McKittrick, thirty-five miles west of Bakersfield, where the Yokuts had gathered asphalt, was early famous for oil seeps oozing crude, tarry petroleum. Many early prospectors were ex-miners. They dug shallow pits, and, as one of those pioneer oil men, John L. Sullivan, explained in 1939, "A dozen of these pits were dug, and as fast as the oil would seep into them, we would bail it out with buckets and put it on the light wagon." In 1866, a small refinery began operation near McKittrick, but lack of transportation doomed the enter-

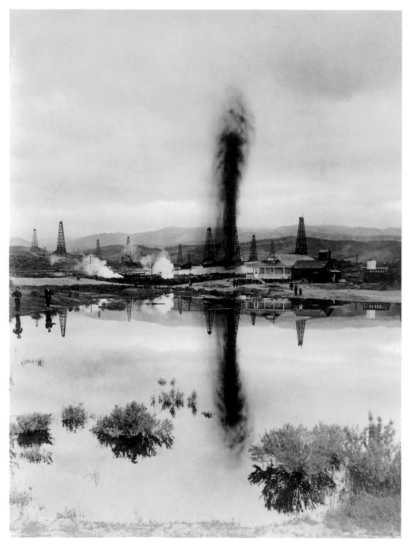

Lakeview Gusher, circa 1910. Photographer Unknown.

process. In winter, dense tule fog surrounding all, lights become soft as drunken dreams and shapes drift toward amorphousness. But they are real, as real as dollars and jobs and refined oil.

Less than twenty miles south of Asphalto, Solomon Jewett and Hugh S. Blodget managed to obtain a small amount of oil from shallow holes they drilled in the Old Sunset field near what would become Maricopa. The oil was used as flux in the melting of asphalt, which was quarried nearby. Because of the heat and the impossibility of cleaning clothes, explained Blodget, "The miners worked stark naked covered with liquid asphaltum." At the end of each work day, the men—looking like glistening ebony statues—were scraped and scrubbed as clean as possible.

The picture of those shiny black bodies is one of two arresting images that emerge from the Midway-Sunset District. The other is the enormous spout of Lakeville Number One, the fabled "Lakeville Gusher," which erupted on March 15, 1910, just south of Taft, and continued spouting for 544 days, producing an estimated nine million barrels of oil, about half of which were recovered. Four hundred men struggled to erect a barricade around the uncontrolled flow, not only to capture the oil for commercial reasons, but also because an ebony torrent—called the "trout stream" by workers—was plunging toward Buena Vista Lake eight miles away. The powerful Miller-Lux farming and ranching company used the lake for irrigation—big trouble, indeed, if oil reached and polluted it. The large crew finally succeeded by building a vast reservoir and diversion dams between the spouting well and the threatened body of water.

The Lakeville Gusher's explosion provided the greatest literal boom during those days, and by 1932 sudden prosperity had made the area's largest town, Taft, one of the richest communities per capita in the United States. At one time, water to drink was actually more expensive there than oil, or beer for that matter.

Rintoul, who was born and raised in Taft and lives today in nearby Bakersfield, is highly knowledgeable about the southern end of the Tulare Basin, where, despite or because of his world travels, he has chosen to make his home. Why does he remain? "Because it's real and it's interesting," he says smiling. "The people are varied and genuine—a lot of them are characters, and a lot have character." He smiles once more, a man content with his place. "It's changing, the oil fields are changing. There are women in them now, and nonwhites. The fields used to be like cowboy movies: white men only. And, of course, there's steam technology."

The aforementioned Kern River field northeast of Bakersfield presents a technical problem. Rintoul explains: "Its crude oil came from the ground looking black as tar and scarcely more mobile." If the field was to become a major producer, a process that would liquefy the thick crude had to be developed. Injecting wells with steam was the answer.

prise. That problem was solved in 1893 when the Southern Pacific Railroad extended a spur line to that area, then known as Asphalto. A second refinery was built, and it prospered.

At night, oil refineries become one of the Central Valley's most spectacular sights: a complex of tubes and tanks, of curved pipes and high gangways and tall stacks, many of shining metal, all radiant in artificial light. They are space stations adrift on the inky blackness of the plain. Steam wafts upward through the light in ghostly waves and, at the top of tall stacks dance perpetual flames, burning gas wicked by the

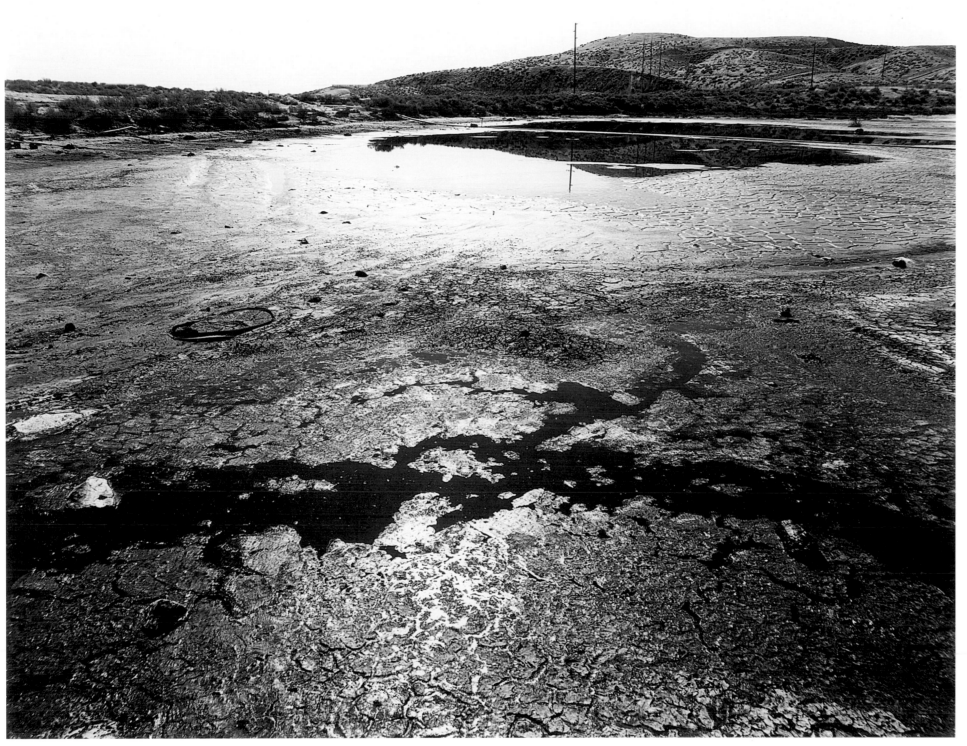

Oil Waste Pond near McKittrick, 1983. Stephen Johnson.

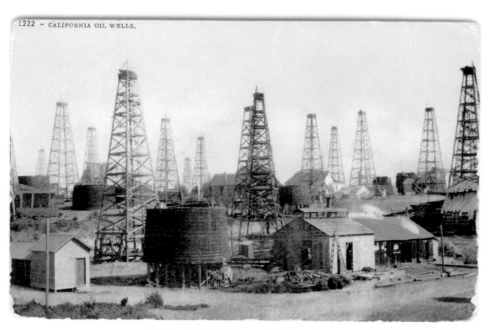

1222 – CALIFORNIA OIL WELLS.

California Oil Wells near Coalinga, circa 1909. California State Library.

"In the 1960s, steam recovery became a reality and today the field's 5,500 wells produce approximately 133,000 barrels a day. This makes it second only to the Elk Hills field near Taft."

By the 1980s, Valley oil fields were producing over 235 million barrels of crude petroleum and over 285 million cubic feet of natural gas annually. But there was a potential problem that, by 1986, was taking its toll: steam recovery is an expensive process, and when oil prices fall, as they did that year, it becomes expedient for production companies to curtail operations. September 1986 was the low point, with production bottoming out at 672,000 barrels a day and only 28,800 of 46,000 pumps still in operation. A slow recovery has been in effect since then, with the Persian Gulf War of 1991 significantly increasing the demand for local oil.

A visit to the McDonald's fast-food outlet in nearby Oildale reveals how delicate the economics of this business are. Many old men—most of them speaking with distinct southwestern twangs—josh with one another over coffee, but with them are other men, younger, much younger, without twangs and without jobs. "It don't look good for these kids," acknowledges one retiree, and a youngster, his arms long topographic maps of tattoos, puffs on a cigarette as he nods in agreement. "We just had our first baby, then I got laid off," he admits, managing a wan smile.

The older man pounds his back. "It'll get better, Buster," he says and his craggy face reveals Depression memories. "It always gets better," the older man adds with a wink, and the younger one smiles. Seven thousand jobs have been lost in Kern County's petroleum industry since

the early 1980s. The cutback has not been limited to oil workers, but has struck support services too, a vast, interrelated web: pipe firms, geologists' laboratories, well-serving corporations, trucking companies, plus all the community businesses that rely on general affluence. And local authorities point out that the level of domestic violence locally has risen proportionately to unemployment.

There is, in any case, more to what workers affectionately or ruefully call "the oil patch" than the production of oil—lives and ways of life are tangled with it. "Some things haven't changed much, you know," Rintoul explains. "You still get dirty working in the oil fields and you can still get killed or hurt. That contributes to a camaraderie that's pretty much what it always was. And values haven't changed much either: they still put a premium on getting the job done. There are more suits and ties in the offices in places like Bakersfield, but there's still a lot of first-name informality."

It is appropriate that Kern County, California's second most productive agricultural county, is also its richest in oil production. Many modern agricultural chemicals are petroleum-derived compounds, to the point where modern farming has been defined as the use of land to convert petroleum into food. In no other locale are land, petroleum, and crops so obviously or so intimately linked.

Oildale, once a separate town to the north, is now little more than a suburb of the southernmost city in the Valley, Bakersfield. The latter is both economically vital and the subject of countless jokes. ("What're the first three words kids in Oklahoma learn? Momma, Daddy, and Bakersfield.") More than a few such jests are actually tinted with wonder and even jealousy at the town's traditional affluence. As Roger Neal observed in 1985, "People come to Bakersfield to work, in the oilfields and on the farms, because that's just about all there is." In the past four years, greater Bakersfield (pop. 300,000) has grown faster than any city in California other than Fresno. Nearly 25% of the city's residents are Hispanic—the fastest-rising segment of the population—and a glance at obituaries in the *Bakersfield Californian* reveals that many older residents were born and raised in Oklahoma, Texas, Missouri, and Arkansas.

Today Bakersfield is one of country music's meccas, with superstars Buck Owens and Merle Haggard especially associated with the town. But at a small cafe on Sundays in Bakersfield, a gray-haired man named Bill Woods gathers with other musicians who migrated here during or just after the Dust Bowl migration. They play traditional honky-tonk music that created the Bakersfield Sound before publicists gave it a name.

Woods never made it big in the music business, but he is one of its most important figures locally. In the late 1940s and early 1950s, when

Storage Bins, Corcoran, 1984. Robert Dawson.

Country Music—Kern County Style

As we plunge down California's core on Interstate 5, tule fog thickens, absorbs our car in the San Joaquin Valley's dense winter: a gray world in which restaurants, gas stations, and other cars—their lights the eerie eyes of deep sea fishes—loom ghostly, then fade. Through this gloom, near Lost Hills we hear a beacon from Bakersfield, radio station KUZZ/AM sends the familiar nasal tones of Hank Snow to guide us home.

Forty years ago the tule fog was lonelier, KUZZ wasn't around and Kern County's country music tradition was still being born in the desperate voices of people out of luck in a strange place, their children's bellies swollen with malnutrition. This area's legacy of country music is one of pain endured and hardships overcome because, as local historian Richard Bailey explains, "Country music didn't get started here until the Dust Bowl. The Okies brought it."

Today, no town other than Nashville, and possibly the rockabilly capital, Austin, is as closely identified with country music as Bakersfield. And no place has remained as true to country's traditional sound—*Time* calls it "scuffier, less polished"; we natives call it less pop, more country. Local musicians have their own roots musically as well as personally. Said a sideman at Oildale's now-defunct Cimmaron Club, "See, when they was all listenin' to Eddie Arnold and Elvis, we was still with Lefty [Frizzell] and ol' Hank [Williams]."

Country music began its climb to big business in Kern County in the 1950s when popular local television shows warred for audiences. Fiddler Jimmy Thomason and piano plunking Cousin Herb Henson were the early favorites. By the mid-fifties, Cousin Herb's show dominated, with Jelly Sanders, Bonnie Owens, and Fuzzy Owen, the Farmer Boys from Farmersville, and a seemingly endless parade of local kids.

So there was a solid, if little known, country music tradition in Kern County long before its recent prominence, and a central figure who played at those ballrooms and honky-tonks and county parks, and who contributed mightily to what makes local music important, was Bill Woods, an Okie who drifted into Bakersfield in the 1930s. Acknowledges Betty Azevedo, Merle Haggard's long-time secretary, "Bill Woods was the grandaddy. You have to give him credit for all of it, because he was here when nobody else was around." Woods formed a band—the Orange Blossom Playboys—that entertained around town, most notably at the Blackboard. I remember him from those days as a stocky man whose eyes sometimes closed to creases when he sang in a moaning baritone, and whose hair occasionally fell onto his forehead. His music could hardly have been called progressive. Azevedo characterizes it as "pure old hillbilly"—and fittingly so, since it presaged the traditional country sound for which the area is now famous. Woods opened his bandstand to newcomers, providing a considerable boost up the ladder for many. Says Haggard, who wrote and recorded a song about Woods, "In Bakersfield, that same helpin' hand just kept reachin' out time after time."

It was truly the emergence of Buck Owens as a superstar that riveted national attention on Bakersfield as a country music citadel. In Nashville, some folks still call this town "Buckersfield," and not without reason, for few more astute businessmen have ever worn overalls and picked guitar. Alvis Edgar Owens, Jr., who grew up in Sherman, Texas, and Mesa, Arizona, is a self-taught musician who had been working as an entertainer since he appeared on a Mesa radio show at the age of sixteen. In 1951, he moved to Bakersfield where he played guitar and sang at the Blackboard, and earned extra cash as a studio musician in Hollywood. His flat, appealing features and short blond hair were familiar to television viewers during the 1950s, as were many of the songs he wrote. Then as now, his music featured a strong beat, with more than a hint of both Western swing and rock'n'roll. He explains, "I was influenced by all the greats, but I never played . . . those types of affairs where people sit down. From Arizona to Bakersfield, I played dances . . . and those people want rhythm. They want to dance." In 1960 he cut "Under Your Spell Again" for Capitol, and his career as a recording artist took off. He has seldom looked back.

If Buck remains the head of country music in Kern County, then Merle Haggard is its heart. The son of Okies who migrated to California in 1934, Merle was born in Bakersfield in April of 1937, a month after I was. He grew up just three blocks west of me in Oildale, within hailing distance of where Buck Owens Enterprises now stands across from Standard School, which Merle and I attended. Unfortunately, that nearly exhausts my knowledge of Merle's childhood because, although we were classmates, we were not close friends, merely acquaintances. Merle suffered a terrible loss when he was nine: the death of his beloved father. "Merle's daddy died," kids whispered; I heard it, but only recently have I begun to comprehend what it meant.

A while later, I heard stories at Bunkys Drive-In or at the River Theater, Oildale's two teenage gathering places, about Merle's exploits as a fighter or lover or adventurer, but by then my folks had sent me to the Catholic high school in Bakersfield and I seldom communicated with him except for an occasional nod—sometimes belligerent, sometimes friendly, in the manner of adolescent males—when we passed on El Tejon Avenue.

In any case, the kid I knew and the man I don't are the same in some essential ways. Merle lets his background show in songs like "Momma Tried," . . . and if the results in the short run were disturbing, perhaps the long run has made them acceptable. Deepened by such things as spending seven of his first twenty-one years behind bars, Merle achieves an honesty and power in his songs rare in country's history. The man is his music, and Hag remains without question the most important oral poet produced by California Okies because many of his songs seem to draw on some deep resource of communal experience that approaches the archetypal.

—"Workin' Man's Blues," in Gerald Haslam, *Voices of a Place*.

"Okie" was still a fighting word, he drove around town in a car with "Bill Woods and His Orange Blossom Playboys" inscribed on it. He played local honky-tonks and promoted what was then called "Okie music," and championed the careers of other singers and musicians. Along with Jimmy Thomason and Cousin Herb Henson, he was a herald of what the local sound would become.

Two decades ago local musicians did not succumb to the allure of overproduced "pop" sounds. Few locals could afford the banks of violins, woodwinds or brass, the choruses and echo chambers that would for awhile at least discredit Nashville itself. Instead they reintrenched country's traditional sound. This community has, in a way, become more Southern than the South.

Bakersfield is unusual among Tulare Basin cities because it isn't flat: it rises from the level flood plain of the Kern River on the west and south into foothills and bluffs to the east and north. When Brewer visited this area, it was known as Kern Island, a place where various chilly distributary channels of the river, rank with riparian growth and noted for quicksand, penetrated the desert on their way to nearby lakes. Today, with the river dammed in the mountains to the east, floods no longer occur and neither do riverine forests.

As is true of the residents of numerous Valley towns—so many of which were built on streams—Bakersfield natives have a special feeling for what they simply and affectionately call "The River"; because the city is surrounded by toasted land, that stream and its wooded environs have seemed all the more miraculous to locals. Acknowledges writer Ann Williams, "For those of us who live here, to mention Kern River is to stir up memories....My father brought home fish and stories from the wildest places on the Kern." For others, it evokes the shared breath of clandestine passion, the devastation of friends drowned, the exhilaration of inner tubes bouncing down rapids: it evokes, in a word, the intensity of youth and discovery.

In the nineteenth century, weirs and canals diverted Kern River water for local irrigation, as that landmark lawsuit pitting the forces of Miller-Lux against Haggin and those of Tevis in 1881 illustrated. Many years later, State Senator Sheridan Downey, who campaigned to repeal the unenforced 160-acre limit on irrigation allocations, sought to deflect criticism of the concentration of land and power by corporate giants, suggesting that the Kern County Land Company—which at the time owned 413,500 acres in that single county—was "an irrelevant cow company." It is one more revealing comment about the underlying philosophy of much Valley politics. Indeed, a good deal of political history hereabouts chronicles battles for the control and allocation of land and water.

Another major source of irrigation both on the San Joaquin Plain and in the Tulare Basin has been groundwater pulled to the surface by deep-well turbine pumps, a major reason why land in the south Valley has in places

Waterworks, Kern River, 1986. Stephen Johnson.

subsided over thirty feet since subsurface water began to be tapped for irrigation. No one is certain what the consequences of such sinkage will be, but it is clear that the groundwater cannot be replaced with present technology, since the subsidence has been caused by overpumping, which, in turn, has collapsed the pore space once occupied by water. Needless to say, some of those who are dependent upon this soil for their livelihoods are defensive about groundwater use. "Do you guys want to be thirty feet higher and starving?" a farmer drinking coffee in a Lamont cafe asked researchers. Fortunately, those are hardly the only options.

There is another problem brewing—and that may be exactly the correct word—because not only does agricultural drain water leach toxic metals and salts (such as lead and selenium) from the soil, it also carries toxic chemical residues: insecticides, fungicides, herbicides, even fertilizers. As investigative reporter Jane Kay points out, "In the entire San Joaquin Valley, more than one quarter of the usable ground water, or 30 million acre feet, is polluted with DBCP [dibromochloropropane]." Moreover, she notes, between 1963 and 1983, "the state Department of Fish and Game reported fish kills reaching 300,000 from 64 episodes involving two now-banned farm chemicals, toxaphene and endosulfan."

Kern County watermelon shipper is reported to have said, "We've got 45 million potential customers for our crop. About 200 people got sick. What percentage is that? Does it warrant this kind of action?" He wasn't one of the people who got sick.

Aldicarb is unusual in that it is a fast-acting toxin and Lawrie Mott, a research scientist with the National Resources Defense Council, suggests that its use may have been fortuitous in the long run, since it made it possible to trace effects to their source. Such is not always, or even often, the case, she asserts: "Most pesticides exert their toxic effects over a long period. In this case, people were the guinea pigs because state and federal monitoring systems…failed."

Slow, long-term chemical pollution has led to the contamination of hundreds—perhaps thousands—of private wells by fifty-seven identified agricultural chemicals, yet some local farmers continue pugnaciously to defend the use of the toxic compounds. A grower in the Fowler district—where a mysterious cancer cluster has struck and where many wells are polluted with DBCP—illustrated paranoid reasoning when he told Jane Kay that restrictions on the use of chemicals are "a conspiracy of environmentalists and liberal politicians." More sensitively, Dr. Vincent V. Leonardo, a physician there, points out a sad paradox: "The farmers were guilty of polluting the groundwater. But they didn't know it. No one knew it. They felt real bad, and it was in their own wells."

On May 5, 1863, Brewer's party encountered a stark scene that would prophesy future problems:

In about six miles we crossed the last slough of Kern River, then struck south for the mountains, across a complete desert. In places there were patches of alkali grass or saline desert shrubs, in others it was entirely bare, the ground crusted with salt and alkali, like snow.

Those salts observed by Brewer signaled a major problem that would develop when continued irrigation leached and intensified them, effectively killing the land's ability to grow crops: soil salinization. As Lowell N. Lewis points out, "In the rich San Joaquin Valley, with 4.5 million acres under irrigation, more than 400,000 acres are now seriously affected by salt. It is projected that by the turn of the century…another million acres could be lost to salinity."

Salt, of course, refers not merely to the familiar sodium chloride but to a variety of soluble crystalline chemical compounds: barium chloride, sodium bicarbonate, zinc sulfate, plus compounds of selenium, phosphates, hydrates, and nitrates. The southern Valley, arid land that was once an arm of the sea, is layered with marine sediments, and salts have been present in groundwater or leached from soil since irrigation began. "The [period from the] late 1870's to about 1915," write historians Robert L. Kelley and Ronald L. Nye, "was characterized by rapid growth in irrigated acreage, a

Irrigation Ditch, Kern County, 1985. Stephen Johnson.

In July 1985, some 1,300 people were poisoned—eight reportedly died—when watermelons grown near Bakersfield that were tainted by aldicarb, a restricted toxin, were sold commercially; a public outcry resulted. All of a sudden chemical toxicity was not a remote problem for families in isolated Valley communities. The general public, for a time at least, supported measures that led to the destruction of melons already on their way to market, plus a field-by-field program of inspections to expose the use of the illegal poison. Some growers allowed their melons to rot in the field rather than permit the state Food and Agriculture Department to test for the use of the prohibited insecticide. In another classic example of the self-serving arguments sometimes heard locally, a

Desertification

The southern reaches of the Central Valley are undergoing desertification. The replacement of native grasses, the introduction of exotic species such as sheep and cattle, the plowing of the land, and the pumping of groundwater, as well as flood irrigation with imported water, have slowly, certainly altered the land, moving onto a track once trod by others.

Desertification and Salinization in Ancient Mesopotamia

The term desertification came into prominence in the 1960s to describe the dramatic southwestern advance of the Sahara desert into Africa's Sahel region. J. Eleanora Sabadell and her colleagues described desertification as "human-induced barrenness of the land," although the process is frequently triggered by natural cycles like drought. Desertification refers to a gradual course whereby arid or semi-arid lands are wrongly occupied, where the pressures of human habitation become too great for the land to be able to sustain life.

Africa's Sahel region, for example, is an arid place which receives about the same rainfall as Sacramento. For millennia nomadic tribes followed a pattern of moving their herds through fragile, seasonal grasslands, thereby averting overgrazing. In arid lands where precipitation is at best unreliable, flexibility becomes the hallmark of successful human adaptation. Nomadism embodies adaptability, a trait that was lost when international lending agencies began offering help to "develop" these countries. This gentle, nomadic land-use pattern was interrupted with the sinking of permanent wells. Waterholes gave rise to continuous settlements overstressing the lands and spreading patches of Sahelean desert. Traditional wisdom is frequently more reliable than the reason pervading overseas aid.

Another contributor to desertification is salinization, an inevitable by-product of irrigated agriculture. Irrigated agriculture requires that enough water be applied to lands to sustain a crop while flushing away unwanted salts that gradually accumulate in the soils.

If such offending salts and minerals are not flushed away, the roots of plants cannot take up sufficient water to survive. Or if the water table rises, bringing excessive moisture close to the surface, it invariably causes trouble. One commonly used means of drawing off excess salts is the installation of subsurface drainage tiles that removes the offending salts from the soils. In fact, as early as 2500 B.C. sources entreated farmers using irrigated water to install tiles to resolve this age-old predicament. Success rates, however, as we shall see, remain quite another issue.

Desertification, hardly a recent problem, has been with us since time immemorial. The Greek philosopher Plato once described the Athenian soils in the *Critias* as resembling "...the skeleton of a sick man, all the fat and soft earth having wasted away, and only the bare framework of the land being left." He captured the consequences of deforestation and overgrazing which are the legacy of stressful human occupation.

In fact, the historical record is littered with civilizations that resorted to irrigated agriculture within semi-arid lands to keep pace with burgeoning populations. That of the ancient Mesopotamians was one such. Occurring in the Tigris-Euphrates river valley of what is now present-day Iraq, these peoples fell prey to an unprecedented ecological collapse.

Originating in Neolithic times, Mesopotamian civilization gradually developed the earliest pattern of city building. Small isolated villages evolved irrigated agricultural practices as early as 5000 B.C. that required successively larger canal systems for greater agricultural production. As villages grew to become small cities, communities as few as ten miles apart began to compete for the same water while resorting to extensive irrigation works. A water bureaucracy evolved to coordinate this increasingly intricate network of canals, abetted by ever-more powerful rulers to keep things functioning. By 3200 B.C., the institution of semi-divine kingship evolved to conquer opposing cities while overseeing armies of slaves required to maintain free-flowing canals. Minions of bureaucrats maintained accurate records of foodstuffs produced that as early as 2500 B.C. were being traded with cultures as far away as India.

The history of Mesopotamia is in many respects traceable through the complex maintenance of irrigated waterworks. The sharp and angular silt washed down from surrounding mountains piled high on artificial canal banks. The tortuous clearing process was made possible by tens of thousands of foreign and domestic slaves.

For over 1,500 years, Sumerian agriculture, the area within the valley that is analogous to our Delta, underwent continual modification and expansion. By 3500 B.C. application of irrigated waters to fields yielded an impressive production of barley and wheat, in equivalent proportions. One thousand years later, however, the continuous irrigation of fields brought about salinization which yielded six times the more salt-tolerant barley than wheat. Eventually, however, this process of salinization left the tops of fields encrusted with visible layers of salt, and by 1700 B.C. the erosion of wheat production signaled the imminent collapse of the Sumerian empire, as populations shifted north to what we now know as Babylon.

Desertification, far from a novel experience, contributed to the decline of the ancient Mesopotamian river valley, just as today California's Central Valley is plagued by these same pressures.

—Michael Black, *Human Gods, Natural Woes.*

References:
Thorkild Jacobsen and Robert M. Adams,
Salt and Silt in Ancient Mesopotamian Agriculture, 1958.

Lewis Mumford, *Myth of the Machine: Techniques and Human Development,* 1967.

J. Eleanora Sabadell, Edward M. Risley, Harold T. Jorgenson, and Becky S. Thornton,
Desertification in the U.S.: Status and Issues, 1982.

Wastewater near Remnant Tulare Lake, 1989. Stephen Johnson.

parallel development of salinity and drainage problems, and generally futile attempts…[by farmers] to rehabilitate their soggy, salt-encrusted fields."

The traditional solution for such problems has been drains that remove saline water and deposit it elsewhere. Recent events at Kesterson Reservoir near Los Banos—which collects runoff from as far south as the Tulare Basin—have clearly demonstrated that this too is a system with hidden costs. Not all salt runs off with wastewater. Moreover, in many settings, water evaporates and leaves surface deposits, which then require still more water to flush, an insidious cycle. As Donald Worster explains, "The use and reuse of that water makes it more and more saline, until the last man on the last ditch might as well be dipping from the ocean."

In 1984, Louis A. Beck, chief of the San Joaquin District of the California Department of Water Resources, listed five alternatives for wastewater disposal: No action, evaporation within the Valley, discharge to the San Joaquin River, discharge to the Pacific Ocean, and discharge to the western Delta; his department recommended a concrete-lined, gravity-flow canal, the Valley Drain, from Bakersfield to wildlife-rich Suisun Bay on the Delta's edge, then ultimately to already-polluted San Francisco Bay and the Pacific. In the light of toxic runoff revealed by the discovery of grotesquely deformed animals at Kesterson, his recommendations to discharge contaminated water elsewhere have not been implemented. Most recently, it has been suggested that saline wastewater—which also carries chemical runoff—be held in ponds, then released during heavy winter rains, when it would be diluted.

An Impacted Land

The Valley's loosely packed alluvial soil is ideal for holding large volumes of underground water. In sediments reaching up to ten miles deep, these aquifers have been vigorously pumped for valley irrigation.

Groundwater Pumping

If groundwater pumping and aquifer replenishment are in balance, this process could go on indefinitely. Unfortunately, the valley's aquifers have been pumped far in excess of nature's capacity to restore the water. In the southern Central Valley, this overdraft was known to be at least 1.2 million acre-feet of water in 1980. This groundwater overdraft is cause for serious concern.

Drawing down the aquifer requires farmers to sink ever deeper wells, incurring ever larger electrical bills to pump that water. In some areas water is being pumped from 800 feet below the surface, costing as much as $80 per acre-foot of water.

Aquifer Collapse

The loose soil that makes valley sediment ideal for holding water, also makes the aquifer cavities subject to collapse as water is removed. Once collapsed, there is no longer space for water to accumulate and the aquifer is destroyed. Aquifer destruction is a major concern of water planners in the state.

Land Subsidence

Another consequence of the collapse of these water cavities is that the surface land actually drops as well. In some areas of the southern valley, towns are sitting forty to fifty feet lower than they did just forty years ago. This falling land has caused damage to buildings, highways, bridges and levees.

Salinity

In many parts of the valley, a layer of impermeable clay lies about forty feet below ground level. As water is applied to the soil for irrigation, this clay layer prevents agricultural waste water from seeping deep into the ground. Over years of irrigation, this trapped waste water rises to the surface, carrying with it years of fertilizer residue and natural salts carried with irrigation water. As this saline wastewater reaches the root zone of crops, the plants die and the land is no longer suitable for agriculture.

By 1983, 650,000 acres had been seriously affected, with 10,000 acres in Kern County already taken out of production. Over one million acres in the Central Valley are threatened by these rising salts. The costs of this lost land is enormous, with estimates ranging as high as $300 million statewide by the year 2000.

–Reference: American Farmland Trust, *Eroding Choices, Emerging Issues,* 1986.

AN IMPACTED LAND

Groundwater Pumping
Aquifer Collapse
Land Subsidence
Salinity

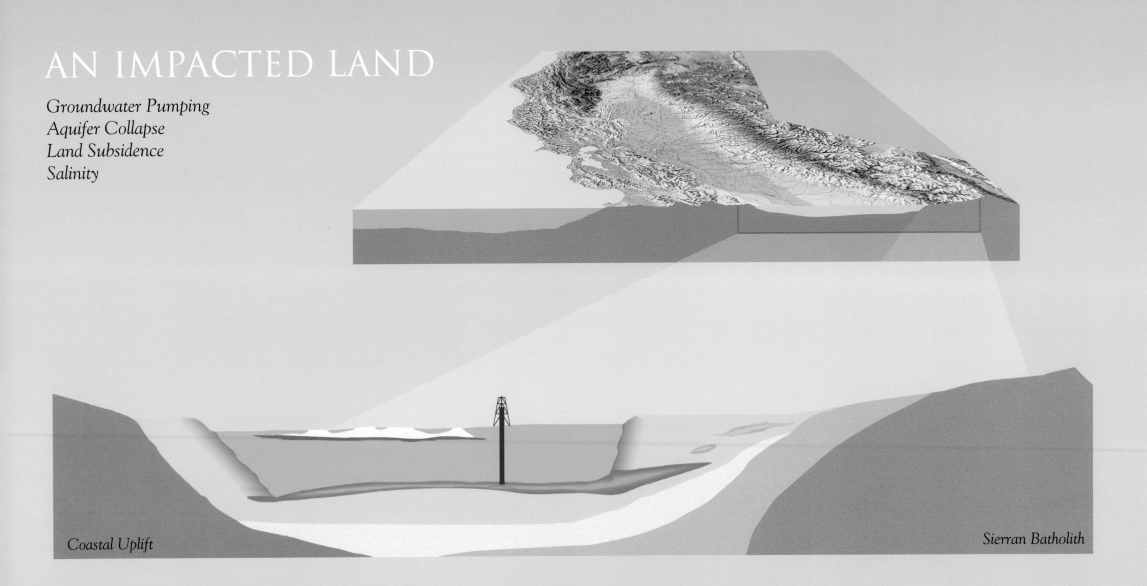

Coastal Uplift

Sierran Batholith

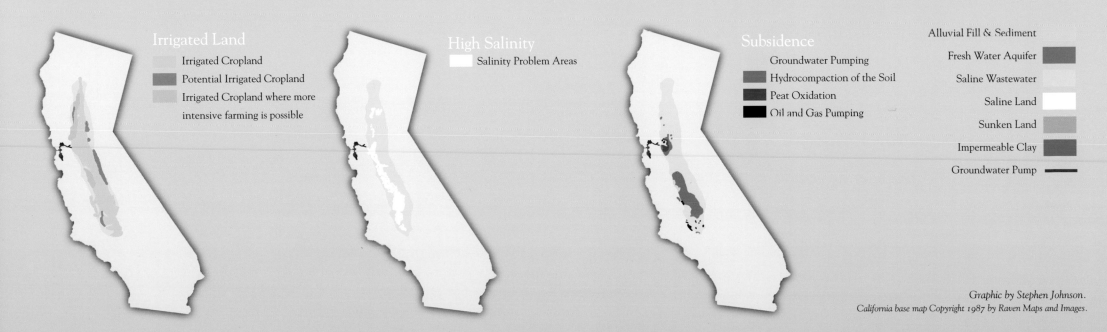

Irrigated Land

- Irrigated Cropland
- Potential Irrigated Cropland
- Irrigated Cropland where more intensive farming is possible

High Salinity

- Salinity Problem Areas

Subsidence

- Groundwater Pumping
- Hydrocompaction of the Soil
- Peat Oxidation
- Oil and Gas Pumping

Alluvial Fill & Sediment
Fresh Water Aquifer
Saline Wastewater
Saline Land
Sunken Land
Impermeable Clay
Groundwater Pump

Graphic by Stephen Johnson.
California base map Copyright 1987 by Raven Maps and Images.

139 Square Miles of Tulare Lake Reflooded, October 1969. California Department of Water Resources.

But now Kesterson itself, once considered part of the solution, has become a significant problem, and then-Secretary of the Interior Donald Hodel agreed that the federal government would clean up that poisoned reserve, building a 45-acre dump to enclose tainted mud and vegetation in a pit lined and capped with impervious, heavy-duty plastic. The cost: $26 to $50 million. Who pays? *Users of Central Valley Project water*, suggests Hodel. *Taxpayers*, assert skeptics.

The primary cause of salinization has been the irrigation of arid, marginal lands such as those found on the Valley's west side; the solution—other than a cessation of regular watering—remains unknown. Marc Reisner sums it up succinctly: "San Joaquin Valley farmers asked for water and got it, asked for subsidies and got them, and now want to use the (San Francisco) bay as a toilet." They may finally be asking for too much.

The Valley's south end illustrates introduced verdancy and the problems attendant to it. No longer is it a desert. If it offers a less spectacular vista than Mount Shasta, which dominates the north, it is not without either history or its own special beauty, for the land begins rising south of Bakersfield, drawing travelers toward Wheeler Ridge and Cañada de Uvas, the fabled Grapevine Grade, toward the secret canyons and spires where the last California condors once soared, toward the remnants of the great Spanish grants.

The condors, those huge carrion birds that in recorded history cleaned up carcasses of ruminants and migratory salmon in the Valley, are gone from the wild, although a program of reintroduction is presently scheduled to begin. Their demise has been a media event, followed with interest by people who wouldn't know an eagle from a turkey buzzard. The California condor is "less an endangered species than an embodiment of *all* endangered species" to the public, David Darlington has observed.

The human tendency to manipulate things we do not fully understand has been exemplified by the captive-breeding program that has removed the last of the great raptors from the environment of which they were an integral part." Says David Darlington: "An animal is first and foremost an expression of its ecosystem; removed from its natural habitat, it literally ceases to be that animal—it is merely a collection of genes in a cage." As of late 1991, however, a cage had been moved to the high mountains between Bakersfield and Los Angeles, and two young condors hatched in captivity had begun the transition to what has historically been their natural habitat. With luck, once more those great shadows may slide across the valley.

Biologist Carl Koford has suggested a logical conclusion to this controversy: "If we cannot preserve condors in the wild through understanding their environmental relations, we have already lost the battle and may be no more successful in preserving mankind." Many Californians are intensely following efforts to reintroduce the great birds.

While debate about capture of the remaining wild specimens continues, there seems little doubt that habitat alteration—"*habitat abandonment*," according to another environmentalist, David Phillips—is the major reason condors' numbers have so diminished. Asserts local rancher Ian McMillan: "It is barbarism, not civilization, that has destroyed the condor. Barbarism with guns, poison, the bulldozer, and ruinous economic growth."

L. T. Burcham, an ecologist and geographer, explains that when the salmon runs into the Valley were killed by cumulative water projects, the great birds may have lost their principal food source. Certainly with spawning anadromous fish little more than a memory, with the great elk and antelope herds gone, and with the ranges once patrolled by predators now cultivated and irrigated, condors have perished because of environmental changes as certainly as they might have succumbed to hunters—and many were indeed shot. Even in recent years, when

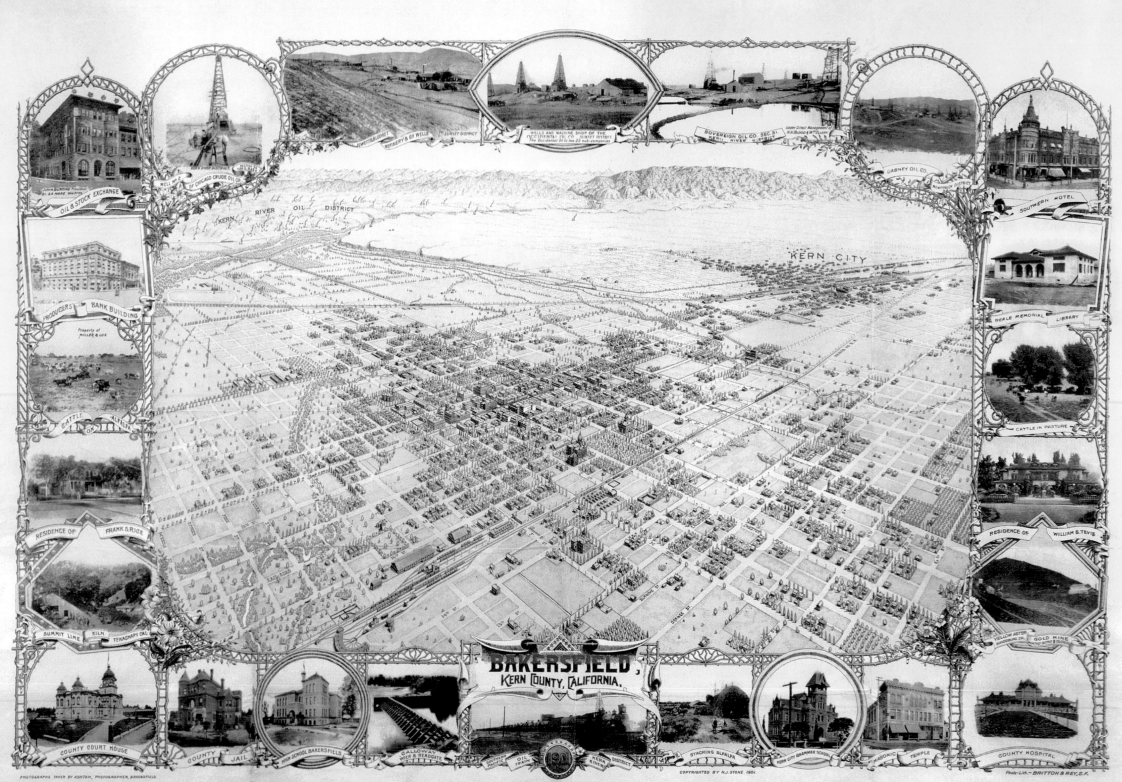

BAKERSFIELD, KERN COUNTY, CALIFORNIA.

N. J. STONE CO. PUBLISHER, SAN FRANCISCO, CAL.

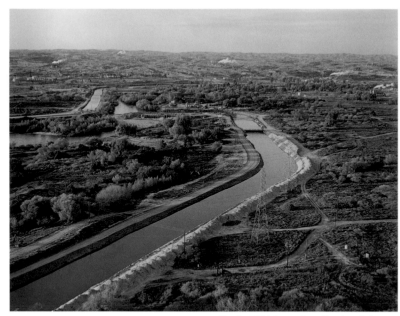

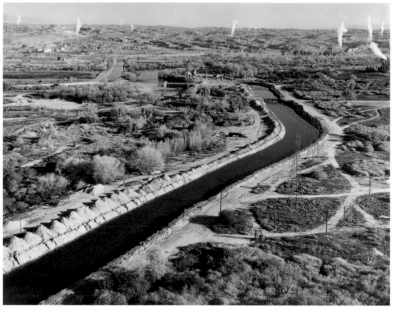

Dusk, Oildale, 1983. Stephen Johnson.

Dawn, Oildale, 1985. Robert Dawson.

ranchers and sportsmen have been forbidden to kill them, the great birds have indirectly been sacrificed to bullets, dying of lead poisoning after eating the carcasses of animals left by shooters.

Never before has the extinction of a species, or efforts to save one, been so clearly chronicled, and the lingering drama is rendered more poignant by human avarice: on the one hand, agencies ostensibly seeking to aid the species publicly engage in petty squabbling; on the other, "there is already pressure from hunting lobbyists to open up the existing condor sanctuaries," John Ogden of the Audubon Society says. "Developers in Kern County will be glad to have the birds gone."

Eben McMillan, Ian's brother and also a rancher, summarizes the larger dilemma symbolized by those great American vultures: "I think we can get along without condors, but we can't get along without taking care of the environment," he points out. "The condor is just a warning signal—if you're driving your car and the oil light comes on, you know you better stop her right there, and not go any farther until you know what's wrong. Well, the condor is our shining red light." And the wild condor is now merely a memory, its great shadow no longer sliding over the prairie as it did for millennia…unless the reintroduction program proves successful.

On May 5, 1863, Brewer described the view as his survey party rode out of the Valley:

The last few miles of the plain had risen rapidly, until the mouth of the canyon where we were had an elevation of over a thousand feet. The country had improved on this slope, with some grass, while on

striking the mountains all was green. All changed and what a relief! We had ridden on this plain *about three hundred miles!*

William Rintoul has driven up and down Grapevine Grade at the Valley's southern end innumerable times over the past sixty years and, moving north into it, not south out of it as Brewer did, he observes:

It used to be when I was coming off the Grapevine looking out over the southern Valley on a clear night, I could see only scattered lights: the column of white in one lane, red in another: cars on Highway 99…a glow from Bakersfield thirty miles off in the distance, and only a few lights in the Wheeler Ridge oil field to the left, and a few on the Tejon Ranch farmlands to the right. Now there are lights everywhere.

A hundred and twenty years earlier, from a point only a few miles to the west, Brewer described what he saw: "San Emidio Ranch is a large and valuable one, near the mouth of the canyon, commanding a lovely view of the plain, of Buena Vista Lake, and of the coast ranges." The plain is still there, though it is a checkerboard of agricultural geometry, and the mountains to the west remain, although their near slopes are dotted with oil rigs. Buena Vista Lake, which covered over 4,000 acres at depths of up to ten feet, is gone.

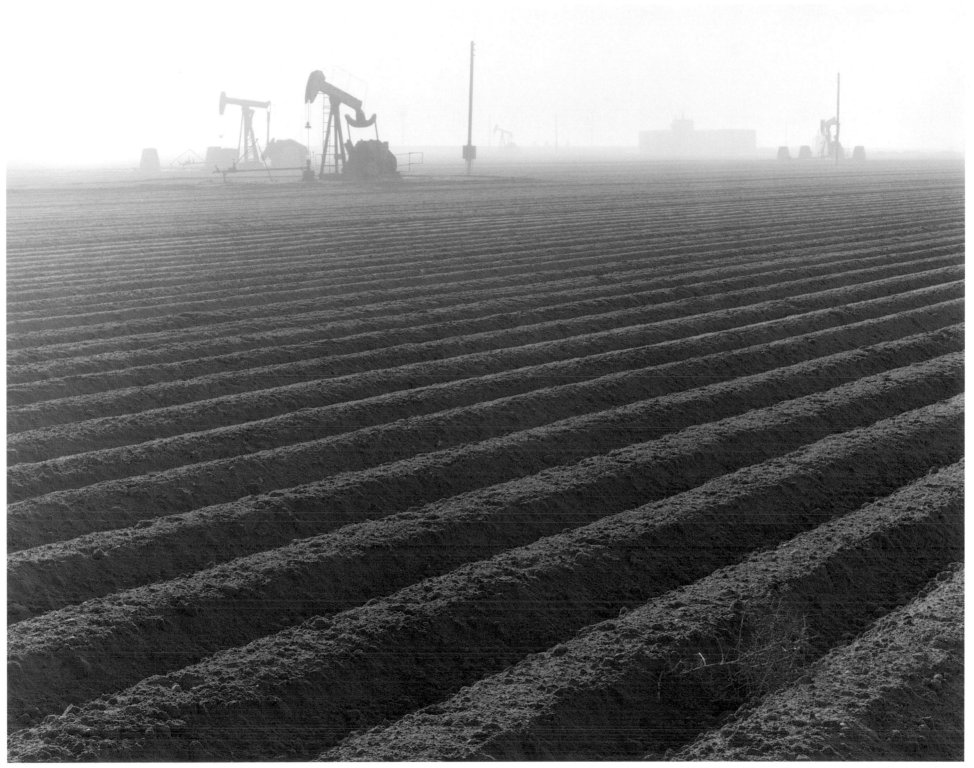

Oil Wells and Fields, Kern County, 1985. Stephen Johnson.

Carleton Watkins: An 1888 Kern County Portfolio

Nearly fifteen feet above the plain, a gray-bearded artist seemed to pose atop his wagon's roof as he carefully uncapped then recapped the lens of a large camera. Carleton Watkins, identified by the local newspaper as "the eminent photographer of San Francisco," worked in the relative coolness of a July morning in 1888—by afternoon temperatures would soar well over 100 degrees—while in front of him a crew cast long shadows across an expanse of alfalfa.

In November of that year, this notice appeared in the *Kern County Californian*:

> *Nearly one thousand splendid photographic views of all the principle places of interest in Kern county (sic) can be had at the Stationery Store of A.C. Maude, Bakersfield, at the small price of fifty cents each, considerable less than the actual cost. A few of these pictures sent to your friends will tell them more of the beauties and resources of this country than can be written. They are all bound in albums for convenience of inspection.*

Carleton Watkins was indeed "eminent" by 1888, and had been since his 1861 landscapes of Yosemite made him one of the West's best known photographers. He was also a friend of land mogul James Ben Ali Haggin and had, in 1881, become embroiled in the famous *Lux v. Haggin* case that created the "California Doctrine" of water rights. Watkins not only took photographs of his friend's Kern River dam and various irrigation channels—employing a huge 14 x 21 inch camera—but he also found himself on the witness-stand enduring a hostile cross-examination.

Little wonder, then, when Haggin and his partner Lloyd Tevis—who would two years later incorporate as Kern County Land Company—decided to sell vast tracts of land southwest of Bakersfield, they commissioned Watkins to create images to aid promotion. Create he did, lugging his 8 x 10 inch camera over that desiccated realm, and over 700 photographs have so far been found. Although Haggin and Tevis wanted straight-forward promotional scenes, they got much more, what Richard Steven Street calls "unique historical documents that evoke the texture of rural life almost a century ago."

Whatever his commission, Watkins remained a careful worker whose artistic vision did not desert him. Street says he averaged "about twenty-four photographs each day. Normally, he photographed between three and six scenes at each site before moving on." And biographer Peter Palmquist points out that the photographer always approached his subjects with an eye for composition, for texture, and for the impact of humans on the landscape.

Haggin and Tevis published booklets and brochures illustrated with Watkins' photos, material designed to lure land buyers with assurances that—according to one publication— Kern County "does not partake of the wild and woolly west." In fact, Kern County did partake of it, but that wasn't the image promoters desired.

In 1893, prints by Watkins were exhibited at the Chicago World's Fair. Others were disseminated as engravings—sometimes altered and sometimes omitting credit to Watkins. In an 1893 issue of *Traveler*, five photographs by Watkins appeared along with text that said, in part,

> *It is safe to say that no other portion of the Coast outside of this offers equal inducements to the home builder. The buyer may rest assured that he gets what he buys, and he buys from the first hands; he should expect, and will certainly receive (if he deserves it), good, fair treatment from the hands of Kern County Land Company.*

The campaign, which coincided with a dramatic fall in the cost of rail fares from the East, was successful. Prospective buyers were feted at barbecues and escorted over the area.

The Kern County photographs by Carleton Watkins were for all practical purposes lost for many years. During the 1930s 415 of his south Valley photographs were given to the Library of Congress, and other smaller collections were located at the Huntington Library, the Kern County Museum, and the Beale Memorial Library in Bakersfield. Much the largest collection of Watkins' work—some 700 images entitled *Photographic Views of Kern County, California*— from the archive of the Kern County Land Company is owned by Tenneco West, which absorbed Kern County Land Company in 1976. They constitute an extraordinary document of the agrarian vision that built a garden in a desert and of one artist's ability to capture what we wished the land to be.

—*Source:* Richard Steven Street, "A Kern County Diary," *California History*

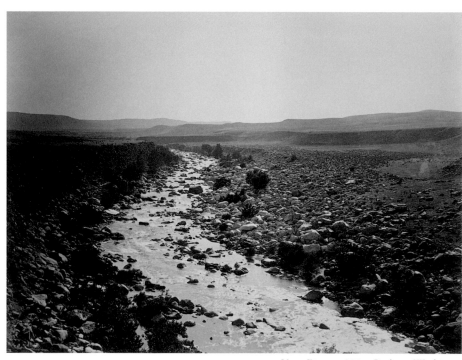

Kern River, 1888. Carleton Watkins.

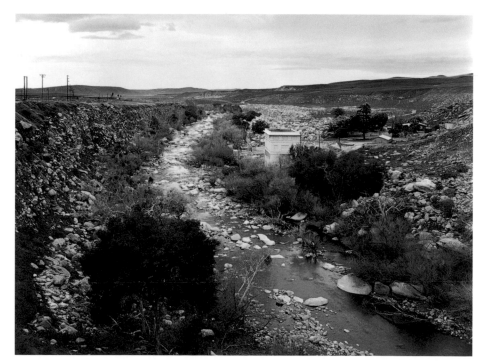

Kern River Entering the Central Valley, 1983. Stephen Johnson.

Wild Grapes, 1888. Carleton Watkins.

Artesian Well, Greenfield Ranch, 1888. Carleton Watkins.

Kern Island Canal, Kern County, 1888. Carleton Watkins.

Calloway Canal, Kern County, 1888. Carleton Watkins.

Sheep Shearing, San Emigdio Ranch, Kern County, 1888. Carleton Watkins.

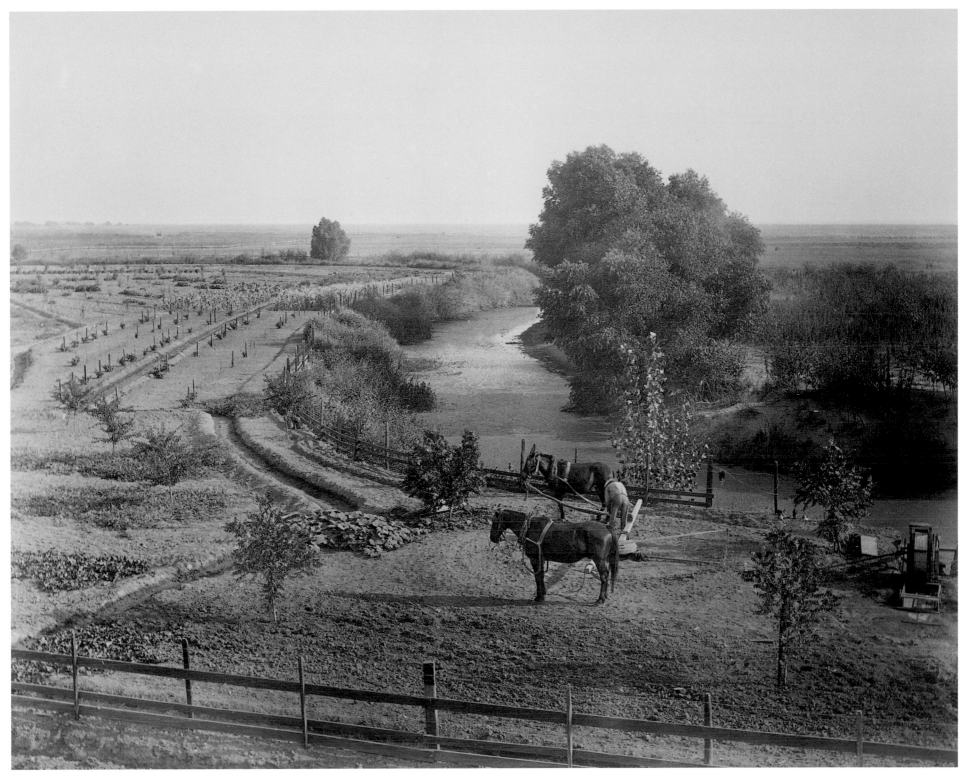

Horse-Drawn Irrigation, Buena Vista Farm, Kern County, 1888. Carleton Watkins.

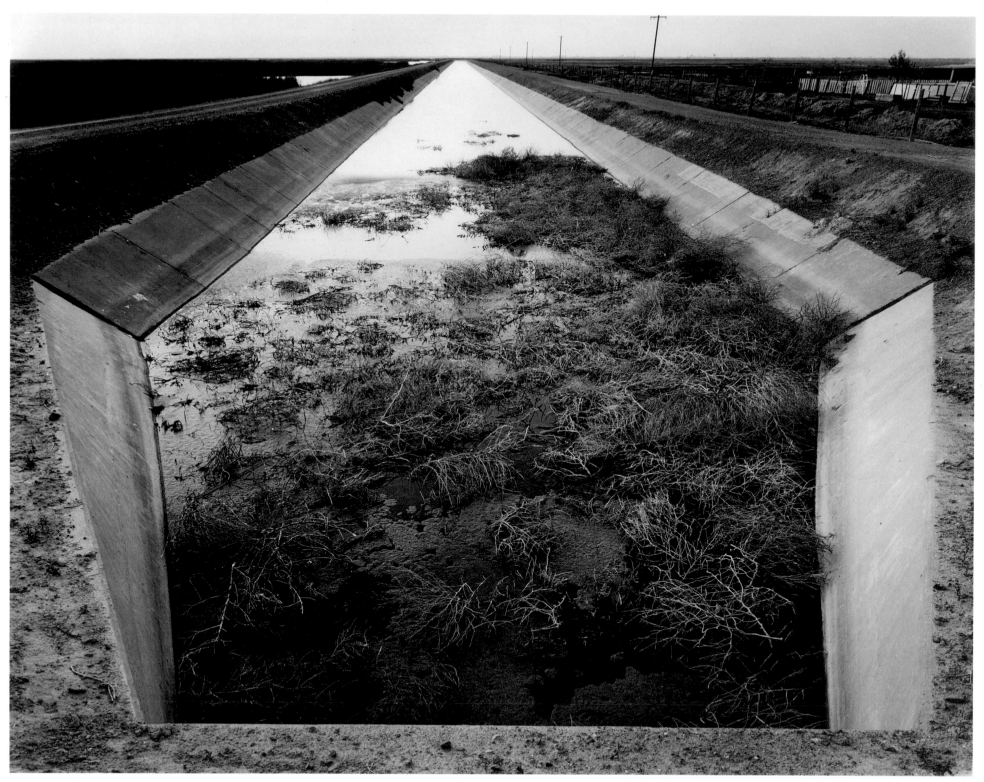

San Luis Drain, Kesterson National Wildlife Refuge, 1985. Robert Dawson.

Chapter VII: Some Issues

**Fresno "City" consists of one large house, very dilapidated, one
small ditto, one barn, one small dilapidated and empty warehouse,
and a corral.**

William H. Brewer, April 8, 1863

Contrasting Brewer's notes with the Valley as it is today
reveals the remarkable metamorphosis from what was then
a thinly settled domain of jackrabbits and buzzards. Fresno,
for example, is presently the fastest-growing urban area in
the nation. Agricultural acreage there has been paved—a second level of
development—and people are increasing in this neo-metropolis now as
crops traditionally have, because it remains the capital of America's rich-
est farming county. Yet Fresno County today is actually considered ur-
ban by the State of California. In the Valley, distinctions between town
and country are increasingly blurred.

In fact, the Great Central Valley's population is growing 2.5 times
faster than that of the rest of the state. It has become California's third
great population center, with thousands of acres of productive farmland
converted annually to urban and suburban development. Gazing east
while driving up Interstate 5 on a clear evening, one sees a galaxy of
lights of various colors and intensities—more each night—stretching for
hundreds of miles along what was not long ago a dark and forbidding
plain. As more people move into this region and more lights snap on, it
becomes increasingly difficult to see the stars in the night sky above.
What the many lights reveal is that some six million people reside in the
area Brewer found so empty. Over ten million are expected to live here
by 2020, when the Valley will conceivably glow like a linear sun.

Population brings problems both expected and unexpected. Consid-
erable and increasing air pollution, for instance, is produced by cars and
more cars, by industrial residues such as farm chemicals, by smoke from
agricultural burning, by many other local sources, and even by contami-
nants sucked into the Valley with cool coastal winds each summer. In-
digenous refuse, it seems, would be quite enough, since local air suffers
from excess ozone, carbon monoxide, particulate matter, and nitrogen
oxide. "There's no doubt smog is causing hundreds of millions of dollars
in damage to crops every year," points out Robert Brewer, a horticultur-
ist at the Kennedy Field Station near Parlier in Fresno County. "And if
we get many more people here in the valley, we're really going to
have a problem."

What's more, Valley smog is creeping into the Sierra Nevada, pro-
ducing not only acid rain and snow but profound ozone damage. Eighty
percent of the pines in Sequoia and Kings Canyon parks and 90% of the
pines in Yosemite evidence such environmental abuse, according to Di-
anne Ewell, a National Park spokesperson. Pollution control in the
southern section of the Central Valley has been regulated by the counties
themselves, and most have been in violation of federal clean-air stan-
dards for years.

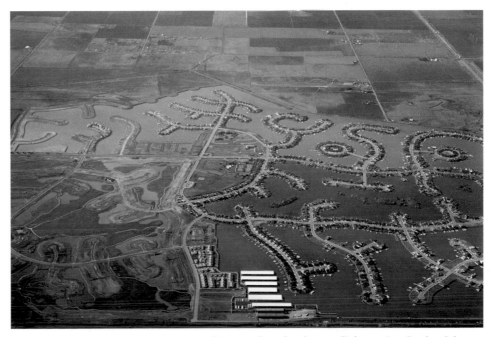

Discovery Bay, San Joaquin Delta, 1985. Stephen Johnson.

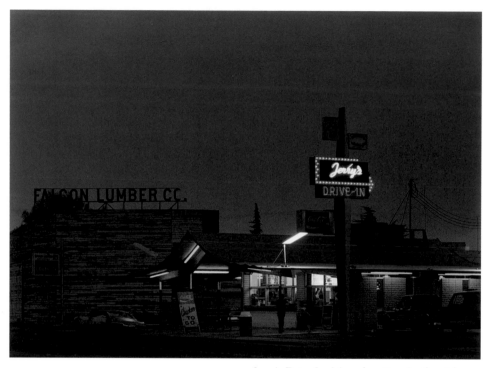

The overpopulation threatening the world is also overflowing California's trendy coast and spilling into the heartland. Such rampant growth not only illuminates the populous strip along Highway 99; it also eliminates farmland as it climbs toward the foothills to the east and spreads over the flats to the west. Moreover, it is changing the traditional character of Valley communities, the Chat 'n' Chew Cafe's intimacy replaced by indistinguishable fast-food outlets. Raymond Dasmann paints a bleak picture:

> In the Central Valley, from the head of sloughs leading to San Francisco Bay as far east as the Sierra foothills, one housing tract replaces another in a formless mass of suburbs that have been aptly termed "slurbs." If it could end at this it would be bad enough, but repairable. Instead the process goes on. Housing and industry spread ever farther, engulfing farm and forest, marsh and pasture with no end in sight except the dismal one of a gigantic, disorganized megalopolis, filling much of the state and depending for its food on distant lands.

If a great many new residents in the Valley are firmly ensconced in the middle class, that has by no means always been the case, and another reason this region is filling up is that a third river as vital as the Sacra-

mento or the San Joaquin has been essential to the area's development, the continuing, multiethnic stream of migrants willing to toil in these unforgiving fields in order to escape poverty. Many do not escape it, no matter how hard they toil. The paternalistic economic pattern that has demanded their labor remains an enduring dilemma.

It is no coincidence that a 1991 report of conditions in Tulare, Kings, Fresno, and Stanislaus counties revealed that a "shadow society" of 86,000 households lived there in poverty. The study conducted by the California Rural Legal Assistance Foundation found that "sixty percent of them are Hispanic, and most are children, who often go to bed hungry, whose parents skip meals so their children can eat. Most of those families work—and work hard—yet they remain poor." The study documents widespread hunger among laborers in the richest farmlands in the world. With hunger comes ill health, less schooling, less opportunity to rise in the society, so the cycle of poverty perpetuates itself here—where a labor force available on demand is necessary for agribusiness.

Many communities in the Valley are actually poorer than urban ghettos. Will Rochin, an agricultural economist at U.C. Davis, points out that while agricultural income is still rising—more than $17 billion in 1990— "we have increasing poverty in rural communities where agriculture is the major employer." Something is dreadfully wrong with the system. "We shouldn't have these kinds of conditions for farm workers," he adds.

In a landmark study of farmworkers in California, *Bitter Harvest*, Cletus Daniel explains what developed historically when industrialized agriculture became the Valley's pattern:

> By the twentieth century, employment in California's large-scale agriculture had come to mean irregular work, constant movement, low wages, squalid working and living conditions, social isolation, emotional deprivation, and individual powerlessness so profound as to make occupational advancement a virtual impossibility. To the typical large-scale farm employer..., seasonal farm laborers had become faceless, nameless units of production.

That namelessness can work both ways in large-scale agribusiness; a 1988 survey by the California Department of Employment Development found that up to 90% of workers on a given grape farm did not know the identity of their employer. This is not surprising when other information is factored in: 3.2% of California's agricultural employers pay 53.2% of farm wages, and that concentration of employment increasingly requires the services of middlemen.

"In the San Joaquin Valley," reports Don Villarejo, of the California Institute for Rural Studies, "it appears that workers employed by labor contractors now perform an actual majority of hired labor in fruits and vegetables during peak season." However its characteristics are changing, farm labor remains a muddled, impassioned issue in the Great Cen-

tral Valley, where a migrant labor force is considered as necessary as sunshine and water.

Nothing seems to occur here without influencing everything else, so irrigation is one reason why peonage and the struggle to escape it continue to be endemic problems. The enduring American dream of 160 acres and independence has not been easily realized in this region. Even though the Reclamation Act of 1902 limited water allotments to a quarter section per farmer (or each member of a farmer's family) and required that farmers live on any land irrigated, officials simply did not enforce the statute despite the heroic efforts of Paul Schuster Taylor to force them to do so. Many spreads were run from corporate boardrooms in big cities, and those owners controlled vast tracts of land, which soaked up enormous amounts of cheap, subsidized water.

Taylor's determination to see the Reclamation Act's irrigation limit enforced was based in part on the classic agrarian vision of a land dominated by small farms and independent growers, not vast corporate spreads worked by peons. But because agribusiness, its attorneys, and its political allies were not to be denied, when the unenforced 160-acre limitation and residency requirements were formally overturned in the Reclamation Reform Act of 1982, decades of noncompliance by those same corporations were legalized, and a suspicious lack of enforcement by government agencies finally ended. The gallant Taylor, who at least had the satisfaction of knowing he had not faltered in his personal attempts to compel the government to enforce its own law, could only say, "Well, it was a good fight."

The Reform Act of 1982 was sponsored by Congressman Morris Udall of Arizona. It completely abolished residency requirements—meaning, among other things, that foreign corporations could more easily invest in Valley land. It set the combined maximum holding for a family at 960 acres, or the equivalent in less-productive soil. Although it limited corporations to 320 acres, it also allowed unlimited leasing if the lessee paid back in full the borrowed reclamation funds, no great problem since government interest rates were approximately half the market figure. Owners of large holdings would be given up to five years to dispose of excess acreage. It seemed on the surface to be a bill that would somewhat limit corporate agriculture, while realistically allowing successful family farms to operate, but it hasn't worked out exactly as expected.

Five years after Udall's legislation passed, Southern Pacific Land Company—progeny of the railroad of the same name—still owned 153,000 acres in the south Valley and had collected $11 million in irrigation subsidies; moreover, it was eligible for $24 million more. Confronted with those facts, a spokesperson for the S.P. said the company was soon going to sell its holdings in the Valley. But the S.P. was not alone: a relatively "small" owner, J. G. Boswell Company, with 24,000

acres in the San Joaquin Valley, was eligible for $9.8 million. These and other subsidies were made public after a congressional committee decided to give owners of large tracts extra time to sell their surplus land, but did not recommend an extension of water subsidies. Nonetheless, Ronald Reagan's Department of the Interior continued to accommodate agribusiness, leading even so staunch an ally of agriculture as former Congressman Tony Coelho of Merced to complain, "They're going around the intent of Congress." This is, it appears, one more example of governance by lobbyists, and another old California story.

Efforts to reduce water subsidies are, of course, met with impassioned arguments. John Harris of Harris Farms, which reaps approximately 15,000 acres in the Westlands Water District, asserts that "the entire San Joaquin Valley would be devastated if we didn't have the water. Agriculture is *the* economy here....If Westlands shuts down, people will be paying an awful lot more for their salads"—a hoary and oft-repeated threat.

California Cornucopia, circa 1900. California Historical Society.

People may in fact *not* be paying an awful lot more, if Villarejo is correct. He points out that the value of the spring 1985 lettuce crop in Westlands was $3,248 an acre and that growers paid only $9.45 per acre-foot for the water that irrigated their land. The actual price of that water was $99.12 per acre-foot. Taxpayers paid the difference. "If the farmers had paid full price"—something they certainly *could* afford—"the maximum price increase they could've posted for the lettuce would've been 3%, given the realities of the market....All that subsidy truly represents is a windfall profit for a few farmers at taxpayer expense—regardless of the dynamics of the market."

Today the average farm in Kern County is 1,473 acres, and it absorbs plenty of subsidized water. Moreover, the trend continues toward bigger properties, more productive farm technology, and increasing concentration of economic power in the hands of businesspeople who do not even touch a shovel, let alone the soil—the very outcome Paul Taylor fought so long to prevent.

The Role of Public Subsidies in California Agriculture

The Central Valley's agricultural industry has benefited from substantial public support. This support takes three main forms in California: USDA commodity programs, irrigation systems, and public university research and technical services.

United States Department of Agriculture Commodity Programs

These programs have their origin in the Agricultural Adjustment Act, a New Deal initiative to address the widespread farm depression of the 1930s. Today, the two major components of the USDA commodity programs are *income supports* and *commodity price supports.*

Income supports are triggered whenever the average world market price for a supported commodity falls below a "target" level set by Congress in the Farm Bill. This target price is intended to be the amount needed for an average farm family producing that commodity to pay all of their crop production expenses and still leave enough to support themselves at the standard enjoyed by an average urban family.

In 1987 some 5,744 Central Valley farms received deficiency payments that totalled $205.2 million, an average of $35,722 per farm; 34,825 Central Valley farms reported harvesting crops in 1987, so just 16% of them received USDA payments.

Commodity price support programs are an indirect mechanism intended to help establish a floor for the market price for the same commodities. Essentially, the USDA sets a "loan rate" for each of these commodities. If the world market price falls *below* the loan rate, then farmers may place their production of that commodity in storage and receive a one-year loan from Commodity Credit Corporation (CCC), an agency supported by the USDA, using the stored commodity as collateral.

In 1987 Central Valley farmers entered into 1,190 new CCC loans. The aggregate value of these loans was $64.7 million, or about $54,340 per farm. It is important to realize that this figure does not represent a direct payment to farmers. Rather, the figures refer to loan value that must be repaid by the farmer either in cash or in an equivalent amount of farm commodities.

Irrigation Systems

Federal officials estimate the amount of the intentional irrigation subsidy to be in the range of $75 to $100 per acre per year. For a 500-acre farm, this amounts to a subsidy of $37,500 to $50,000 per year. Estimates by critics of the water projects place the figure even higher. Congress has set a limit of 960 acres as the amount of federally subsidized water that any farm is entitled to receive. But critics point out that huge farms, with tens of thousands of acres of irrigated land, have been able to circumvent this acreage limitation by setting up 960 acre "paper farms," which are then managed in common. Studies show that the majority of the federal subsidy is captured by landowners, the "unearned increment" of land values increased by the availability and low cost of water.

Research and Technology Subsidy

Every year the California legislature appropriates tens of millions of dollars to support agricultural research to be conducted by the state's public universities. Federal support from the USDA contributes a like amount. The equivalent of more than 500 scientists working full time are supported to conduct activities that will be of commercial value to the state's agriculture. From new plant varieties to new pest-control technologies, a substantial public effort is put forth to keep California at the leading edge of agricultural technology. In addition to the research effort, additional millions are spent to support a network of extension agents, or farm advisors, whose job it is to bring the latest information directly to farmers. Most of the advice offered is production-oriented. No other industry enjoys such an elaborate system of public research and education support. Critics point out that the state's 42,000 farmers benefit greatly from this system, while the 1.16 million farm workers derive little or no benefit. Overall, however, the public has benefited from all publicly subsidized programs in the form of low food prices, a strong agricultural economy, and the multiplier effects of that economy.

—California Institute for Rural Studies.

Sources: U.S. Department of Commerce, Bureau of the Census, *Census of Agriculture, 1987.* Vol. 1, Part 5, California, State and County Data.

U.S. Department of the Interior, Bureau of Reclamation, *Statistical Summary, 1986.* Vol. III.

State of California, Joint Legislative Audit Committee, Office of the Auditor General, *The California Agricultural Experiment Station,* Report P-906.2, March 21, 1980.

The struggle for control of the land in the Valley endures. "Of these conditions [reflecting the American character] the first was the state of the land tenure in all the most promising agricultural regions of the new state," Josiah Royce observed in his classic and controversial 1886 book *California, from the Conquest in 1846 to the Second Vigilance Committee in San Francisco: A Study of American Character.* Villarejo succinctly summarizes the current situation this way: "Too few people control too much land."

Driving over the vast, empty stretches that characterize the west side of the San Joaquin Plain and the Tulare Basin today, one is struck by the lack both of small farms and of communities: empty, it all seems so empty. This is the domain of an economy that has little to do with that aforementioned dream of 160 acres and independence or even with stewardship of the land. This is the domain of great, impersonal empires, of plantations that employ a largely Hispanic work force that huddles in the infrequent towns and survives on marginal incomes. Along with the borderline poverty of so many workers, the ownership of giant tracts by outsiders results in a lack of commitment to the local environment and local community.

Tulare County, which generates nearly $2 billion annually from agriculture, also illustrates the vulnerability of the current economy because farming is virtually the only major local industry. When a horrific fourteen-day freeze occurred in December 1990, the local economy all but collapsed. Nationally, this disaster attracted little attention. "Five years ago there was a three-day freeze in Florida that was on the national news for weeks," points out David Lee Gibson of the Lindsay Chamber of Commerce. "Here it was a fourteen-day freeze and there's nothing." After a three-week delay, President George Bush declared the region a disaster.

But in small rural towns like Woodlake, Farmersville, Lindsay, and Orange Cove, half the work force was suddenly jobless—this at a time when the statewide rate was 7.4%. Most of these laborers now without jobs, of course, had earned no more than tenuous incomes at best, had danced with poverty even during fat times, so they had few financial resources; as a result, local homelessness surged. "Tell people that the cornucopia is also where there is the most poverty and the most unemployment," said Acadio Viveros, mayor of nearby Parlier. "Now this devastating freeze adds on to the wound that has been lacerated for many years. People here are suffering even more."

By March 1991, some 173,725 people were out of work in the eight contiguous counties from Stanislaus in the north to Kern in the south. Increasingly, the jobless were not only farm laborers, but also employees displaced in the economic chain by the sudden lack of commerce. Calvin Dooley, who was a congressman at the time, claimed that the U.S. Department of Agriculture had offered surplus food for freeze victims, but

Farm, Fresno County, 1985. Stephen Johnson.

that newly elected Governor Pete Wilson's office had turned it down. It seemed to be one of those black comedies best understood only by God or politicians, and people continued to go to bed hungry.

While distant gentry in corporate boardrooms—gentry unfamiliar with hunger except as an abstract concept—do operate many ranches, the ranches still require numbers of seasonal laborers during normal years. Those indispensable laborers clear and plant, irrigate and cultivate, and finally harvest fields from which they reap few financial rewards and absorb few losses. That fact continues to shape and divide local society. The division—social oil on social water, a thin layer of rich not only floating over the poor but requiring them in order to float at all—has not encouraged, and for a long time has barely tolerated, upward mobility. Until education became more accessible after World War II, there were precious few opportunities to rise within this social paradigm; even now, it is the second generation who *may* begin the upward climb…or may not.

The hard edge, the sense of the possible, even the conviviality that has characterized the Valley's rural towns are products of the fact that always, no matter what the technology, Valley agriculture has offered

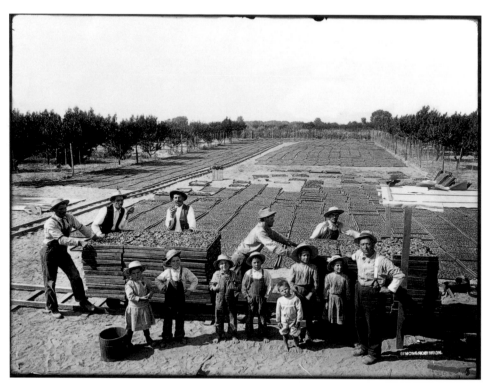

Workers and Drying Fruit, Merced County, circa 1920. Frank Day Robinson.

jobs both skilled and unskilled to people from all over the nation and the world. Although many important immigrant groups—Cantonese and Filipino, Basque and Greek—have been virtually all-male during the early stages of their tenures in the Valley, migration here has by no means been a male-only affair.

It has long been common to see men and women toiling side by side—sometimes, indeed, whole families working together—in the Valley's unforgiving fields, and there developed a rough egalitarianism and a special pattern of settlement where women played a major role. As historians Sally Miller and Mary Wedegaetner point out, women "strengthened their peoples by maintaining some continuity with tradition yet simultaneously adapting new elements of the larger community that speeded and eased adjustment." In groups where women were scarce, "the development of community institutions was a slow and limited process."

Social institutions often retain elements of the old country, and, of course, various migrants have also brought from their previous environments agricultural skills as well as new crops. "It would be difficult to exaggerate the importance...varied immigrants have made to the mosaic of California agriculture," historian W. H. Hutchinson asserts. The

same can be said of the mosaic of Valley life, because immigrants have contributed to a heterogeneous culture.

As noted elsewhere, there exist (or have existed) many immigrant enclaves, such as Swedes in Kingsburg, Sikhs in Stockton, Portuguese in Merced, Cantonese in Locke, Armenians in Fresno, Germans in Shafter, Basques in Bakersfield, and now approximately 25,000 Hmongs—a significant portion of one of Southeast Asia's major tribes—in the region between Fresno and Merced. The Hmongs are here owing to American foreign policy decisions made two decades ago rather than some sudden urge to move, and U.S. foreign policy has also been a major factor in the migration of an increasing number of Central Americans now working in Valley fields.

In another sense, however, latter-day migrants such as Southeast Asians are not unlike earlier arrivals. Frank Viviano observes: "What brings the Hmong to Fresno is a peculiar vision, composed equally of hope for a better tomorrow and nostalgic longing for a lost agricultural past"—shades of the Dust Bowl migration. Like earlier migrants, the Hmong have entered a domain that is not exactly as it seems: the agricultural dream that attracted them has been thwarted by the price of California land.

Because so many immigrants and refugees have settled here, there has been much ethnic blending, which itself remains controversial, since intermarriage often defies the local caste system. There is also little reason to become sanguine; racism is still expressed and practiced—although it increasingly appears to be as much a matter of economic manipulation and social class as of race itself. "Wealth is viewed as racial, the proper domain of whites," asserts political scientist George Zaninovich. Economics has been "as important a factor as race in the relationship of various groups," historian Anne Loftis says.

That reality is, in fact, reflected in a traditional, self-serving myth that has been repeated by many in the Valley since the 1860s: some people are uniquely suited for field labor and, by implication, for nothing else. As Cletus Daniel points out, moral discomfort over the plight of migratory workers could be considerably relieved if you believed that Chinese or Italian or Mexican workers, anyone new or different, "were naturally suited to agricultural work by reason of their relatively small physical stature, ability to tolerate hot weather, native stoicism, their lack of ambition...consigned to the farm work force by a mechanism of natural selection." The cultivation of such beliefs has unquestionably influenced Valley communities and contributed to rumors of social regressiveness.

It is certainly true that the Valley has not been an unusual bastion of brotherly love. New migrants, especially nonwhites, have faced resistance here, and it has frequently been led by residents most desperate for scapegoats or simplistic solutions to their own problems. Opposition not infrequently becomes fodder for anachronistic groups such as the Ku

Klux Klan—which not long ago precipitated a storm of controversy when it announced plans to move its western headquarters to Visalia—groups that do not recruit their members from society's best-educated, most accomplished elements.

Racism here remains closely linked to class and poverty—poverty of mind, if not means—the desperate grasp of those whose personal lives leave them little to cling to other than illusions of racial superiority. Although they are not major chords, such rumblings have led some out-siders to stereotype the entire Valley negatively, since more than racial or ethnic prejudice has been alleged. "Something very evil and dark is going on in the Central Valley," gay rights activist John Wahl of Stockton recently asserted.

Despite such problems, this remains a place where poor people of any background can at least try to escape the cycle of poverty, one generation toiling so that the next may take advantage of the region's promise. It has also been a true *refuge* for refugees like the Hmongs, Vietnamese, Cambodians, and Laotians who have arrived during the past decade; previously White Russians did the same thing, as did Mexicans displaced by the 1917 revolution and Okies during the Depression. For the desperate it has offered, if not hope, the hope of hope. But that very intensity of aspiration also presents the possibility of exploitation. As a result, the Valley remains a place where continued peonage is considered an economic necessity by those in a position to profit from it, and the average farm laborer finds less than six months of work a year and earns less than $10,000 in that time, despite that frequently heard local litany: "Hell, some of 'em get rich at it."

Nativists and racists—especially those who, paradoxically, are themselves newcomers—conveniently ignore the historical importance of immigrant cultures in this sphere. Arguably, the Valley's most famous grower has been Sicilian-born Joseph DiGiorgio, who came west in 1915 with money earned wholesaling fruit on the East Coast. DiGiorgio discovered that figs and grapes thrived near Arvin in the southern end of the Valley, where he acquired some 20,000 acres. He took advantage of modern techniques to improve his harvest, and had the capital necessary to dig deeper wells and pump groundwater from aquifers unavailable to those less wealthy. Eventually, his holdings included some thirty farm properties in California, a dozen packing sheds, the Klamath Lumber and Box Company, three wineries, fruit auction houses in major eastern cities, and the Baltimore Fruit Exchange—a considerable "farm" even by Californian standards, and the list could be much longer. The *San Francisco Chronicle* once said that "DiGiorgio is to farming what Tiffany's is to jewelry."

In the north Valley, another immigrant farmer, Didar Singh Bains, has become America's biggest grower of cling peaches. His grandfather came to the Yuba City area from Punjab in 1905 with the first wave of East Indian migrants and endured taunts of "Raghead" from some lo-

Storefront, Merced, circa 1925. Frank Day Robinson.

cals. "By 1920," notes Anne Loftis, "there were between three and four thousand East Indians in California, some of them working in rice cultivation near Willows, or in the hop fields in Yuba County." Hindus, as they were called, turned out to be experts at irrigation and aided many a farmer who sought to employ imported water effectively. Even such skills did not deflect racism, however, and East Indians were victims of Asian-exclusion laws. A commissioner of the State Bureau of Labor Statistics said that "the Hindu" was "the most undesirable immigrant in the state…unfit for association with American people."

Today, in addition to his peach orchards, the grandson of that early Sikh migrant farms 1,500 acres of plum trees, 1,200 acres of walnut trees, plus almonds, wheat, and berries. Warren Unna calls him "Yuba City's leading citizen and entrepreneur…a global success story." Bains's achievements may explain in part why the Yuba City–Marysville region holds the largest concentration of Sikhs in the United States, some 10,000, with new immigrants arriving each day. One key to the success of both DiGiorgio and Bains has been their willingness to take advantage of technological developments.

From the start, local farmers not only depended upon large numbers of workers during the planting and harvesting seasons but also

Crops and Smudgepot near Porterville, 1985. Robert Dawson.

federal and state scientists researching everything from irrigation techniques to genetic alterations that produce greater crop yields. The University of California, long accused of a farm strategy favoring big landowners and the chemical industry, has been especially active in the Great Central Valley's agricultural preeminence.

Richard Smoley of the *California Farmer* points out that "critics of UC's agricultural research charge that it encourages capital-intensive rather than labor-intensive technology....This, they say, means that California agriculture is getting bigger at the expense of the small farmer and farm laborer." Smoley's observation is accurate: the accusation is indeed that technology—while ostensibly impartial—has, in fact, tended to most benefit large-scale operators who can best afford innovations.

Ken Farrell, the University of California's chief of agriculture and natural resources, disagrees. "The reasoning of many universities has been that the research and technology is sort of size-neutral. It can be used by big farmers; it can be used by small farmers, and I think that is the case in the vast majority of the research we do." Size-neutral or not, however, vast agricultural corporations have far more money to spend on technological developments. So who is most apt to benefit?

In any case, prompted by the recognition of problems accompanying technological and scientific wizardry, and influenced by legislative scrutiny, the University of California has begun lending at least some of its influence to a concept called "sustainable agriculture," offering less immediate yields, but a much longer productive span—"economically viable, ecologically sound, socially just and humane," according to Terry Gips of the International Alliance for Sustainable Agriculture.

Chemical-intensive farming *may* be on its way out—a problematic *may*—but creative technology of one sort or another is apt to continue dominating this artificial garden, where it is a long tradition. Valley farmers, as Harold Gilliam points out,

> *invented such agricultural bulwarks as the combine harvester, the Fresno scraper, the Stockton gang-plow, the Randall harrow, special adaptations of the clamshell dredge, peach defuzzers, olive pitters, wind machines to fight frost, hydraulic platforms for pruning, pneumatic tree-shakers for bringing down the fruit and nuts—a technological efflorescence perhaps not strictly comparable to the artistic output of Florence in the Renaissance but nevertheless an amazing display of creative energy.*

In 1871 Henry George predicted that "the steam plow and the steam wagon [will] develop, perhaps in agriculture the same tendencies to concentration which the power loom and the trip hammer have developed in manufacturing." He was correct. As English writer Michael Davie observed a hundred years later, "agricultural technology reached California earlier than it did elsewhere, [and] biased development in

sought efficient crops and effective machinery—the most productive possible combination of those things. Today, over $2.5 billion is invested in farm equipment here. Combined with irrigation, chemical fertilization, crop rotation, genetic manipulation, and pesticides, machinery helps Valley growers produce one-quarter of *all* table food consumed in the United States: 100% of the U.S. raisin supply; 90% of the nation's plums; 60% of its table grapes and almonds; 40% of its peaches, safflowers, cantaloupes, and potatoes; 30% of its walnuts; and 20% of its carrots and processed tomatoes; as well as 20% of its cotton (for many years the largest cash crop raised in California). The Valley is also among the nation's largest suppliers of short-grained rice, asparagus, commercial roses, and flower seeds. Even bees, which are used to pollinate fruit and nut crops, are themselves a cash crop produced here and exported to other farming areas. And, of course, the holdings of the Gallo family near Modesto still constitute the largest winery in the world.

The list of crops is continually expanding as new varieties are planted: exotic herbs and condiments this year, kiwifruit and frost-hardy berries the next. One major reason for this is the continuing efforts of

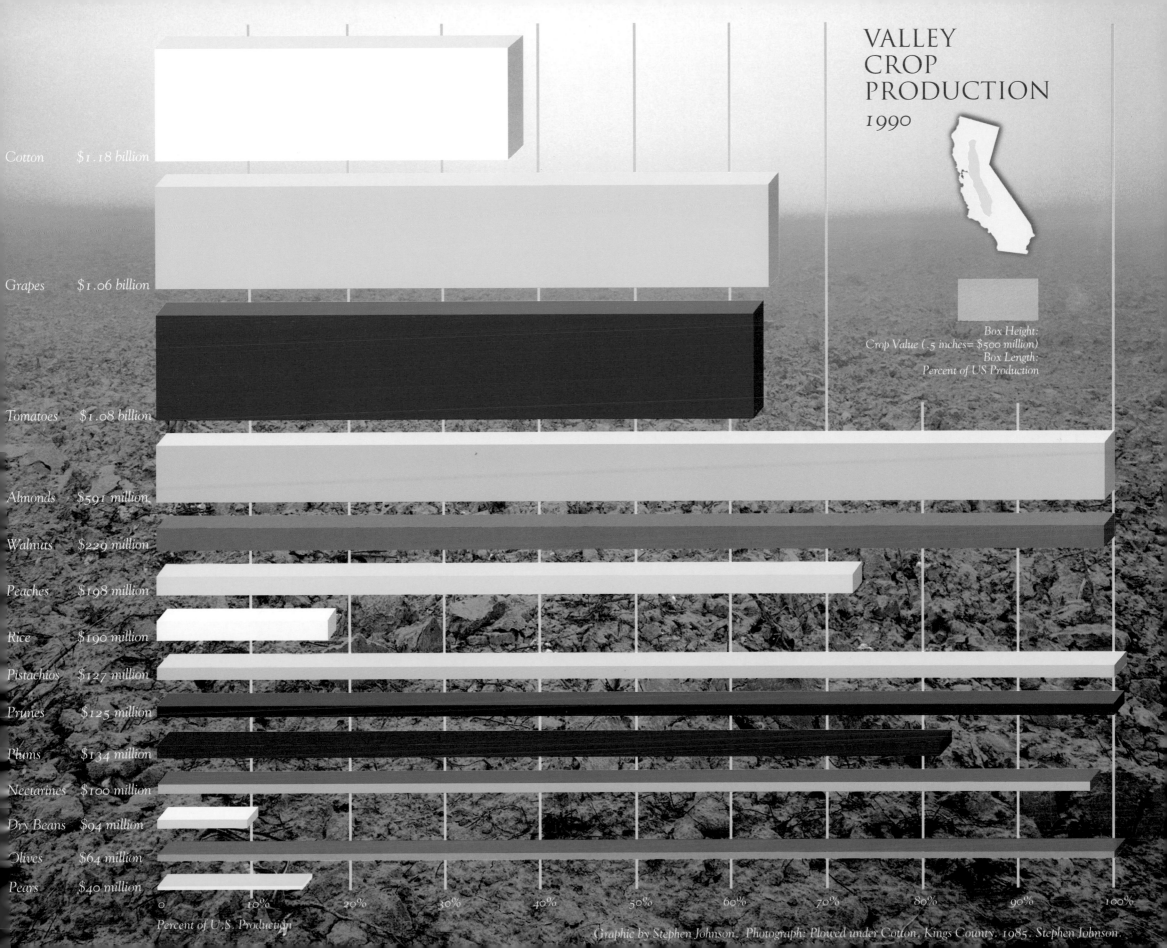

VALLEY
CROP
PRODUCTION
1990

Box Height:
Crop Value (.5 inches= $500 million)
Box Length:
Percent of US Production

Crop	Value
Cotton	$1.18 billion
Grapes	$1.06 billion
Tomatoes	$1.08 billion
Almonds	$591 million
Walnuts	$229 million
Peaches	$198 million
Rice	$190 million
Pistachios	$127 million
Prunes	$125 million
Plums	$134 million
Nectarines	$100 million
Dry Beans	$94 million
Olives	$64 million
Pears	$40 million

0 10% 20% 30% 40% 50% 60% 70% 80% 90% 100%

Percent of U.S. Production

Graphic by Stephen Johnson. Photograph: Plowed under Cotton, Kings County. 1985. Stephen Johnson.

favor of large-scale ownership." And what resulted? "Between 1950 and 1970 the number of small California farmers was halved"—fewer farmers, more wealth.

What makes Davie's comments important is his suggestion that this state's—which means this valley's—agriculture "points the way ahead for agricultural activities elsewhere. In Europe, one of the main ideas behind the Common Market is to abolish the small peasant and turn the continent over to large-scale cultivation." With little thought to social or long-term economic ramifications, *more* has simply been assumed to be better. So, while the Valley with its remarkable productivity is an example for world farming, the price of its abundance is only belatedly being questioned. Wes Jackson, an expert on low-impact farming, argues that "we have yet to develop an agriculture as sustainable as the nature we destroy."

Modern technological farming is expensive. As stated and restated, agriculture here has not and does not favor growers unless they possess large capital or great reserves of credit. It is called agribusiness in the Valley for good reason: large profits tend to be reaped from large investments on large tracts, and so do large losses. Not only is there a struggle for land and water hereabouts, there is also a competition to take advantage of technological advances. As producer Leo Lee wrote for Western Public Radio: "California has Silicon Valley, the world's leading high technology center. California also has another state-of-the-art center; it's not as well known as Silicon Valley but it's just as revolutionary and just as important to the future. It's the Central Valley."

Distinguished author Wallace Stegner points out one more, perhaps less obvious aspect of contemporary farming: "In the Valley, technicians have created an unnatural agriculture: crops that grow naturally elsewhere—the Midwest, perhaps—have been introduced and nurtured artificially, but over-irrigation and too many chemicals will inevitably burn out the Valley, then those same crops will go back where nature developed them, but the Valley won't be recoverable. It will never be what it was."

Valley Indians practiced what is today called "adaptive agriculture"—a system subordinated to gathering strategies that made use of nature's bounty. The notion of manipulating an environment to produce food, while practiced to a limited degree, did not loom large in their cultures, so the remarkable metamorphosis of the Valley's vast dry areas into the richest farming domain in the world's history may be seen as an event of mythic portent, such as when the Great Man of the Maidu tore open the Coast Range to create the Sacramento River. In a sense, economically driven American technology has done the same thing: creating rivers, reshaping mountains, even laser-leveling naturally flat plains to perfection. But this modern miracle costs money—great sums of it.

As a result, a blight far worse than nematodes or brown rot is sweeping the Valley: farm foreclosures. Between 1984 and 1987, 10% of all farm bankruptcies nationally occurred in California, a state with only 4% of the nation's farms. Ken Billings, president of the Federal Land Bank in Fresno, speculates that the state may lose as many as one-third of its growers, most of them small operators. This would all but kill the family farm in the Great Central Valley.

What would be the long-term effect in a state with 35,000 full-time growers, 500,000 agricultural employees, and an unknown but rapidly growing number of farm labor contractors? "The shakeout is going to produce a concentrated, more monopolized food system," suggests Ken Danaher of Food First Institute. Moreover, family farms and personal farming bespeak a different philosophy, a far more intimate relationship with nature, than does agribusiness; it is a vision less economically productive but by no means less wise. "The ultimate goal of farming is not the growing of crops but the cultivation and perfection of human beings," suggests philosopher Masanobu Fukunoka.

Decreasing international markets, higher interest rates, lower land values, overexpansion, increased cheap imports, and other factors have combined to threaten many rural livelihoods. "Cattle ranchers, cotton farmers, and rice growers have taken the worst beating," reports Henry Voss, president of the California Farm Bureau Federation. Adds one farmer, Bernard Furlan of the Yuba City area, "Our problem isn't growing crops....Our problem isn't farming. It's the low prices we get and the exorbitant interest we pay."

What do mortgage holders say about conditions? "This thing's gone well beyond people who mismanaged," Cornelius Gallagher of Bank of America asserts, while John Schumann of Cigna Insurance points out that most foreclosures have been against investors, not hands-on farmers, whom the company treats with "more human sensitivity, because [farming's] a way of life."

"Farmers have a strong survival instinct," says Frank Cross, who tills in Fresno County. "Some have already lost their farms, and the financial and emotional burden is tremendous. But farming gets in your blood and if there is *any* way to continue, farmers will." Another Fresno County grower, this one anonymous, observes, "How humiliating, to be raised on a ranch for 40–50 years and have somebody wearing a necktie telling you what to do."

Many families date their entry into Valley agriculture to the period just after World War I when the unregulated pumping of groundwater allowed fields here to blossom. But a problem soon developed, especially in the otherwise arid San Joaquin Plain and Tulare Basin, where the groundwater level began dropping rapidly as increased irrigation led to expanded cultivation which, in turn, demanded added water. During the 1920s, drought rendered the land thirstier. Eventually farmers were

Abandoned Vineyard, Kern County, 1985. Stephen Johnson.

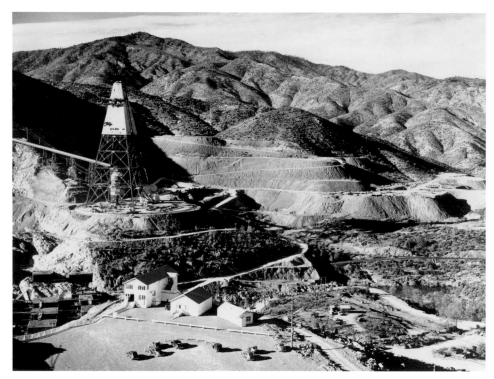

Shasta Dam Construction, 1942. Russell Lee. Library of Congress.

pumping more and more from wells, which had to be drilled deeper and deeper into unreplenishable aquifers.

In 1933, the State Water Plan, which called for the transfer of northern water to southern farms and cities, was passed by the legislature, for it had become obvious that groundwater had to be supplemented as a source for irrigation. About this time the view that water not used for irrigation was somehow wasted—a notion that assumes streams have no intrinsic value—was promoted and, from 1930 until 1980, the total number of irrigated acres increased by about 100,000 *annually,* according to the state Water Resources Department. By 1981, some 9.7 million acres were being watered in California, the vast majority of them at the southern end of the Great Central Valley.

When, some two decades later, the dams and channels proposed in the plan became a reality called the California State Water Project— scheduled to deliver 4.2 million acre-feet annually—relief seemed to be in sight. But the project only delivered half that much, so groundwater problems did not significantly ease even then. Pumping from aquifers continued to be unregulated; in fact, it increased after huge stores of surface water became available. Growers treated the latter as a supplement, not a replacement, opening more and more previously dry land for cultivation.

In the south Valley, the demand for more seems paradoxically to *grow* in proportion to the availability of subsidized, imported water. "Inevitably," suggests Gilliam, "cheap water is wasted water." Certainly, the pumping of subsurface water has not significantly lessened since the construction of the state's nearly twelve hundred dams and reservoirs. On the San Joaquin Plain and in the Tulare Basin, pumping now exceeds replenishment by over *half a trillion* gallons annually.

As drilling for water has continued, not only has soil subsidence increased, but another unforeseen consequence is now considered possible: a saltwater aquifer lies beneath the fresh water presently being pumped, and there is danger that it may rise and fill emptied pore space. Moreover, because the fossil water pulled from caverns deep within the earth cannot be replaced by present human technology, Stegner suggests, this area's agriculture may have "to shrink back to something like the old, original scale, and maybe less than the original scale because there isn't the groundwater there anymore. It's more desert than it was when people first began to move in....At the very least," he predicts, "your grandchildren will see the Central Valley not by any means the abounding, productive horn of plenty that it is now."

In fact, what may seem an irrelevant change summarizes the mindset inherent in water gluttony. Before irrigation projects, salmon and steelhead from inland streams such as the San Joaquin, Stanislaus, and Merced rivers, as well as the mighty Sacramento to the north, were staples in the diets of Valley Indians. Today the spawning runs of anadromous fish in the south Valley have been reduced by more than 90%, primarily as a result of the diversion of river water for flood irrigation. William Davoren of the Bay Institute explains, "Any river flows for fish were written off as a waste of water and public interest." In Kern County, giant agribusinesses have bought that water for under $10 per acre-foot, while northern California householders have paid well over $1,000 for the same acre-foot. It seems to critics that the water supplied to agribusiness is simply too inexpensive for it to be used wisely and that hubris is manifest in the illusion that water not deployed by humans is squandered.

Various projects sending river water to farmers via weirs, canals, and sluices date to the nineteenth century and, as mentioned earlier, by 1930 the Kings River was irrigating over one million acres, a remarkable achievement. But even that would be dwarfed by the Central Valley Project, which realized the dream of a geographer named Robert Bradford Marshall and led directly to the Valley's present abundance and dilemma. During the last decade of the nineteenth century and the first two of the twentieth, Marshall had worked out a plan for remaking the Valley. His 1919 pamphlet *Irrigation of Twelve Million Acres in the Valley of California* contained a scheme remarkably like what has followed in the Central Valley Project and the California Water Project, right down

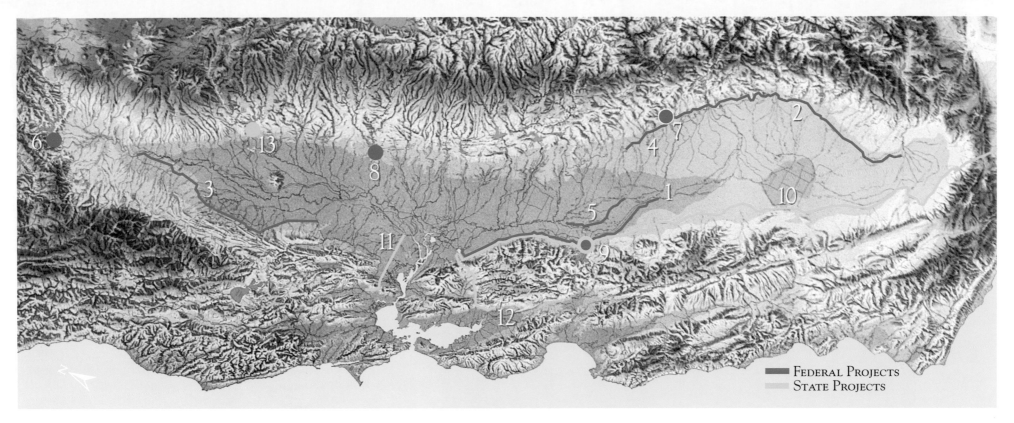

The Water Projects

California's long growing season and fertile soils give the state great potential for agricultural productivity. All that is lacking is water. Seasonal rainfall in the San Joaquin Valley is not adequate to support the production of vegetables, fruit or nuts. Even in the Sacramento Valley, where rainfall is greater, the wet season is concentrated during a few months of the late fall and winter. During the long growing season there is no rain at all. Groundwater is available in many areas but is expensive to pump, especially from the drawdown depths of many Central Valley aquifers.

To fully realize the potential for crop production in the Central Valley, state leaders developed and promoted a series of ambitious plans to irrigate the area with surface supplies. Starting in the 1880s, they proposed to collect and store vast quantities of water in the northern mountains during the winter rainy season and then transport it to southern areas during the dry growing season.

The two major systems built to date are the Central Valley Project (federal) and the California Water Project (state). Both projects store the major portion of their water supplies in the northern Sacramento Valley and then transport them south of the Delta. Since the San Joaquin Valley slopes uphill from sea level in the Delta south to an elevation of more than 500 feet near Bakersfield, enormous quantities of irrigation water must be pumped *uphill* to reach the fields and orchards where they are needed.

The capital costs (principle only) of the irrigation component of each project are supposed to be paid by water users by repayment contracts. The interest on construction bonds (less interest income on money invested) is payed by taxpayers. Authorized bonds on the State Water Project did not prove sufficient to cover costs. In 1961 state officials decided that a $325 million bond authorization from 1933 (for what later become the federally funded Central Valley Project) could be used to finance the current State Water Project. Bonds were issued after the courts decided the action was legal.

These systems of intertwining canals, dams, reservoirs and pumps stand as the largest irrigation projects ever undertaken in the world.

Federal: Central Valley Project

Construction began: 1937
Construction status: incomplete
Construction cost (*through 1990*): $3,215,860,279

Major features: 24 reservoirs, 600 miles of canals
thousands of miles of distribution systems
major hydro-electric power stations

Canals:
1. Delta-Mendota Canal
2. Friant-Kern Canal
3. Tehama-Colusa Canal
4. Madera Canal
5. San Luis Drain and Kesterson Ponds (*shut down*)

Dams:
6. Shasta Dam & Shasta Lake (*Sacramento River*)
7. Friant Dam & Millerton Lake (*San Joaquin River*)
8. Folsom Dam & Lake (*American River*)
9. San Luis Dam & Reservoir (*joint with state*)

Repayments
Contracts (*irrigators*): $54,029,358
Power revenues: $25,807,412
Service contracts: $19,439,497

Total (*through 1984*): $99,276,267

State: State Water Project

Construction began: 1961
Construction status: incomplete
Construction cost (*through 1989*): $3,743,593,000

Major features: 25 dams and reservoirs
683 miles of aqueducts
8 hydro-electric power plants

Canals:
10. California Aqueduct (*joint with federal*)
11. North Bay Aqueduct
12. South Bay Aqueduct

Dams:
13. Oroville Dam & Lake (*Feather River*)
14. San Luis Dam & Reservoir (*joint with federal*)
15. Castaic Dam & Lake (*not shown above*)
16. Pyramid Dam & Lake (*not shown above*)

Annual operating costs (*1990*): $328,903,000
Annual operating revenues (*1990*): $465,162,000
Total repayments (*through 1989*): $4,293,968,000
Net costs to taxpayers (*through 1989*): $2,289,122,000
(*construction costs & interest minus repayments*)

Interest paid by state taxpayers
on construction bonds (*1952-1992*): $2,839,497,000

Annual interest paid on debt (*1992*): $53,640,000

Construction costs and interest as of 1992: $6,583,090,000

State estimated total interest(*1963-2022*): $6,546,575,000

Construction costs and interest (*through 2022*): $10,290,168,000

Source: U.S. Dept. of Interior, Bureau of Reclamation, *Summary Statistics, 1984*, Vol. III, Project Data.
Source: State of California, Department of Water Resources, *California State Water Project, 1980*, Bulletin 132-80. *Management of the California State Water Project*, Bulletin 132-89, Appendix A, June 30, 1989 *Financial Report.*
Management of the California State Water Project, Bulletin 132-90, Tables 19-25, June 30, 1990, Appendix A, June 30 ,1990 *Financial Report. State Water Project, DWR Offical Statement Relating to its $180,000,000 Central Valley Project Water System Revenue Bonds, Series I, May 14, 1991.*

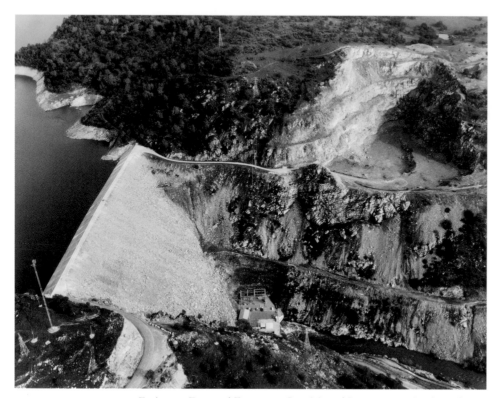

Exchequer Dam and Excavation Site, Merced River, 1986. Stephen Johnson.

to Shasta Dam in the north and the A. D. Edmonston Pumping Station in the south—the elaborate complex of stored and transferred water that is at the core, not only of Valley agriculture, but of much economic and political power as well.

Over the past half-century, that complicated series of dams, channels, and strategically placed pumps has salvaged water from mountain snowpacks. The Central Valley Project, a federal endeavor that delivers an astounding 8 million acre-feet annually, is considered the most ambitious public works project ever built. It includes not only Shasta Dam, its core, but also eighteen reservoirs, fifteen pumping plants, five power-generating complexes, and 540 miles of aqueduct. "The golden faucet," as Donald Worster calls it, eventually irrigated three million new acres of privately owned land, a bonanza greater than the Gold Rush. As large and important as the Central Valley Project is, however, it is in some ways less spectacular than the California State Water Project.

The fact that a single state has funded a scheme as elaborate and as expensive—something over $3 billion—as the California State Water Project bespeaks both political clout and economic pressure. Best of all for growers, the state project was not encumbered by a 160-acre limita-

tion. Some commentators have suggested that the California State Water Project should be called the "Kern County Water Project," because that single, dry-yet-rich county receives thirty times more water from it than all of the state north of San Francisco (where, of course, rainfall is much higher). More recently and more insistently, others have suggested it be named after the thirsty Westlands Water District, in which the Kesterson Reservoir is located. Investigative reporter Patrick Porgans calls the State Water Project "a multi-billion-dollar boondoggle," asserting that it is "underfinanced and overcommitted." Whatever it is called, the project is remarkable and controversial.

Beginning at Oroville Dam on the edge of the Sacramento Valley, which impounds the Feather River, the State Water Project sends water downhill to the Delta, where giant pumps lift it uphill into the cement channel of the California Aqueduct—the state's longest stream, extending 444 miles. Some of the water is impounded at San Luis Reservoir near Los Banos, but most continues south and it has allowed the Valley's previously arid west side, which did not receive Central Valley Project water, to bloom. "This project was a godsend to the big landowners of the state of California. It really increased the value of their property tremendously," admits former governor Edmund G. "Pat" Brown, a strong proponent. "But also the ordinary citizen has been helped by it too," he adds.

Eventually, Feather River water is thrust two-thirds of a vertical mile over the Tehachapi Mountains toward the crowded, parched Los Angeles Basin. The State Water Project employs huge electric pumps first to boost water into the California Aqueduct, then to send it into the reservoir behind San Luis Dam, and finally to lift it across the mountains into Southern California, requiring enough electricity to light most of the western United States.

These two great projects, along with the considerable groundwater pumped locally, allow growers here to water three-quarters of all the irrigated crop land in California, one-sixth of the total in the United States. On the San Joaquin Plain and in the Tulare Basin, 97% out of the nearly five million cultivated acres are watered. But irrigation, which has produced so much food for the national larder and so much wealth, is darkened not only by its history of political chicanery—as Worster, Taylor, Hutchinson, McWilliams, and Reisner, among others, have shown—but also by a number of increasingly obvious and ominous dilemmas.

As early as 1981, the President's Council on Environmental Quality described the San Joaquin Valley as "one of the few areas that has suffered from all the major forces of desertification." That conclusion was reached after studying a December 1977 dust storm that blew twenty-five million tons of soil from the Bakersfield-Arvin area over a 300-square-mile region in twenty-four hours. It even spread spores of valley

San Luis Reservoir, 1978. Stephen Johnson.

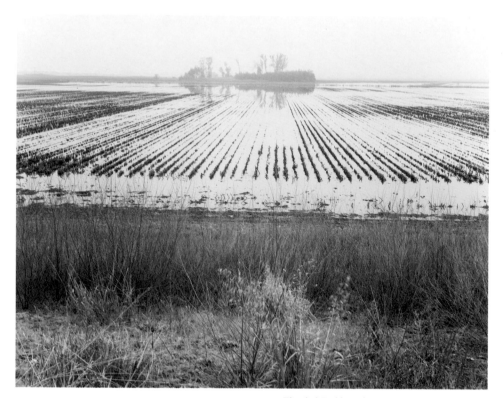

Flooded Field, Delta, 1986. Robert Dawson.

ring water and appears to be a self-perpetuating organism that will continue doing just that, despite growing opposition to excessive water use and despite the availability of new technologies such as sprinkler or drip irrigation that considerably reduce the need for such vast diversions. Most allotted water, it should be noted, goes not to struggling family farmers, who cannot afford to change their practices, but to jumbo corporations—Shell Oil, Prudential Insurance, Getty Oil, Tejon Ranch, Equitable Insurance, Chevron, Southern Pacific, Blackwell Corporation, Travelers Insurance, Unocal, Metropolitan Insurance, Mobil, and until recently, Tenneco West—that certainly can adjust methods of water delivery if they choose.

In the Valley the proverbial pot of gold is to be found, not at the end of the rainbow, but at the end of the irrigation ditch. "We have a use-it-or-lose-it mentality because that's the way water rights, allotments and contracts are written," explains Aldo Sansoni, himself a farmer. "They should be rewritten," he urges. "If a farmer's going to lose half an acre-foot of water in the spring if he doesn't use it today, what do you think he's going to do?"

In fact, Valley cities are also berated for water gluttony. During drought years, when residents of the rain-rich north had their water use rationed, they have been galled by photographs and telecasts of Valley folk washing sidewalks or flood-irrigating lawns. A study of fifteen large metropolitan areas conducted by the Water Resources Department between 1982 and 1985 showed that water usage was greatest in dry Bakersfield, with 360 gallons a day per capita. Fresno and Sacramento residents both used 300 gallons daily. San Franciscans, by contrast, use only about 150 each day. Why such high consumption in the Central Valley? Hot summers and unmetered water are considered to be the principal causes—those and human nature.

Irrigation in the Valley is big, big business and both vast water projects were justified, in part at least, as measures that would save existing farms and perhaps increase the number of acres cultivated by small farmers. Both have, in fact, led to more and more acres under cultivation, principally by large agricultural corporations, thus following a long-established pattern. On such rich, thirsty land, there has also tended to be a direct link between centralized irrigation systems and centralized political and economic power, and that in turn has shaped society.

An interesting, perhaps revolutionary, development took place in 1986 when a federal appeals court ordered the State Water Resources Control Board to reexamine all water rights permits, taking into consideration their effects on ecosystems, the rights of upstream users, and the impact on fisheries on the Bay and on the Delta, not merely the desires of farmers. Already a report authored by three scientists, Michael Rozengurt, Michael Herz, and Sergio Feld, all from the Paul F. Romberg Tiburon Center for Environmental Studies, has asserted that

fever (coccidiodomycosis)—an indigenous, sometimes fatal fungal disease common in this region—to the distant Bay Area. Experts who had predicted that up to half a million acres in the south Valley could be lost to desertification by 1990 concluded that federal soil conservation programs had failed. Their prognostications have proven accurate, if high. Suggested remedies included more efficient irrigation practices and switching to crops requiring less water.

Local farmers weren't impressed. "These things do happen but they can be minimized. The occurrences so far have been very limited, not all that drastic," said Les Diffenbaugh. Paul Sears, in *Deserts on the March,* offers another view: "So long as there remains the most remote possibility that the drier grasslands, whose sod has been destroyed by the plow, can be made to yield crops under cultivation," he writes, "we may count upon human stubbornness to return again and again to the attack."

Despite salinization, polluted runoff, soil compaction, the compression of pore space in aquifers, and so forth, flood irrigation of the south Valley continues; the Bureau of Reclamation is proposing more water shipments south. The bureau is in the business of storing and transfer-

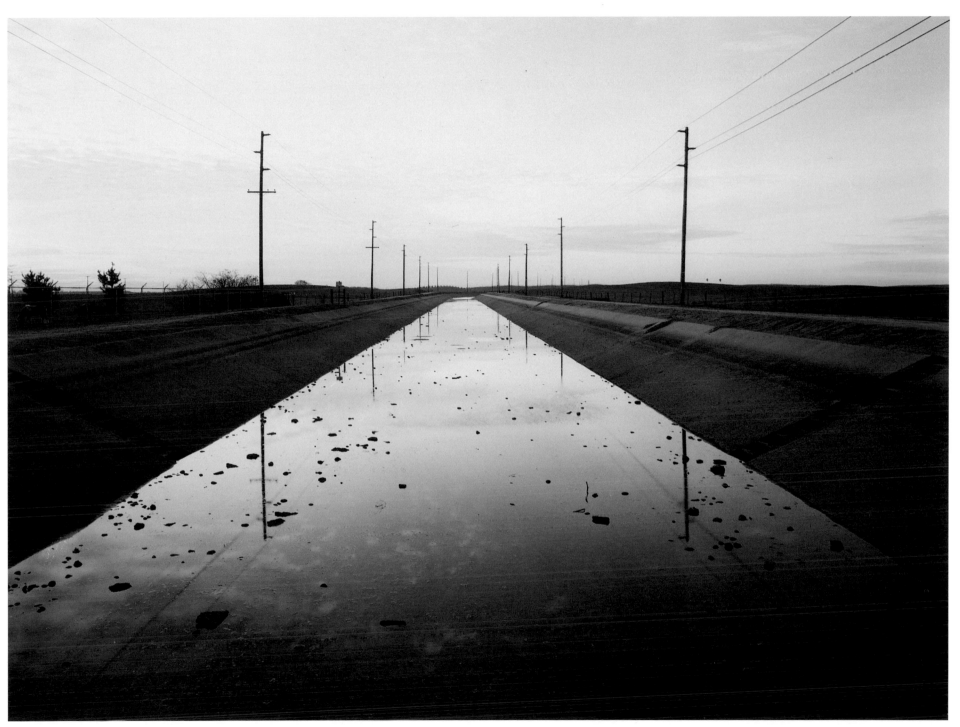

Canal, Merced County, 1987. Robert Dawson.

"the water needs in the South exceed the natural capacity of the Sacramento-San Joaquin river system." Moreover, it points to a series of problems that have already resulted from the diversion of fresh water: a reduction of 70–80% in the fish population of San Francisco Bay; increased salt intrusion into the Delta; and a 100% extension in the time pollutants remain in the Bay.

Hearings are scheduled to continue into the 1990s, and this could signal an entirely new approach to water distribution in California. As Laura King of the National Resources Defense Council explains: "The new issue is reasonable use—balancing of all beneficial uses—agricultural, fisheries, wildlife, water quality. Is it reasonable, for instance, to sacrifice water quality in the Delta in order to grow more surplus cotton in the San Joaquin Valley?" If that is indeed the question, then the answer, however irrational, has been yes. What it will be in the future remains to be seen.

Irrigation, necessary or not, has been implicated in increased chemical contamination not only of underground water but of fog as well. Many local residents fear that chemical pollution in one form or another is *the* problem. Wastewater from traditional flood irrigation carries the residues of the agricultural chemicals that are a major, apparently indispensable component of the Valley's abundance: herbicides, insecticides, rodenticides, fungicides, plus all kinds of fertilizers.

In the Sacramento Valley, rice growers apply chemicals to deal with army worms, water grass, and various broad-leafed weeds. In the Tulare Basin, cotton farmers chemically attack lygus bugs, aphids, and pink bollworms. Valley agriculture has developed a chemical dependency as intense and as potentially destructive as any junkie's. Chemicals have promoted abundant yields, but long-term effects remain unknown and increasingly ominous. By 1978, Valley growers were already spending nearly $1 billion a year on pesticides alone, and today they use almost one-third of *all* pesticides produced in the United States.

Price per bag of chemicals isn't the only cost. Joel Schwartz, for example, documents the fact that between 1950 and 1961 more than 3,000 farmworkers were poisoned by agricultural chemicals, resulting in 85 deaths. At the same time, producers, distributors, and users of farm chemicals have accumulated great political clout, and, as a result, criticizing them has been considered risky business, especially for field workers. Since agricultural labor has been organized, however, the United Farm Workers has attacked and a battle over chemical contamination has been joined.

The gradual, almost grudging acknowledgment of problems seems to mirror the gradual accretion of toxins in the environment. Suddenly, it seems to some, there are cancer clusters. Suddenly there are studies such as the one on birth defects released in June 1988 by the University of Washington, which revealed that in counties with high pesticide use,

Agricultural Chemicals

California farmers spent more on agricultural chemicals in 1988 than the farmers of any other state. With just 2.5% of the nation's cropland, the Golden State's farmers used 11.6% of all of the synthetic chemical fertilizers and pesticides used in agriculture in the United States, making them the nation's most intensive users of farm chemicals.

Central Valley farmers spent $380 million to purchase agricultural chemicals in 1987 and another $289 million for chemical fertilizers. These figures represent two-thirds of all California farm expenditures for farm chemicals. They also show that farm chemicals accounted for 6% of all farm production expenses, and that fertilizers accounted for 4.5% of expenses.

Pesticide use in agriculture is reported to the California Department of Food and Agriculture (CDFA). In 1988, the leading crop uses were for sugar beets, cotton, and grapes.

Central Valley pesticide use, as reported to the CDFA in 1988, amounted to 68,565,683 pounds of active ingredients. This is equivalent to pouring 3.87 tons of chemical pesticides on each square mile of harvested cropland in the Central Valley every year.

Major Pesticide Uses by County–1980

County	Pounds Applied
FRESNO	14,464,000
KERN	10,744,000
SAN JOAQUIN	9,092,000
TULARE	5,773,000
MERCED	5,521,000
STANISLAUS	4,077,000
MADERA	3,984,000
TOTAL	53,655,000

About 90 million pounds of pesticides applied to fifteen crops accounted for about 80% of all reported agricultural pesticides used in California in 1980.

Sources: Census of Agriculture 1987. Vol. 1, Part 51, United States, Summary and State Data, U.S. Department of Commerce, Bureau of the Census, November 1989, State Data, Table 3: Farm Production Expenses, 1987 and 1982, pp. 165 ff.

Pesticide Use Report, 1988 and *Pesticide Use Report by Commodity,* State of California, Department of Food and Agriculture, 1990.

a mother faced 1.9 times the normal possibility of bearing children with limb deformities; merely living in an agricultural county involved a 1.7 risk. Of twelve counties identified in the study as high both in agricultural production and in pesticide use, ten are in the Great Central Valley. Of course, it takes a while for those kinds of negative results to manifest themselves, while the immediate positive effects—high production, ample jobs—are obvious and exhilarating.

Predictably, working people protest when their jobs are jeopardized by concern over long-term health problems that are not yet obvious. The big picture is always difficult to see when one's own livelihood is threatened. After the fire that released dioxin over Oroville in April 1987, for example, when the burned plant was closed by the Environmental Protection Agency, a laid-off employee asserted, "If you took a poll today, who do you dislike more, the gentleman who caused the accident or the EPA, 95% would choose the EPA." But another Oroville resident offered this perspective: "It amazes me that people can be so darn blind. What good will it do us to be an economically flourishing county if we can't drink our water and breath our air?"

Another brouhaha arose when that spectacular killer of nematodes DBCP (dibromochloropropane) was banned in 1977. Growers complained bitterly. "They predicted they couldn't grow grapes without DBCP," explains Ralph Lightstone of the California Rural Assistance Foundation, "but that prediction turned out to be dead wrong....Now one of the primary problems continues to be overproduction rather than loss of yield."

DBCP, which was banned after it was linked to sperm damage among employees at an Occidental Chemical Company plant in Lathrop, was supposed to break down after use, or so said Shell Chemical Company and Dow Chemical Company, which produced and promoted it. They were incorrect, and DBCP has trickled into groundwater to such an extent that today it taints 80% of the state's polluted wells. More than two-thirds of the nearly 2,000 wells tested in Fresno County since 1979 contain DBCP. Most of those are, of course, on farms, so the use-chemicals-at-any-cost philosophy of some growers is changing. "When it was a health problem and involved their own family and children, they were afraid to use it," comments Dr. Vincent Leonardo, a physician in Fowler.

When one feels one's own life—or the lives of one's children—to be in jeopardy, perspectives can rapidly alter; chemicals once fervently defended have become sudden enemies. "If you asked those farmers around Fowler if they'd still use DBCP, knowing what they know now," says Terry Alexander of Clovis, "you can bet they'd say no. But if you told them today they shouldn't use some chemical that hasn't caused problems yet but might, you can bet they'd argue with you."

Perhaps more threatening is that whole belief systems are brought into question: if this agricultural truism turns out to be false, what else

Phostoxin (aluminum phosphide) Fumigation Tents, Selma, 1985. Stephen Johnson.

might be? Everything is complicated by the human tendency to defend long-held positions even in the face of strong countering evidence. Only ten years ago, those suggesting that commonly used chemicals might prove harmful were met with labels: "communists," "liberal do-gooders," "Sierra Clubbers," and so on. But cancer often takes years to develop after a person is exposed to a carcinogen and, what's more, chemical toxicity is not a one-shot, one-dimensional problem—it is cumulative. Like DDT (dichloro-diphenyltrichloroethane) stored in body fat, DBCP has accumulated in tailwater, perhaps in the soil itself, then perked gradually into groundwater, poisoning wells long after it was originally applied to protect roots from nematodes.

In 1988 illegally applied aldicarb—the villain in the 1985 watermelon poisonings—contaminated cucumbers that in turn sickened some consumers. Public confidence in the regulation of toxins used on food crops sank to an all-time low, and that troubling fact was addressed by a panel of experts at an Agricultural Issues and Outlook Symposium held in Visalia. Chuck Collings, president of Raley's Supermarkets, cut

Tractors, Wasco, 1985. Stephen Johnson.

through varied claims when he said, "The consumer thinks there's a problem, you have to address how to handle that." He also added that his own company's tests had not turned up any produce "with pesticide residues above legal tolerance levels."

Acknowledging that community concern is great, Theodore Hullar, chancellor of the University of California at Davis, pointed out that food grown in the United States "is probably the cleanest in the world, and food grown in California is probably the cleanest in the U.S." "Even if you believe the problem is solely one of perceptions…you've got to change the system to make safety come first," Carl Pope of the Sierra Club observed. Collings advised agribusiness, "Tell the consumer you're going to move toward less pesticides, do what the consumer wants."

In 1988, consumers wanted Proposition 65 and voted that tough new anti-toxic measure into law. It required, among other things, that food containing carcinogens or reproductive toxicants at significant levels carry warnings. Agricultural interests had claimed fears were exaggerated and that passage of the proposition would put them out of business—another loud howl of "Wolf!" that the public ignored. Farmers

have since adjusted and survived, although matters turned out in many instances to be worse than expected—F.M.C. Corporation, for instance, has found unsuspected dangerous compounds in its products and has moved to remove them. It has turned out to be better business to reduce pollution than to contribute to it.

McFarland, Fowler, and Earlimart, blighted by cancer clusters, have come to symbolize worst-case outcomes of long-term chemical contamination. County health officials refuse to reveal exactly how many cases have occurred in Fowler, but state authorities confirm that it, like Earlimart and McFarland to the south, is suffering from an inordinately high concentration of malignancies. In the small Kern County town, at least fourteen children have fallen ill (a rate more than thirty times normal), at least six have died, and there has also been elevated fetal and infant mortality. Dr. Richard Whitfield, investigating for the Kern County Health Department, is "quite concerned about the distinct possibility that this may be environmentally caused." In early 1988, state investigators confirmed that they had narrowed the search to a dozen pesticides commonly used in the area.

Connie Rosales, mother of one of McFarland's afflicted youngsters, has become an activist in the search for answers, and her experiences reveal a good deal about local politics and society, for those things are intimately entwined with agriculture hereabouts, and an investigation into chemical toxicity may be deflected by the claim that it threatens free enterprise or local jobs. No one is immune to such thinking, and Dr. Thomas Lazar, who resigned as coordinator of Kern County's study of the cancer cluster, reports "county officials were pressuring me to give McFarland's water a clean bill of health."

Mrs. Rosales has persevered. "I felt that if we were an affluent area, something would have been done immediately," she says. "I was outraged that we weren't important. We could actually die as long as the ag' business looked good." Such pronouncements have not endeared her to local officials and, she reports, the town's mayor complained to her, "You're giving McFarland a bad name." In fact, cancer and whatever is causing it, along with obfuscation by officials, is giving McFarland a bad name.

What is the human cost of all this? Nine-year-old Mirian Robles died from cancer in early 1992. Her parents, Guillermo and Maria, own a small goat farm just outside Earlimart. They earn about $8,000 a year, but their daughter's therapy cost approximately $500,000—more money than all the members of the Robles family can expect to earn collectively in their lifetimes. And now they have lost their little girl. Whatever the causes—pesticides, herbicides, water, or factors not yet understood— real children are dying.

Like McFarland, Earlimart is a town populated largely by low-income farmworkers, most of them Hispanic, many of them trapped in

poverty and malnutrition. Marlene Johnson, a local school principal, suggests that the reason folks have taken little action about the cancer cluster is that "they're afraid of losing their jobs if they make farm owners angry. Agriculture is the economy of this town." Hunger is common enough even when laborers can find work; "The school provides two meals a day, and you know which students aren't getting enough to eat at home—they always leave an empty plate," Johnson points out. "You would not believe the conditions under which people are living here, under which they've been living for the past fifty years."

The local economic system stands indicted because a recent study of 1,744 children in McFarland by the State Department of Health Services suggests that malnutrition and attendant lower resistance may be major culprits. Seventy-one percent of the examined children—most of them from farmworker families—required follow-up medical care.

Formally, the jury remains out on whether agricultural chemicals are directly at fault in Earlimart, Fowler, and McFarland. "We never even thought about chemicals. One time I fell into a vat of corrosive sublimate solution that we were dipping seed potatoes in," recalls a fifty-year-old white man, who prefers not to be named and who worked as a boy at Cawelo near McFarland. His lean, muscular body could belong to a younger man, but his leathery face shows the effect of too many years in Valley sun and wind. "I remember another time I was irrigating when this joker flies over and sprays me with whatever he was putting on the neighbor's field, oily crap. I had to go home to take a bath. Those kinds of things happened to lots of people in those days. Nobody even thought about it then." After a moment he adds, "I got skin cancer bad."

Today, nearly forty years later, everyone seems to be thinking about it one way or another, and farmworkers, bolstered by a union, are no longer mute. Says Cesar Chavez, "Our children are at risk as never before. Pesticides are in the fields, in the air above their school yards, in the water they drink and in the food they eat." Dr. Rick Kreutzer, a state epidemiologist who has worked on the McFarland cluster for two years, says of the theory that agricultural pesticides are causing the town's blight, "I think it is a plausible thing for which there is not sufficient evidence at the state level to answer."

On the other hand, most growers consider charges against chemicals overwrought and false. Said Vido Fabbri, a 64-year-old Kern County farmer, "I used to have the crop duster leave on the spray when he went over my house…We'd leave the windows and doors open. My wife loved it because it killed the spiders. We're in that area—if you want to call it what environmentalists call it, the total toxic zone—and we're totally exposed. Here I am. Do I look sick? I've had no skin cancer. No operations. Nothing."

Guillermo Robles perhaps summarized the attitudes of many when asked if he thought the state would tighten controls. "I don't believe that

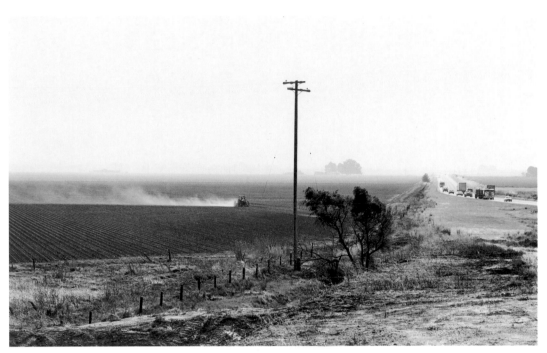

Tractor and Dust, Highway 132, 1982. Stephen Johnson.

will ever happen," he said. "I believe the farmers are stronger than the government. The farmers are the ones who move everything in California. They are bigger than the government. And they want the chemicals."

Pollution in the Valley may be even more pervasive and dangerous than previously imagined. James N. Seibert, an environmental toxicologist, has identified sixteen different pesticides in tule fog. Because this radiation fog sits in a locale for long periods of time, its water particles may absorb concentrations of pollutants up to a thousand times higher than found in surrounding air; "We found that the concentrations of organic materials were much higher than we had expected," Seibert says. He speculates that some of the pesticides—most of them highly toxic organophosphates—likely evaporated from leaves, while the majority were probably carried by dust particles. In any case, contaminated fog may pose a greater threat to residents than bad air—an acknowledged hazard—because "there is a difference [in] inhaling concentrated particles [in fog]. The particles stay in the lungs, whereas vapors can be exhaled." "Seems like every day it's something new to worry about," says long-time Oildale resident Frances Clark.

Yes, it does. Haze has always been common here, but it didn't use to contain poisons. Another University of California scientist, Robert F. Brewer, has demonstrated that the Valley's polluted air is directly affecting agricultural yields. At an experimental farm near Parlier, Brewer is

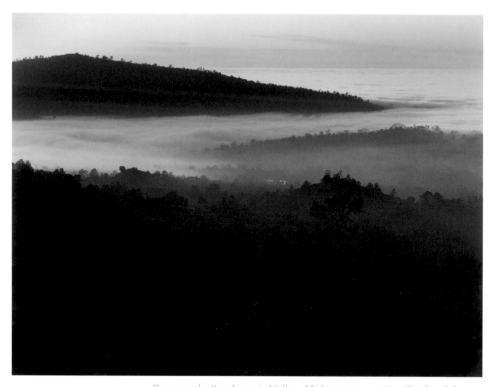

Fog over the San Joaquin Valley, Highway 140, 1980. Stephen Johnson.

growing crops in filtered air next to others in ambient atmosphere; he finds that 18–28% more Thompson seedless grapes, and 15–20% more alfalfa and tomatoes, are grown in clean air. Still, Brewer says that many growers are reluctant to believe that their yields are reduced by air pollution, perhaps because it is one more problem over which they feel they exercise few options and little control. "Those farmers hear about it," says the scientist, "but there's not much they can do."

How serious actually is air pollution in the Valley? Climbers on the crests of Mount Lassen in the north and Bear Mountain in the south frequently gaze across the Valley toward the western ranges without seeing its floor; from up there the trough resembles a banana-split dish filled with thin brown soup. The sources are varied—auto emissions and the ozone they produce, industrial waste, smoke from fireplaces or agricultural burns—but the results are the same. People and animals and plants are breathing it. "We're like a box canyon," explains Brewer. "It's worse here than in the L.A. basin. Smog only has to rise 1,500 feet to get out of the L.A. Basin." It must rise as much as 4,000 feet to escape the Valley. As more and more people and businesses move into this vast "box canyon," the air pollution becomes progressively worse.

Ironically but not surprisingly, an oil company executive a few years ago received enthusiastic applause when he warned a Bakersfield service club that the imposition of air-quality controls would "have a devastating effect on the local economy." Many in attendance agreed that such rules had to be resisted. Today, because Bakersfield hasn't met mandated air-quality standards, strict emission limits have been imposed. The result, according to Tom Paxon, an engineer with the county Air Pollution Control District, is that "it makes it very difficult for new industry to locate here." In the future it may become difficult for *people* to locate there.

For the time being, however, habitation continues and, as the historian George V. Burger writes, "From North Africa and Asia Minor to Greece and Spain, this planet is replete with examples of the catastrophic effect of imposing intensive land use for short-term gain on vulnerable landscapes." The Great Central Valley is a vulnerable landscape. The chemicals and salts carried by irrigation runoff, for example, must go somewhere; they do not miraculously evaporate sans residue.

On the Valley's arid west side, wastewater flows through the San Luis Drain to the 4,900-acre Kesterson National Wildlife Refuge near Los Banos. That run-off illustrates at least two major problems—salinity and chemical residues—resulting from the intensive irrigation and cultivation of what may be unsuitable soils, which a U.C. Davis research team describes as "saline, sodic, or both." The researchers—James W. Biggar, Dennis E. Rolston, and Donald R. Nielsen—go on to point out that even the existing subsurface water in Coast Range deposits contains relatively high concentrations of sulfate, calcium, and magnesium. Moreover, the area's poor drainage, coupled with the arid climate, high salt content in "the parent material," and a high water table, produces conditions for the accumulation of salts.

Another soil scientist, Eugene Duckert, distinguishes between what he calls "new salt" (washed down from the Sierra each year) and "old salt" (leached from Cretaceous sediments on the Valley's floor), the latter being "characterized by relatively high concentrations of potentially toxic trace elements." He suggests that salt-bearing tailwater—thoroughly monitored for chemical residues, of course—be washed to the ocean, but critics remain dubious about the quality of monitoring the state could or would provide.

Salts old and new continue to accumulate. Wastewater carries metals and salts leached from the soil—most notably, selenium—plus pesticide and fertilizer dregs. Those ingredients have, in turn, concentrated in Kesterson Reservoir, killing and deforming waterfowl, and putting the human population on notice that something is seriously amiss. By contrast, the Volta Wildlife Area, only thirty miles away, does not receive drain water and does not suffer Kesterson's problems.

Frank Freitas, whose 5,800-acre ranch abuts on Kesterson, is suing the Bureau of Reclamation, claiming his land has been contaminated.

Asparagus Planters near Tracy, 1983. Stephen Johnson.

His livestock and plants have died, and family members have fallen ill, but their first warning came from wildlife. "We'd see the dead birds," explains Freitas. "I guess they would be feeding together and hit a hot spot. Once we had 3,500 dead coots in our fields."

Some critics refer to the various plans offered to deal with drainage problems as technical quick fixes that avoid serious consideration of values and ends. An eventual answer may well lie with a new mode of thought rather than a new technological advance. For example, Aldo Sansoni suggests, "We manage our incoming water. There's no reason we can't manage the outflow." He is one of many farmers who already recycles irrigation water and asserts that if wastewater from farms had to meet a designated standard such as already met by urban industries, it could be done. "We use the hell out of that water, but we blend it with groundwater before we send it to the [San Joaquin] river....I'm saying treat that drainage with water itself. Blend it. We shouldn't have to be forced. We should take the initiative." While this may or may not be a solution for the San Luis Drain, it nonetheless represents the traditional creativity of local growers.

It is revealing that more than a few farmers blamed everyone but themselves and turned to agencies like the Bureau of Reclamation and the Lawrence Berkeley Laboratory for solutions. "Somehow technology will save us" seems to be an enduring faith in the Valley. Three major plans were proposed: a "wet-flex" option that would, as suggested by Sansoni, dilute contamination with groundwater; a complicated "immobilization" program that would alter crops, change water levels, and employ chemicals to keep excessive selenium out of the food chain; and a scheme to dry out Kesterson's ponds and scrape their topsoil into a sealed, perpetually monitored dump. This last was the winner and the Central Valley Regional Water Quality Control Board allocated $24.6 million to accomplish it, but that is considered only a minimum figure. There is yet another problem. Early in 1988, an internal report of the Bureau of Reclamation revealed that the plan not only might cost as much as $50 million—most to be paid by farmers who caused the problem—but that it could cause contaminated groundwater to rise. By summer of 1988, the estimated cost had risen to $100 million, and it is still going up.

That same summer, another aspect of the mess became public. The Kesterson region is naturally dotted with what are called ephemeral pools—low spots that each winter fill with groundwater, now selenium-polluted. Since these ponds are favored by many varieties of wildlife, they pose a considerable menace. But the U.S. Bureau of Reclamation, while acknowledging the threat, claimed it would be unable to fill them in—it would require 350,000 to 617,000 cubic yards of earth—before the rainy season. The state Water Resources Control Board nonetheless continued insisting that the depressions be covered immediately. Local

Kesterson and the San Luis Drain

Diverting and rerouting water in the Central Valley has made it possible to irrigate vast tracts of land.

Although phenomenal productivity has resulted, irrigation has also produced major problems. As water is applied to the soil, it carries pesticides and fertilizers, natural salts and minerals, concentrating them in the soil and groundwater. This concentrated water is called agricultural wastewater.

In the Valley, this wastewater is leaching into the groundwater in some areas, and in other locations it is trapped by a layer of impermeable clay, gradually building up and rising to the surface.

As part of the Central Valley Project, the U.S. Bureau of Reclamation built a subsurface tile drain system to carry away some of this excess water from selected areas, mostly from the Westlands Water District in western Fresno County.

Originally designed to dump wastewater into the Delta, the San Luis Drain encountered political and financial problems, resulting in this waste water being channeled into evaporation ponds at Kesterson National Wildlife Refuge in Merced County.

In 1985, the Department of the Interior closed Kesterson after mounting evidence that birds at the refuge were suffering mutations, deformities, and death due to selenium in the wastewater stored at the refuge.

Waterfowl are being driven from the area by sirens; while various proposals have been studied for cleaning up Kesterson's toxic waste.

Cost estimates for clean-up range from $26 to $50 million, with recent estimates reaching as high as $100 million.

In 1991 the Bureau floated a new and controversial proposal to use the existing drain to funnel wastewater, but to dump it in the San Joaquin River instead of allowing it to evaporate at the now-banned Kesterson Ponds.

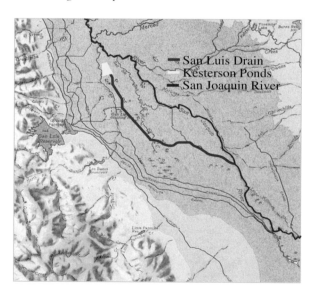

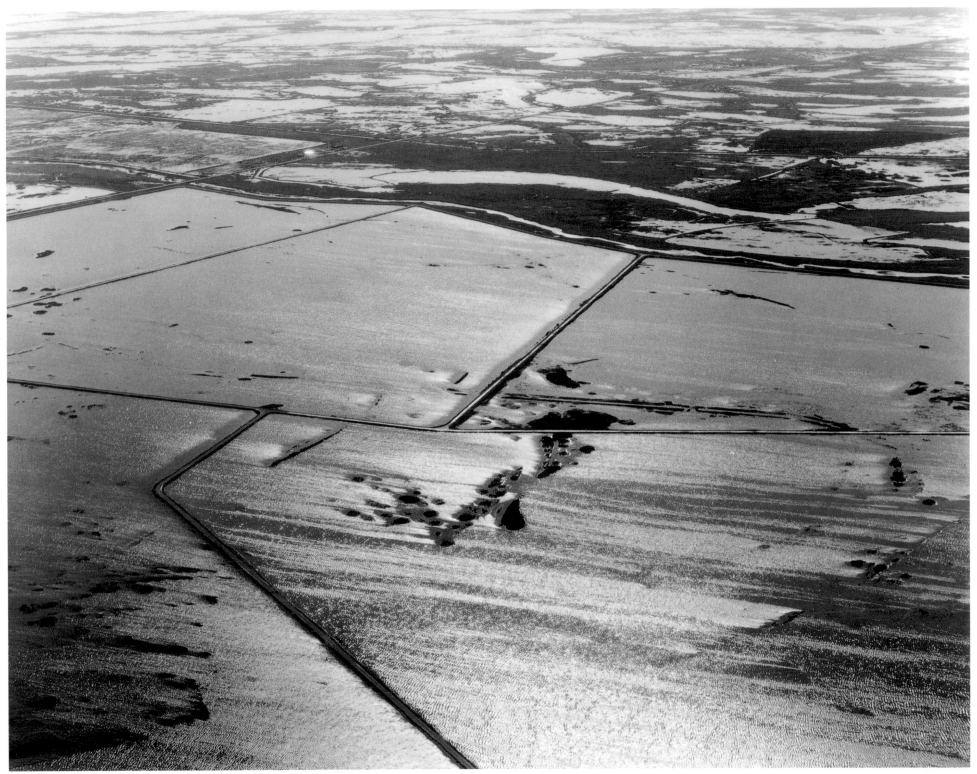

Kesterson Ponds, Terminus of the San Luis Drain, Merced County, 1986. Stephen Johnson.

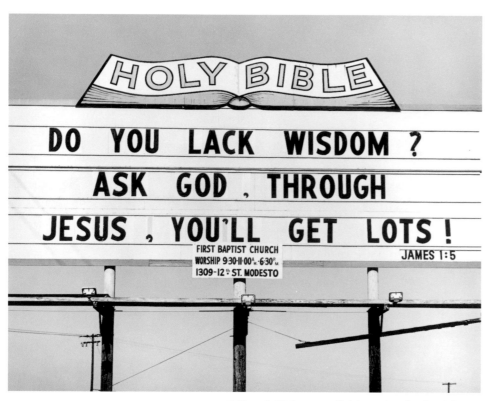

Billboard, Highway 99, Salida, 1984. Stephen Johnson.

ranchers, businesspeople, and environmentalists accused the bureau of stalling, and the whole matter seemed to be out of control, no work being done, while the problem festered.

Two scientists at U.C. Riverside, William Frankenberger and Ulrich Karlson, discovered in 1987 that the growth of naturally occurring fungi that very slowly turn selenium into a relatively nontoxic gas can be speeded up by the addition to their environment of more carbon, more oxygen, and trace amounts of zinc as an activator. Lawrence Berkeley Lab scientists agree that nature itself may provide the best answer, although at present the process is scheduled for use only "post-excavation," after the contaminated topsoil has been scraped from the beds of poisoned ponds. In fact, even the scientists' test sites may be scraped and dumped.

Kesterson is a small but dramatic example of what is happening throughout much of the Valley's irrigated regions where arid lands are plied with chemicals and watered abundantly to produce rich yields. In 1988, a University of California study group suggested that selenium-contaminated water flowing into the San Joaquin River through mud and salt sloughs near Kesterson may also be crippling wildlife and urged

a ban until conditions could be fully studied. That agriculture can unintentionally cause severe ecological harm has been established. The only question is, where next?

"Are a few dozen coots more important to preserve than irrigated agriculture in the San Joaquin Valley?" a grower from Merced named Ken Groetsema nonetheless demanded at a 1989 meeting of the California Irrigation Institute. But the real issue is what those coots represent. Do their deaths presage the demise of an ecosystem? Are their deaths related to the cancer that wracks children in Fowler, Earlimart, and McFarland or to the contamination of hundreds of water wells in Fresno County? What, finally, is the long-term cost of flood-irrigated, chemical-intensive farming?

In May 1988, the Interior Department revealed that the animals at the 398-acre Westfarmers evaporation ponds in the Tulare Lake Basin contained *higher* concentrations of selenium than those found at Kesterson, plus higher-than-normal levels of mercury, zinc, chromium, and cadmium. That degree of pollution "suggest[s] a high potential for adverse biological effects," reported Jonathan Deason. Potentially dangerous levels of contamination were also identified in the Salton Sea Basin and the Lower Colorado River Valley in Southern California, the Middle Green River Basin in Utah, and the Kendrick Reclamation Area in Wyoming. Developments such as those, long hidden from the view and consciousness of most westerners, suggest previously unimagined consequences of modern agriculture.

Few people, natives or outsiders, understand how dramatically this open territory has been altered by human manipulation. Poisoned wells are not obvious to those who don't need them, nor is testicular degeneration among farmworkers widely discussed, but natives *do* notice the cadaverous faces of empty buildings that once housed popular businesses, the sudden carcasses of trees in groves being cleared by developers, the increasing absence of familiar landmarks.

This place, which Lawrence Clark Powell calls the state's *cor cordium*, so defies California's glitzy media image that there are those—outsiders, of course—who question whether it is California at all. In truth, there are many Californias, and none is more vital than this deceptively fragile one. Natives cannot help wondering what the future holds. Certainly change is nothing new here. To Brewer in 1862, the Valley looked like this: "The soil and herbage is dry and brown, few green things cheer the eye, no trees (save in the distance) vary that great expanse....Often for miles we see nothing living but ourselves, except birds or insects, reptiles, and ground squirrels."

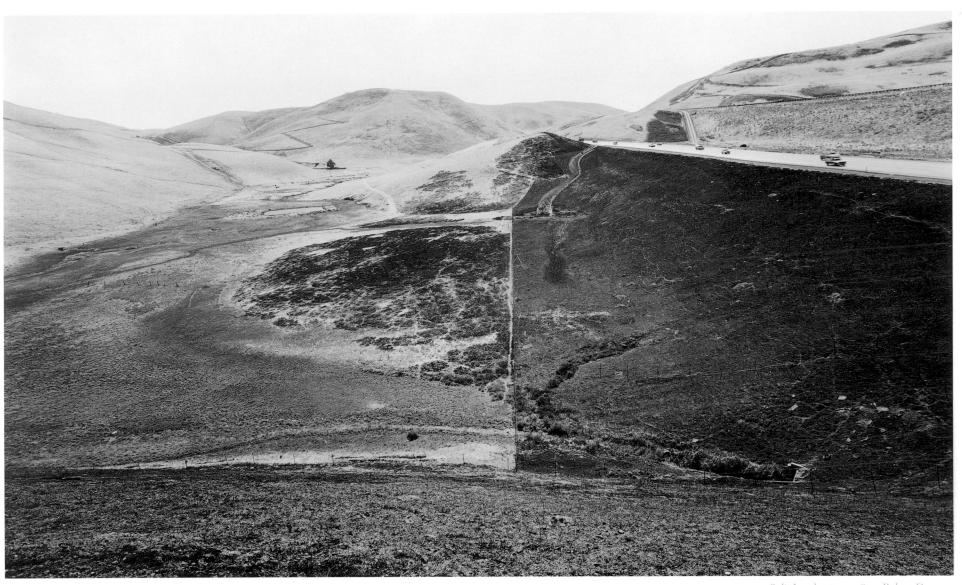

Split Landscape, 1982. Robert Dawson.

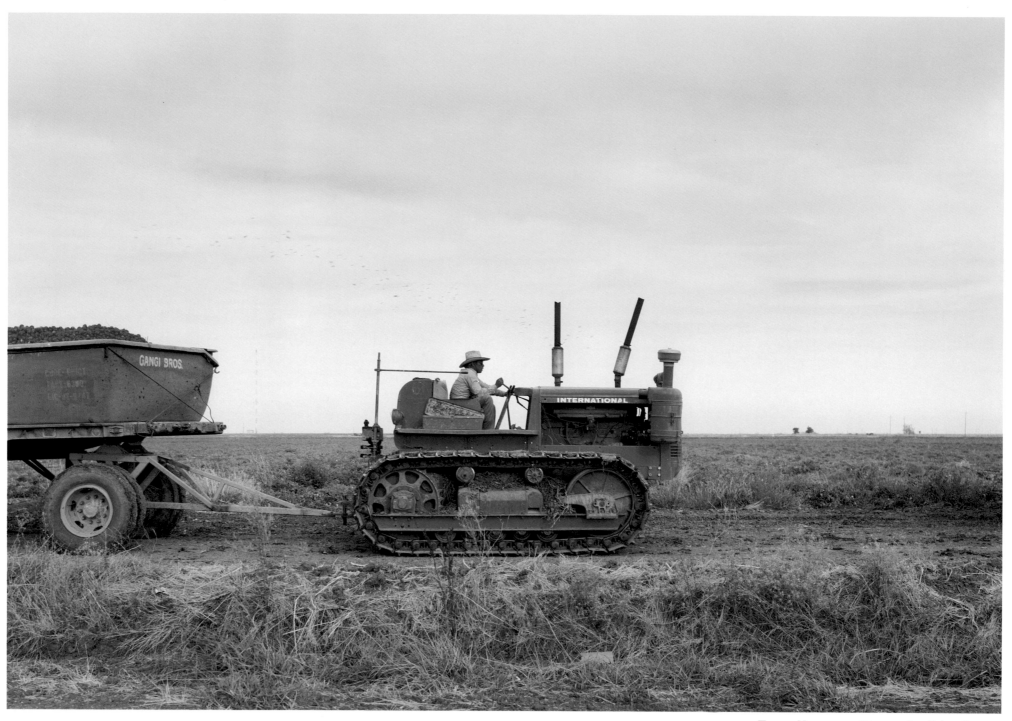

Tomato Harvest near Dixon, 1984. Robert Dawson.

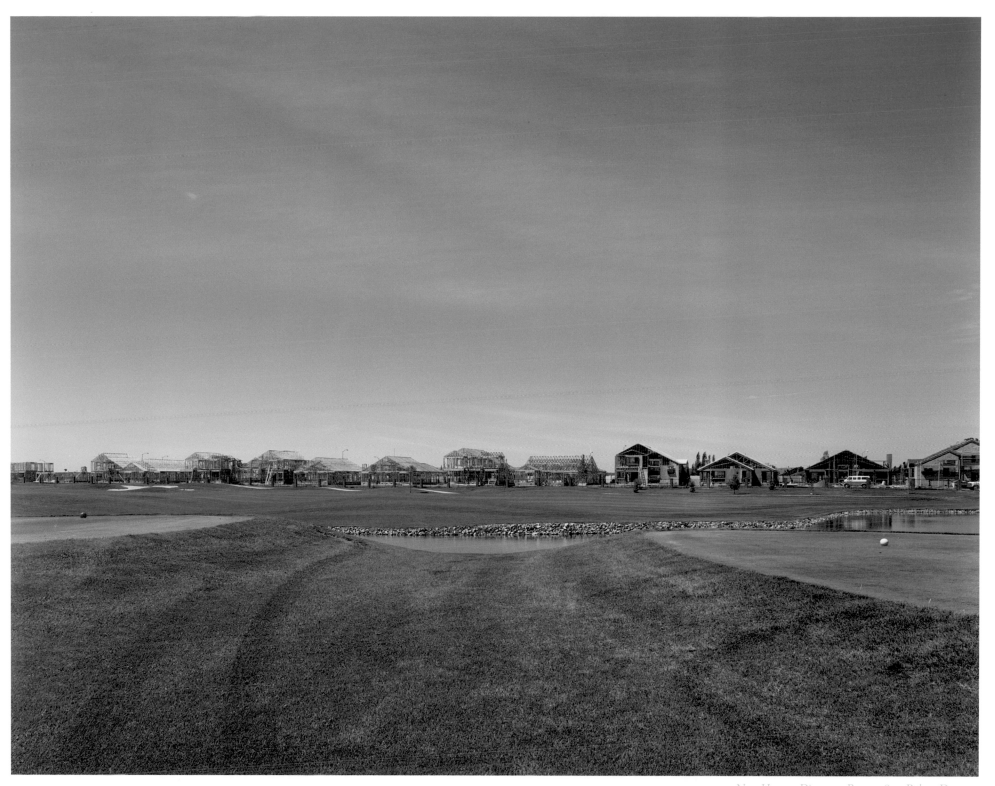

New Homes, Discovery Bay, 1987. Robert Dawson.

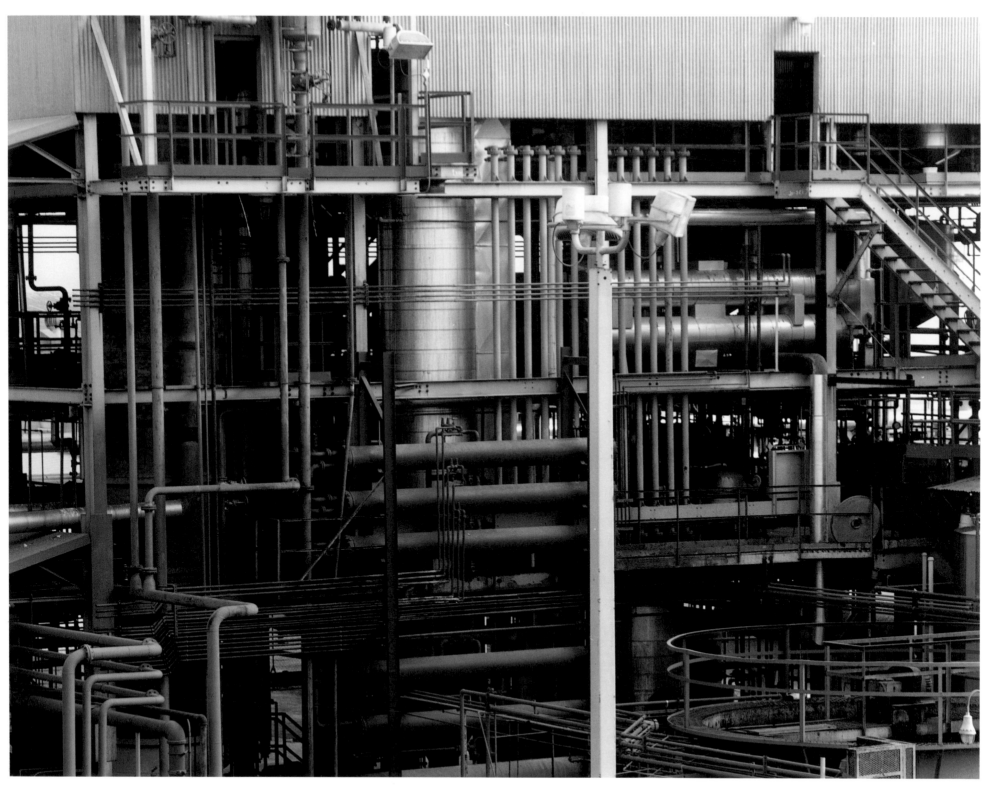

Cottonseed Oil Processing Plant, Shafter, 1984. Stephen Johnson.

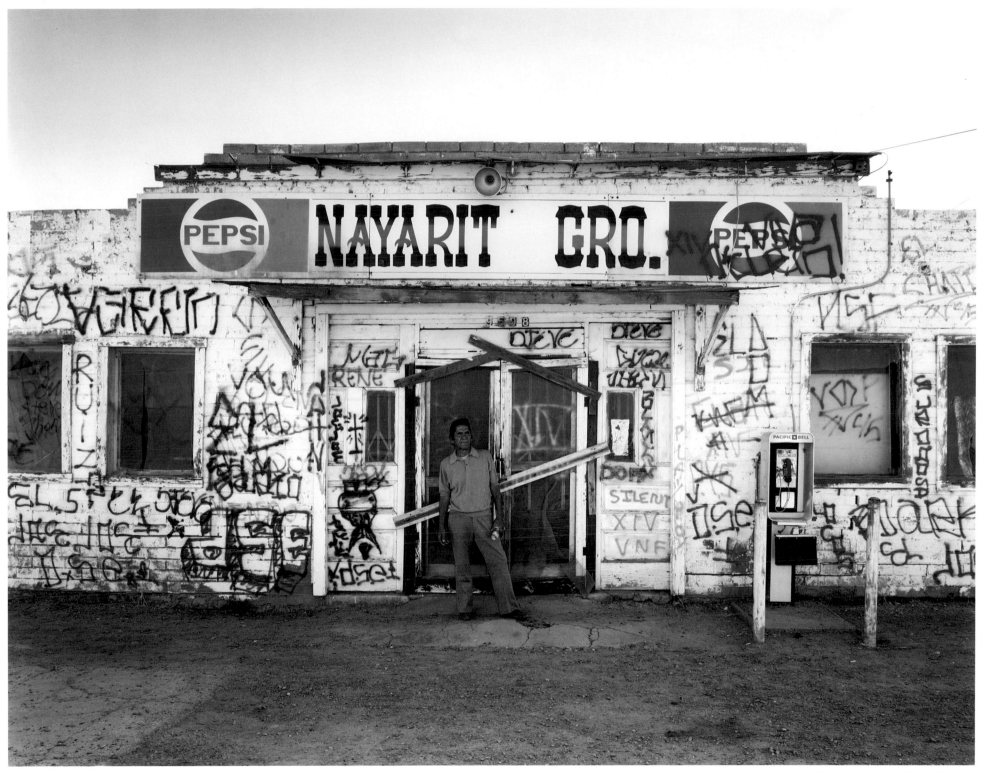

Nayarit Grocery, South Dos Palos, 1987. Robert Dawson.

Rancho Seco Nuclear Power Plant near Sacramento, 1983. Stephen Johnson.

Tank and Cross, Porterville, 1984. Stephen Johnson.

Sacramento Valley Spring, 1879. Albert Bierstadt. The Fine Arts Museums of San Francisco.

Chapter VIII: The Cusp of the Future

**I question if the next generation here will care for Shakespeare, or
any other author, growing up in ignorance, far from school, church,
or other institution of civilization.**

William H. Brewer, May 5, 1863

As it turned out, the barriers to civilization Brewer perceived proved ephemeral. Four disparate regions constitute the Valley; in the over five hundred miles from Grapevine Grade to Mount Shasta can be found one of the most agriculturally varied, most technologically altered, most abundantly productive landscapes in the world. Its nearly fifteen million acres constitute two-thirds of all tillable land in the state, producing that amazing 25% of all table food consumed nationally. In it may also be found farmers and entrepreneurs as innovative as can be discovered anywhere and a society that has allowed countless migrants to achieve some version of the California dream.

But in this region, the dream itself is undergoing testing and change. Philosopher Stan Dundon summed up the findings of the 1986 California Academy of Sciences' symposium *Heartland in Transition* this way: "Awareness of new, environmentally sensitive agricultural technologies and an explicit concern for equity in the interest of Valley residents" may allow guidance of future agricultural impact "to provide both an environmentally and humanely better outcome." However, "short range economic market forces will remain the dominant determinant in the future of the Valley," thus remaining the major constraint *against* sustainable agriculture and, potentially, against an improved social and economic environment for residents. Given adequate political will and openness to change, however, many of the short-term demands may be met and a lower-impact sustainable kind of farming introduced.

Perhaps it is time to grow more farms and somewhat less short-term produce. Certainly it is time to shed the nineteenth-century delusion that more—more acres of land, more acre-feet of water, more lugs of rubber tomatoes—is inevitably better. Big agribusiness in this region has the resources, both financial and intellectual, to move toward less damaging, more enduring methods of farming—but businesspeople must believe, for instance, that it is not absolutely necessary to spread thirty tons of pesticide on these fields each year. Old ways of thinking do die hard, and no corporation makes expansive and expensive changes casually.

Nonetheless, if the quality of life that has made the Valley a fine place to live and raise one's family is not to be lost, then local people must look at the larger picture. Do they *really* want to dwell in suburbs indistinguishable from those in the Santa Clara Valley or the San Fernando Valley? Do they *really* want family farming entirely replaced by corporate agriculture? Do they *really* believe that immediate profits compensate for cancer clusters and poisoned wells? Dundon suggests that participation in planning and research by farmers who are committed to this place "may be the most important factor in reconciling the various factors affecting the future of the Valley." In fact, all local residents should participate for, although corporate boards elsewhere may control the deeds to much land here, they do not know the call of a dove or the chill of river water slicing from the Sierra Nevada or the dawn smell of a freshly mown alfalfa field.

This final point is vital: deliberations concerning the Valley's future should be made by all those whose lives will be most directly affected—the shoemaker in Chico and the field foreman in Edison—not only the lobbyist in Sacramento. Effective change cannot be exclusively the domain of theorists, of technocrats, of corporate executives or their "house" politicians, but must include representative elements of entire communities. However, the expansion of possible alternatives for the future is, as Dundon points out, "a principal responsibility of research institutions."

The Valley now boasts eight colleges and universities, and they, along with other, less proximate institutions, have been producing native-born scholars deeply concerned with the future of this area; the generations for whom Brewer feared have increasingly contributed to a body of knowledge that may allow the heartland to continue as an economic and social force. Local folk, farmers and others, have the toughness, the inventiveness, the spirit to deal with their problems, but first they must face them squarely, casting aside old, obscuring illusions and

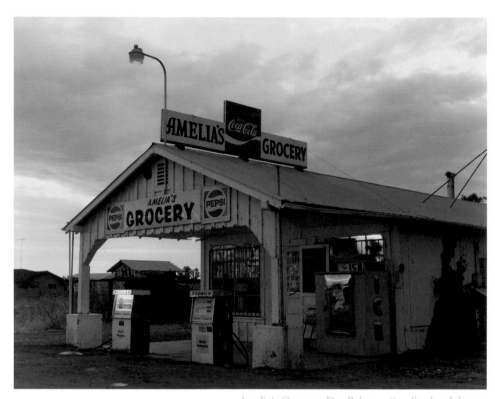

Amelia's Grocery, Dos Palos, 1985. Stephen Johnson.

prejudices. "We're so parochial. We want to live in our own little world," admits Aldo Sansoni. "Everybody else is wrong. No one else's problem is our problem….We on the farms and those folks in the cities need each other. We've got to stop viewing each other as enemies." And, of course, most Valley folk dwell in urban settings.

But it is not enough merely to think in terms of a rapprochement between growers and their urban markets. Agriculture is an international business, and Valley farmers produce quantities of food and fiber that exceed the demands of domestic markets. "Consequently," points out J. B. Kendrick, Jr., long-time chief of Agriculture and Natural Resources at the University of California, "for economic survival, it is imperative that our major crops and many of our specialty commodities find receptive and rewarding foreign markets." Productivity—and thus competition—is rising worldwide, but so is population, so is hunger. Kendrick goes on to caution that, in order for U.S. agriculture to remain competitive in the international trade environment, "it must continually improve its productivity and its efficiency."

Catch-22 is that "efficiency" has traditionally been interpreted in the Valley to mean bigger, more concentrated holdings and fewer family farms, along with more and more technology. "The trend toward larger-scale farming is often justified on the grounds that it is more efficient," Richard Smoley agrees. "Small is not always inefficient," Chuck Geisler of Cornell University argues. "Many inefficiencies in the large end of the production scale don't get reported….They may be energy inefficiencies, labor inefficiencies, environmental trade-offs."

Finally, Dundon's suggestion that Valley dwellers themselves must decide what they want. Do they prefer family farms with somewhat reduced production but longer productive lives, for example, or greater concentrations of land and power in the hands of a few, with greater short-term production? Local folk must determine which and live with the society that results.

Residents complain that outsiders too often focus on negative aspects of Valley life in general, and agriculture in particular, while those who study the region complain that locals prefer to wear blinders. Thus, for example, two recent books by outsiders have railed against the physical and political dangers of irrigation in the area without acknowledging the positive aspects of life here; thus, too, many locals railed against "outside agitators" and "communists" when farm labor was being organized here, ignoring the patterns of agricultural peonage that actually predicated the disruption.

Today, the issues cannot be avoided. If they are, Valley residents will by default end up with what outsiders—politicians from elsewhere or corporate executives—prefer. The blinders must be removed, justifiable criticism must be considered, and important decisions must be made. Solutions for a great many contemporary problems of both farm and town lie in progressive, creative modes of thought here, not in the insistent hope that technologists will save the day.

Francis DuBois is chairman of an eight-family cooperative that cultivates 6,000 acres in the Sacramento Valley. His credo defies stereotypes of Valley growers and illustrates the quality of mind that is now necessary and, happily, available. "Though we farmers, or our banks, own the farmland," he points out, "we are in truth only custodians of it. We hold it in trust for future generations and we must not exploit it, erode it, poison it, bury it, nor may we violate the rights, dignity, welfare and friendship of those who together with us farm this most productive of all the valleys in the world."

It is also important to recognize that no other region of our state—perhaps of our nation—better illustrates the cherished and enduring illusion that ours is a land of yeoman farmers, cultivators of the soil who draw strength from the earth itself. Here we have created what Henry Nash Smith identified in *Virgin Land* as "The Garden of the World": "The master symbol of the garden embraced by a cluster of metaphors expressing fecundity, growth, increase, and blissful labor in the earth, all centering about the heroic figure of the idealized frontier farmer armed

Sustainable Agriculture

The goals underlying the concepts of sustainable agriculture are to adopt practices that are environmentally sound, economically viable, fair, and humane. There are seven broad areas which must be addressed in order to meet these goals.

1. **Rural Communities.** Increasing farm size and absentee and corporate land ownership diminish rural community life. The need to promote and sustain rural communities was identified as necessary to provide equitable living environments for farmers, farmworkers, and their families, and for the continuation of farming wisdom and traditional values.

2. **Transition Support.** Making the transition to sustainable practices will require support for development of information, training, and apprenticeship programs, and economic incentives such as tax forgiveness to ease financial stress on new and transitional farmers.

3. **Consumer Values.** If consumers understand the improved quality of the food supply of sustainable production (reduced pesticides, improved nutrients), they will be more willing to pay prices that reflect the true cost of production.

4. **Land Ethics and Animal Rights.** The humane treatment of farm animals and stewardship of the land are intrinsic to the recognition of the gifts of nature, intrinsic to sustainable systems. Leaving these gifts in better condition than when they were received is part of sustainability.

5. **Expanded Knowledge.** Demonstration farms, farmer-to-farmer field tours, and studies of successful alternative farms of all sizes are needed to speed adoption of sustainable practices. Redirection of university teaching, research and extension toward understanding whole farm ecology and away from chemical dependence in farm management is needed.

6. **Government Support.** Redirection of government support, such as subsidies, grants, and loans, away from concentrated corporate interests and toward fair returns to farmers is needed to convert significant portions of industrial agriculture to a sustainable system.

7. **Global Community.** The present global agriculture trade is placing unnecessary pressures on the sustainability of the earth's resource base. The United States could assert a leadership role by restricting trade in dangerous substances and encouraging international programs like AID, the World Bank, and research institutions to adopt sustainable programs.

—Summary of the "Asilomar Declaration for Sustainable Agriculture," drafted by leaders in the field of alternative agriculture and approved at the 1990 Ecological Farming Conference, January 9–12.

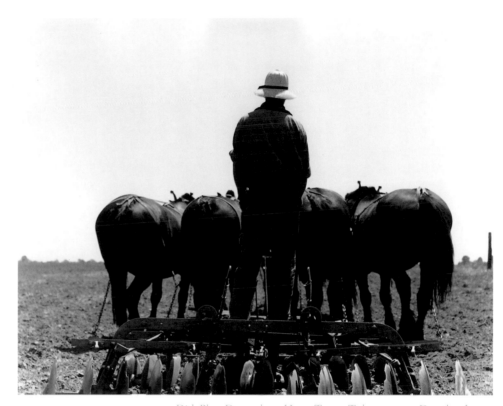

Disk Plow Drawn by 7-Horse Team, Tulare, 1937. Dorothea Lange.

with that supreme agrarian weapon, the sacred plow." In the Great Central Valley today, many farmers face the frontier of the boardroom and drive the sacred Cadillac, while *campesinos* do the plowing. Others, meanwhile, struggle to retain family farms, exhausting their bodies for the mystical intimacy with the soil that personal farming retains, and they do so despite conditions little more promising than those faced by Ishi. "In 1982, 4% of the farms that harvested crops—those of 1,000 acres or more—brought in 56% of the harvest," Katharine Ulrich points out. That leaves a slim gleaning for the other 96% who farm in the Valley.

This is a land of paradox, full of friendly people whose sudden xenophobia can shock. Its open spaces lull those who do not realize that those straight irrigation rows and neat white houses starkly demonstrate the impulse to harness nature. Moreover, to the classic tension between the natural and the artificial, a third element is added here: the introduced. Despite increased urbanization, most of the Valley is covered not by plastic or concrete but by vegetation imported from elsewhere. Native grasslands are gone from this great, enclosed prairie, and so are most of the riverine forests and the wetlands, as well as many of the animals that lived in those habitats. Gone too are most of the Yokuts, the

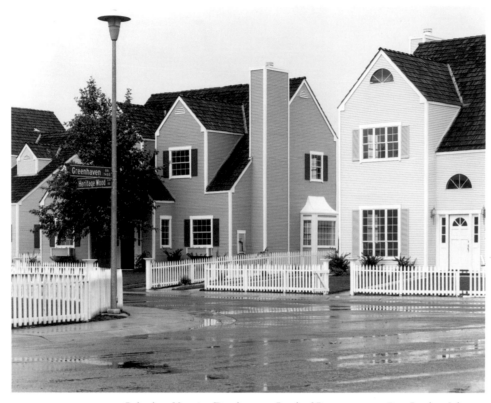

Suburban Housing Development South of Sacramento, 1983. Stephen Johnson.

Miwok, the Wintun, and the Maidu. But the soil remains—the soil, the water, the sunlight, those and the people who still migrate here searching for the cusp of the future.

That future may be urban now that the Valley is the fastest growing section of the state. Sacramento, Stockton, Redding, Modesto, Fresno, Chico, and Bakersfield, once considered sleepy Valley towns, are cities surrounded by suburbs that are in turn swallowing farmland. "William Saroyan's quiet home town will exceed the size of San Francisco by the century's end," Frank Viviano points out. To accomplish such dynamic and rapid growth, rich agricultural acreage is being covered with stucco houses and shopping malls, which in turn leads to marginal land being irrigated and plied with chemicals. But the amount of even marginal land available is finite, and K. Patrick Conner is correct when he writes:

> *Urbanization—or, more properly, suburbanization—now constitutes the single greatest threat to the Central Valley. For example, between 1976 and 1981, more than 50,000 acres of prime agricultural land was lost forever to urban development. Each day, new fields are being paved over.*

The old vaquero Arnold Rojas, who lived in this Valley for three-quarters of a century, saw things clearly: "Some day," he advised, "we will have to plow up the malls to plant something we can eat."

Increasing urbanization is not necessarily the principal force for change in the Valley, let alone the region's major dilemma—not with salinization, toxicity, soil erosion, land subsidence, racism, economic inequity, farm foreclosures, these and a host of other issues also pressing—but it is visible and undeniable and in many places illustrates the lack of substantive, long-range planning that has caused most of this vulnerable region's other problems. For instance, still another difficulty is looming because there will be fewer agricultural jobs for future migrants if the development of more and more automated technology in farming continues.

Nonetheless, migrants continue to stream in, and one-time migrant, poet Wilma Elizabeth McDaniel, reflects that social reality in "Old Neighbor Reports on a Trip to Merced":

> *Everything has changed*
> *he lamented*
> > *nothing like the old Merced*
> > *drive out any direction*
> > *all the new houses*
> > *big air base at Winton*
> > *strange faces*
>
> *Oh, now and then you will see*
> > *an old Portugee ranch*
> > *with a tankhouse*
> > *and pomegranate bushes*
> > *in the yard*
> > *but don't expect it to be the*
> > *same*
>
> *and all them little kids playin'*
> > *in the dust*
> > *ain't Okies now*
> > *they call 'em boat people*

Forty years ago, Floyd Renfrow was an Okie child playing in the dust, and he understands well what it means to have remained in the Valley and made both a living and a way of life in that dust. "You know," he says in the parking lot of one of the grocery stores he now owns in Bakersfield, "my folks didn't have much whenever they came out here, but they worked real hard and saw us kids through school. It's been a real good place to live and raise my own family, a real neighborly place. I like this old Valley."

Tulare Dust, Western Tulare County, 1986. Robert Dawson.

View of the City of Stockton, 1854. Alburtus del Orient Browere. Oakland Museum.

For well over a century, this old Valley has been plowed and irrigated and chemically infused to produce crop yields unimagined by the most optimistic of the region's early settlers. It has developed communities with opportunities and problems beyond the ken of the most prescient of its original boosters. Fields that once grew native bunchgrass now sprout mylar ribbons waving from short wooden stakes, those and the remains of trees strewn over what was once an orchard like bodies across a cratered battlefield—casualties in the intensifying combat between a growing population and a finite expanse of land.

This is not a static place. As new folks move in and as old folks recognize new realities, there is growth in awareness and in action. The recognition that flood irrigation may no longer be best, that chemical farming may do more harm than good, that other forms of agriculture may in fact offer viable alternatives to industrial farming, all these illustrate hopeful developments, as does activism of all sorts; not long ago, for instance, local growers sent 2,500 fruit trees to farmers in drought-ravaged Ethiopia. The development of coalitions such as the Central Valley Safe Environment Network is especially hopeful, for it reveals an expanded awareness of regional issues. As John Latta, a Merced County rancher, suggests, "I think all farmers have to be environmentalists if they're going to survive on the land. You have to know what makes it viable. When the wildlife goes away, you're going to be gone pretty soon, too." According to recent estimates, only 4% of the Valley's original wildlife habitat remains, and groups like the Nature Conservancy, Ducks Unlimited, California Trout, and the Sierra Club are trying to save it.

Based on his observations in the 1860s, William Henry Brewer was dubious about the Valley's cultural future, but it has—in spite of the continued enormous economic gap between haves and have-nots—allowed generations of poor migrants to achieve economic stability and to open up a world of wider horizons for their children. Kids of various colors wander barefooted over this rich soil and these paved streets, frequently together, with an easy multi-ethnicity uncomfortable to their elders; they still wing clods at one another, still gaze silently at dust devils dancing across the horizon, still plunge naked into irrigation ditches.

Many will indeed pursue possibilities unimagined by their parents—many will dream new dreams. And those dreams, with their power to expand not only the region's but the world's artistic or scientific or moral boundaries, those dreams, not three hundred varieties of produce or ubiquitous shopping malls, are the Great Central Valley's most vital crop.

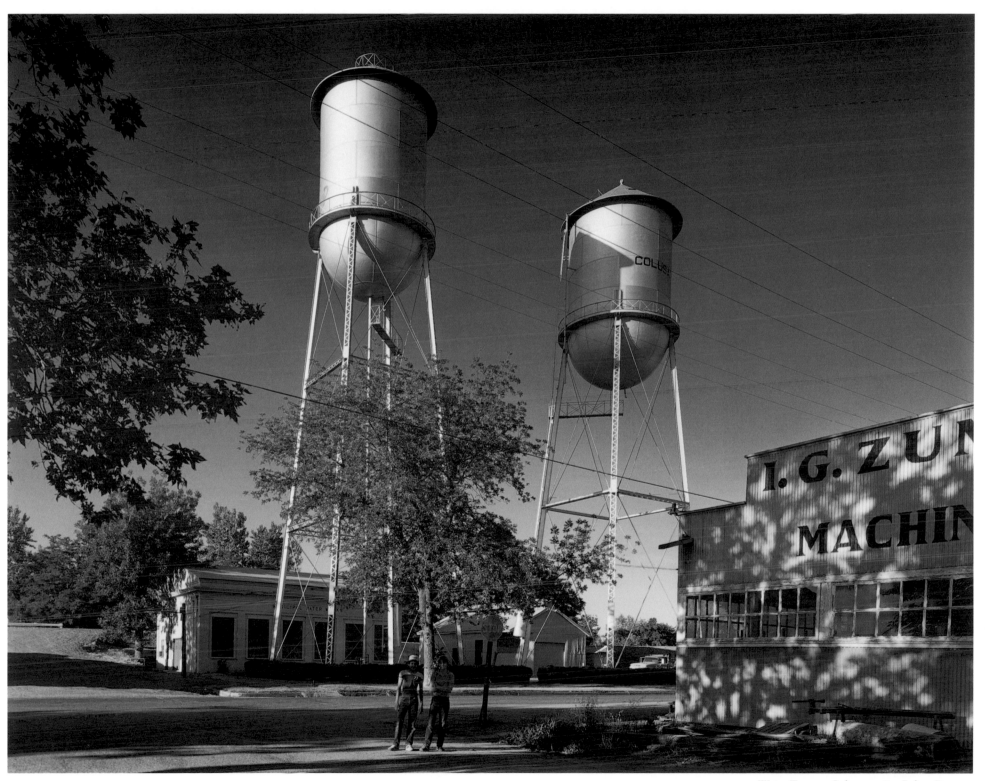

Water Towers, Colusa, 1984. Robert Dawson.

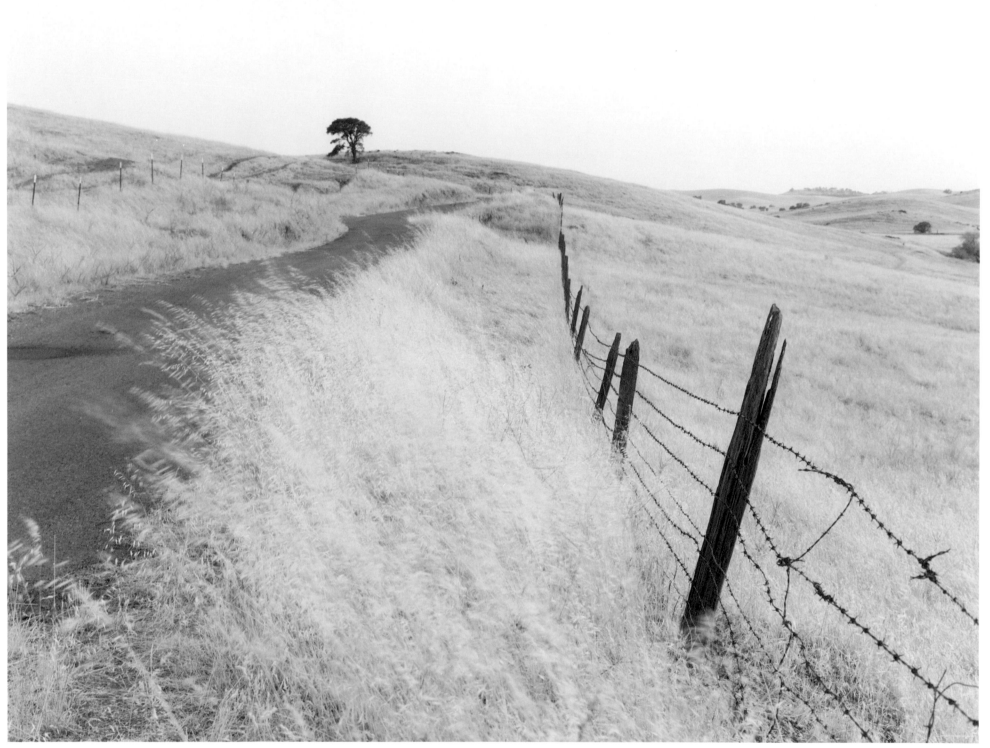

White Rock Road, Mariposa County, 1984. Stephen Johnson.

Epilogue

Summary 1986: A Journey

Late as usual, we are speeding east on Interstate 80 over the low pass near Vacaville toward a turnoff that will take us to Woodland and a family reunion. From our air-conditioned car, we view grass already more charred than dry, oaks dark against tan slopes, range cattle near tanks, and, as we crest, houses—rows and rows of houses.

"Why did I have to come?" complains our thirteen-year-old son.

"Because it's a family reunion and you're in the family."

"Great," he hisses with the bitterness peculiar to abused teens.

Already stressed, I bite my lip, wait, allow quick anger to pass. Then I explain: "Your great-grandmother was born on the farm there—my dad's mother. She died in the great flu epidemic of 1918, but Woodland's where the Martins live and we're Martins."

No reply. I'm driving us east, but we can't see the Sierra Nevada ahead because that range is hidden by summer smog. From the radio, we hear it is an agricultural burn day. A few minutes later, before reaching Davis, I veer our automobile north on Route 505, and the Sacramento Valley's heated prairie opens before us, shimmering as though soaked in perspiration. On the road directly ahead dashes a mirage—the shining pond unreachable, untouchable: like the Valley itself, we pursue the illusion of water.

"I still don't see why…," he groans.

After pausing, I try another tack. "When you see that farm, that town, when you feel them, that's your history and mine and Grandpa's. We're not just going some place, we're going into our own past."

It is just occult enough an explanation to quiet him, but a moment later our eighteen-year-old twins are giggling. "What's wrong?" asks my wife.

"Just dad," explains one, "he can make anything sound so weird."

"He likes to," the other agrees. "Dad's putting you on," she assures her younger brother.

This time I laugh. Those are, after all, my own genes speaking. But what they don't know, not yet at least, is that my explanation is from the heart.

Squinting ahead toward late-morning sun, the day still heating, I say nothing more, only smile, strangely relaxed after turning the car right onto a county road and beginning that final stretch through languid orchards toward a grandmother I never knew and a past as certain as flesh and breath and the towering trees of Woodland.

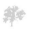

INTRODUCTORY SECTION

1. CANAL NEXT TO SAN JOAQUIN RIVER 20X24
 Type C print, 1984
 Stephen Johnson

2. MODESTO SIGN 20X24
 Gelatin-silver print, 1986
 Robert Dawson

3. KETTLEMAN PLAIN, KINGS COUNTY 16X20
 Type C print, 1983
 Stephen Johnson

4. WILDFLOWERS AND ORCHARD, BRENTWOOD 11X14
 Type C print, 1985
 Stephen Johnson

5. SACRAMENTO VALLEY FROM 60,000 FEET 20X20
 LOOKING NORTH OVER THE SUTTER BUTTES
 Gelatin-silver print, 1968
 Courtesy United States Geological Survey

6. SUMMER CORN, TYLER ISLAND 16X20
 Type C print, 1983
 Stephen Johnson

7. DELTA FARM, SACRAMENTO RIVER 11X14
 Gelatin-silver print, 1984
 Robert Dawson

8. RAILROAD TRACKS AND LANDCUTS, 11X14
 ALTAMONT PASS
 Gelatin-silver print, 1982
 Robert Dawson

9. WHEAT STUBBLE 16X20
 Gelatin-silver print, 1984
 Robert Dawson

HISTORICAL SECTION

10. VIEW OF AN INDIAN RANCHERIA, YUBA CITY 4X5
 Printed material, circa 1850
 Artist unknown
 Courtesy California State Library

11. THE EXTERMINATION OF WILD GEESE 5X7
 COLUSA COUNTY
 Printed material, 1882
 Frank Leslie's Illustrated Newspaper
 Courtesy California Historical Society

12. SACRAMENTO CITY WATERFRONT 4X5
 Printed material, 1855-56
 Artist unknown
 Courtesy California State Library

13. LAYING TRACK, 6X9
 WP RAILROAD NEAR OROVILLE
 Gelatin-silver print, circa 1909
 Photographer unknown
 Courtesy California State Library

14. RABBIT DRIVE, KERN COUNTY 6X9
 Gelatin-silver print, circa 1915
 Photographer unknown
 Courtesy California State Library

15. GILBERT RANCH, CHICO 8X10
 Gelatin-silver print, circa 1900
 George G. Collom
 Courtesy California Historical Society

16. HORSEDRAWN HARVESTER, 6X9
 RANCH NEAR BIGGS
 Albumen print, 1885-90
 Photographer unknown
 Courtesy California State Library

17. SACRAMENTO VALLEY 6X3
 Engraving, circa 1905
 Courtesy California State Library

18. BUILDING THE LEVEE, 4X5
 SOUTH OF SACRAMENTO
 Gelatin-silver print, circa 1900
 Photographer unknown
 Courtesy California State Library

19. WOMEN PACKING RAISINS, FRESNO COUNTY 5X5
 Gelatin-silver print, circa 1915
 Photographer unknown
 Courtesy California Historical Society

20. OIL WORKERS AND OILFIELDS, COALINGA 5X20
 Gelatin-silver print, 1911
 Courtesy of Dave Woods, Maricopa Market

21. GUSHER AND OIL WELLS NEAR TAFT 10X8
 Gelatin-silver print, circa 1912
 Photographer unknown
 Courtesy of Dave Woods, Maricopa Market

22. IRRIGATING, STANISLAUS COUNTY 8X10
 Gelatin-silver print, circa 1920
 Photographer unknown
 Courtesy California Historical Society

23. AZEVEDO HOME NEAR SACRAMENTO 8X10
 Gelatin-silver print, circa 1920
 Photographer unknown
 Courtesy California Historical Society

24. CHOWCHILLA SIGN 4X5
 Gelatin-silver print, 1913
 Courtesy California State L:ibrary

25. PICKING WILDFLOWERS 4X5
 Gelatin-silver print, 1937
 Courtesy California State L:ibrary

26. POSTCARD, FRESNO COUNTY 4X5
 Printed material, circa 1900
 Courtesy California State L:ibrary

27. CALIFORNIA OIL WELLS NEAR COALINGA 4X5
 Printed material, 1909
 Courtesy California State Library

28. LOADING GRAPES, RIPON 4X5
 Gelatin-silver print, circa 1915
 Courtesy California State Library

29. HOLT CATERPILLAR TRACTOR FACTORY, 4X5
 STOCKTON
 Gelatin-silver print, 1915
 Courtesy California State Library

30. CALIFORNIA CORNUCOPIA 10X8
 Printed poster, circa 1900
 Artist unknown
 Courtesy California Historical Society

31. WAREHOUSE, FRESNO 8X10
 Gelatin-silver print, circa 1917
 Photographer unknown
 Courtesy California State Library

32. ACRES OF BARRELS OF GREEN OLIVES, 8X10
 LINDSEY, TULARE COUNTY
 Gelatin-silver print, circa 1930
 Photographer unknown
 Courtesy California Historical Society

33. BEAN THRESHER 8X10
 Gelatin-silver print, 1936
 Dorothea Lange
 Courtesy Farm Security Administration

34. DISK PLOW DRAWN BY 7-HORSE TEAM, 8X10
 TULARE
 Gelatin-silver print, 1937
 Dorothea Lange
 Courtesy Farm Security Administration

35. COMPANY HOUSING 8X10
 FOR MEXICAN COTTON PICKERS
 Gelatin-silver print, 1938
 Dorothea Lange
 Courtesy Farm Security Administration

36. COTTON FARMER, KERN COUNTY 8X10
 Gelatin-silver print, 1938
 Dorothea Lange
 Courtesy Farm Security Administration

37. CAMP OF TWO FAMILIES, HIGHWAY 99 8X10
 Gelatin-silver print, 1939
 Dorothea Lange
 Courtesy Farm Security Administration

38. THERMALITO MAP 32X45.5
 Printed poster, circa 1912
 Courtesy California State Library

39. BAKERSFIELD MAP 32X45.5
 Printed poster, 1901
 Courtesy California State Library

40. FRUIT AND VEGETABLE BOX LABELS (16) 4X8
 Printed material
 Courtesy California Historical Society

WATER

41. SAN LUIS RESERVOIR 11X14
 Type C print, 1978
 Stephen Johnson

42. FRIANT DAM, SAN JOAQUIN RIVER 11X14
 Gelatin-silver print, 1983
 Robert Dawson

43. SPILLWAY, LAKE BERRYESSA 11X14
 Gelatin-silver print, 1986
 Robert Dawson

44. KERN RIVER 11X14
 Type C print, 1985
 Stephen Johnson

45. THREE MILE SLOUGH BRIDGE 11X14
 NEAR RIO VISTA
 Gelatin-silver print, 1986
 Robert Dawson

46. STANISLAUS RIVER, CASWELL STATE PARK 11X14
 Type C print, 1985
 Stephen Johnson

47. DELTA DRAWBRIDGE, THREE MILE SLOUGH 11X14
 Type C print, 1985
 Stephen Johnson

48. YANKEE SLOUGH NEAR RIO OSO 11X14
 Gelatin-silver print, 1984
 Robert Dawson

49. IRRIGATION WORKS, 11X14
 SACRAMENTO RIVER, BRODERICK
 Type C print, 1985
 Robert Dawson

50. LAKE KAWEAH 11X14
 Type C print, 1985
 Stephen Johnson

51. WIND GAP PUMPING STATION, 11X14
 CALIFORNIA AQUEDUCT, KERN COUNTY
 Type C print, 1985
 Stephen Johnson

52. FLOOD, SACRAMENTO RIVER NEAR REDDING 11X14
 Type C print, 1985
 Robert Dawson

53. DISCOVERY PARK, SACRAMENTO 16X20
 Gelatin-silver print, 1985
 Robert Dawson

WEALTH

54. PACKING SHED, NEWMAN 11X14
 Type C print, 1984
 Stephen Johnson

55. COTTON FIELD NEAR FIVE POINTS 11X14
 Type C print, 1985
 Robert Dawson

56. OIL WELL NEAR MCKITTRICK, KERN COUNTY 11X14
 Gelatin-silver print, 1983
 Stephen Johnson

57. ABANDONED VINEYARD, KERN COUNTY 11X14
 Type C print, 1985
 Stephen Johnson

58. RICE MILL, WOODLAND 16X20
 Type C print, 1985
 Robert Dawson

59. INDUSTRIAL PARK, LINCOLN 11X14
 Type C print, 1985
 Stephen Johnson

60. CAPAY FIELD
Gelatin-silver print, 1982
Stephen Johnson
11X14

61. SHERMAN ISLAND, SACRAMENTO DELTA
Gelatin-silver print, 1982
Robert Dawson
11X14

62. WALNUT ORCHARD NEAR BEAR RIVER,
YUBA COUNTY
Type C print, 1984
Stephen Johnson
11X14

63. SOIL AND STUBBLE NEAR YETTEM
Type C print, 1985
Robert Dawson
16X20

64. COTTON RAILROAD CARS, BUTTONWILLOW
Type C print, 1985
Robert Dawson
11X14

65. GRAPES AND PALMS, RIPON
Type C print, 1983
Stephen Johnson
11X14

66. CATTLE, HILMAR, MERCED COUNTY
Type C print, 1986
Stephen Johnson
11X14

67. COURTLAND
Gelatin-silver print, 1985
Robert Dawson
11X14

68. FRUITSTAND #33, NEWCASTLE
Type C print, 1985
Stephen Johnson
16X20

CONTENTMENT

69. YARD, WHITE ROCK ROAD, LE GRAND
Gelatin-silver print, 1985
Stephen Johnson
11X14

70. MAIN STREET, CERES
Type C print, 1986
Stephen Johnson
11X14

71. HUB BARBER SHOP, VACAVILLE
Type C print, 1984
Robert Dawson
11X14

72. YETTEM
Type C print, 1985
Stephen Johnson
11X14

73. RIPARIAN WOODS, SACRAMENTO RIVER
Gelatin-silver print, 1984
Stephen Johnson
16X20

74. DUSK, TRANQUILLITY
Type C print, 1985
Stephen Johnson
11X14

75. RIPARIAN FOREST, LAKE OF THE WOODS
Gelatin-silver print, 1984
Robert Dawson
11X14

76. JOHNNIE, MERCED
Gelatin-silver print, 1975
Stephen Johnson
11X14

77. BRODERICK
Gelatin-silver print, 1977
Robert Dawson
11X14

78. CHINESE TREES OF HEAVEN,
MERCED COUNTY
Gelatin-silver print, 1983
Robert Dawson
11X14

79. ROADSIDE, MANTECA
Type C print, 1983
Stephen Johnson
11X14

80. SUTTER BUTTES
Gelatin-silver print, 1985
Robert Dawson
11X14

81. COWTRAILS NEAR BRENTWOOD
Gelatin-silver print, 1983
Stephen Johnson
11X14

82. BACKLOT, ISLETON
Type C print, 1986
Robert Dawson
16X20

83. FARMINGTON RESERVOIR
Gelatin-silver print, 1982
Robert Dawson
11X14

84. TEX'S USED CARS AND TOWING
NEAR CARUTHERS
Type C print, 1986
Robert Dawson
11X14

85. CANAL, NEXT TO TULARE LAKE
Type C print, 1985
Robert Dawson
11X14

86. RANCHO MURIETA AND RANCHO SECO
Gelatin-silver print, 1986
Robert Dawson
11X14

HEALTH

87. CANAL, TULARE LAKE
Type C print, 1985
Stephen Johnson
11X14

88. TOMATO HARVEST NEAR DIXON
Type C print, 1984
Robert Dawson
11X14

89. FENCE AND BURNLINE, ALTAMONT PASS
Gelatin-silver print, 1982
Robert Dawson
11X14

90. TURKEY RANCH, STANISLAUS COUNTY
Gelatin-silver print, 1986
Stephen Johnson
11X14

91. KESTERSON PONDS,
TERMINUS OF SAN LUIS DRAIN, MERCED COUNTY
Gelatin-silver print, 1986
Stephen Johnson
16X20

92. DESERT, MCKITTRICK
Type C print, 1983
Stephen Johnson
11X14

93. GROUNDWATER PUMP NEAR ALLENSWORTH
Gelatin-silver print, 1984
Robert Dawson
11X14

94. USED CANS, CROP-DUSTING AIRSTRIP,
NEWMAN
Type C print, 1984
Stephen Johnson
11X14

95. ASPARAGUS PLANTERS NEAR TRACY
Gelatin-silver print, 1983
Stephen Johnson
11X14

96. CORPORATE FARM NEAR BAKERSFIELD
Gelatin-silver print, 1984
Robert Dawson
11X14

97. STORAGE BINS, CORCORAN
Gelatin-silver print, 1984
Robert Dawson
11X14

98. SAN LUIS DRAIN,
KESTERSON NATIONAL WILDLIFE REFUGE
Gelatin-silver print, 1985
Robert Dawson
16X20

99. CALIFORNIA AQUEDUCT NEAR TRACY
Type C print, 1984
Stephen Johnson
11X14

100. FLOODED ORCHARD NEAR MANTECA
Gelatin-silver print, 1982
Robert Dawson
11X14

ADDITIONAL GROUPINGS

101. WATERWORKS,
MOUTH OF KERN RIVER CANYON
Gelatin-silver print, 1986
Stephen Johnson
8X10

102. KERN RIVER
Albumen print, 1888
Carleton Watkins
Courtesy Library of Congress
8X10

103. DUSK, OILDALE
Gelatin-silver print, 1983
Stephen Johnson
8X10

104. DAWN, OILDALE
Gelatin-silver print, 1985
Robert Dawson
8X10

105. JAMES RANCH, KERN COUNTY
Albumen print, 1888
Carleton Watkins
Courtesy Library of Congress
8X10

106. SHEEP SHEARING, SAN EMIGDIO RANCH,
KERN COUNTY
Albumen print, 1888
Carleton Watkins
Courtesy Library of Congress
8X10

107. BUENA VISTA FARM,
HORSE-DRAWN IRRIGATION, KERN COUNTY
Albumen print, 1888
Carleton Watkins
Courtesy Library of Congress
8X10

108. INDIAN RANCHERIA, TEJON RANCH,
KERN COUNTY
Albumen print, 1888
Carleton Watkins
Courtesy Library of Congress
8X10

109. ARTESIAN WELL, KERN COUNTY
Albumen print, 1888
Carleton Watkins
Courtesy Library of Congress
8X10

110. CALLOWAY CANAL, KERN COUNTY
Albumen print, 1888
Carleton Watkins
Courtesy Library of Congress
8X10

111. MERCED COUNTY
Gelatin-silver print, circa 1915
Frank Day Robinson
Courtesy Docherty/Day Collection
8X10

112. MERCED COUNTY
Gelatin-silver print, circa 1915
Frank Day Robinson
Courtesy Docherty/Day Collection
8X10

113. MERCED COUNTY
Gelatin-silver print, circa 1915
Frank Day Robinson
Courtesy Docherty/Day Collection
8X10

114. SAN JOAQUIN RIVER
Calotype print, circa 1873
Thomas Moran
4X5

Selected Bibliography

Abrams, Richard. "Residents Take Last Stand in Oil-Patch Company Town." *Sacramento Bee*, March 6, 1988, A3, 5.

Anderson, Walter Truett. "A Bumper Crop of Bedrooms Crowds the Central Valley." *This World*, March 18, 1990, 22.

Austin, Mary. *The Land of Little Rain*. Boston: Houghton Mifflin Company, 1903.

Bailey, Richard. *Heritage of Kern*. Bakersfield: Kern County Historical Society, 1957.

Bakker, Elna. *An Island Called California: An Ecological Introduction to Its Natural Communities*. Berkeley: University of California Press, 1972.

Barry, W. James. *The Central Valley Prairie*. Sacramento: Department of Parks and Recreation, 1972.

Batman, Richard. *The Outer Coast*. New York: Harcourt Brace Jovanovich, 1985.

Bean, Walton, and James J. Rawls. *California, An Interpretive History*. New York: McGraw-Hill, 1983.

Beck, Louis A. "Case History: San Joaquin Valley." *California Agriculture* 38, no. 10 (October 1984): 16–17.

Beitiks, Edwins. "City with a Shriveled Image." *San Francisco Examiner*, November 16, 1986, A1, 20.

Bidwell Mansion State Historic Park. Sacramento: Department of Parks and Recreation, 1974.

Biggar, James W., Dennis E. Rolston, and Donald R. Nielsen. "Transportation of Salts by Water." *California Agriculture* 30, no. 10 (October 1984): 10–11.

——— "Effects of Salt on Soils." *California Agriculture* 30, no. 10 (October 1984): 11–13.

Birmingham, Stephen. *California Rich*. New York: Simon and Schuster, 1980.

Bohakel, Charles A. *The Historic Delta Country*. Antioch, Calif.: Charles A. Bohakel, 1979.

Boyd, Vicky. "NRC Panel Criticizes Recently Released SJV Drainage Report." *Ag Alert*, Oct. 25, 1989, AA5N.

Boyd, W. Harland. *A California Middle Border: The Kern River Country, 1772–1880*. Richardson, Tex.: Havilah Press, 1972.

Brandon, William. *The Indian Historian* 4, no. 2 (Summer 1971).

Brank, Glen. "Ag Workers Feel Victimized by Cancer System." *Sacramento Bee*, February 17, 1991, I1, 3.

——— "The Rural Poor Suffer from Lack of Health Care." *Sacramento Bee*, February 17, 1991, I1, 4.

Brazil, Eric. "Another Battle over Delta Water." *San Francisco Examiner*, September 4, 1988, B1, 4.

——— "Bakersfield Reels as Oil Prices Dive." *San Francisco Examiner*, February 17, 1987, A1, 5.

——— "Visalia's Nerve Keeps Paying Off." *San Francisco Examiner*, February 17, 1987, A1, 10.

Brewer, William Henry. *Up and Down California in 1860–1864*. Edited by Francis P. Farquhar. New Haven: Yale University Press, 1930. 3d ed. Berkeley: University of California Press, 1966.

Brown, Ethan. "Riparian Rescue." *California Nature Conservancy Newsletter*, Winter 1990, 1–2.

Brown, Walton John. *Portuguese in California*. San Francisco: R. and E. Research, 1972.

"Buck-O Turns to Publishing." *Graphic Arts Monthly*, June 1988, 90, 94.

Bryant, William Cullen, ed. *Picturesque America*. New York: D. Appleton and Company, 1872.

Bunch, Lonnie G., III. "Allensworth: The Life, Death and Rebirth of an All-Black Community," *The Californians* 5, no. 1 (November–December 1987): 26–33.

Burmeister, Eugene. *The Golden Empire: Kern County, California*. Beverly Hills: Autograph Press, 1977.

California Agriculture. Special Issue: Salinity in California. Vol. 38, no. 10 (October 1984).

Campbell, Eileen. "Between the Delta and the Deep Blue Sea." *Pacific Discovery* 41, no. 4 (Fall 1988): 8–17.

Carter, Lloyd. "Flyway of Broken Promises." *Bay on Trial*, Summer 1989, 1–3.

——— "Friant Lawsuit Reappears." *Fresno Bee*, February 26, 1989, B1, 6.

Caughey, John, and Laree Caughey. *California Heritage*. Los Angeles: Ward Ritchie Press, 1962.

Caughey, John W., and Norris Hundley, Jr. *California: History of a Remarkable State*. Englewood Cliffs, N.J.: Prentice-Hall, 1982.

Chan, Sucheng. *This Bittersweet Soil: The Chinese in California Agriculture, 1860–1910*. Berkeley: University of California Press, 1987.

Christians, George. *Don't Shoot in the Oilfields Carelessly*. Santa Barbara: Capra Press, 1973.

Clemings, Russell. "Officials Say Time Too Short to Fill All Kesterson Pools." *Fresno Bee*, June 24, 1988, B1, 5.

——— "Pollution Harming Valley Crops." *San Francisco Examiner*, September 3, 1985, B4.

——— "UC Study Urges Ban on Dumping Farm Water into San Joaquin." *San Francisco Examiner*, April 19, 1988, B7.

Community Childhood Hunger Identification Project in California's Central Valley. *Hunger in the Heartland*. Sacramento: California Rural Legal Assistance Foundation, 1991.

Connell, Sally Ann. "And the Children Keep on Dying." *Sunday Punch, San Francisco Chronicle*, June 10, 1990, 3,5.

Conner, K. Patrick. "Dirty Air Robs the Farmer." *This World*, October 19, 1986, 15.

——— "Pawn in the Water Game." *This World*, September 7, 1986, 18–19.

——— "Vanishing Oaks." *This World*, August 31, 1986, 17–18.

——— "Water, Wealth, Contentment, Health." *This World*, July 27, 1986, 10–11.

Cook, Gale. "'Cancer Cluster' Prompts Probes in a Small Town near Bakersfield." *San Francisco Examiner*, July 21, 1985, B3.

Cox, Bob. "Environmentalists, Farmers Link Up to Market Excess Water." *San Francisco Examiner*, July 21, 1987, B4.

Crampton, Beecher. *Grasses in California*. Berkeley: University of California Press, 1974.

Crow, John A. *California as a Place to Live*. New York: Charles Scribner's Sons, 1953.

Cuelho, Art, ed. *Proud Harvest: Writing from the San Joaquin Valley*. Big Timber, Mont.: Seven Buffalo Press, 1979.

Daniel, Cletus E. *Bitter Harvest: A History of California Farmworkers, 1870–1941*. Ithaca: Cornell University Press, 1981.

Darlington, David. *In Condor Country*. Boston: Houghton Mifflin, 1987.

Dasmann, Raymond. *The Destruction of California*. New York: Collier Books, 1965.

Davie, Michael. *California: The Vanishing Dream*. New York: Dodd, Mead, 1972.

Davoren, William T. "Agricultural Wastewater Dumped in Aqueducts." *Bay on Trial*, Summer–Fall 1990, 1, 3–4.

Dawdy, David R. "Comments on Phyllis Fox Appendix 6." Report submitted to State Water Resources Board. n.d.

"Defects Linked to Farm Area." *San Francisco Examiner*, July 7, 1988, A18.

De Roos, Robert. *This Thirsty Land: The Story of the Central Valley Project*. Stanford, Calif: Stanford University Press, 1948.

Dillon, Richard, and Steve Simmons. *Delta Country*. Novato, Calif.: Presidio Press, 1982.

Dundon, Stan J. "On the Cultivation of Morals." *California Farmer*, March 7, 1987, 6–7, 41E.

Durrenberger, Robert. *California: The Last Frontier*. New York: Van Norstrand Reinhold, 1969.

Dyar, Cecil. "The Lakeside Story." *The Plow*, September 1976, 1–4.

Edwards, Leland. "Come in, Sheriff Kay, and Welcome." *Los Tulares*, March 1988, 1–3.

Eisen, Jonathan, and David Fine, with Kim Eisen, eds. *Unknown California*. New York: Collier Books, 1985.

Elias, Solomon P. *Stories on the Stanislaus*. Modesto, Calif.: Self-published, 1924.

Elias, Thomas D. "Use of Pesticide Suspected in Valley 'Cancer Cluster.'" *San Francisco Examiner*, January 25, 1988, B4.

Ely, Ed. "In Defense of the Weakest Link." *Aqueduct* 54, no. 3 (1988): 23–25.

Englebert, Ernest A., with Ann Foley Scheuring, eds. *Competition for California Water: Alternative Solutions*. Berkeley: University of California Press, 1982.

Everson, William. *San Joaquin*. Los Angeles: Ward Ritchie Press, 1939.

Federal Writers' Project. *California: A Guide to the Golden State*. Rev. ed. New York: Hastings House, 1967.

Fernandez, Elizabeth. "Pastor's Slaying Shakes Gays." *San Francisco Examiner*, March 9, 1986, A1, 20.

Ferrell, J. E. "Field Tests of Selenium Plan Begin." *San Francisco Examiner*, July 30, 1987, E1, 2.

——— "Kesterson Plan Could Backfire, Report Reveals." *San Francisco Examiner*, March 23, 1988, A1, 6.

——— "Queen of the Riparian Jungle." *San Francisco Examiner*, April 30, 1986, E1, 4.

——— "Wildlife Might Be Saved by New Process." *San Francisco Examiner*, July 2, 1987, E1, 2.

Flinn, John. "Bay Area Spreads into Valey." *San Francisco Examiner*, July 19, 1987, A1.

——— "Wind Frams Start to Pay Off." *San Francisco Examiner*, January 14, 1990, B1.

Fox, Phyllis. "Average Monthly Delta Outflow." Exhibit 353, State Water Resources Control Board Bay-Delta Hearing, Sacramento, California, July 14, 1987.

——— "Freshwater Inflow to San Francisco Under Natural Conditions." State Water Resources Control Board, Exhibit Number 262, Appendix 2, 1987.

Frame, Walter. "First in the West." *Golden Notes*, April 1969, 1a–19.

Friedman, Roberta. "Strangers in Our Midst." *Pacific Discovery* 41, no. 3 (Summer 1988): 22–30.

Fujimoto, Isao. "The Agricultural Crisis and Local Self-Reliance." Paper presented at the International Symposium on Rice and Self-Reliance, Tokyo, Japan, August 27, 1988.

——— *The Communities of the San Joaquin Valley: The Relations Between Scale of Farming, Water Use, and the Quality of Life*. Sacramento: Community Services Task Force, 1977.

Gavin, Camille, and Katy Leverett. *Kern's Movers and Shakers*. Bakersfield: Kern View Foundation, 1987.

George, Henry. *Progress and Poverty*. New York: Robert Schalkenbach Foundation, 1938.

Gillenkirk, Jeff, and James Motlow. *Bitter Melon: Stories from the Last Rural Chinese Town in America*. Seattle: University of Washington Press, 1987.

——— "This Was Our Place: Memories of Locke." *California History* 66, no. 3 (September 1987): 170–87.

Gilliam, Harold. "California Farming is Digging Its Own Grave." *This World*, April 6, 1986, 15–16.

——— "The Coming Water Revolution." *This World*, April 12, 1987, 16–18.

——— "The Good News Out of Kesterson." *This World*, November 10, 1985, 17–18.

——— "More Sons of the Peripheral Canal." *This World*, April 5, 1987, 15.

——— "Our Plundered Water." *This World*, August 17, 1986, 18.

——— "Will Success Spoil the Central Valley?" *This World*, November 19, 1986, 17–18.

Goldschmidt, Walter. *As You Sow: Three Studies in the Social Consequences of Agribusiness*. Montclair, N.J.: Allanheld, Osmun, 1978.

Gray, Thorne. "Island Water Traps Planned for Delta." *San Francisco Examiner*, July 12, 1987, B1.

Gregory, James N. *American Exodus: The Dust Bowl Migration and Okie Culture in California*. New York: Oxford University Press, 1989.

Griffin, Paul F., and Robert N. Young. *California, The New Empire: A Regional Geography*. San Francisco: Fearon, 1957.

Hammond, Richard, and Nick Zachreson. *The San Joaquin Valley*. Visalia, Calif.: Corralitos, 1979.

Harris, Tom. "U.S. to Pay High Cost of Kesterson Cleanup." *San Francisco Examiner*, April 8, 1987, B1, 9.

Hartman, David N. *California and Man*. Dubuque, Iowa: Wm. C. Brown, 1968.

Haslam, Gerald. "Californians from Everywhere." *This World*, July 5, 1987, 10–12.

——— *Coming of Age in California*. Walnut Creek: Devil Mountain Books, 1990.

——— "Journey to the Center of the State." *California*, May 1987, 58–62, 120.

——— *The Other California: The Great Central Valley in Life and Letters*. Santa Barbara: Capra Press, 1990.

——— *Voices of a Place: Social and Literary Essays from the*

Other California. Walnut Creek: Devil Mountain Books, 1987.

Haslam, Gerald, and James D. Houston, eds. *California Heartland: Writing from the Great Central Valley.* Santa Barbara: Capra Press, 1978.

Hayden, Mike. *Guide to the Sacramento Delta Country.* Los Angeles: Ward Ritchie Press, 1973.

Hedgepeth, Joel W. "Some Comments on the Testimony of J. Phyllis Fox." Unpublished report. September 4, 1987.

Heizer, Robert F., ed. *The Destruction of California Indians.* Santa Barbara: Peregrine Smith, 1974.

Hendrickson, Adele, ed. *Lore of Madera: Through Juniors' Eyes.* Madera, Calif.: Madera Union High School, 1965.

Hendrix, Louise Butts, ed. *Sutter Buttes: Land of Histum Yani.* Marysville, Calif.: Normart Printing Company, 1981.

Hill, Mary. *California Landscape: Origin and Evolution.* Berkeley: University of California Press, 1984.

History of Kern County, California, with Illustrations. San Francisco: Wallace W. Elliot, 1883.

Holland, Robert F., and F. Thomas Griggs. "A Unique Habitat—California's Vernal Pools." *Fremontia* 4, no. 3 (October 1976): 3–6.

Holliday, J. S. *The World Rushed In.* New York: Simon and Schuster, 1981.

Holmstrom, David. "Oil Pioneering in the Golden State." *Exxon USA* 24, no. 3 (Third Quarter 1985): 23–27.

Hornbeck, David, et al. *California Patterns: A Geographical and Historical Atlas.* Palo Alto, Calif.: Mayfield, 1983.

Houston, James D. *Californians: Searching for the Golden State.* New York: Alfred Knopf, 1982.

——— "Looking for the Great Central Valley." *Golden State* 1, no. 2 (Autumn 1984): 38–41.

Howard, John. "Major Water Projects Planned as State's Population Grows." *San Francisco Examiner,* January 3, 1988, B3.

Hutchinson, W. H. *California: The Golden Land by the Sunset Sea.* Palo Alto: Star, 1980.

——— "Forty Years Make a Rearview Mirror." *Chico News and Review,* Fall 1986, 35–36, 38.

Jackson, Wes, Wendell Berry, and Bruce Coleman, eds. *Meeting the Expectations of the Land.* San Francisco: North Point Press, 1984.

Johnson, Stephen, ed. *At Mono Lake.* San Francisco: Friends of the Earth, 1983.

——— "A Visual Artist in Today's Landscape." *California History* 68, no. 4 (Winter 1989/90): 182–187.

Jurmain, Claudia K., and James J. Rawls, eds. *California: A Place, a People, a Dream.* San Francisco: Chronicle Books and The Oakland Museum, 1986.

Kappheim, Joe, and Ed Rice. "Alta Irrigation District." *Los Tulares,* March 1988, 4–6.

Kay, Jane. "And Not a Drop to Drink?" *San Francisco Examiner,* May 19, 1988, C1, 3.

——— "Bass Index Helps Gauge Level of Pollution in Bay." *San Francisco Examiner,* April 6, 1986, B1, 9.

——— "Farmers Pass a Fatal Legacy to Their Chilren." *San Francisco Examiner,* January 18, 1987, A12.

——— "Farm Wastes Target of Tough New Regulations." *San Francisco Examiner,* February 5, 1989, B1, 4.

——— "Runoff." *San Francisco Examiner,* January 18, 1987, A11.

——— "Selenium Finds the Heartland." *San Francisco Examiner,* January 18, 1987, A10, 11.

——— "Toxic Dawn." *Image,* June 14, 1987, 25–29, 36–37.

——— "Toxic Harvest." *San Francisco Examiner,* January 18, 1987, A1, 10.

——— "Toxic Kesterson's Clean-Water Bird Lure: Will It Fly?" *San Francisco Examiner,* March 1, 1987, B1, 4.

Keaton, Diane. "Premium Properties." *California Farmer,* April 4, 1987, 6–7, 30.

Kee, Beryl. "My Memories of the Delano Plains," Part 1. *The Plow,* September 1979, 2–4.

——— "My Memories of the Delano Plains," Part 2. *The Plow,* December 1979, 1–3.

Kelley, Barbara Bailey. "Rockets and Plowshares." *Image,* September 27, 1987, 26–28, 30, 39.

Kelley, Robert L. *Gold vs. Grain.* Glendale, Calif.: The Arthur Clark Company, 1959.

Kelley, Robert L., and Ronald L. Nye. "Historical Perspective on Salinity and Drainage Problems in California." *California Agriculture* 30, no. 10 (October 1984): 4–6.

Kendrick, J. B., Jr. "Reflections and Projections." *California Agriculture* 32, nos. 5–6 (May–June 1986): 2–3.

Kirk, Robin. "The Paving of the Central Valley." *Image,* February 28, 1988, 10–16, 32–33, 36.

Kramer, Mark. *Three Farms: Making Milk, Meat, and Money from the American Soil.* Boston: Little, Brown, 1980.

Kroeber, Alfred. *Handbook of the Indians of California.* New York: Dover, 1976.

Kroeber, Theodora, and Robert Heizer. *Almost Ancestors: The First Californians.* San Francisco: Sierra Club, 1968.

Lantis, David, with Rodney Steiner and Arthur E. Karinen. *California: Land of Contrast.* Dubuque, Iowa: Kendall/Hunt, 1981.

Latta, F. F. *Handbook of Yokuts Indians.* Oildale, Calif.: Bear State Books, 1949.

Latta, Frank F. *Joaquin Murrieta and His Horse Gangs.* Santa Cruz, Calif.: Bear State Books, 1980.

Lavender, David. *California: A Bicentennial History.* New York: Norton, 1976.

Lawbaugh, Penny. "Sounding the Horn of Plenty." *Aqueduct* 53, no. 2 (1987): 10–13.

Lee, Leo. *The Great Central Valley.* Western Public Radio (documentary radio program), 1984.

Leopold, A. Starker, with Raymond F. Dassman. *Wild California.* Berkeley: University of California Press, 1985.

Leung, Peter C. Y. "When a Haircut Was a Luxury: A Chinese Farm Laborer in the Sacramento Delta." *California History* 65, no. 2 (Summer 1985): 210–17, 244.

Lewis, Lowell N. "A Vital Resource in Danger." *California Agriculture* 38, no. 10 (October 1984): 2.

Loftis, Anne. *California: Where the Twain Did Meet.* New York: Macmillan, 1973.

Ludlow, Lynn. "Valley Folk Cling to Hope Fog Will Dissipate Someday." *San Francisco Examiner,* December 29, 1985, B1, 4.

MacCannell, Dean. "Agribusiness and the Small Community." *Technology, Public Policy, and the Changing Structure of American Agriculture.* Background Papers, vol. 2. Washington, D.C.: Office of Technology Assessment, 1986.

McDaniel, Wilma Elizabeth. *A Girl from Buttonwillow.* Special issue of *The Wormwood Review* 30, nos. 2–3 (November 1990).

——— *Sister Vayda's Song.* New York: Hanging Loose Press, 1982.

McGowan, Joe. "Racing on the River." *Golden Notes,* Spring 1980, 1–10.

McGowan, Joseph A. *History of the Sacramento Valley.* 3 vols. New York: Lewis Historical Publishing Company, 1961.

——— *The Sacramento Valley: A Students' Guide to Localized History.* New York: Teachers College Press, 1967.

McWilliams, Carey. *California: The Great Exception.* Santa Barbara: Peregrine Smith, 1976.

——— *Factories in the Fields.* Santa Barbara: Peregrine Smith, 1971.

Maharidge, Dale. "An Unseen Tragedy Stalks Troubled Town." *Sacramento Bee,* February 22, 1987, A3.

Marshall, Robert Bradford. *Irrigation of Twelve Million Acres in the Valley of California.* Berkeley, 1919.

Martin, Glen. "At the Public Water Trough." *This World,* January 29, 1989, 14–16.

Masumoto, David Mas. *Country Voices: The Oral History of a Japanese American Family Farm Community.* Del Rey, Calif.: Inkada Countryside Publications, 1987.

Matthews, Alice Madely. "The Great Flood of 1861." *Golden Notes,* Summer 1982, 1–22.

Maughn, Thomas, II. "Central Valley Fog Found to Be Highly Polluted." *Los Angeles Times,* February 12, 1987, I1, 36.

Medeiros, Joseph L. "The Future of the Great Valley Pools." *Fremontia* 4, no. 3 (October 1976): 24–27.

Melenbacker, Laura, ed. *Lore of Madera: Through Juniors' Eyes,* vol. 2. Madera: Madera Union High School, 1965.

Miller, Sally, and Mary Wedegaetner. "Breadwinners, and Builders: Stockton's Immigrant Women." *The Californians* 4, no. 4 (July–August, 1986): 8–28.

Minick, Roger, and Dave Bohn. *Delta West: The Land and People of the Sacramento–San Joaquin Delta.* Berkeley: Scrimshaw Press, 1969.

Mitchell, Annie. *Land of the Tules.* Visalia: Visalia Delta-Times, 1949.

Muir, John. "The Bee Pastures." *The Mountains of California.* New York: The Century Company, 1894.

Muller, Thomas. *The Fourth Wave: California's Newest Immigrants.* Washington, D.C.: Urban Institute Press, 1984.

Nava, Julian, and Bob Barger. *California: Five Centuries of Cultural Contrasts.* Encino, Calif.: Glencoe, 1976.

Neal, Roger. "They Come to Work." *Forbes,* March 11, 1985, 76–77, 80, 82.

Oakeshott, Gordon B. *California's Changing Landscapes: A Guide to the Geology of the State.* New York: McGraw Hill, 1971.

O'Brien, Robert. *California Called Them.* New York: McGraw-Hill, 1951.

Oglesby, Jack. "Chrysopolis: The Sacramento River's Most Glamorous Paddlewheeler." *Golden Notes,* Winter 1987, 1–28.

Ornduff, Robert. *Introduction to California Plant Life.* Berkeley: University of California Press, 1974.

Parsons, James J. "A Geographer Looks at the San Joaquin Valley." *Geographical Review,* October 1986, 371–89.

Parsons, Rod. "Schools and Education in Allensworth." *The Plow,* March 1984, 1–4.

"Paul Schuster Taylor, California Social Scientist." Transcribed oral history, Bancroft Library, University of California, Berkeley, 1975.

Pappagianis, Demosthenes and Lars Einstein. "Tempest from Tehachapi Takes Toll or Coccidioides Conveyed Aloft and Afar." *The Western Journal of Medicine,* December 1978, 527-530.

Payne, Walter A., ed. *Benjamin Holt: The Story of the Caterpillar Tractor.* Stockton: Holt-Atherton Pacific Center for Western Studies, 1982.

Pearsall, Robert, and Ursula Spier. *The Californians: Their Writings of Their Past and Present.* San Francisco: Hesperian House, 1961.

Peattie, Noel. "Meanwhile, Back at the Ranch." *Sipapu,* Spring 1986, 2–22.

Pisani, Donald J. *From the Family Farm to Agribusiness.* Berkeley: University of California Press, 1984.

Pollock, Kent. "Shrinking Stomachs a Growing Problem in Sacramento." *The Sacramento Bee,* February 22, 1987, A1.

Poole, William. "The Mountains in the Middle." *This World,* April 10, 1988, 7–8.

——— "Remnants of California's Great Lake." *This World,* July 12, 1987, 5–6.

——— "Retracing a Trail of Tears." *This World,* August 7, 1988, 8–9.

Porgrans, Patrick. "The Great Drought Hoax." *San Francisco Bay Guardian,* September 7, 1988, 7–9, 12.

Powell, Lawrence Clark. *California Classics.* Los Angeles: Ward Ritchie Press, 1971.

Powers, Stephen. *Tribes of California.* Government Printing Office, 1877. Berkeley: University of California Press, 1976.

Preston, William L. *Vanishing Landscapes: Land and Life in the Tulare Lake Basin.* Berkeley: University of California Press, 1981.

Rector, Liam. "An Interview with Philip Levine." *AWP Newsletter,* September–October, 1987, 4–9.

Redmond, Judith. *Troubled Waters—Troubled Lands.* Davis: California Institute for Rural Studies, 1989.

Reid, Dixie. "On the Road." *Sacramento Bee,* December 10, 1988, Scene 1, 4–5.

Reisner, Marc. *Cadillac Desert: The American West and Its Disappearing Water.* New York: Viking, 1986.

——— "California Fraud: Bending the Laws of Nature." *This World,* August 17, 1986, 10–12.

——— "Delta Shakedown." *Pacific Discovery* 41, no. 4 (Fall 1988): 18–19.

Rice, Richard, William Bullough, and Richard Orsi. *The Elusive Eden: A New History of California.* New York: Alfred A. Knopf, 1988.

Ridge, John Rollin. *The Life and Adventures of Joaquin Murieta, the Celebrated California Bandit.* San Francisco: W. B. Cook, 1854.

Rintoul, William. *Oildorado: Boom Times on the West Side.* Fresno: Valley Publishers, 1978.

——— *Spudding In: Recollections of Pioneer Days in the California Oil Fields.* San Francisco: California Historical Society, 1976.

Robinson, W. W. *The Story of Kern County.* Los Angeles: Title Insurance and Trust Company, 1961.

Rodriguez, Richard. "Reflections on the Flatland." *California*, May 1987, 63, 113.

Rojas, Arnold R. *These Were the Vaqueros: The Collected Works of Arnold R. Rojas*. Shafter, Calif.: Chuck Hitchcock, 1974.

Rolle, Andrew F. *California: A History*. Arlington Heights, Ill.: AHM Publishing Corporation, 1978.

Roosevelt, Theodore, Theodore S. Van Dyke, D. G. Elliot, and A. J. Stone. *The Deer Family*. New York: Macmillan, 1902.

Royce, Josiah. *California, from the Conquest in 1846 to the Second Vigilance Committee in San Francisco: A Study in American Character*. New York: Alfred A. Knopf, 1948.

Scheuring, Ann Foley, ed. *A Guidebook to California Agriculture*. Berkeley: University of California Press, 1983.

Schwartz, Joel. "Poisoning Farmworkers." *Environment*, June 1975, 32.

Sears, Paul. *Deserts on the March*. Norman, Okla.: University of Oklahoma Press, 1947.

Secrest, William. "The Horrifying History of a Highwayman's Head." *The Californians*, November–December 1986, 28–34.

Smith, Felix E. *A Double Threat to California's Wetlands*. Sacramento: United States Fish and Wildlife Service, n.d.

Smith, Gar. "Science Fails the Condor." *This World*, February 23, 1986, 9–12.

Smith, Henry Nash. *Virgin Land: The American West as Symbol and Myth*. Cambridge: Harvard University Press, 1970.

Smith, Wallace. *Garden of the Sun*. Fresno: Max Hardison, 1939.

Smoley, Richard. "Democracy in Research?" *California Farmer*, March 7, 1987, 2.

——— "Telling Our Story." *California Farmer*. February 21, 1987, 2.

——— "You See?" *California Farmer*, March 7, 1987, 8, 38–39.

Starr, Kevin. *Americans and the California Dream, 1850–1915*. New York: Oxford University Press, 1973.

——— *Inventing the Dream: California Through the Progressive Era*. New York: Oxford University Press, 1985.

Stebbins, G. Ledyard. "Ecological Islands and Vernal Pools." *Fremontia* 4, no. 3 (October 1976): 12–18.

Stein, Walter. *California and the Dust Bowl Migration*. Westport, Conn.: Greenwood Press, 1973.

Steinhart, Peter. "A River of Birds." *Pacific Discovery*, October–December 1987, 16–33.

Stone, Irving. "California." In *American Panorama: West of the Mississippi*. Garden City, N.J.: Doubleday, 1960, 35–57.

Street, Richard Steven. *A Kern County Diary*. Bakersfield: Kern County Museum, 1983.

Swan, Christopher. "A Vision of the Valley." *California Living*, December 30, 1979, 8, 10.

Tarr, Denise. "Lost in the Tules." *Aqueduct* 54, no. 3 (1988): 2–6.

Taylor, Bayard. *El Dorado; or Adventures in the Path of Empire*. Glorieta, N.M.: Rio Grande Press, 1967.

Taylor, Paul Schuster. "The Excess Land Law." *Rocky Mountain Law Review* 30 (1958): 499–508.

Thompson and Warren. *Business Directory and Historical and Descriptive Hand-Book of Tulare County, California*. Tulare: Pillsbury and Ellsworth, 1888.

Thompson, Don. *Granite Station*. Bakersfield: Self-published, 1977.

Thompson, John. "The People of the Sacramento Delta." *Golden Notes*, Fall–Winter, 1982, 1–41.

——— "The Settlement Geography of the Sacramento–San Joaquin Delta." Unpublished thesis, Stanford University, 1957.

Tosi, Umberto. "The New Water Politics." *Image*, December 6, 1987, 26–27, 40.

"Toxic Threat of Selenium at New Sites." *San Francisco Examiner*, May 11, 1988, A1, 22.

Ulrich, Katharine. "Vital Statistics: A Factual Profile of California's Heartland." *Pacific Discovery*, July–September 1986, 25.

Veinberg, Jon, and Ernest Trejo, eds. *Piecework*. Albany, Calif.: Silver Skates, 1987.

Villarejo, Don. "Farm Restructuring and Employment." *Rural California Report*, January 1989, 2–3.

——— *How Much Is Enough?* Davis: California Institute for Rural Studies, 1986.

Villarejo, Don, and Judith Redmond. *Missed Opportunities—Squandered Resources*. Davis: California Institute for Rural Studies, 1988

Viviano, Frank. "Make Way for the New Californians." *West*, March 11, 1984, 5–7, 20–25.

——— "Stanislaus County Says It Might as Well Join Bay Area." *San Francisco Chronicle*, February 28, 1990, A1, 8.

Wallace, David Rains. "The Living, Dying Bay." *Image*, December 6, 1987, 17–18, 25–26, 28, 41–42.

Wallace, David Rains, and Morley Baer. *The Wilder Shore*. San Francisco: Sierra Club / Yolla Bolly Press, 1984.

Wallace, William J. and Francis A. Riddell eds. *Contributions to Tulare Lake Archaeology*. Redondo Beach: The Tulare Lake Archaeological Research Group, 1991.

Wasserman, Jim. "Meet the Hydraulic Brotherhood." *Fresno Bee*, April 16, 1989, B1.

Watkins, T. H. "California: The New Romans." *The Water Hustlers*. San Francisco: Sierra Club, 1971.

Weaver, Nancy. "Federal Cuts Feed a Rise in Poverty." *Sacramento Bee*, February 22, 1987, A1.

Wells, Rob. "Grape Claim 'Reckless,' Group Says." *San Francisco Examiner*, August 12, 1988, A7.

Williams, Ann. *Midgebuzzings*. Tehachapi, Calif.: Beco-Sierra Graphic Services, 1985.

Wischemann, Trudy. "Resource Distribution and Community Development: A Case Study from Rural California." *Environmental Change/Social Change* (Proceedings of the 16th. conference of the Environmental Design Research Association, New York, June 10–13, 1985), ed. Stephen Klein, Richard Wener, Sheila Lehman. New York: Environmental Design Research Association, 1985.

Witham, Helen. "Rings of Bright Color and Puddles of Sky." *Fremontia* 4, no. 3 (October 1976): 7–8.

Wogaman, Emily, ed. *Lore of Madera*, vol. 3. Madera: Self-published, 1966.

Wollenberg, Charles. "A Usable History for a Multicultural State." *California History* 64, no. 2 (Summer 1985): 202–9, 243–44.

Wollenberg, Charles, ed. *Ethnic Conflict in California History*. Los Angeles: Tinnon-Brown, 1970.

Worster, Donald. *Rivers of Empire: Water, Aridity and the Growth of the American West*. New York: Pantheon, 1985.

Young, Stanley P., and Edward A. Goldman. *The Wolves of North America*. New York: Dover, 1944.

Additional Box Sources:

Asilomar Declaration for Sustainable Agriculture. 1990 Ecological Farming Conference, January 9–12.

Black, Michael. *Human Gods, Natural Woes*. Doctoral dissertation, unpublished.

California Institute for Rural Studies. Commissioned research on various subjects, 1989.

Census of Agriculture 1987. Vol. 1, Part 51, United States, Summary and State Data, U.S. Department of Commerce, Bureau of the Census, November 1989, State Data, Table 3: Farm Production Expenses: 1987 and 1982, pp. 165 ff.

Census of Agriculture 1987. Vol. 1, Part 5, California, State and County Data, U.S. Department of Commerce, Bureau of the Census.

Eroding Choices, Emerging Issues. American Farmland Trust, 1986.

Haslam, Gerald. "Workin' Man's Blues" (in *Voices of a Place*). See Bibliography.

Herman, Masako. *The Japanese in America, 1843–1973*. Dobbs Ferry, New York: Oceana Publications, 1974.

Jacobson, Thorkild, and Robert M. Adams. "Salt and Silt in Ancient Mesopotamian Agriculture," *Science*, Vol.128, No. 3334, November 1958, pp. 1251–58.

Mumford, Lewis . *Myth of the Machine*, Vol. 1, *Technics and Human Development*, New York: Harcourt, Brace, Jovanovich, 1967.

Pesticide Use Report, 1988 and *Pesticide Use Report by Commodity*. State of California, Department of Food and Agriculture, 1990. State of California, Joint Legislative Audit Committee, Office of the Auditor General, The California Agricultural Experiment Station, Report P-906.2, March 21, 1980.

Sabadell, J. Eleanora, Edward M. Risley, Harold T. Jorgenson, and Becky S. Thornton. *Desertification in the U.S.: Status and Issues*. Bureau of Land Management, GPD 153, 2:D45 2, April 1982.

Taylor, Paul Schuster. *Essays on Land, Water, and the Law in California*, 1979.

U.S. Department of the Interior, Bureau of Reclamation, *Statistical Summary*, Vol. 3, 1986.

Illustration Accession References:
(where available)

Artist Unknown.

———Engravings on pages 27 & 28 from *Tribes of California*. Stephen Powers. Government Printing Office, 1877. Berkeley: University of California Press, 1976.

———Engravings on pages 40, 44, 142, 204 from *Marvels of the New West*. William M. Thayer. The Henry Hill Publishing Company, Norwich, Conn, 1890.

———*Sacramento Valley Engraving*, from original drawing. Page 87. California State Library #4049.

———*The Extermination of Wild Geese, Colusa County*. Page 105. California Historical Society Neg #5367.

Bierstadt, Albert. *Sacramento Valley Spring*, 1879. Page 232. The Fine Arts Museums of San Francisco.

Browere, Alburtus del Orient. *View of Stockton, 1854*. Page 240. Gift of the Kahn Foundation, Oakland Museum, #65.64.

Collom, Geo. G. *Gilbert Ranch, Chico, Butte Co*. Page 39. Gift of Albert Dressler. California Historical Society, neg #6246.

Cosgrave, John O'Hara. Illustrations on pages 65, 96, 136. *The Sacramento, River of Gold*. Julian Dana. Farrar and Rinehart, New York, 1939.

Croocks, J.B.M. & Co. *Sacramento City Waterfront with contemplated improvements*. 1855-56. Page 60. Copied from lithograph, McCurry Photo Collection, California State Library, neg # 631.

Curtis, Edward S. *Yokuts Woman, Chukchansi tribe (no date)*. Page 32. The Southwest Museum, item # N. 37653.

Dixon, Rolland B. *Johnny Paiyute (Maidu)* 1900. Page 32. American Museum of Natural History Neg #12232.

———*Johnny Bob (Maidu)* 1900. Page 33. American Museum of Natural History, Neg #12239.

———*Lawson Anderson (Maidu)* 1900. Page 33. American Museum of Natural History, Neg #12556.

Galloway, Ewing. *Acres of barrels of green olives in the heart of the olive growing district. Lindsay, Tulare County*. Page 54. Philadelphia Commercial Museum. California Historical Society, #158401.

Gifford, R. Swain. *The Marysville Buttes*. Page 94. *Picturesque America*. William Cullen Bryant, ed. New York: D. Appleton and Company, 1872.

Hahn, William. *Harvest Time, Sacramento Valley, 1875*. Page 111. The Fine Arts Museums of San Francisco. Gift of Mrs. Harold R. McKinnon and Mrs. Harry L. Brown, Accession No. 1962.21.

Lange, Dorothea. *Kern County, 1938*. Page 14. Library of Congress, LC-USF 34 Neg #18401.

———*Migratory Field Worker Picking Cotton, San Joaquin Valley, 1938*. Page 47. Library of Congress, LC-USF 34-Neg #18392-E (U.S. Dept. of Agriculture, FSA).

———*Ditched, Stalled, and Stranded, San Joaquin Valley, 1935*. Page 135. Library of Congress, LC-USF 34-Neg. #2470-E.

———*Bean Thresher, 1936*. Page 137. Library of Congress, LC-USF 35-Neg. # 9852-C (U.S. Dept. Agriculture, FSA).

———*Disk Plow Drawn by 7-Horse Team. Tulare, 1937*. Page 237. Library of Congress, LC-USF 34 Neg #16564-E.

Lee, Russell. *Shasta Dam Construction, 1942*. Page 212. Library of Congress, LC-USF 34-Neg #38128-D (U.S. Dept. Agriculture, FSA).

Merriam, C. Hart. *Joe Guzman (Yokuts) 1934*. Page 33. Lowie Museum of Anthropology, University of California, Berkeley, cat #23-206.

———*Chowchilla Family (Miwok) 1903*. Page 32. Lowie Museum of Anthropology, University of California, Berkeley, cat. # 23-221.

———*José Vera (Yokuts) 1935*. Page 32. Lowie Museum of Anthropology, University of California, Berkeley, cat. # 23-207.

———*Capitan Eph (Miwok) 1903*. Page 33. Lowie Museum of Anthropology, University of California, Berkeley cat #23-224.

Narvaez, Jose Maria. *Plano del Territorio de la Alta California, 1830*. Page 29. Bancroft Library, Map 5.C2 1830a B.

Photographer Unknown.

———*Cotton Strike, San Joaquin Valley, 1933*. Page 168. Paul Taylor Collection, Library of Congress, LC-USF 344 Neg #RA 7488-ZB.

————*Irrigating, Stanislaus County*. Page 45. California Historical Society #5748.

————*Loading Grapes, Ripon*. Postcard. Page 55. California State Library, neg # 22294.

————*Mexican Agricultural Laborers Topping Sugar Beets, Stockton 1943*. Page 169. Library of Congress. LC USW 3-Neg #26242-D.

————*Nellie Graham and baby (Yokuts) 1922*. Page 32. Lowie Museum of Anthropology, University of California, Berkeley cat # 6861.

————*Southern Maidu Man c. 1850*. Page 33. The Southwest Museum Item #N24675.

————*Wildflower field. Bakersfield, Kern circa 1937*. Page 54. California State Library neg # G 3386, neg # 23903.

Watkins, Carleton. *Photographic Views of Kern County California, 1888*. Library of Congress Prints and Photographs Collection (400 prints, acquired 1929), and the Kern County Library.

————*Malakoff Diggings, 1871*. Courtesy of the Fraenkel Gallery, San Francisco.

Interviews, Lectures, Conversations, and Exchanges of Letters:

Many of the quotations included in this text, as well as some key insights, were the products of personal exchanges over a seven-year period (1985–91). While these cannot be included in the bibliography, they merit noting. The following folks, knowingly or not, contributed material:

Terry Alexander
Tom Alexander
Michael Black
L.T. Burcham
Ken Byrum
H. O. Carter
Lloyd Carter
Frances Clark
William Davoren
Fred Dominguez
Rachel Dominguez
Francis DuBois
Stan Dundon
James Fix
Isao Fujimoto
Camille Gavin
Harold Gilliam
Fred M. "Speck" Haslam
Lorraine Haslam
James D. Houston
Alberto Huerta
Dolores Huerta
W. H. Hutchinson
Francisco Jiminez
Hector Lee
Leo Lee
Eddie Lopez
Larry Lopez
Dan Markwyn
Justin Meyer
Claude Minard
Joseph Molinaro
Michael Moratto

Kirby Moulton
Clyde Nance
Richard Orsi
Lucha Ortega
Isabel Plank
William Preston
Patricia Puskarich
DeWayne Rail
D. W. Rains
James J. Rawls
Floyd Renfrow
William Rintoul
Dudley Roach
Richard Rodriguez
Arnold Rojas
Aldo Sansoni
Richard Smoley
Carolyn Soto
Gary Soto
Robert Speer
Garrison Sposito
Wallace Stegner
Bob Stephens
Clayton Turner
Levi Turner
Alvin Urquhart
Don Villarejo
Gerald White
Sherley Anne Williams
Trudy Wischermann
George Zaninovich

Index

Page numbers in italics refer to illustrations.

Colophon

Text:
Adobe Granjon
Adobe Goudy Italic

Display Type:
Adobe Trajan

Page Layout:
Aldus PageMaker
Quark X-Press

Illustration Software:
Adobe Illustrator
Adobe Photoshop
Aldus Freehand

Image Restoration Software:
Adobe Photoshop

Color Separations:
Color Tech, Redwood City, CA, and Stephen Johnson using Adobe Photoshop and Candela 4 Seps

Film Output:
Color Tech, Redwood City, CA and DPI, San Francisco

Printer:
Tien Wah, Singapore

Paper:
157 gsm V-Matt LX

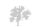

About the Photographs

Approximately 10,000 negatives were made in the course of the five years of field work for this project. Reproductions in this book were scanned from exhibition prints, original negatives and transparencies. Scanners included a Crosfield 636 drum scanner, a Leafscan 45, an Agfa Horizon, and a Ricoh IS60 and FS1. Separation film was output to an Agfa Select-Set 5000 and a Scitex Dolev imagesetter.

The Frank Robinson photographs came to the project in a very circuitous fashion. As the story goes, boxes of Robinson's glass-plate negatives were discovered and retrieved from the Merced County Dump sometime in the 1940's. They then sat in a local garage for another 40 years until James Docherty started to print and preserve the collection. He generously loaned many of the plates to make the prints reproduced here.

Stephen Johnson's photographs were made with a 4x5 Graphic View, a 4x5 Burke and James, a Mamiya RB67, a Brooks Veri-Wide, and a Graflex K-20 aerial 5" roll-film camera.

Robert Dawson's photographs were made with a 4x5 Calumet View, and a Brooks Veri-Wide camera.

Kodak Vericolor negative film was used for most of the color work. Agfapan 25 and 100 and Ilford FP-4 were used for most of the black and white photographs, with Agfa Rodinal and Edwal FG-7 used as film developers. Prints were made on Oriental Seagull paper and Kodak Ektacolor paper.

About This Book

This book was conceptualized on many trips back home from 1982 through 1986. When it came time to put those ideas down on paper, they were translated with the help of a computer. This book was designed entirely on an Apple Macintosh computer over the period 1988 through 1992.

Design began with a Macintosh II computer with 5 mb of RAM, an 80 mb hard drive with a standard 8 bit 13 inch color monitor. That equipment was supplemented with a rewritable optical disk drive, a 24 bit 19 inch color monitor and a dye-sublimation color printer. A Macintosh IIfx with 128 mb of RAM and a Macintosh Quadra 950 with 256 mb of RAM were added to the configuration along with flatbed and slide scanners.

Output was direct to film for proofing and printing plates. Some of the color separations and duotones were done directly on the Macintosh; all scans were soft proofed on-screen.

Image restoration was done on some of the historical photographs, primarily for the purpose of removing the artifacts of age (mostly cracks and serious scratches). In some cases, contrast and brightness were altered to make the image more visible. No real objects were removed from, or added to, any of the photographs.

I am very grateful to the following companies, whose donation of equipment, software and services helped make this book possible.

–Stephen Johnson

Adobe Systems
Mountain View, California

Newer Technology
Wichita, Kansas

Aldus Corporation
Seattle, Washington

Ricoh Corporation
San Jose, California

Apple Computer
Cupertino, California

Relax Technology
Union City, California

Barneyscan Corporation
Hayward, California

SuperMac Technology
Sunnyvale, California

Caere Corporation
Los Gatos, California

Color Tech Corporation
Redwood City, California

Digital Pre-Press International
San Francisco, California

Eastman Kodak
Rochester, New York

The Authors

Stephen Johnson
Editor/Designer
The Great Central Valley: California's Heartland
Co-director and Photographer
The Great Central Valley Project

Stephen Johnson is a photographer, teacher, designer, and curator. His photography explores the concerns of a landscape artist working in an increasingly over-developed world.

He was the editor and designer for his first book, *At Mono Lake* (1983), and Exhibition Coordinator for the exhibit from which it was drawn. *At Mono Lake* received an National Endowment for the Arts grant in 1980. The exhibit surveyed 115 years of photography at this endangered lake by 53 photographers and toured nationally with the Art Museum Association, reaching an audience of two million people. In 1984 he was invited to curate an exhibit including his work for display in the United States Senate. In 1988 he was given a *Congressional Special Recognition Award* for his work on behalf of Mono Lake.

With Robert Dawson, he created *The Great Central Valley Project* exhibit on which this book is based.

Johnson's photography includes *Western Artifacts,* a color series depicting icons on the western landscape. Recently, his work has explored computers as new photographic and design tools. *The Great Central Valley: California's Heartland* was designed on an Apple Macintosh computer. His work in digital photography has included software and technology development and consulting for Eastman Kodak, Apple Computer, Adobe Systems, Leaf Systems, and Ricoh Corporation.

Johnson's work has been exhibited nationally and published in many national and regional magazines including: *Audubon, American Photographer, Omni, Sierra, California* Magazine, *Pacific Discovery, California History, Camerawork Quarterly,* and *The New York Times.* His work has been featured in The Mono Lake Coalition's *Mono Lake Calendar* (1986-92), in the book *One Earth* (1991), and in public and private collections.

A native of Merced, he earned his B.A. and M.A. from San Francisco State University. He teaches photography at Foothill College, and in his own workshop program since 1977.

Gerald Haslam
Author
The Great Central Valley: California's Heartland

A native of Oildale, Gerald Haslam writes fiction and nonfiction that explores his Valley home and its complex identity. He has published six collections of short stories including *Okies* (1973), *Snapshots* (1985), and *That Constant Coyote* (1990), which won the Josephine Miles Award from PEN Oakland. Haslam has also written three essay collections—*Voices of a Place* (1987), *Coming of Age in California* (1990) and *The Other California* (1990)—as well as a novel, *Masks* (1976).

Also a literary anthologist, he most recently edited *Many Californias: Literature from the Golden State* (1991). Earlier he produced *Forgotten Pages of American Literature* (1969) and *Western Writing* (1974), and co-edited (with James D. Houston) *California Heartland: Writing from the Great Central Valley* (1978) and (with Thomas J. Lyon et al.) *A Literary History of the American West* (1978).

Haslam's stories, essays, and articles have been published in numerous periodicals and are widely anthologized. His work is the subject of a booklet written by Gerald Locklin for Boise State University's Western Writers Series, as well as numerous essays, scholarly papers, and theses. He is a graduate of San Francisco State University, where he earned both bachelor's and master's degrees, and of Union Graduate School, where he was awarded his Ph.D. Haslam is Professor of English at Sonoma State University.

Robert Dawson
Co-director, Photographer
The Great Central Valley Project

Robert Dawson's photographs of the American West have been recognized by a Visual Artists Fellowship from the National Endowment for the Arts, a Ruttenberg Fellowship from The Friends of Photography, a Photographer's Work Grant from the Maine Photographic Workshops, and a James D. Phelan Award through the San Francisco Foundation.

His first book, *Robert Dawson Photographs* (1988), was published by Min Gallery in Japan. Portfolios of his work were recently published in Aperture 120 "Beyond Wilderness" and *Between Home and Heaven: Contemporary American Landscape Photography* (Smithsonian Institution, 1992). He is founder and co-director of the Water in the West Project, a large-scale collaboration with several other photographers. His work, along with others' from the project, was recently published in *A River Too Far: The Past and Future of the Arid West* (1991). A second book of the project's work, *Arid Waters: Photographs from the Water in the West Project,* will be published in 1992.

He is currently working on the Water in the West Project with his wife Ellen Manchester and nine other photographers, the California Toxics Project with Lonny Shavelson, the Pyramid Lake Project with Peter Goin, and the Wisconsin Land Project.

Dawson's photographs have been widely exhibited and are in the permanent collection of the Museum of Modern Art in New York, the National Museum of American Art (Smithsonian Institution) in Washington, D.C., the Museum of Modern Art in San Francisco, and the Museum of Fine Arts in Houston.

A native of the Central Valley, Dawson received his B.A. from the University of California at Santa Cruz and his M.A. from San Francisco State University. He currently teaches at San Jose State University and City College of San Francisco.